We also recommend two separate Collector's Editions with photographs by Steve Schapiro:
Wir empfehlen Ihnen auch die beiden Collector's Editions mit Fotografien von Steve Schapiro:

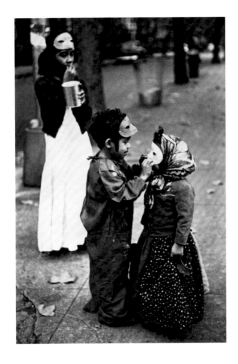

Halloween in Brooklyn Heights, 1960
(p. / S. 67)
Handmade print, with signed book /
Handabzug mit signiertem Buch
Sheet size / Blattgröße: ca. 38 x 28 cm
Limited edition of 18 + 4 a.p., signed
and numbered / Limitierte Auflage von
18 + 4 e. a., signiert und nummeriert

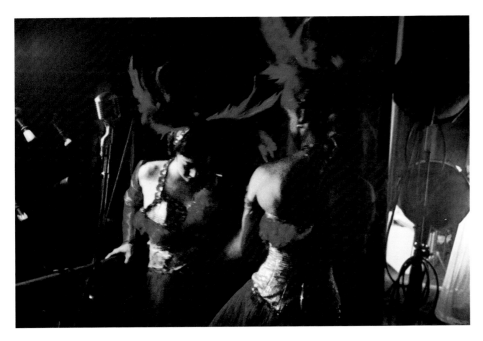

Dancers at The Apollo Theater,
Harlem, 1961
(pp. / S. 104–05)
Fine Art Premium Print on /
auf Hahnemühle Photo Rag 308 g, with /
mit UPON PAPER #02
Sheet size / Blattgröße: ca. 50 x 60 cm
Limited edition of 100 + 10 a.p., signed
and numbered / Limitierte Auflage von
100 + 10 e. a., signiert und nummeriert

Mit weiteren Fragen oder Ihrer Bestellung wenden Sie sich bitte an collectorseditions@hatjecantz.de.
For more information or to place an order, please contact Hatje Cantz at collectorseditions@hatjecantz.de.

HATJE
CANTZ

STEVE SCHAPIRO

For Maura
without whom this book
could not have happened

# STEVE SCHAPIRO
## THEN AND NOW

HATJE
CANTZ

# CONTENTS

Matthias Harder

# CHARACTERS, IN FILM AND ON THE STREET

There are extremely diverse approaches for getting close to fellow human beings with the camera; this is why each photographer should develop a unique selling point in the course of his or her career, which applies to portraiture as well as to other genres. Steve Schapiro has succeeded in doing so. We have him to thank for the impressive photographs from the sets of such films as *The Godfather* and *Taxi Driver*. Yet beyond these icons, there is also a multifaceted oeuvre that has nothing to do with film.

From early on, Steve Schapiro already welcomed Henri Cartier-Bresson's proverbial "decisive moments" in photography with enthusiasm. In attempting to emulate his famous colleague, he initially floundered, he says, and first returned to visualizing the world photographically via detours through literature. Since studying with the prominent American magazine photographer W. Eugene Smith, Schapiro has worked journalistically and documentarily from 1961 up to the present day—not only shooting portraits of actors and musicians. His photographs have been published in prestigious magazines and on numerous covers around the world, including *Life*, *Look*, *Vanity Fair*, *Paris Match*, *People*, and *Rolling Stone*—with people as the constant focus of his work. For half a century, he has been creating innumerable photographs, with black and white and color on an equal footing, of many famous contemporaries, mostly of American origin; but Schapiro is also interested in his fellow "unknown" human beings, as we can see throughout this book. In his photographs, they are stylized into types within the open-air studio of big cities—those theaters of everyday life. Many of these portraits have been transformed into genre scenes that we might also associate with street photography. It was the era of so-called humanistic photography, and it thus comes as no surprise that Schapiro, commissioned by magazines, actively turned his camera toward socially critical and political subjects in the nineteen-sixties, subjects such as the difficult working and living conditions of migrants in Arkansas, the situation after the assassination of Martin Luther King, Jr., or Robert F. Kennedy's campaign for president—all of this can be encountered in this monograph, which amounts to a survey of Steve Schapiro's oeuvre. He is thus among the great storytellers of America, even when this story is compressed into static, two-dimensional images.

The New York photographer seems to react to picture-taking situations more spontaneously than many of his colleagues—occasionally even creating such situations himself. He has an immense talent for communication and empathy; without it, such various and discrete modalities of expression would be simply impossible. Steve Schapiro seems to look at and behind the façade of human life while subtly playing with any antagonisms that may arise at the same time. He thus becomes a precise observer of natural self-awareness, of artificial poses, or shy looks. Schapiro not only documents the appearances of his famous or nameless contemporaries but also captures their charisma; among them, there are lots of characters. This all remains admittedly subjective.

Since the beginning of the nineteen-seventies, he has been interested in the medium of film and its protagonists—since then, Schapiro's portraits of actors have been used for advertising or as poster motifs, and many of his portraits of musicians have landed on record covers. Thus, within celebrity photography, he has continued the pictorial language of an Alfred Eisenstaedt or Edward Quinn. At the same time, the first paparazzi were emerging and obtaining access to the world of actors and musicians, the rich and the beautiful, with intrusive tricks—their "stolen" snapshots, including, for example, Ron Galella's famous photographs of Jackie O., were offered to the highest bidders from the same magazines for which Schapiro was working. Nevertheless, it would still be a huge step to David LaChapelle's gaudily colored photographs of American society and its cult of the celebrity, staged with the stylistic device of exaggeration.

Steve Schapiro, in contrast, is more interested in straight-line image compositions without baroque or dramatizing ornateness. His works include surprisingly few classical studio shots. The majority of his photos are created in public space, on filmsets, or in private surroundings. Staged images stand on an equal footing next to spontaneously created images, and, despite some action or reaction of those portrayed, Schapiro's photographs seem measured and serene. They combine distance and proximity, concentration and immediacy: at times an open and expectant gaze is present, such as in the case of Orson Welles and Marlon Brando, Frank Zappa, or children playing on the street; in other photos, a certain captivating concentration is present, as in the case of David Bowie and Aretha Franklin, Paul Newman or Steve McQueen. Nonetheless, we can never be sure whether the concentration that these media professionals present is not actually only a pose; yet the internalization in the photo of an unknown black man entering a church is real—sometimes, as we see here, Schapiro is also a clandestine observer. His portrait of Martin Scorsese is surprising in terms of the composition of the image: the director looks spellbound at the muzzle of a black pistol in his right hand while he holds some grapes in the left, as if wanting to balance out the two accessories. Before Schapiro's camera, Scorsese almost becomes the actor. This change of roles is not uncommon in Schapiro's photographic oeuvre. Acting and reacting converge at the moment the photo is taken.

In his street pictures, we encounter many people who are dressed up and masked, in a Batman costume, with a rabbit head, or in an anonymous mask; they relinquish their personality for a moment and slip into roles, despite not being professional actors. Barbra Streisand, in contrast, is figured here a few times: among others, in a representative portrait before a dark background, and again in an intimate snapshot with her son—a touching, human gesture. Many of his dramatis personae seem to forget Schapiro's camera while and at the same time valuing his presence as a person. The photographer has thus become an integral part of the art-scene jet set and of show business in general, although he prefers to work behind the scenes rather than on the red carpet.

In his portrait sessions, whether in the nineteen-seventies or today, what presumably prevails is an intellectual and communicative game of two equals, a giving and taking, a revealing and concealing. The photographer allows his protagonists enough space to choose their own staging, although he himself provides the majority of the staging ideas. Compelling portrait photography always attempts to elicit and channel the subjects' desire to present oneself. René Magritte, for example, appears in both of the portraits presented in this book as an actual figure in front of and in interaction with his illusionistic paintings, which are situated directly behind him. Woody Allen supposedly takes an ant for a stroll on a dog leash, or so we're at least told by the caption, while in another image, Dustin Hoffmann leaps through a long corridor while Schapiro's camera watches closely. We also

encounter Muhammad Ali as he knots a tiny pair of boxing gloves together, or Jack Nicholson, who grinningly sticks his tongue out at the photographer (and thus also at the viewer) during the filming of *Chinatown*. These are captivating characterizations of the actor and his role(s), and, as a result of such forms of interaction, the person opposite the camera becomes the photographer's accomplice. At the same time, these are unusual and surprising moments that also make the portraits into visual commentaries on those figured. Schapiro's virtually essential portraits can also be understood as providing an interpretation to us, the people who receive them, making us feel that we've come closer to the essence of those portrayed—which is, of course, pure illusion.

In Berlin, Steve Schapiro recently discovered a larger-than-life graffiti portrait of Marlon Brando in the role of Don Corleone on the wall of a building. Francis Ford Coppola's character and Steve Schapiro's iconic visualization have been, therefore, transposed into the present day by an unknown street artist with the assistance of a medial leap. Every photographer is a child of his or her time, of his or her generation. Only very few are able to jump between decades and styles and yet remain timelessly contemporary. Schapiro seems to succeed in doing so. With humor and curiosity, as fearless and indefatigable as ever, he continues to approach the stars and starlets, in front of and behind the scenes, as well as their public, his fellow human beings, all the way up to the globally active demonstrators of the Occupy movement. Early on, Schapiro developed an individual, essayistic style in his photography, with which he links himself to W. Eugene Smith and Henri Cartier-Bresson, and reflects, en passant, the spirit of the times. It is not only his famous individual photos and groups of works from his engagement with Hollywood that ensure him a firm place in the history of photography of the twentieth and twenty-first centuries, but also the diversity of his subjects and the sovereign, continuing mastery of them over such a long period of time.

"I photographed everything, from presidents to poodles"

# MATTHIAS HARDER IN CONVERSATION WITH STEVE SCHAPIRO

**Matthias Harder:** How did you come to photography and to people as your preferred subject matter?

**Steve Schapiro:** I started taking photographs when I was ten years old at summer camp. I still remember seeing those small deckle-edged prints miraculously form into images of clouds, skies, and lakes as they emerged from the chemical bath in our makeshift darkroom. But people became more interesting to me than landscapes, although I was initially shy about just shooting on the street. During my early teens, Henri Cartier-Bresson's *The Decisive Moment* book appeared and I was amazed at his ability to catch moments at the height of emotion and design. I went out onto the streets of New York City and tried to emulate his work, but often my timing was a few crucial seconds off and I would return with contact sheets that made no sense at all. For a while I stopped taking pictures and decided I wanted to become a novelist. The complexity of the human world has always intrigued me. After college I spent six months in Paris and Spain and wrote a book, which does happen to have four great pages if nothing else. I discovered with writing I was never sure if I had conveyed a visual image of a scene with words. While with photography you know at once what you are presenting. As a budding photographer the most alluring job you could imagine at the time was becoming a *Life* magazine photographer. I went out on my own to do essays on "Migrant Workers in Arkansas" and "Narcotic Addiction in East Harlem," and stories like that which I brought constantly to the *Life* picture editor. Finally I got my break and was assigned a story that worked out, and I continued to work for *Life* and other magazines. I have done covers for most of the magazines in the world from *Rolling Stone* to *Time, Life, Sports Illustrated, Vanity Fair, Stern,* and *Paris Match,* as well as the first *People* magazine cover.

**M.H.:** Over the years you have created an impressive body of diverse work. Does it bother you when people think of you foremost as a film still photographer?

**S.S.:** Yes, it does bother me when people think of me primarily as a film photographer. Because my photographs from *The Godfather* movies and *Taxi Driver* have been seen widely in the last few years I have been noted as a photographer who worked on movie sets. The documentary projects, which form the bulk of my work, and the stories I am presently involved with, have nothing to do with film. And these remain the focal point of my interest. Throughout the sixties, which has been called "the golden age of photojournalism" I worked constantly. As a photographer, if you had a good idea you could find a magazine that would assign you to do it. I was fortunate in the assignments I asked for and those that I received. I traveled with Bobby Kennedy and did his campaign posters. I photographed

the Selma March with Martin Luther King, Jr. I did Andy Warhol in The Factory and Muhammad Ali when he was still Cassius Clay. I photographed everything, from presidents to poodles. And when Dr. King was shot, *Life* had me go immediately to Memphis to cover this sad event, which changed history. This work and the projects I am involved with now are much more important to me than work I have done on films, even though I was fortunate enough to do iconic images for *The Godfather*, *Midnight Cowboy*, *Taxi Driver*, and many other major film productions. I never worked as a unit photographer but rather what is termed a "special photographer" who comes in to do photographs for advertising and publicity at the high points of production, with the hopes that he could place his images in major magazines throughout the world. For me there is little difference in the way you photograph people in the so-called real world or on a movie set. As a photographer, you are looking for those same qualities of emotion, design, and information that make a photograph successful. You are looking for that iconic moment that will reveal the spirit of a person or a specific moment in time. The only difference is that working on a movie set, if you have read the script then you have a good idea of what might be happening next, while in the outside world you can never be quite sure.

**M.H.:** Where do you prefer to see your photos published: in newspapers or magazines? In photo books or in exhibitions? Galleries or museums?

**S.S.:** I am most happy to see my photographs in museums. That is not to say that I do not treasure gallery exhibitions or books, where the flow of images contributes to form a larger sense of an event or a person perhaps more than a single photograph might. Although I have worked at photography for fifty years I still have the feeling that I've not yet come of age, and that my future lies ahead of me. I am hoping to better my craft and look to the future with new projects and new ideas. The nature of communication itself is constantly changing and always creates new possibilities for the photographer.

**M.H.:** You have photographed famous actors on the film set as well as anonymous people on the street. Which approach is easier?

**S.S.:** What determines the ease of photographing people on the street or actors on a film set is the attitude of the photographer. If you are relaxed and low-key, people tend to like you. Most people like the idea of being photographed as long as they feel that you are not making fun of them or have some devious purpose in mind. Of course, when photographing on the street, being quick and inconspicuous often helps, so that the intrusion is the camera's and not your personality. Actors often have a problem with still photography. While on a film set or stage, they know everything about the character they are playing inside and out, but when it comes to who they themselves are, facing a still camera can be an ordeal. They are often not sure of who they should be. They hear the click of the camera and become nervous as to what image they are projecting. It is no longer a role they are playing, and strangely being yourself becomes more complex. Working with particularly talented actors often becomes a great collaboration either consciously or unconsciously. Often they create ideas for you that are better than what you yourself might bring to the table. Working with Barbra Streisand, it was her ideas that motivated the images we formed for the *Streisand Superman* and *Lazy Afternoon* albums. David Bowie loved creating a whole range of visual characters, and the only problem was that you had to shoot quickly before he ran back into the dressing room to change into another persona.

**M.H.:** Photography "freezes" the moment; good portraits capture something narrative despite their immobility. Is your aim to tell a story with your photographs?

**S.S.:** It is always more fun to be able to tell a story in a single photograph, but not always possible. To tell a story, usually the surroundings become important because they tell you something about the life of your subject. When I did my series of photographs about migrant workers in Arkansas, when photographing in the fields and cabins, the surroundings crept into every portrait and depicted the hard life around them. W. Eugene Smith, whom I studied with, liked it when there were two points of interest in a photograph, so your eyes went back and forth and you gained more information. My photograph of James Baldwin holding an abandoned child could have been a tight portrait of the two of them, but deciding to include the cabin, the photographs, and the Christ tapestry all adds to the narrative quality.

**M.H.:** The actors and artists you photograph have a lot of room for self-expression in your portraits. Who comes up with the poses? Do you arrive at a photo shoot with a clear visual concept or do you react spontaneously to the given situation?

**S.S.:** Usually I do not come to a photo session with a set idea unless I am involved with props and how they will play into the final photographs. I may have done research, but for the most part I do not know what to expect and I am open to what may develop. I am, after all, looking for the unique qualities of a person I probably have not met before. While I do have preconceptions, I am open to what I may see.

**M.H.:** Some believe that every portrait is also a kind of self-portrait. What do you think?

**S.S.:** With certain photographers, the style of their images immediately expresses the photographer as well as the subject. An Irving Penn portrait, while revealing a strong aspect of the subject, is readily identifiable as an Irving Penn portrait. A Bill Brandt portrait is first and foremost a Bill Brandt portrait because of his lighting style and the high contrast quality of his prints. Since I do not work that much in a studio, my lighting may vary from session to session and I do not have a specific set of poses that I work toward. I try to keep a relaxed mood going and to keep my personality (except for a smile) as much as possible out of the picture. I want my subjects to be themselves, and then I quietly pounce. But every portrait you take is a self-portrait in the sense that the photographer chooses when to press the shutter button. A photograph may be worth a thousand words but a photograph is definitely not "truth." It is the photographer's unique point of view that determines when that button is pressed. I can show you as being happy or sad, presidential or deceitful. When that photograph appears in a magazine, millions of people will form an immediate opinion about who you are from the photograph I took.

**M.H.:** How has "people photography" changed over the years and decades?

**S.S.:** I first started working professionally in the sixties, which, as I mentioned before, was a big time for photojournalism. Shooting for a magazine like *Life*, you would often spend anywhere from four days to six months with a personality. While photographing the story you would be on a one-to-one basis. After the story was finished, you may never see them again, but during that time you had often seemed to be best friends. I did the first *People* magazine cover which heralded in an approach to what I call "media journalism." By the mid seventies, the Public Relations people had arrived and became dominant in the handling of their client's careers. The one-to-one relationship between photographer and subject was put in jeopardy. There was always a third person sitting in on everything and affecting the mood and direction of the shoot. Media journalism brought a change from a loose relationship with your subject—where, over time, you could develop a flow to your images and discover new facets of their personalities—to suddenly being confined to a two-hour notch of time

in which you had your subject change clothes every fifteen minutes to give the illusion that you had followed them for days, when the story appeared in a magazine. In terms of photography in general, the camera is almost obsolete. In 1963 there were still newspaper photographers working with a large four-by-five camera and flash bulbs they had to pop out after every exposure. Thirty-five-millimeter-film cameras were already popular and being used everywhere. Now digital has replaced film. But today, when you see a celebrity or political figure in a crowd, everyone has a smartphone held up. The smartphones continue to be refined so you can make larger and larger prints. Communications continues to change and it will change again. The secret to good photography is not in the equipment but in the unique imagination and qualities of the photographer. Everyone sees in a unique way, and the more unique you are the better your images.

**M.H.:** Have any of the prominent figures that you photographed ever insisted that the picture not be published, even though they consented at the time to the photo shoot? Did people sign releases at all in the nineteen-seventies?

**S.S.:** I first photographed Anthony Hopkins with a blood-smeared face holding two severed heads when he was working on Francis Ford Coppola's *Dracula* film. In the middle of the shoot Anthony realized his last movie had been *The Silence of the Lambs* and he asked me not to publish the photo we were doing, because the character had too many reminiscent qualities. On another occasion I was doing a magazine cover with the TV comedienne Carol Burnett and her daughter. I had worked with Carol quite a bit, and this time, as hard as I tried, there was hardly a moment where I could get a smile out of her. What she and the magazine had not told me was that the cover was about her daughter coming out of addiction rehabilitation.

**M.H.:** After such a long time of creative activity, isn't it difficult to remain curious about the next encounter with an actor you haven't met yet?

**S.S.:** Photographing film actors has been only a small portion of the work I've done. Because of the popularity of *The Godfather* and *Taxi Driver*, you tend to be typecast as one thing or another. In actuality, my first book *American Edge* had no film stars represented in it, and while *Schapiro's Heroes* had a series of Barbra Streisand photographs and one of Buster Keaton, the rest of the book had a more serious tone with the likes of Muhammad Ali, Martin Luther King, Jr., Samuel Beckett, and Robert F. Kennedy. But to answer your question, if you are not curious and energized about who or what you are shooting, why photograph at all?

**M.H.:** Do you still always leave the house with a camera (as do many photographers)? Or do you ever use your smartphone to take a picture?

**S.S.:** When I go out hoping to find a good situation to photograph, I use a camera as my visionary conveyer. While the smartphone will eventually make the camera obsolete, that as yet has not happened.

**M.H.:** Would you say that there is one particular photograph, which you have taken over the years, that is most important to you? Or do you consider all of your pictures (that you have accepted as such in the past) as being equal?

**S.S.:** I don't think I have yet taken my most important photograph. I am happy with many of the images I've taken: portraits of Samuel Beckett and René Magritte, the Warhol entourage, Martin Luther King, Jr.'s motel room, pictures from the Selma March, and many others. But I always look to the future.

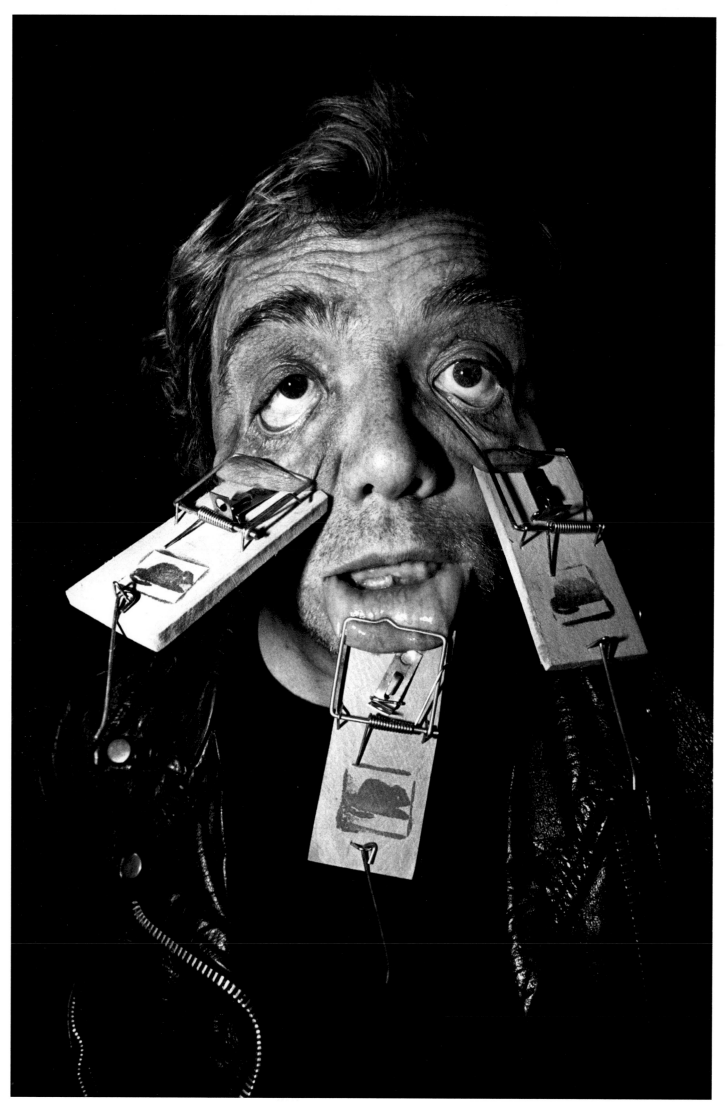

The Los Angeles Mousetrap Man, 1998

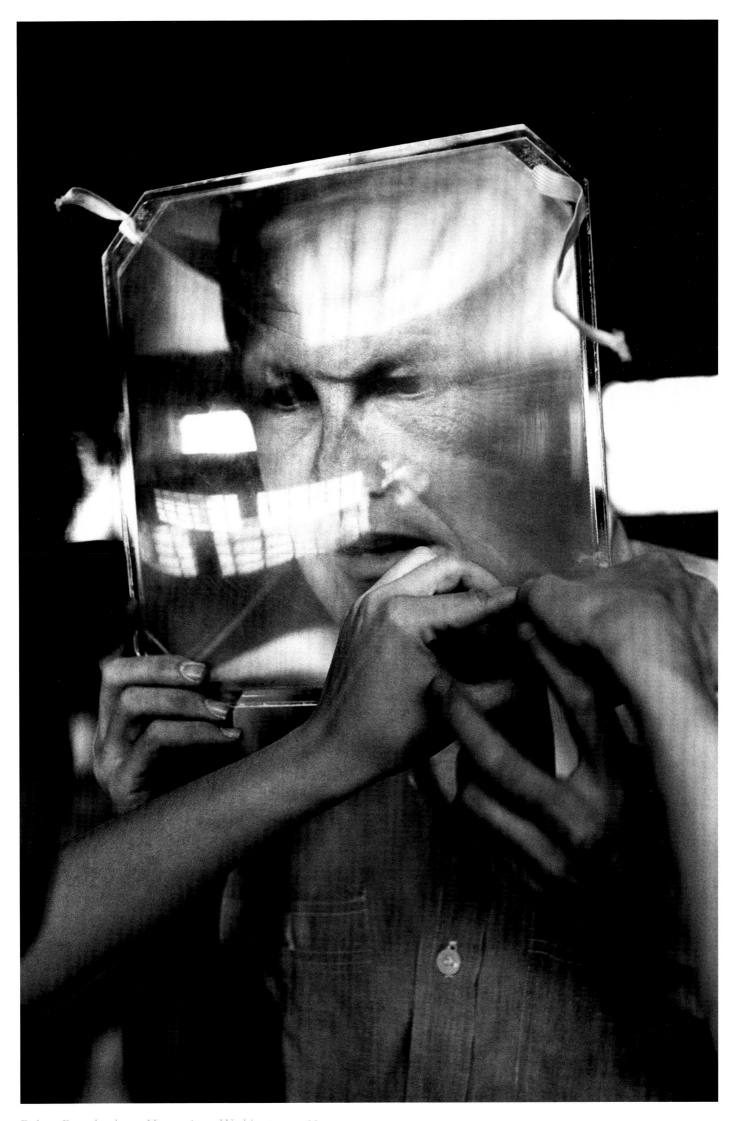

Robert Rauschenberg, Happenings, Washington, 1966

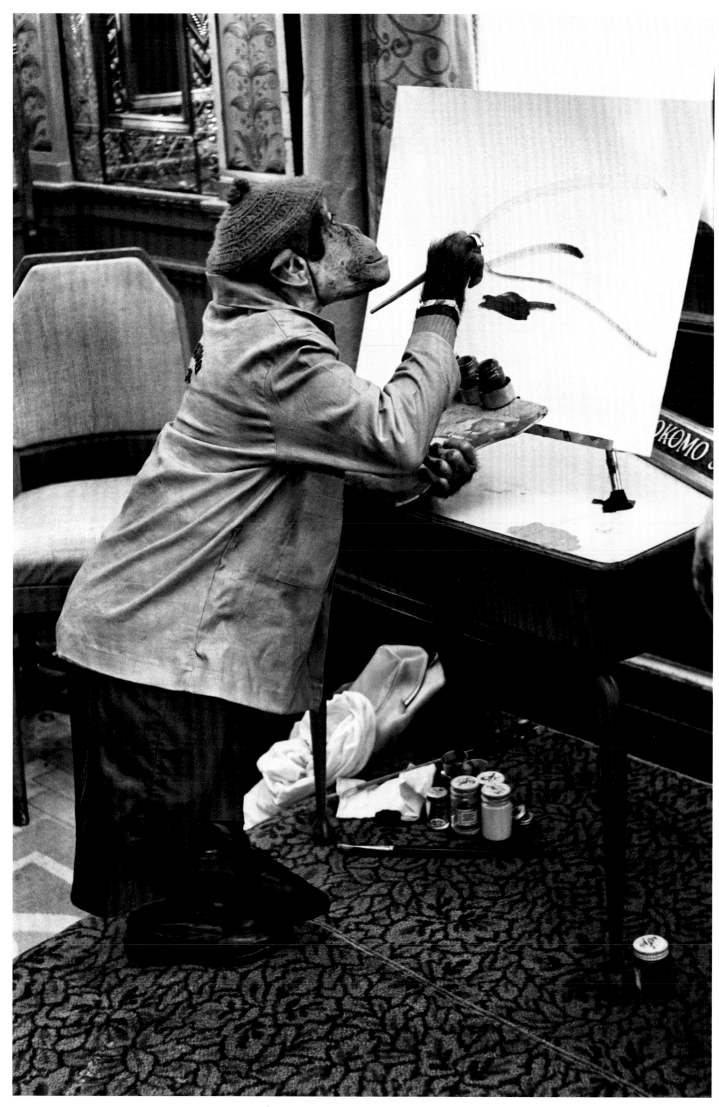

Kokomo, Jr., Chimpanzee Artist, New York, 1963

James Rosenquist, One of My Favorite Artists and a Good Friend, Long Island, 1969

East Berlin Sign, 2011

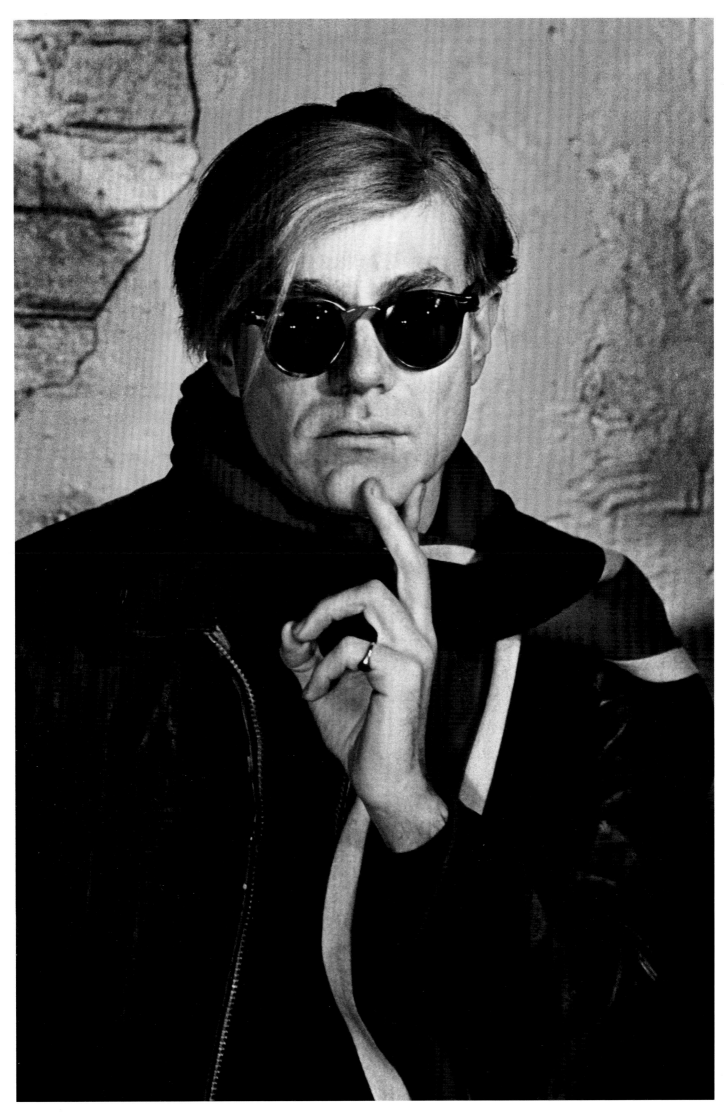

Andy Warhol at The Factory, New York, 1963

X PAN FILM

→ 9A                    → 10

Warhol Entourage Triptych, New York, 1965

Just like Jackie Kennedy, Jim Morrison, and William Burroughs, I was enamored to be at "the place to be" in the sixties: Andy Warhol's Factory. My career had just gotten into gear, and, as a shy twenty-nine year old with little sophistication, I was suddenly where every young photographer wanted to be—taking pictures for *Life* magazine. I started photographing Andy in the mid sixties when few took his silk-screen canvases to be serious art. Andy Warhol went from making shoe drawings for department stores to becoming one of the most influential artists of the twentieth century—through his silk-screen paintings, his movies, and his words. An incredibly shy person, he gradually learned how to project a charisma the whole world fawned over. Today, his influence and appeal is greater than when he was alive.

Andy Warhol gave the impression of being introverted, naïve, and innocent, but his quiet charisma easily engulfed people into his au courant world. We all know stories of his soft-voiced response to interviewer questions: "Gee I don't know. Why don't you just answer it for me?" And then there was the sending of pretend-Andys to give talks throughout the country. With a finger to the side of his mouth, he watched everything with an emotionless face, taking it all in and saying little. He loved gossip and kept a diary of all that he heard.

In the mid sixties I walked into the bathroom at the gallery of his dealer, Leo Castelli. Stacked above the toilet seat was a long shelf of multiple and identical Jackie Kennedy silk-screen paintings, all unsold at $350 a piece. Andy produced paintings the way Campbell's produced soup. I once brought home six of his brightly colored self-portrait canvases that are now perhaps worth millions. If only I had just kept them.

Warhol was invited to dinner parties by all the New York socialite art collectors, who wanted to show how "with it" they were, as if Warhol was their close confidant. (For $35,000 Warhol would paint a silk screen of you.) But Andy at those parties rarely talked, and stayed close to his entourage who whispered hushed comments back and forth amongst themselves. Every hipster and "world class" pop-culture star wanted to visit The Factory, the legendary aluminum foil and silver-painted loft where Andy made his first counter-culture movies, and where there were endless stories of sex, drugs, and (oh well) sex and drugs. Bob Dylan, Dennis Hopper, and, at one party alone, Tennessee Williams, Judy Garland, and Rudolf Nureyev appeared.

When in public, it was as if he was hiding behind a posed, emotionless mask, which allowed him to watch everything without being called on to react to anything. In photographs he preferred to strike a pose, finger to the side of his mouth. As a photographer, a surprising moment for me is the photo I took at a party of Andy's with Edie Sedgwick, where Andy looks enthralled by Edie's beauty and effervescence. For one moment, the mask had parted, and out came a great, human smile.

In the Warhol Entourage Triptych, Henry Geldzahler (behind Edie) was curator of contemporary art at the Metropolitan Museum of Art in New York. He was virtually the "eye" of the Pop-Art movement. An especially good friend of Andy's, many of the themes Andy pursued were first suggested by Henry, like the series on Death and Disaster and the Flower paintings.

Edie Sedgwick was discovered by Andy and became a leading actress in Andy's "factory-made" films, including *Poor Little Rich Girl*. Edie became a fantasy goddess for sixteen-year-old girls in suburbia because she lived the bohemian life their parents told them not to.

On Andy's left is Gerard Malanga, poet and Andy's loyal assistant, who probably silk screened and made a substantial amount of Andy's multitude of paintings. Warhol coined the phrase that everyone will be famous for fifteen minutes. But Andy certainly has outlived those fifteen minutes. His fame increases with every year.

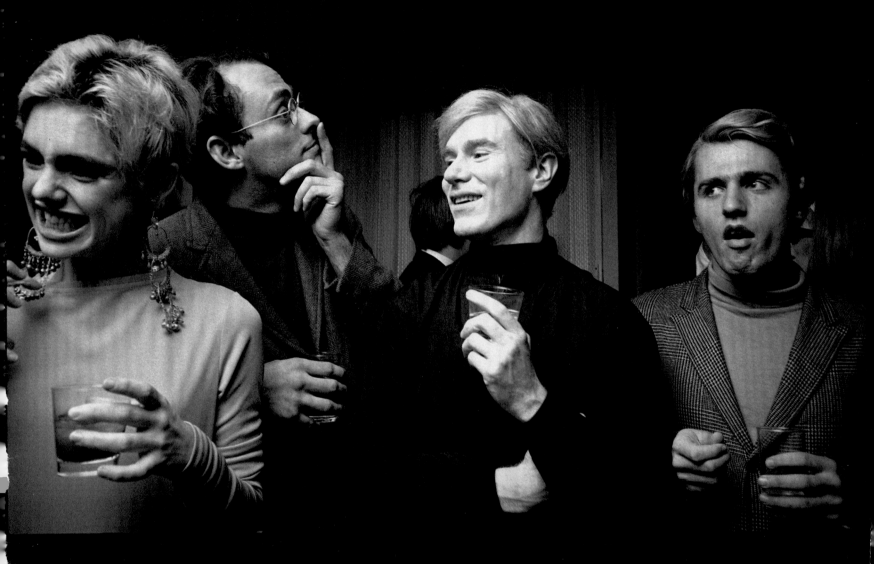

SAFETY FILM

→ 11A

→ 12

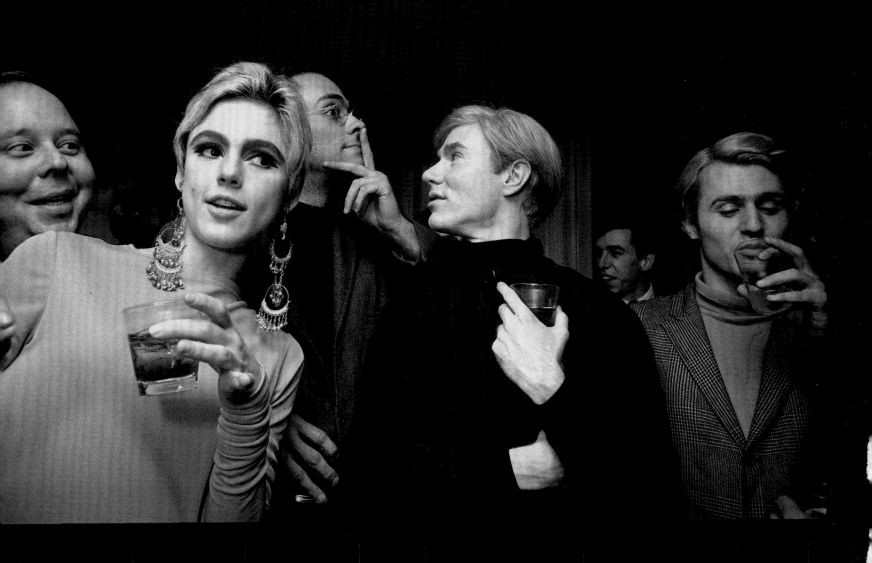

22      Silver Man, West Hollywood, 2003

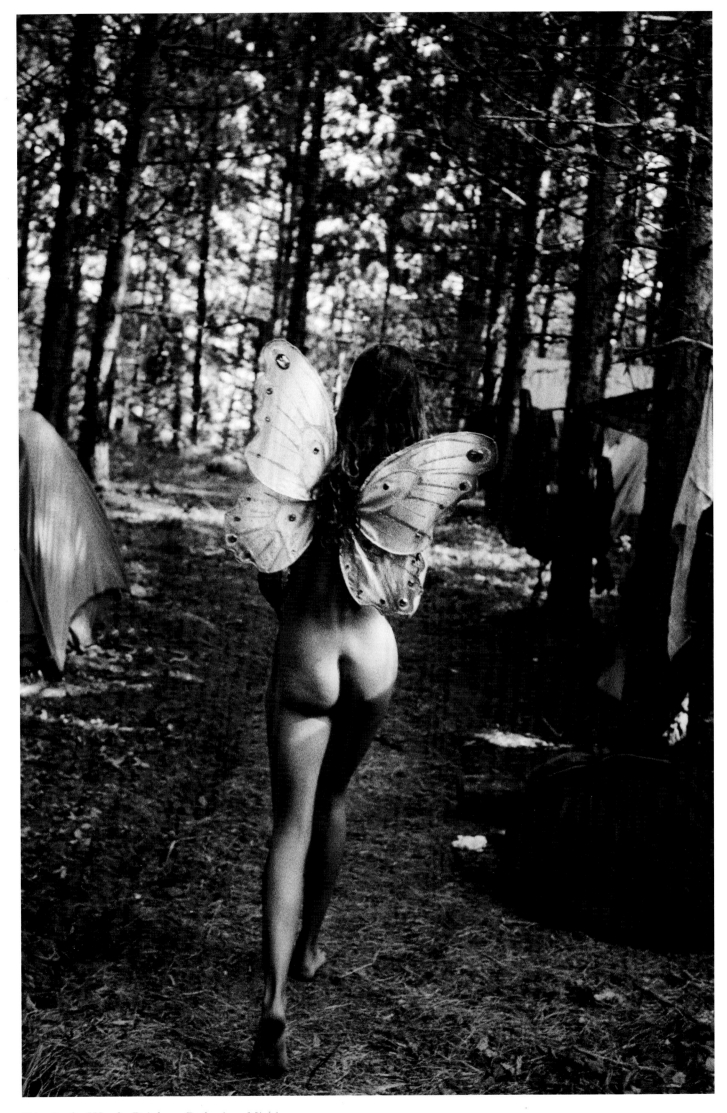

Fairy in the Woods, Rainbow Gathering, Michigan, 2001

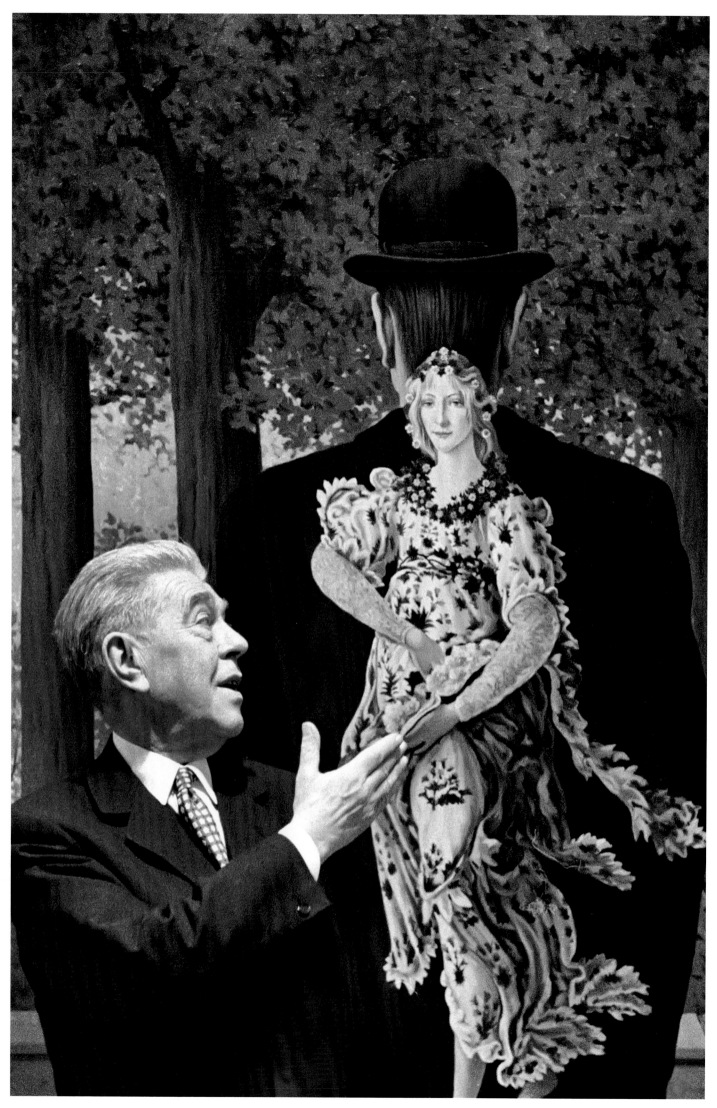

René Magritte / Sandro Botticelli, Museum of Modern Art, New York, 1965

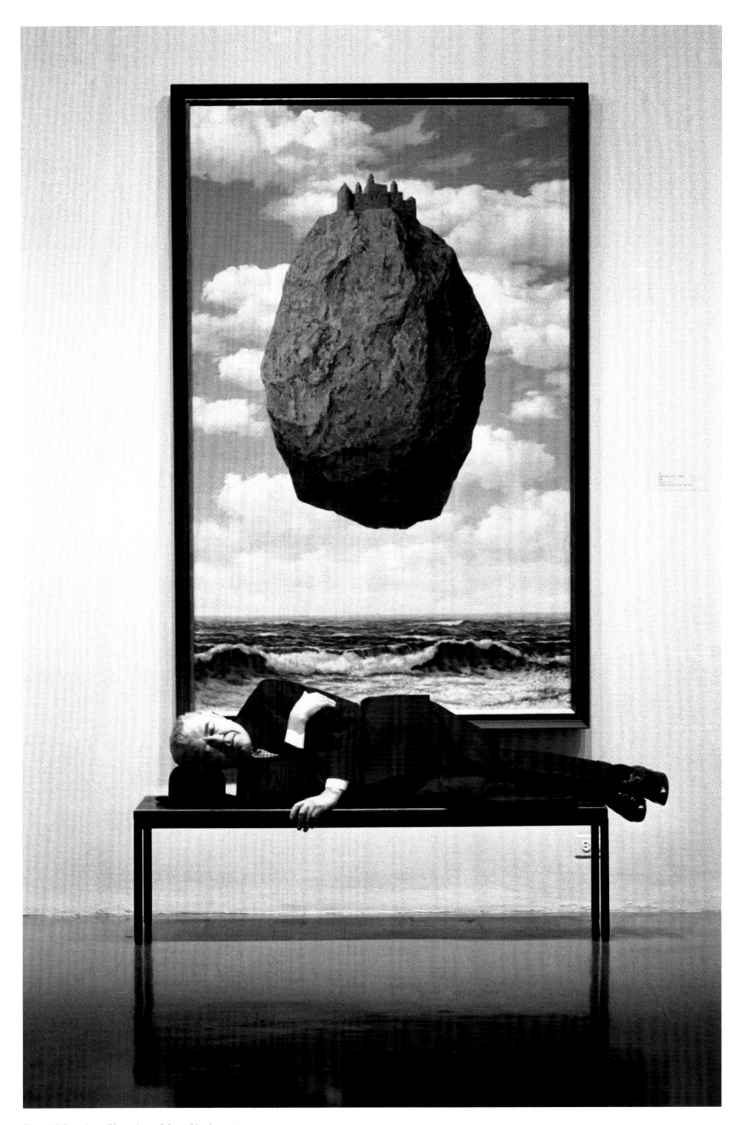

René Magritte Sleeping, New York, 1965

Howdy Dowdys, Los Angeles, 2000

New Kids on the Block, Los Angeles, 1989

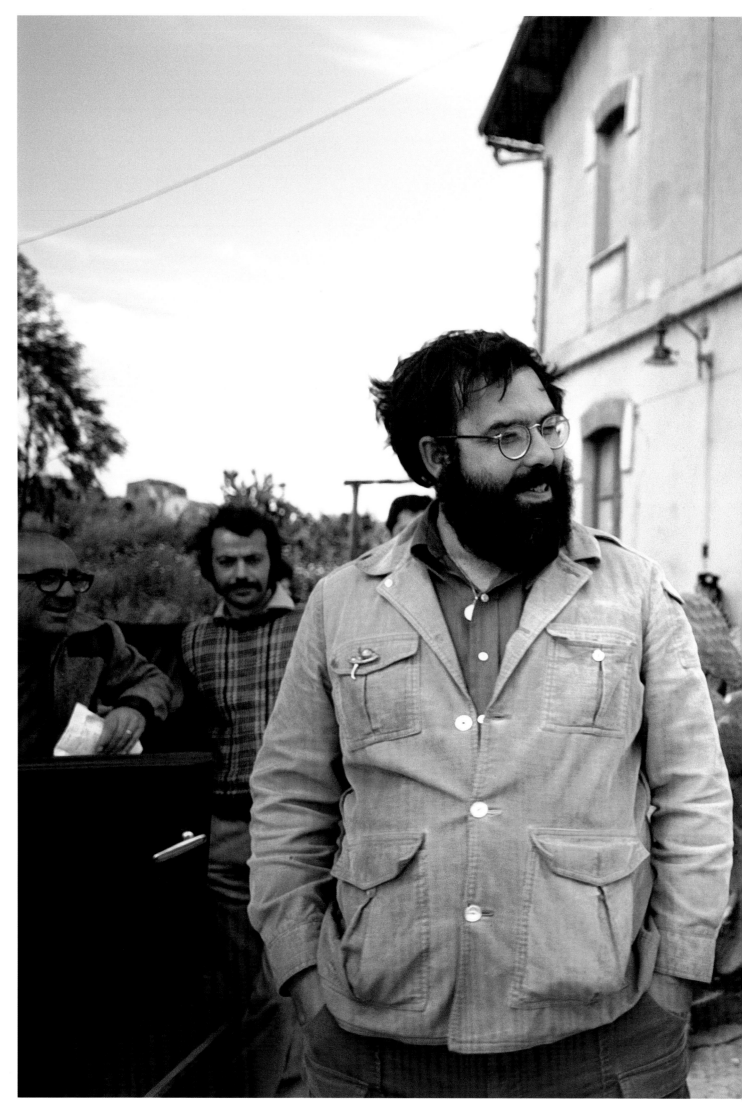

Francis Ford Coppola and His Mother, Corleone, Italy, 1973

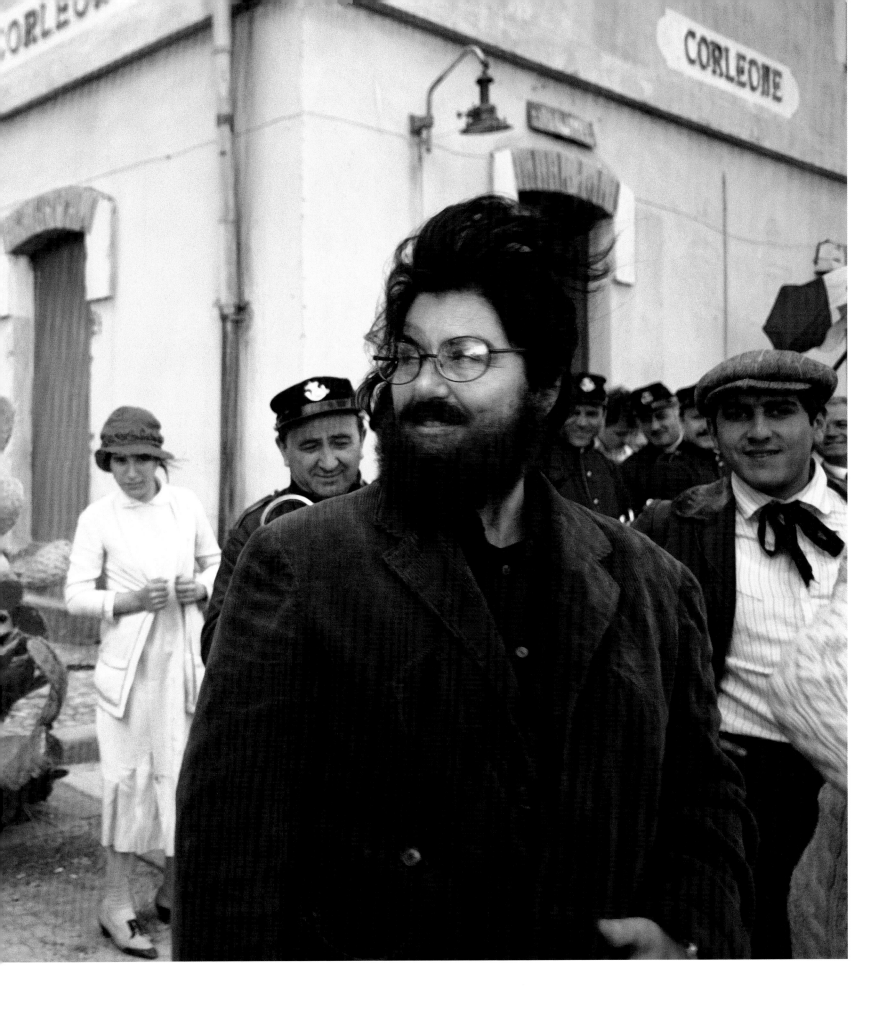

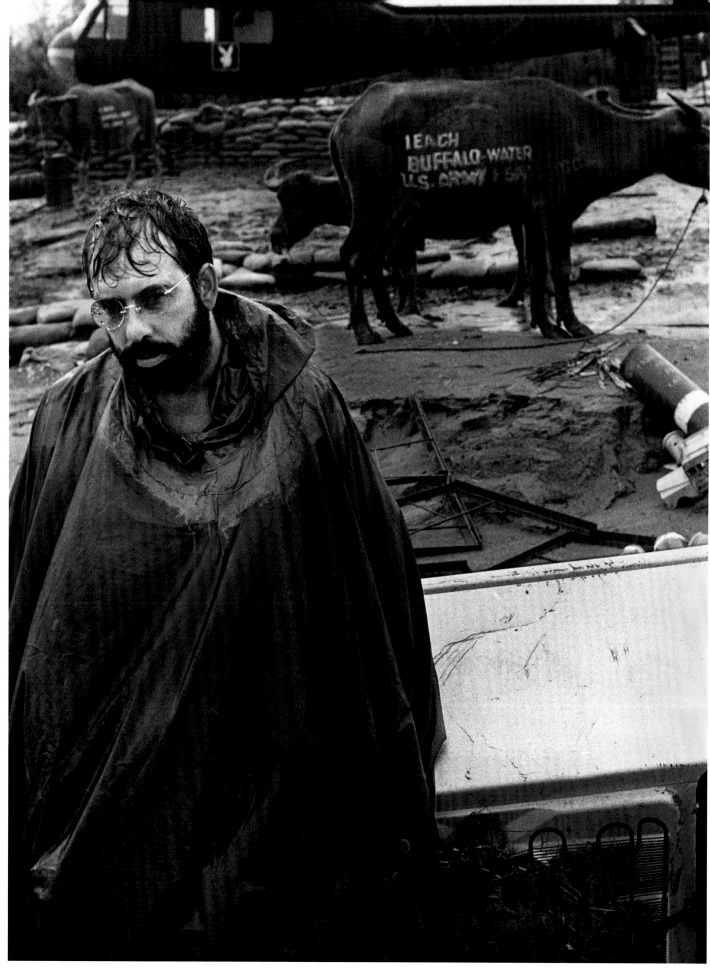

Francis Ford Coppola, *Apocalypse Now*, the Philippines, 1976

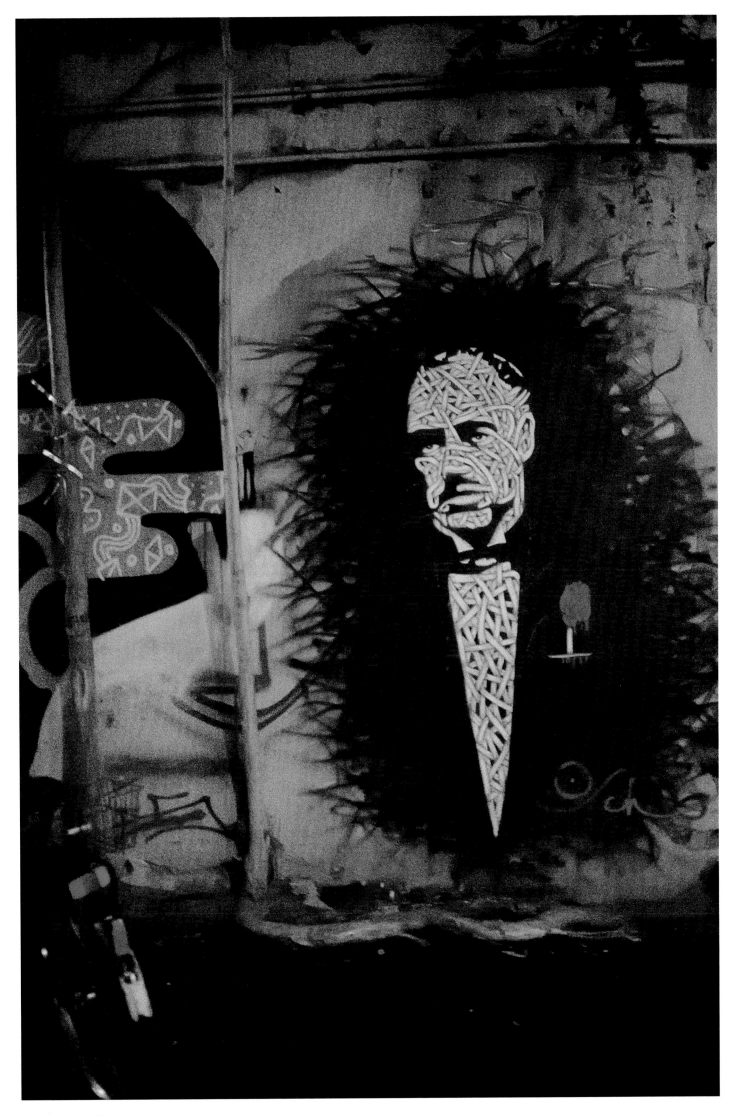

East Berlin Alleyway, 2011

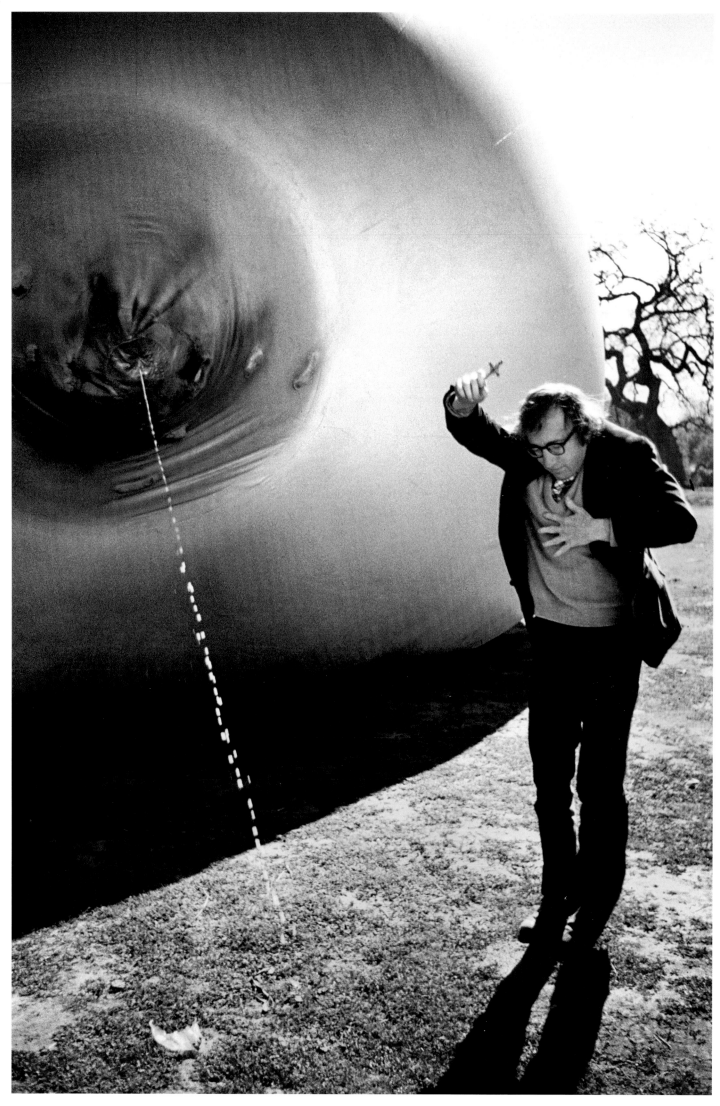

Woody Allen, *Everything You Always Wanted to Know about Sex*, Los Angeles, 1974

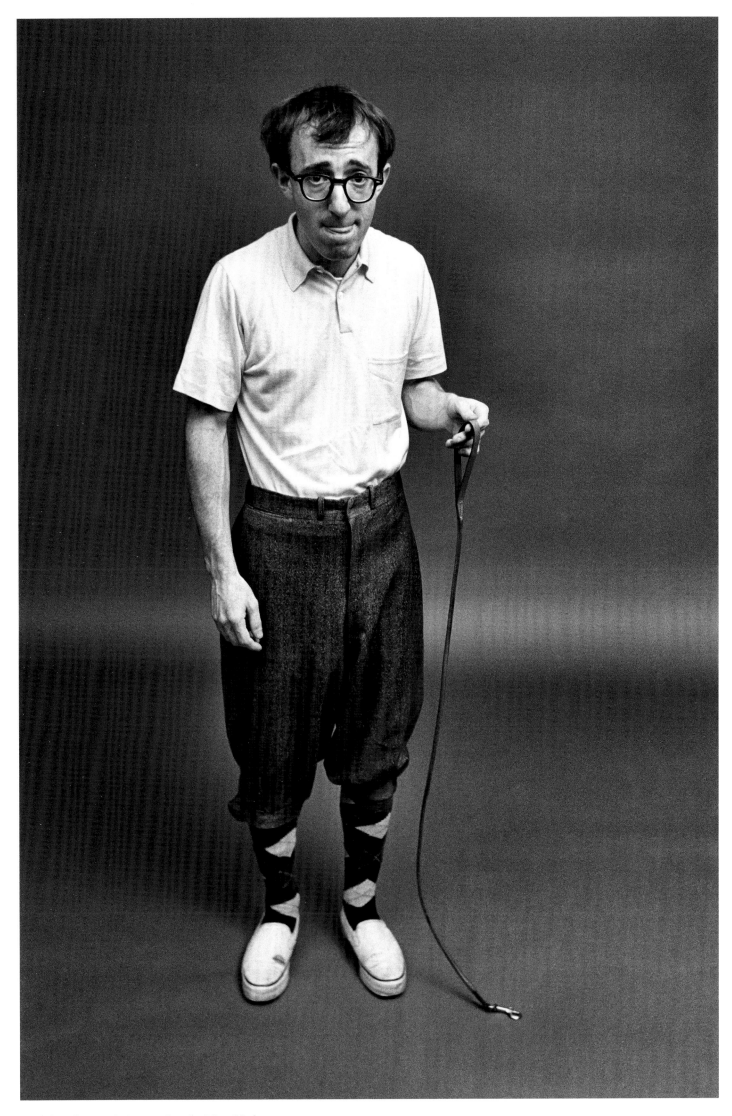

Woody Allen with Ant on Leash, New York, 1964

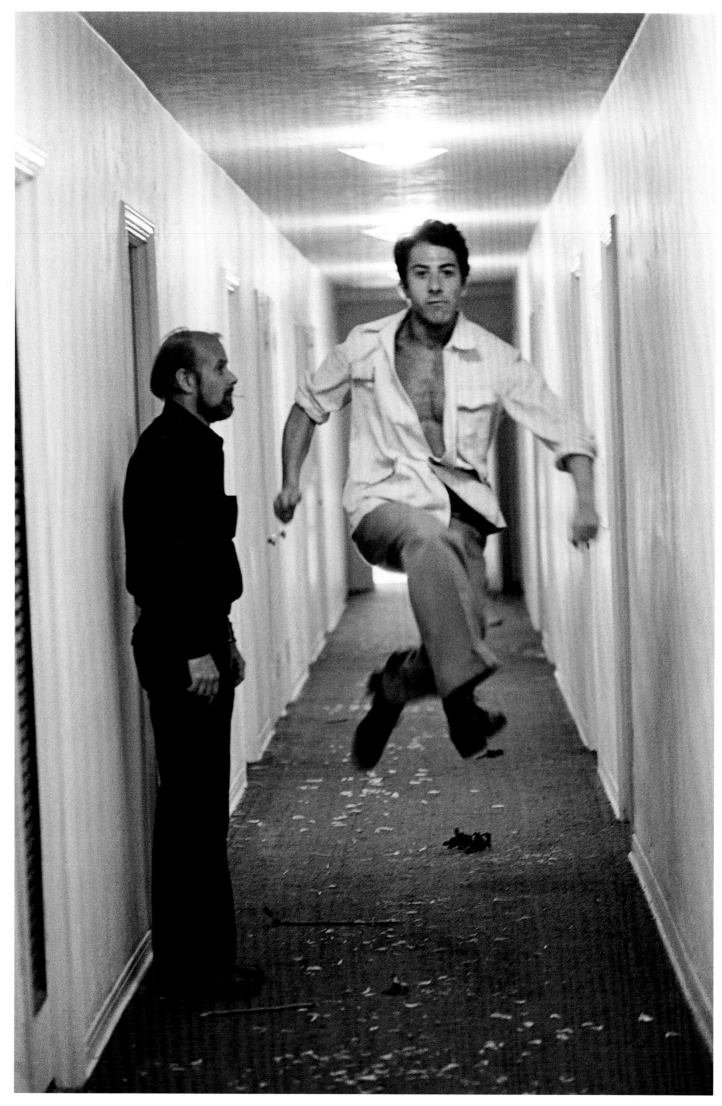

Dustin Hoffman and Bob Fosse, Miami, 1973

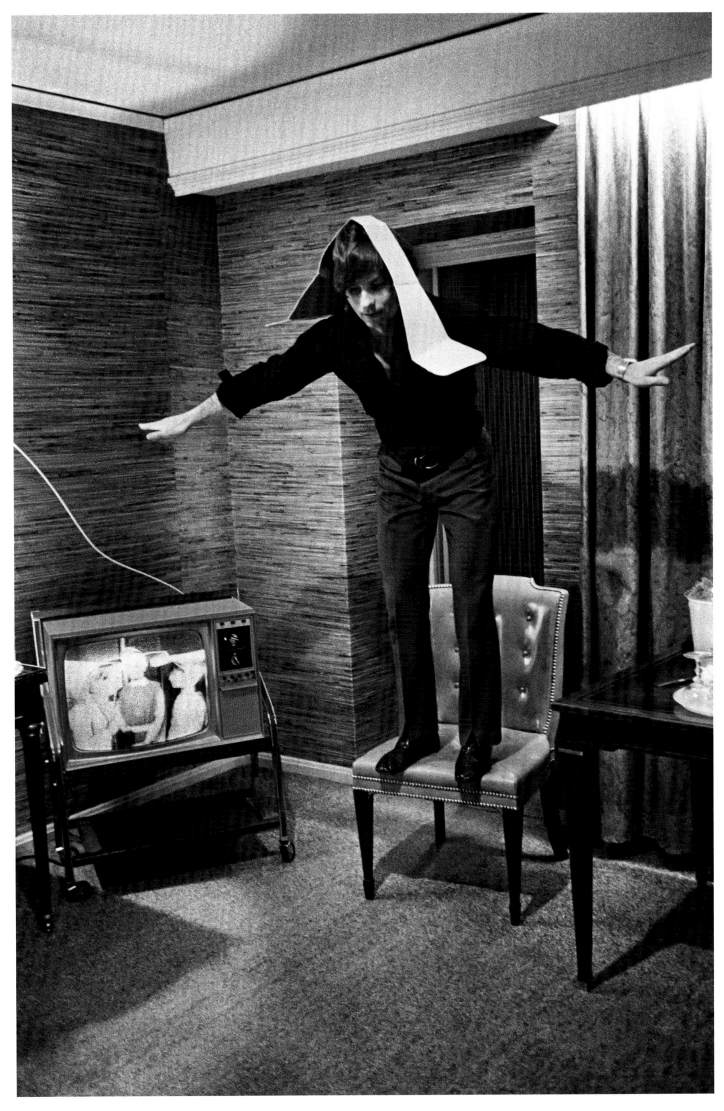

Roman Polanski as "The Flying Nun," Kansas, 1968

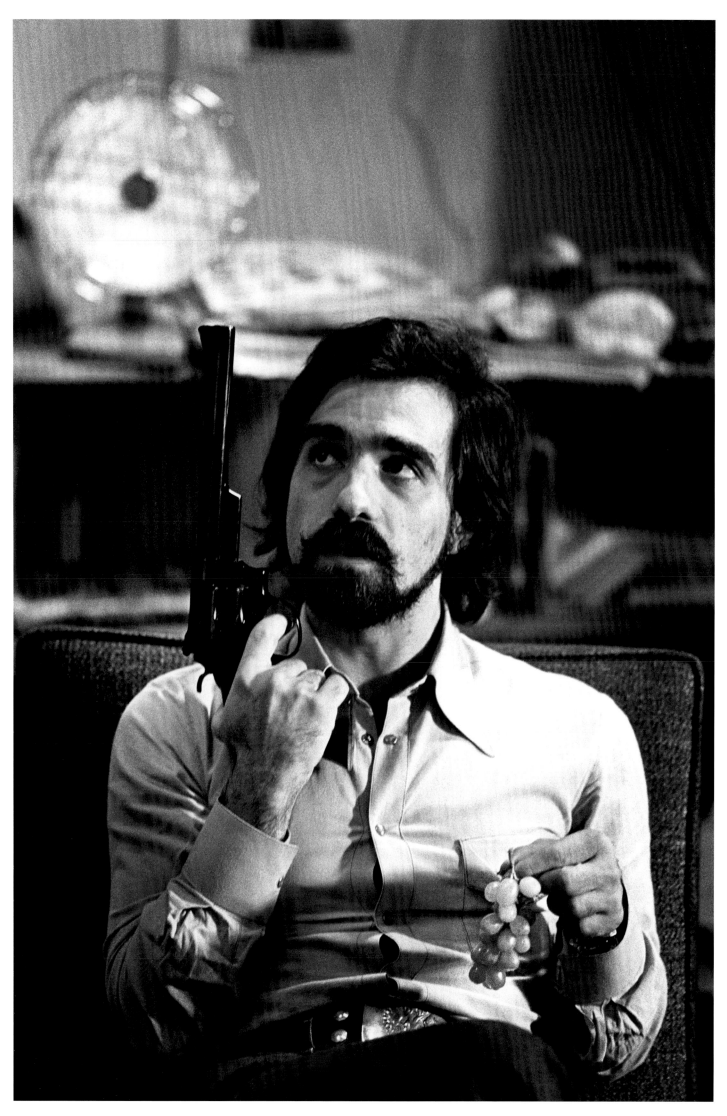

Martin Scorsese, *Taxi Driver*, New York, 1975

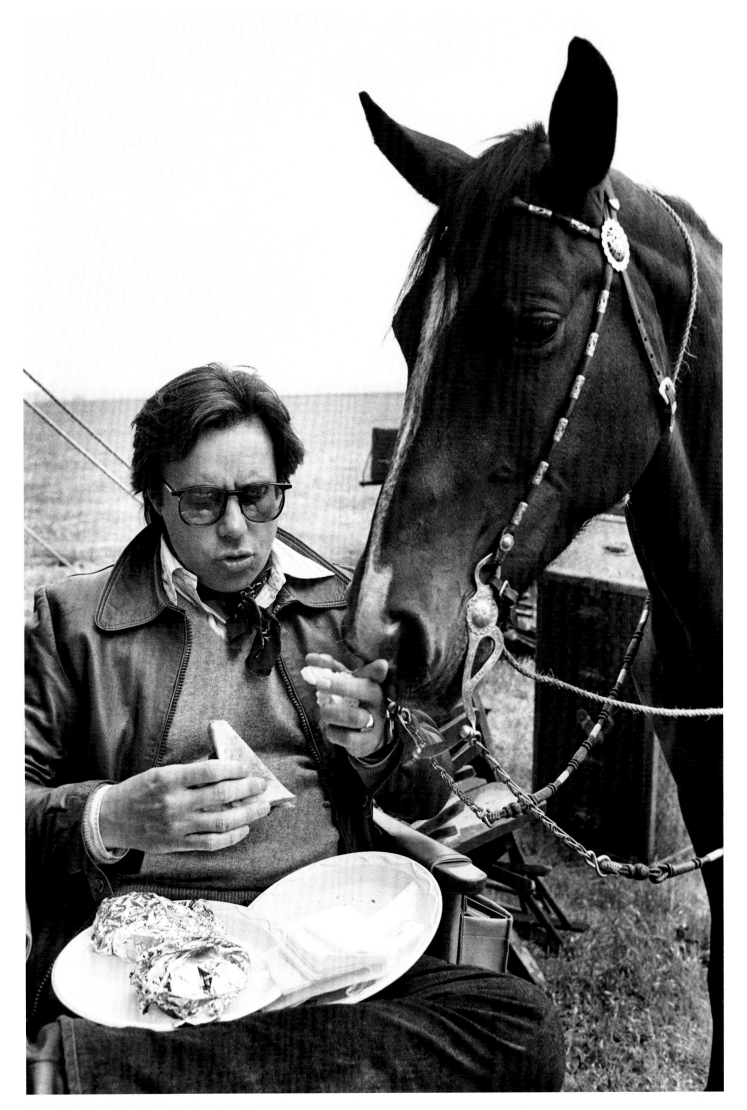

Peter Bogdanovich, *Texasville*, Los Angeles, 1990

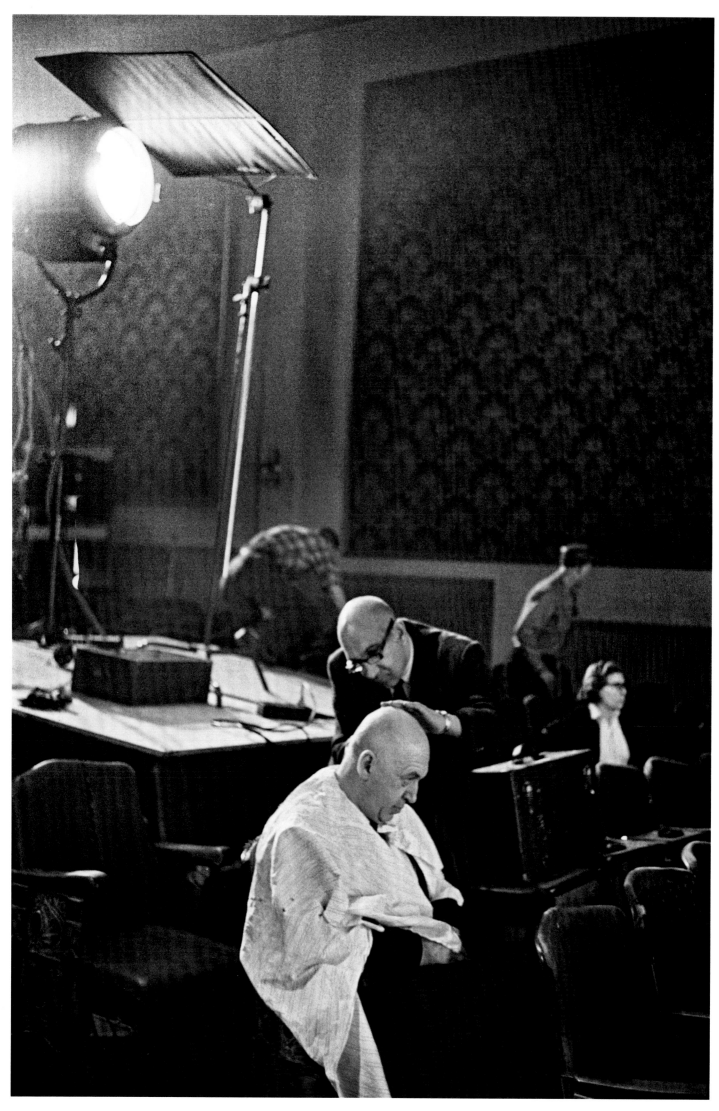

Otto Preminger Gets a Haircut, 1962

Otto Preminger, *The Cardinal*, Massachusetts, 1962

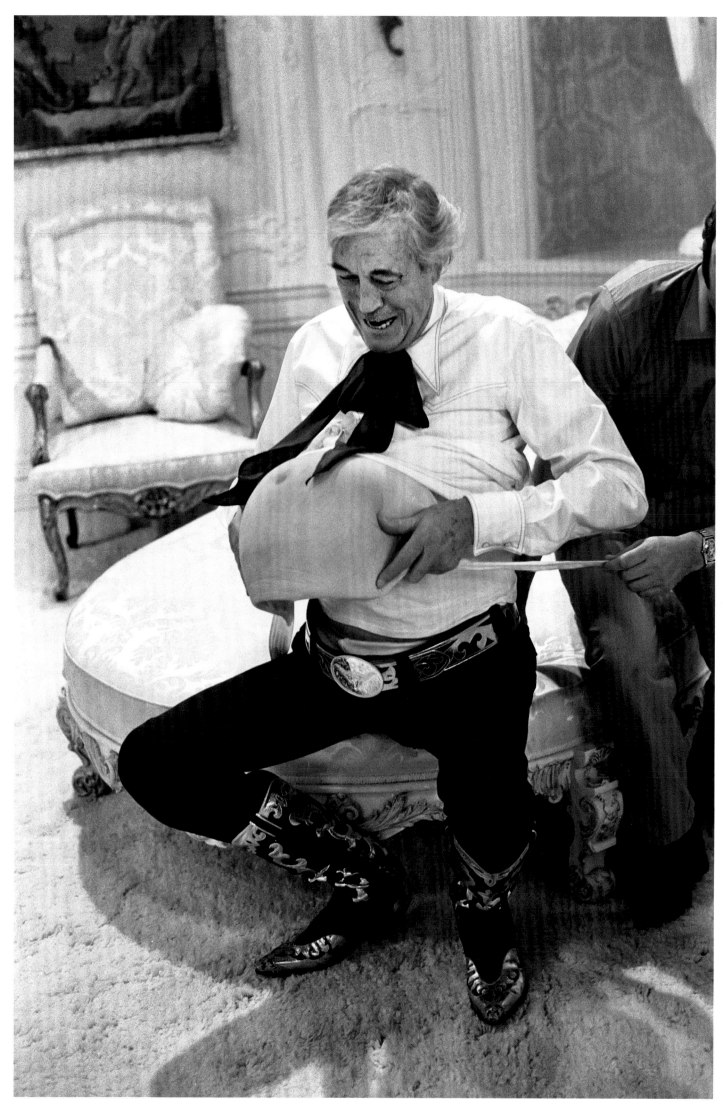

John Huston, *Myra Breckinridge*, 1969

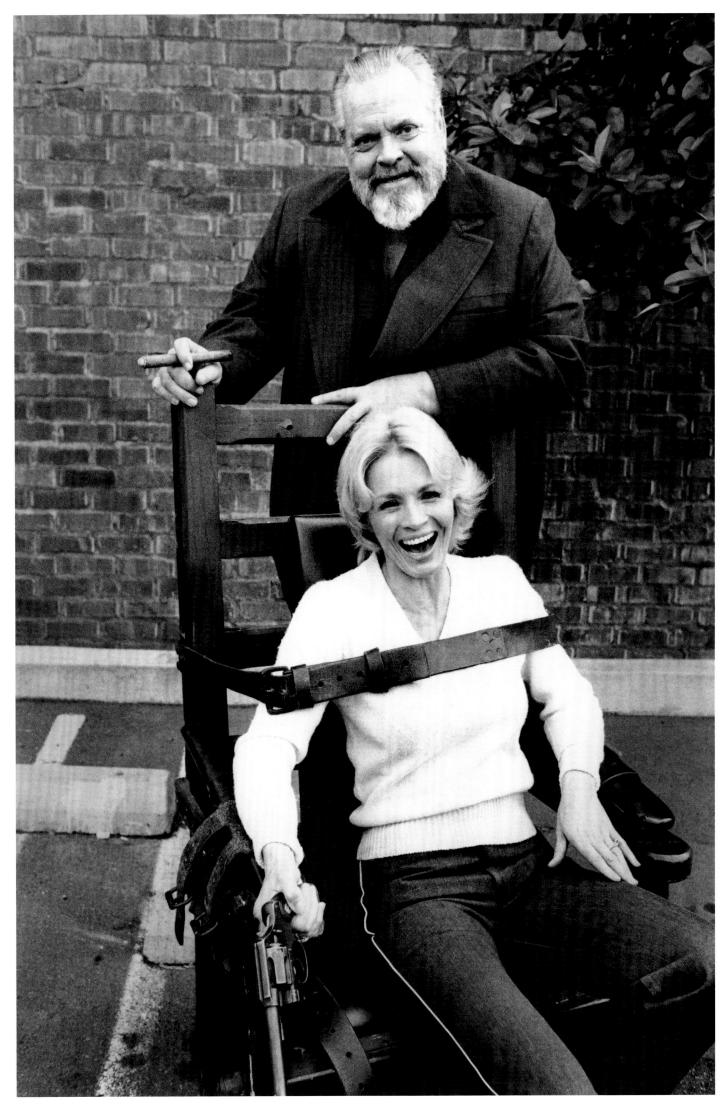

Orson Welles and Angie Dickinson, Los Angeles, 1978

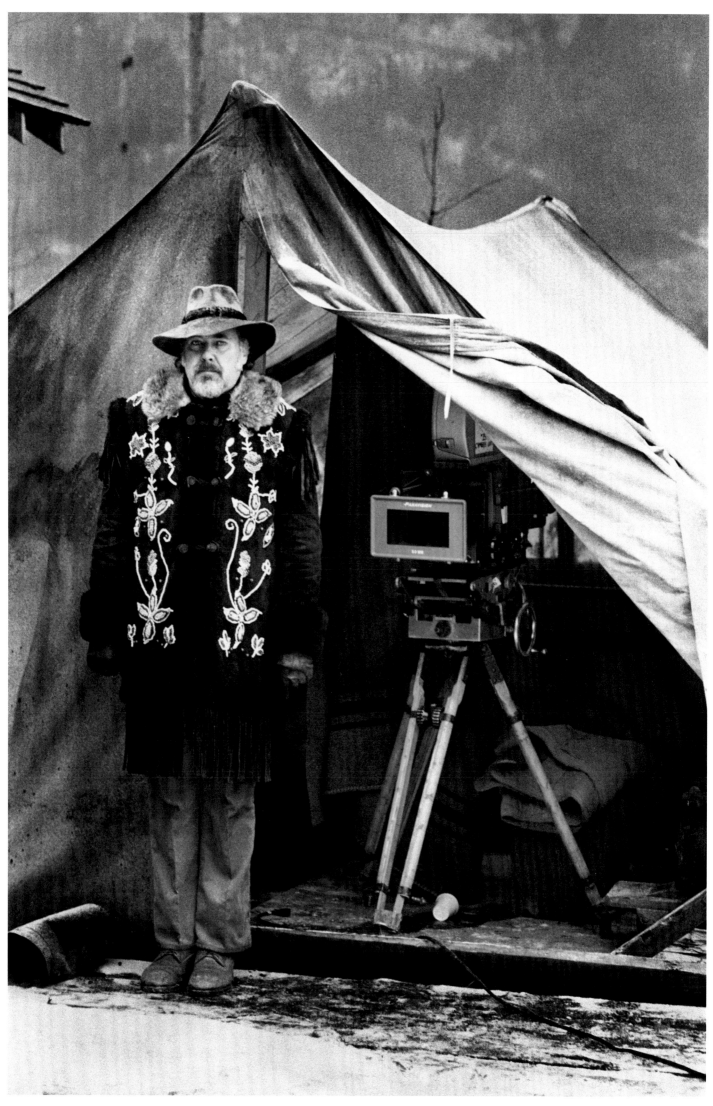

Robert Altman, *McCabe & Mrs. Miller*, Vancouver, 1970

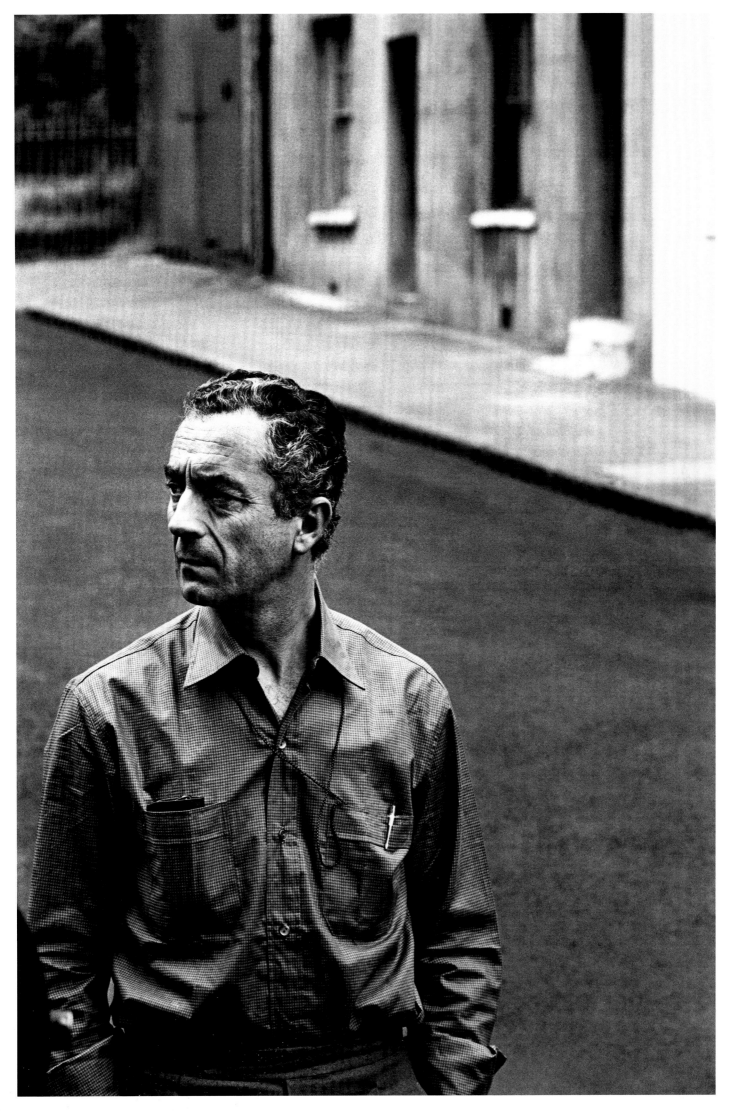

Michelangelo Antonioni, *Blow-Up*, London, 1964

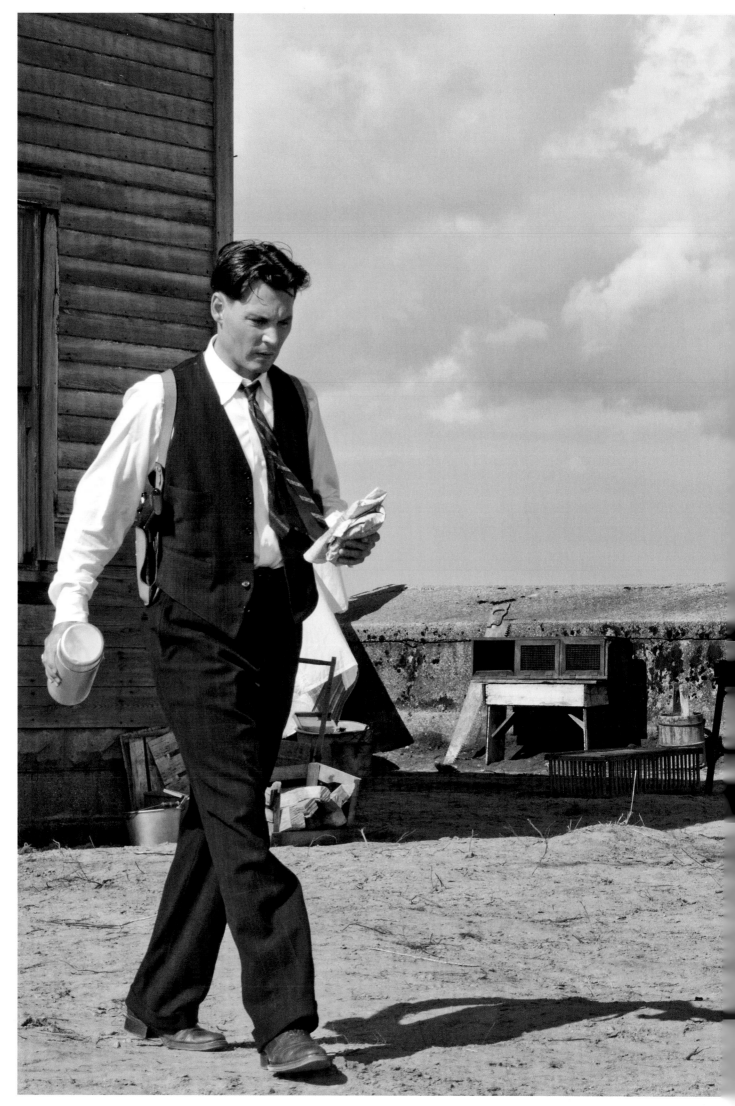

Michael Mann and Johnny Depp, Chicago, 2008

Dublin Hippies, 2003

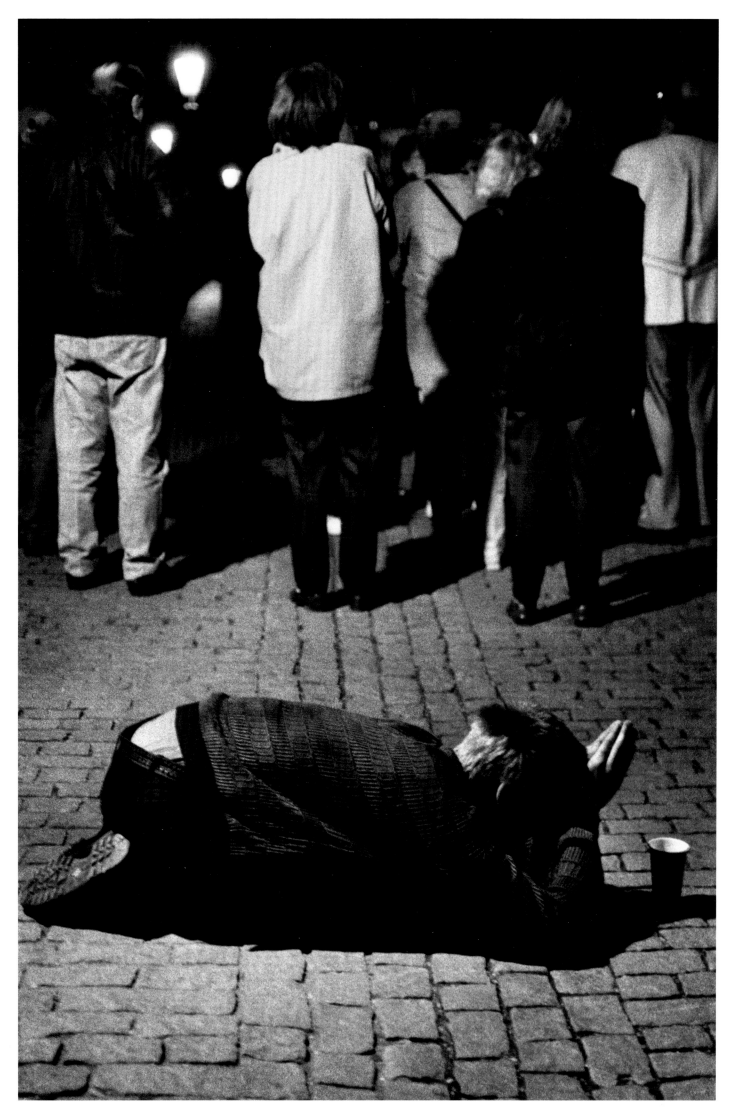

Beggar in Prague, 2001

Hollywood Wall and Car, 1998

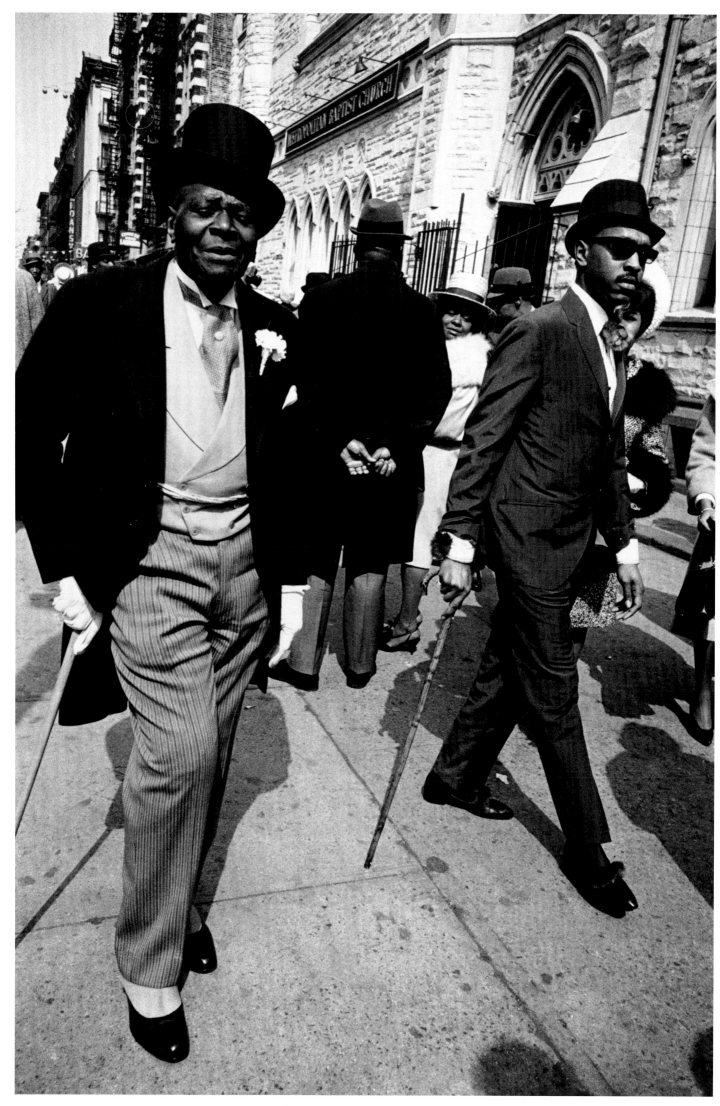

Man with Spats, Easter in Harlem, 1970

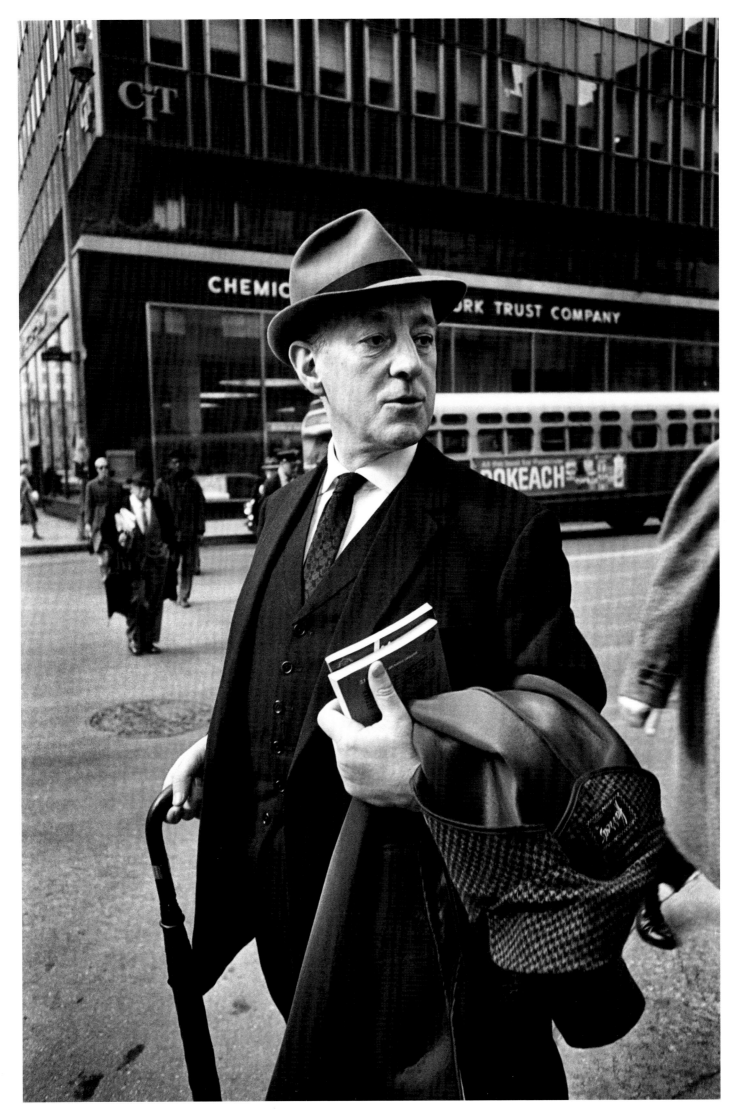

Alec Guinness, New York, 1964

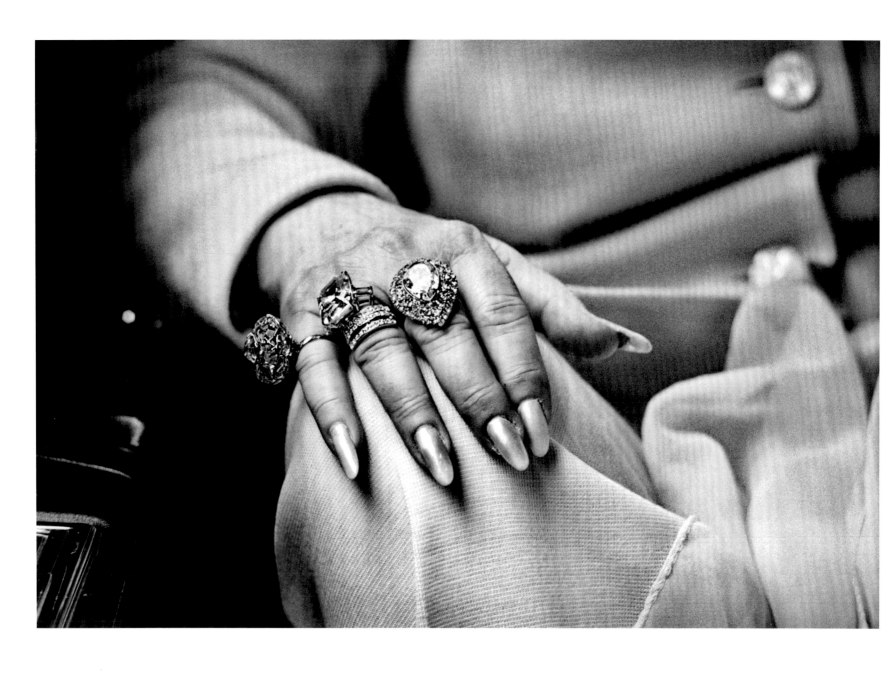

Mae West's Hand, Los Angeles, 1969

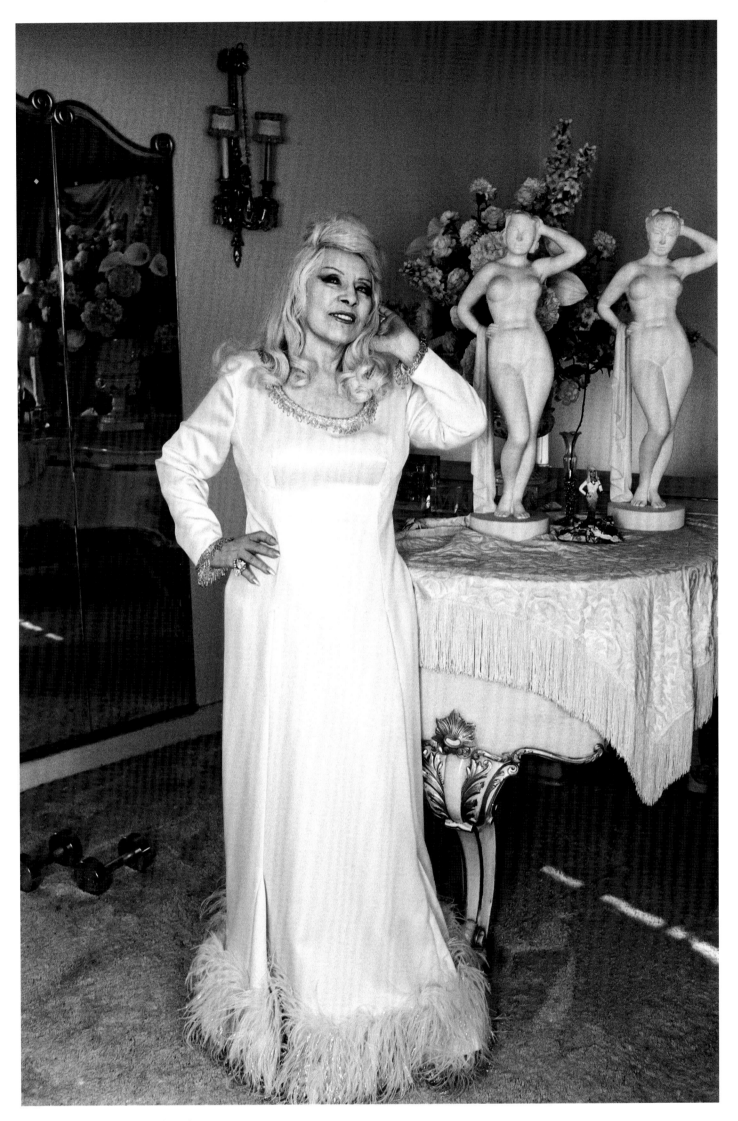

Mae West at Home, Los Angeles, 1969

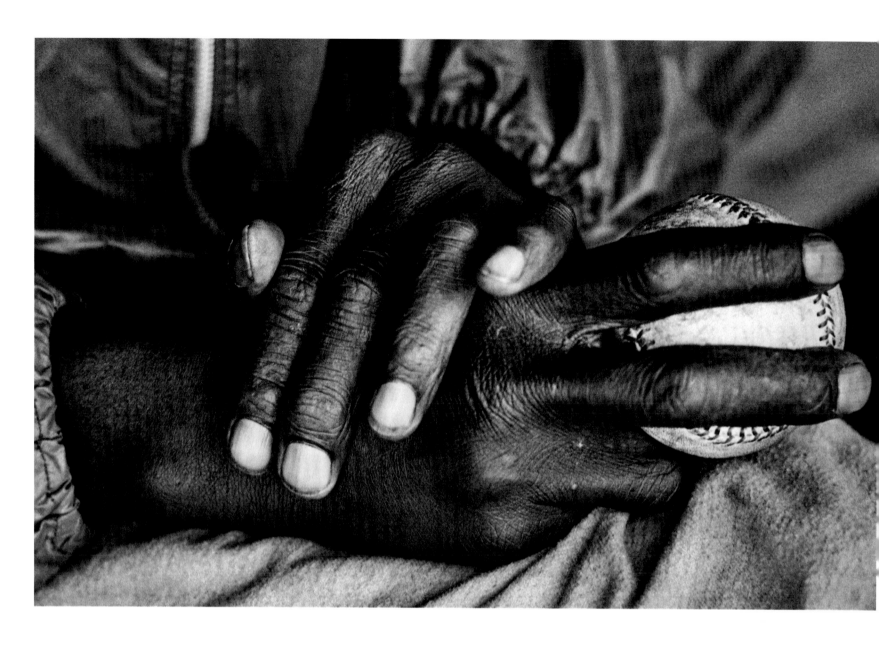

54  Satchel Paige's Hands, 1962

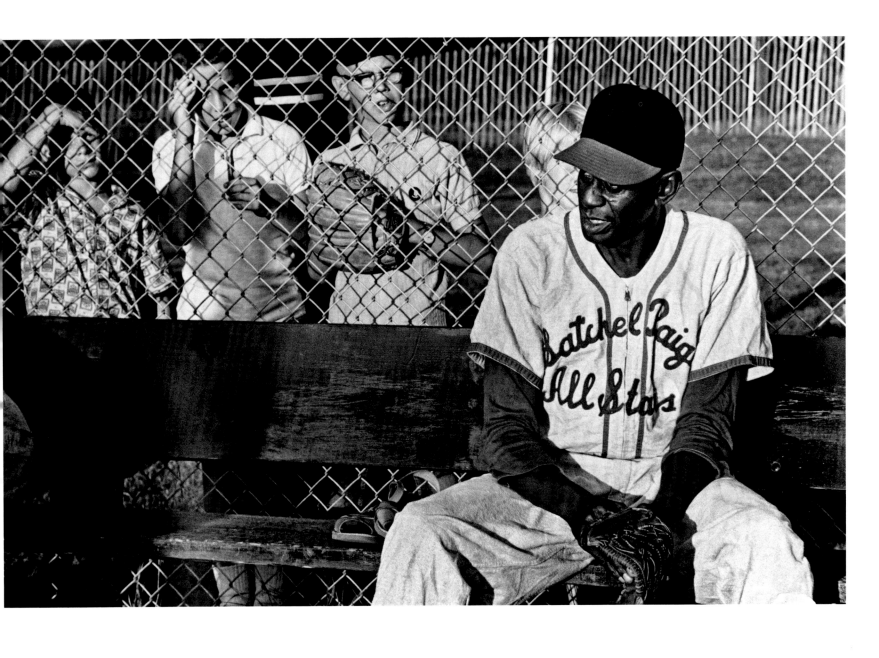

Satchel Paige, 1962

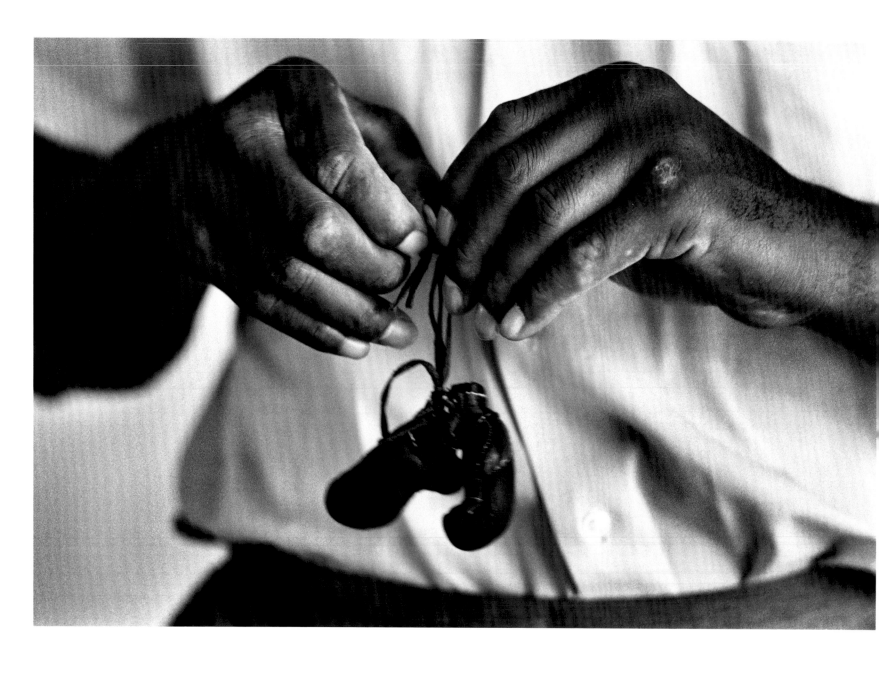

Muhammad Ali with Mini Gloves, Louisville, Kentucky, 1983

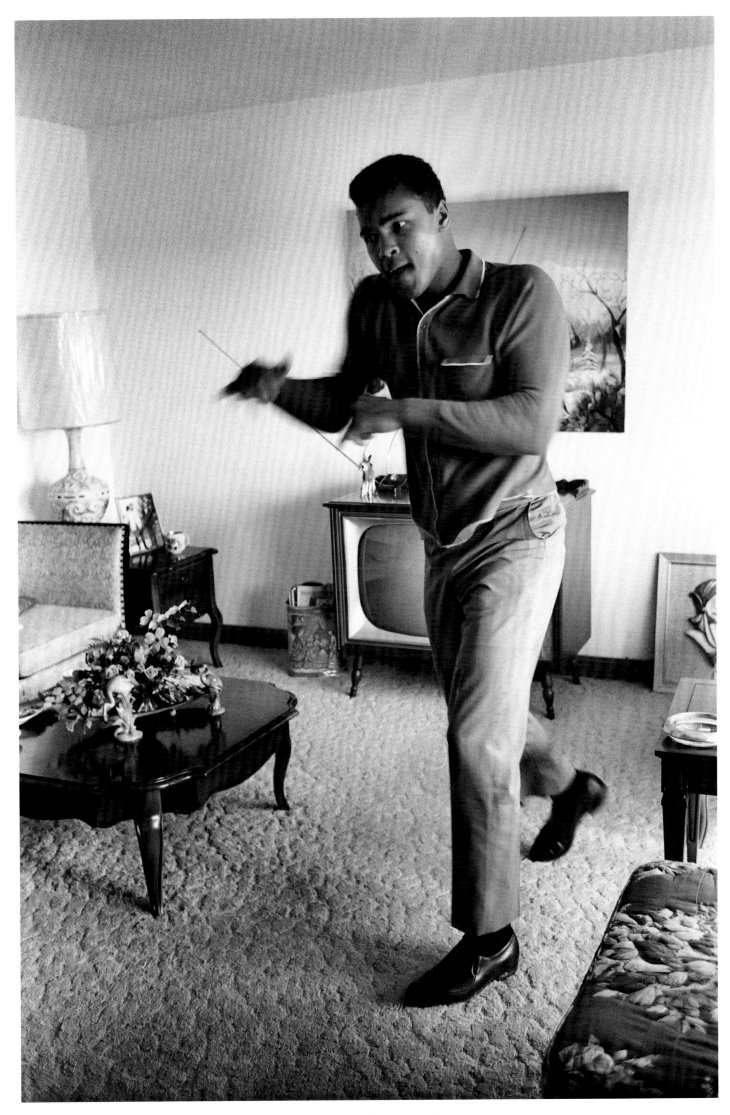

Muhammad Ali (Cassius Clay) Shadowboxing at Home, Louisville, Kentucky, 1963

Monopoly, Beverly Hills, 1990

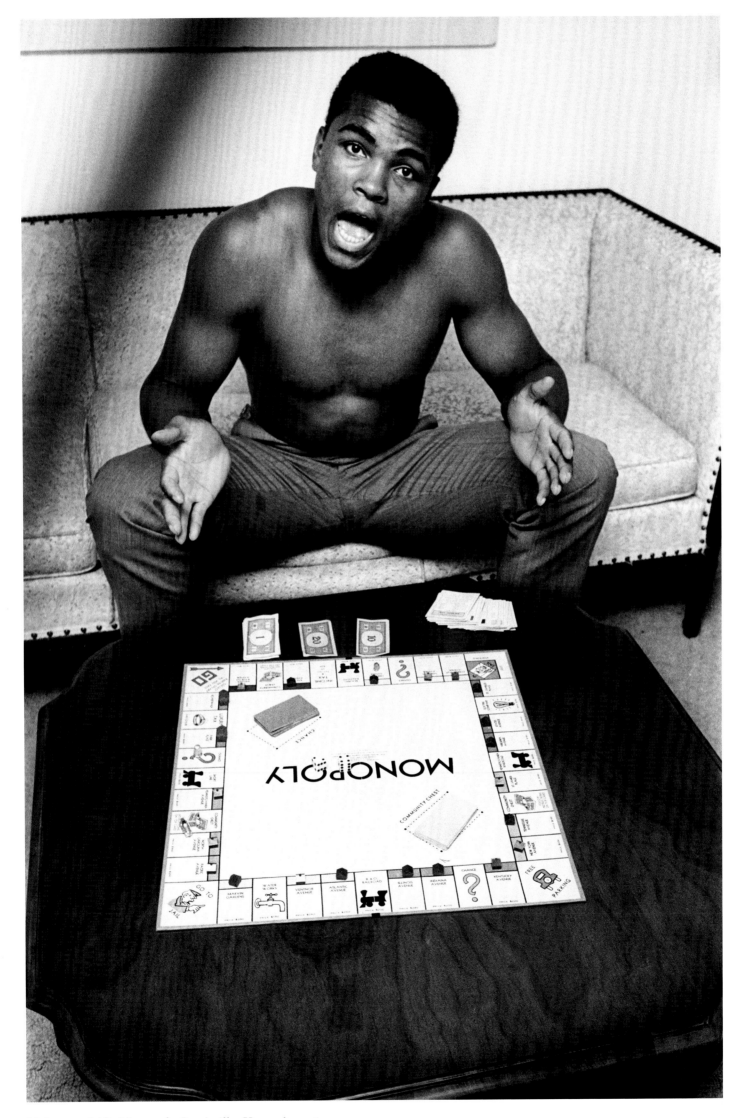

Muhammad Ali, Monopoly, Louisville, Kentucky, 1963

February 12, 2012

Dear Mr. Schapiro,

My name is Lonnie Ali. I am the wife of Muhammad Ali. Almost fifty years ago (1963), you came to Louisville and photographed Muhammad, then Cassius Clay, at his parents' home on Verona Way. That was the day I first met Cassius Clay. It was quite fateful that you were there photographing that May day because you actually snapped a picture of the moment Cassius and I met. I was the only little girl in a crowd of neighborhood boys. We were newcomers to the neighborhood. Shortly thereafter, you sent our family several copies of the photographs you took that day that included me and my brothers with "Cassius."

I never knew your name, or how to find you. As luck would have it, last week I walked into my hair salon in Scottsdale and noticed a book on the shelf that had Muhammad's face on the front along with Martin Luther King, Jr. and Bobby Kennedy, called *Schapiro's Heroes*. Having never seen this particular book before, I picked it up and opened to a picture that was so familiar—a photo of Muhammad taken in front of his parents' home with my little brother looking up at him in complete wonderment.

This past Friday, I was with Howard Bingham at Angelo Dundee's funeral and told him about my find. Again, to my surprise he told me he had seen you recently in L.A. I wish I had known years ago that Howard knew you. I would have contacted you long ago.

Well, believe it or not, I still have the picture you took of the moment I first met Muhammad. It is framed and in our home in Michigan. I want to thank you for sending those pictures to our family because I do believe it was fate that I met Muhammad that day and you were there to memorialize it forever in black and white.

I don't know if these particular photographs are part of your collection that are available for purchase but I'd like to get the entire series of the pictures you took that day. Would you be so kind as to contact me? I'd love to introduce myself, for a second time.

Warmest regards,
Lonnie Ali

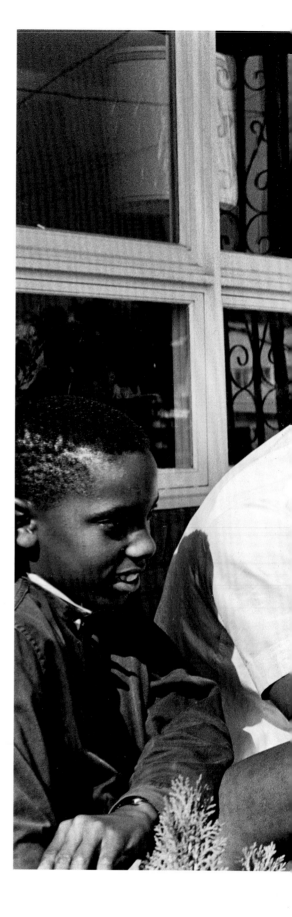

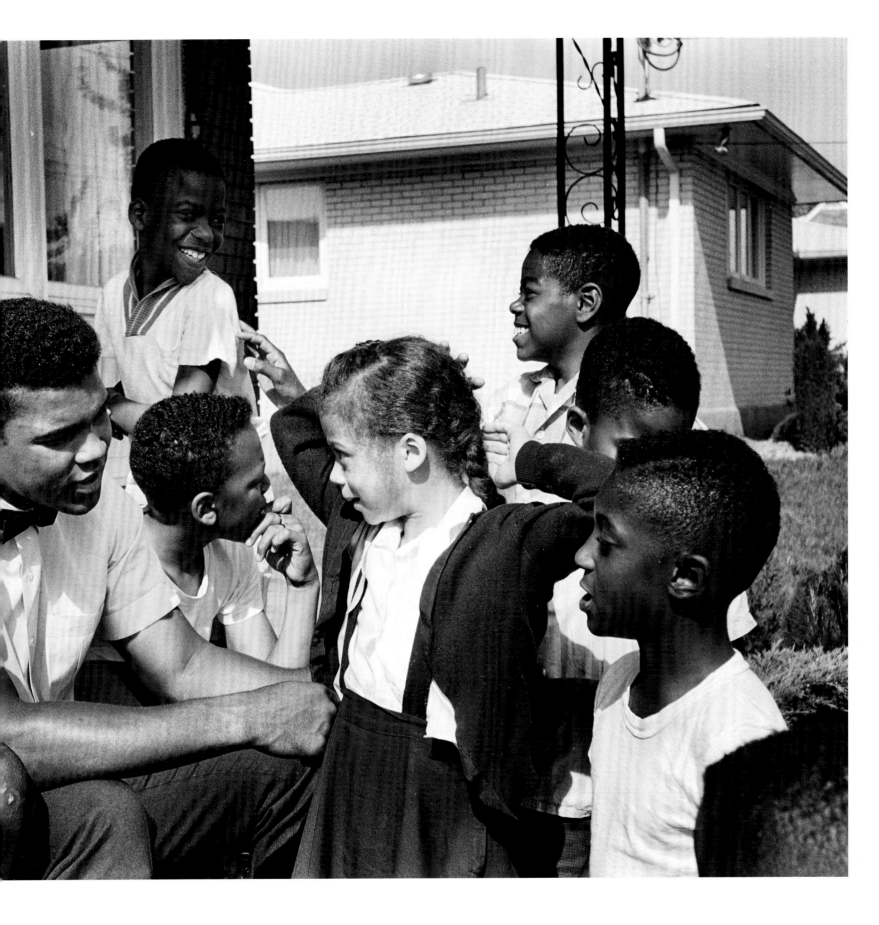

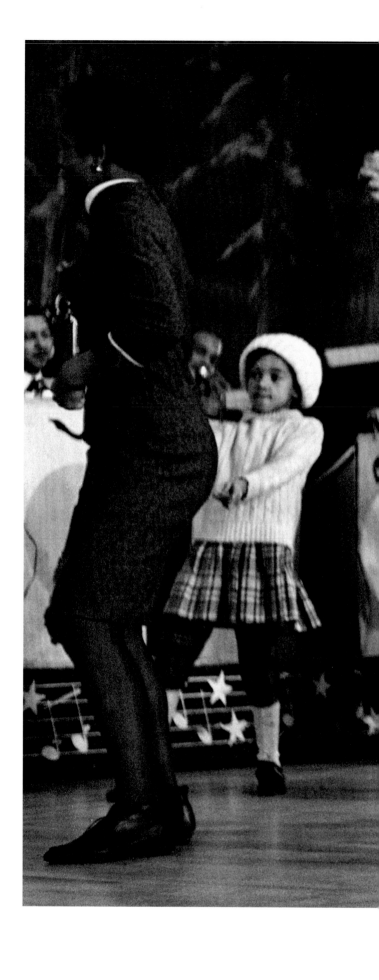

Amateur Hour, The Apollo Theater, Harlem, 1961

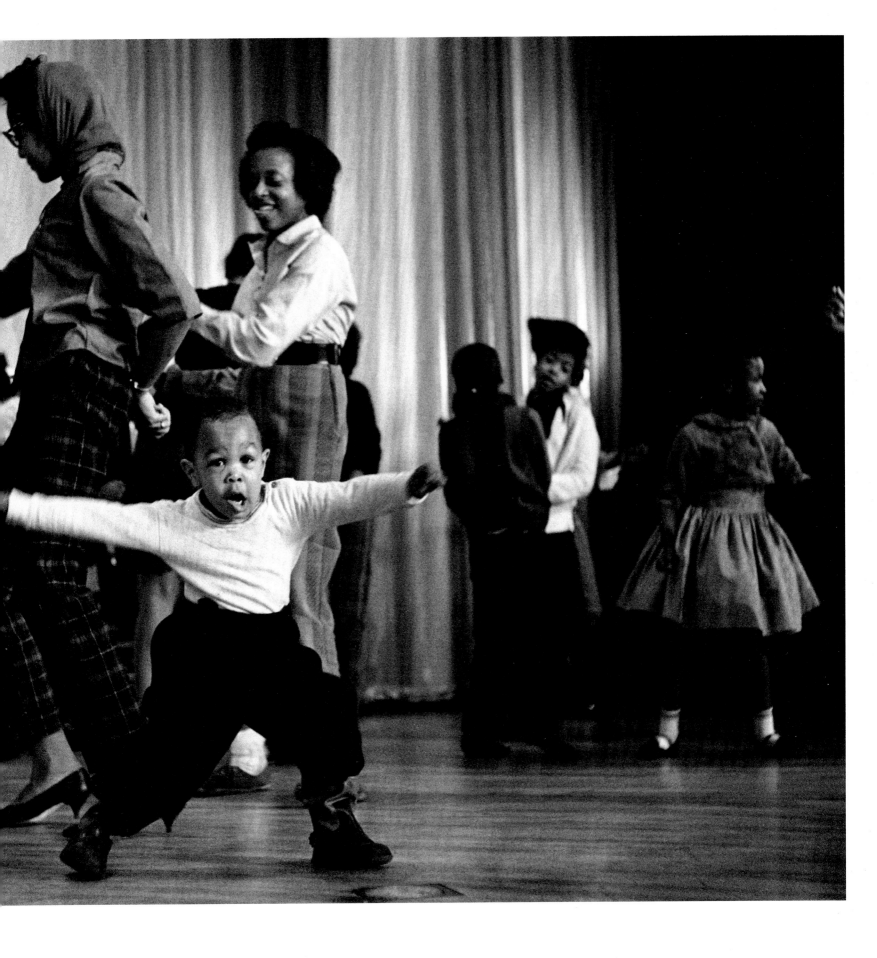

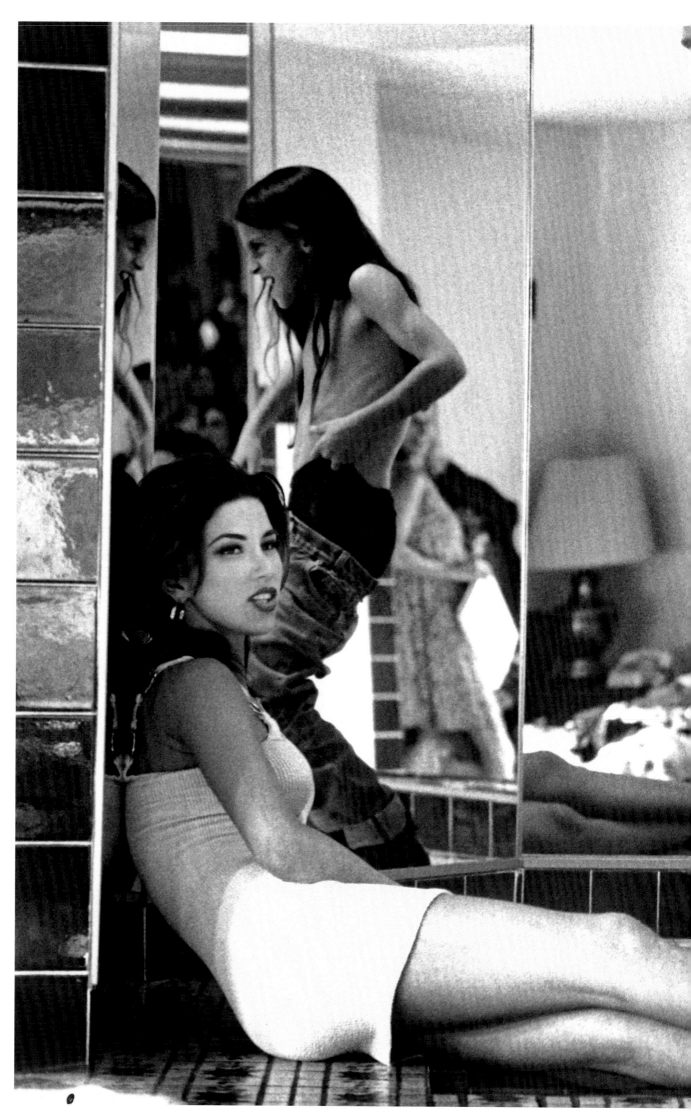

Studio City, 1990

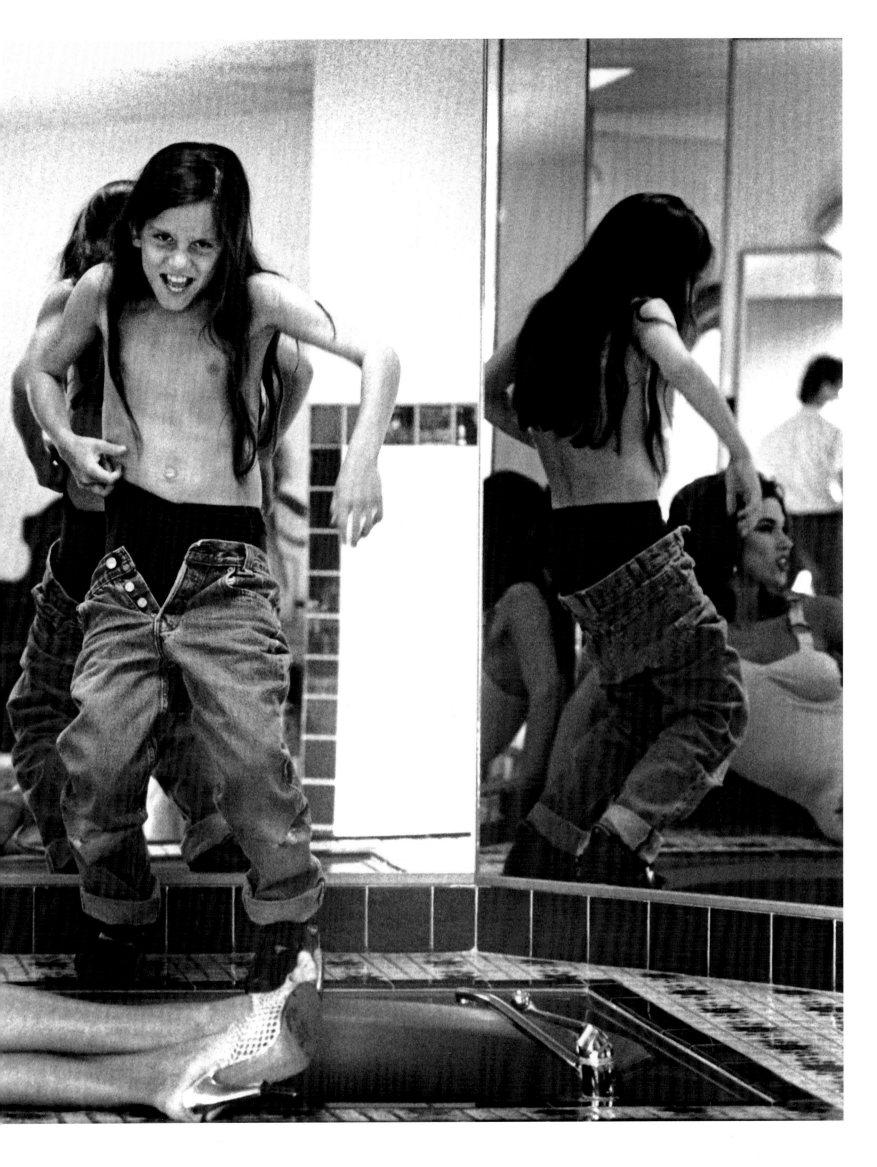

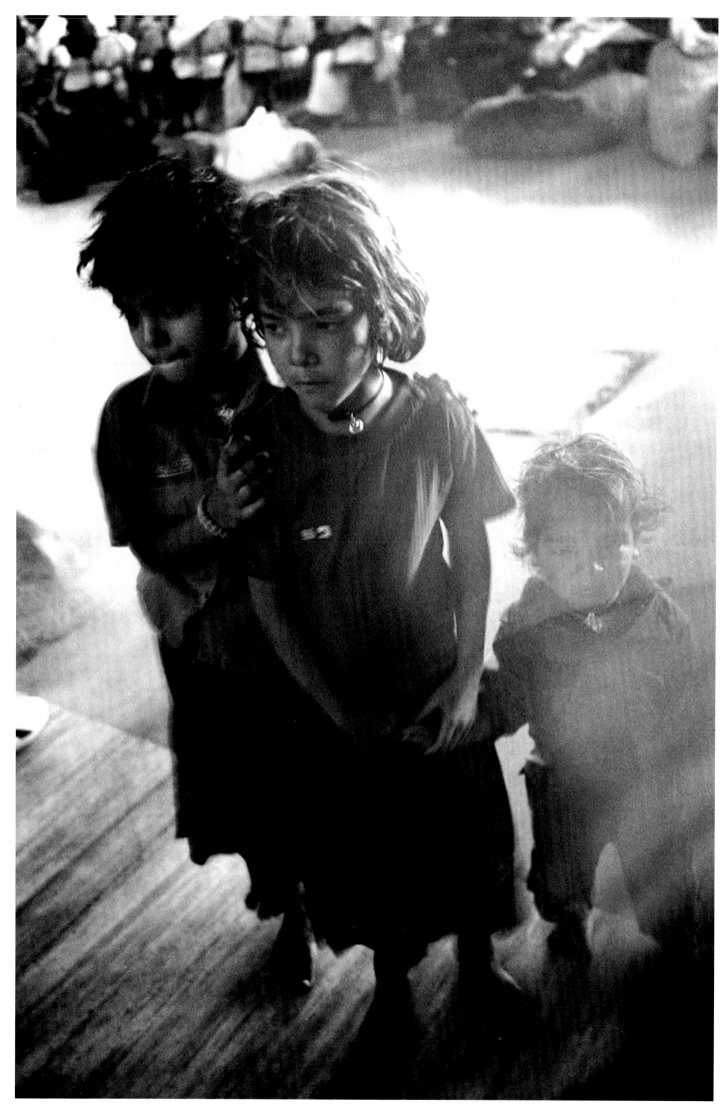

Station Children, Mumbai, India, 2005

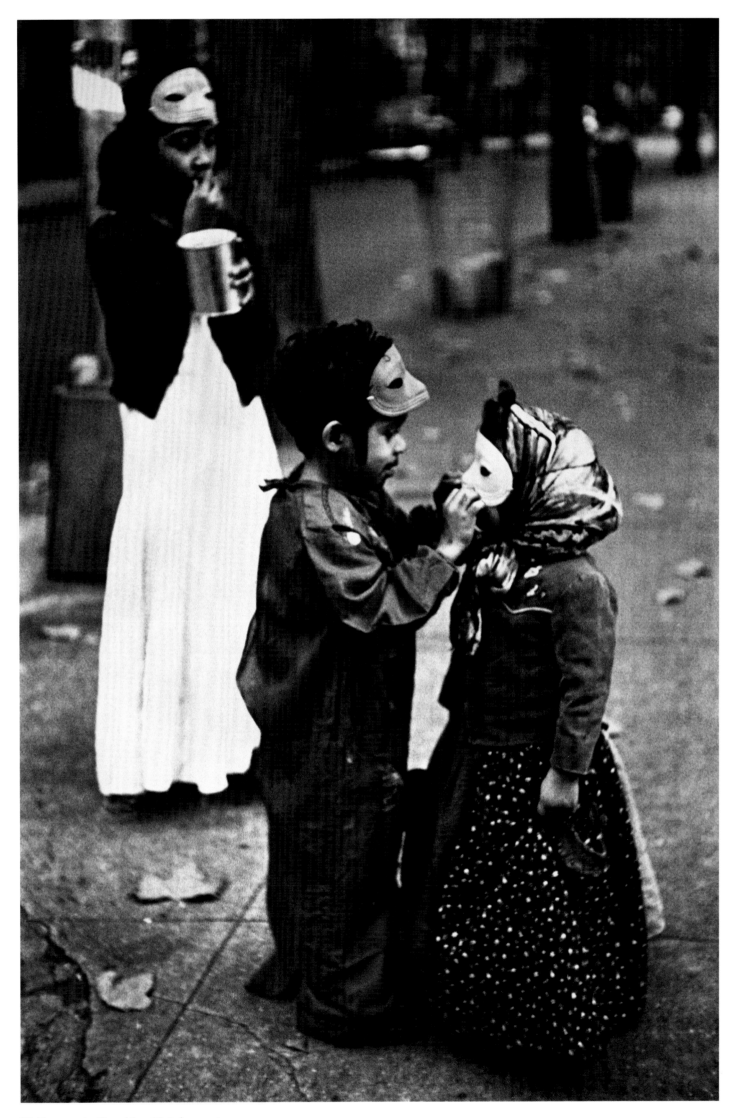

Halloween in Brooklyn Heights, 1960

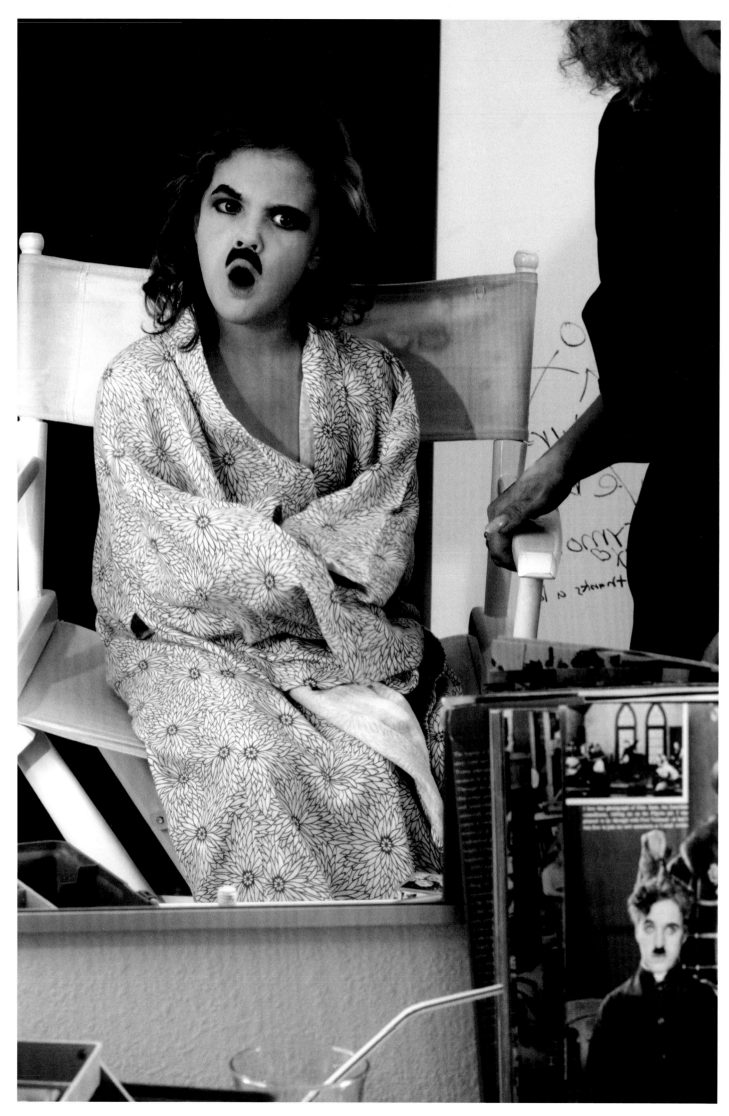

Drew Barrymore Becoming Charlie Chaplin, 1984

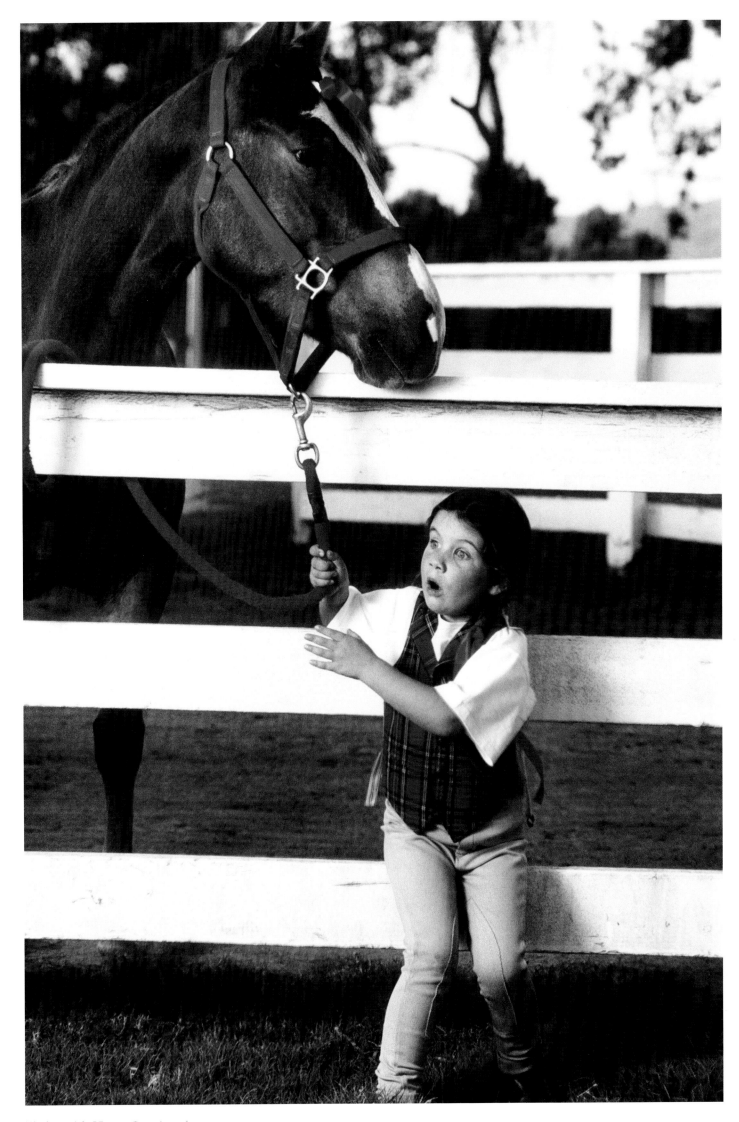

Taylor with Horse, Los Angeles, 1990

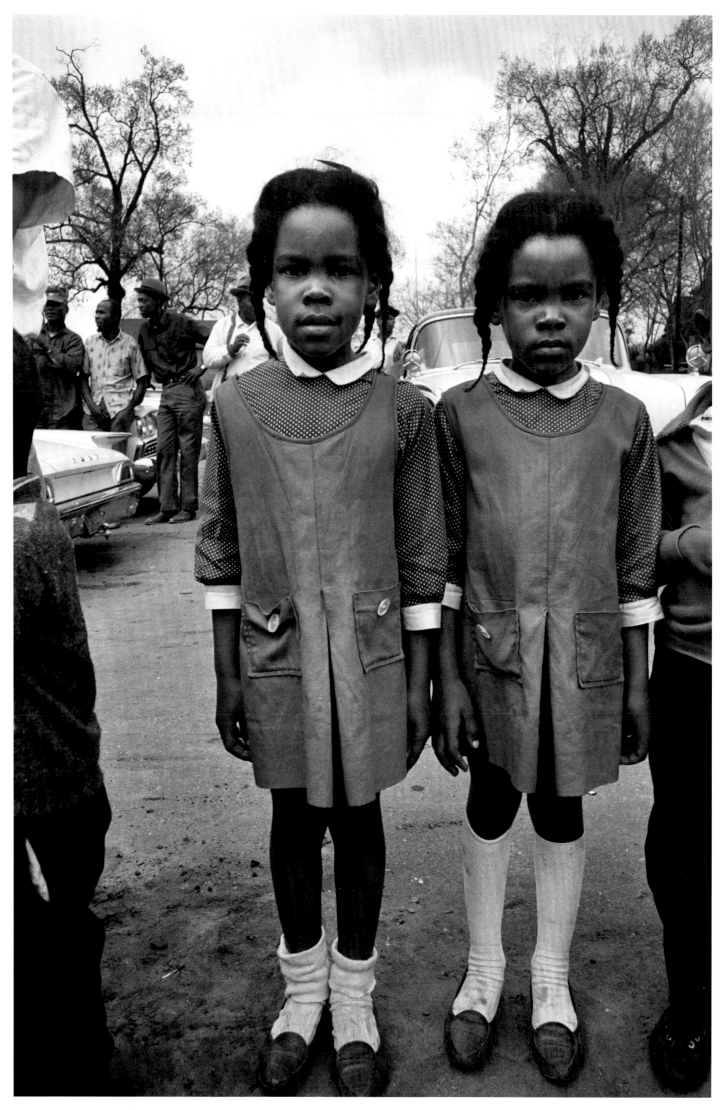

Watching the Selma March, Alabama, 1965

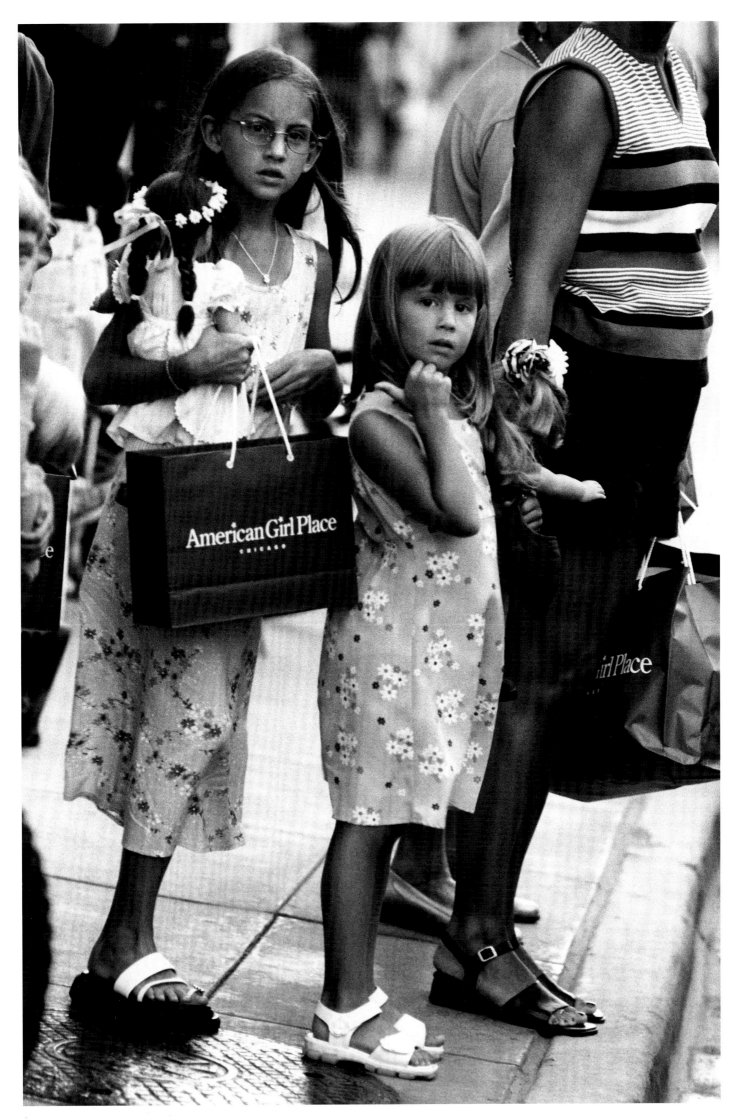

American Place Girls, Chicago, 2000

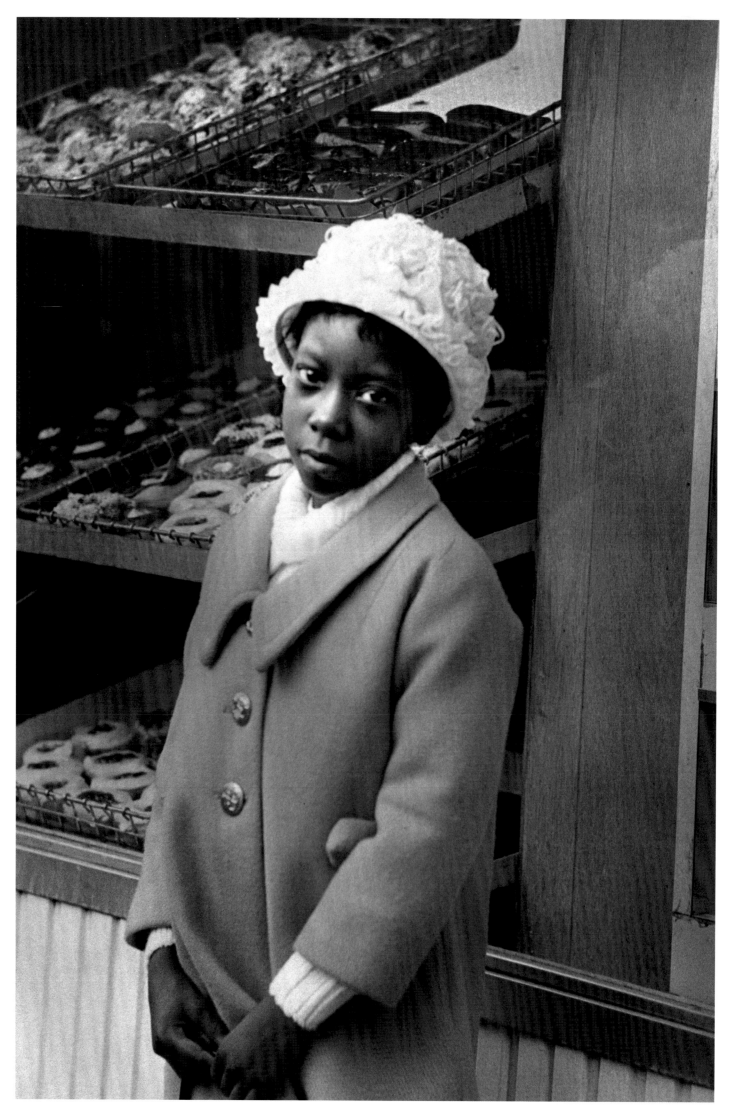

Girl at Bakery, Easter in Harlem, 1970

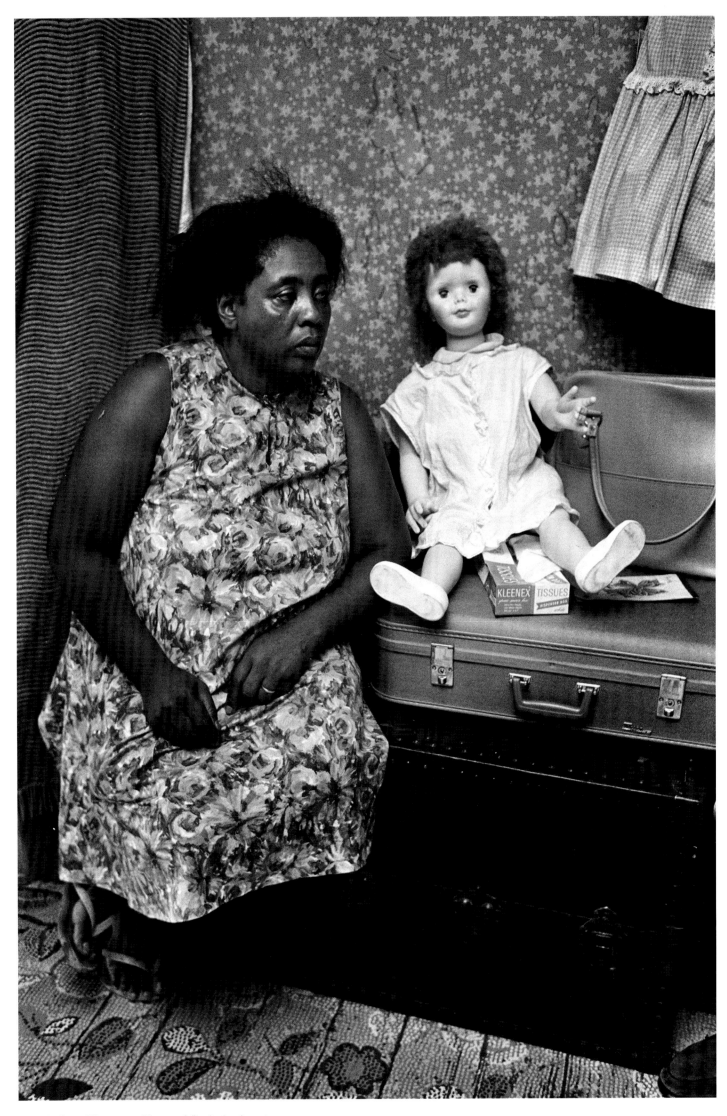

Fannie Lou Hamer at Home, Mississippi, 1963

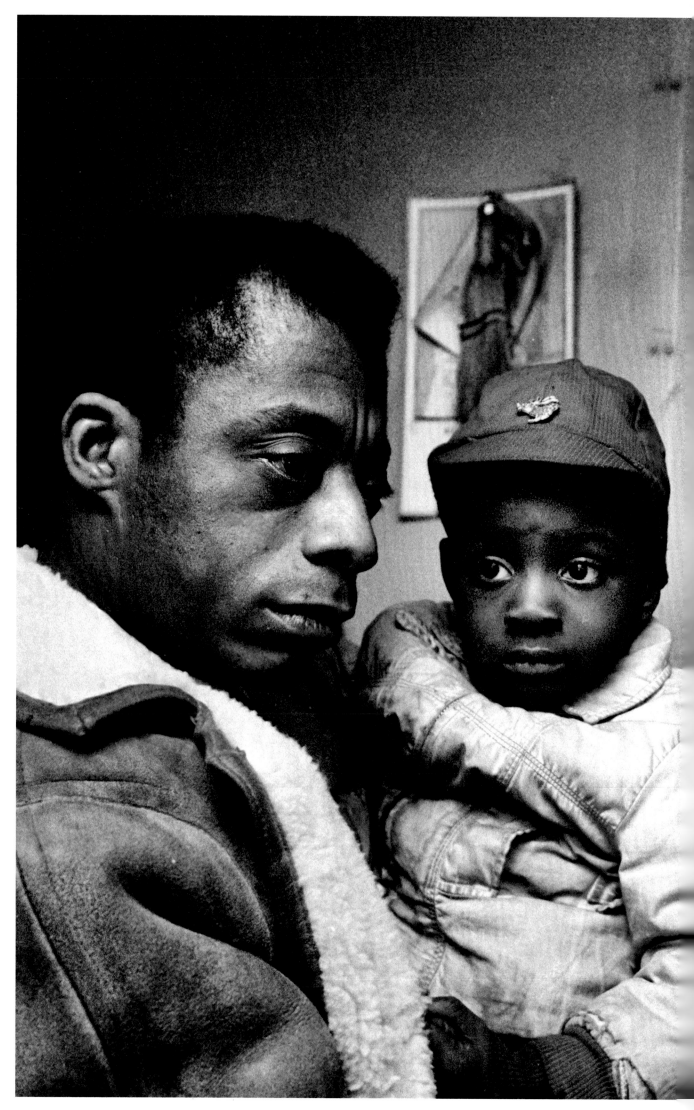

James Baldwin with Abandoned Child, Durham, North Carolina, 1963

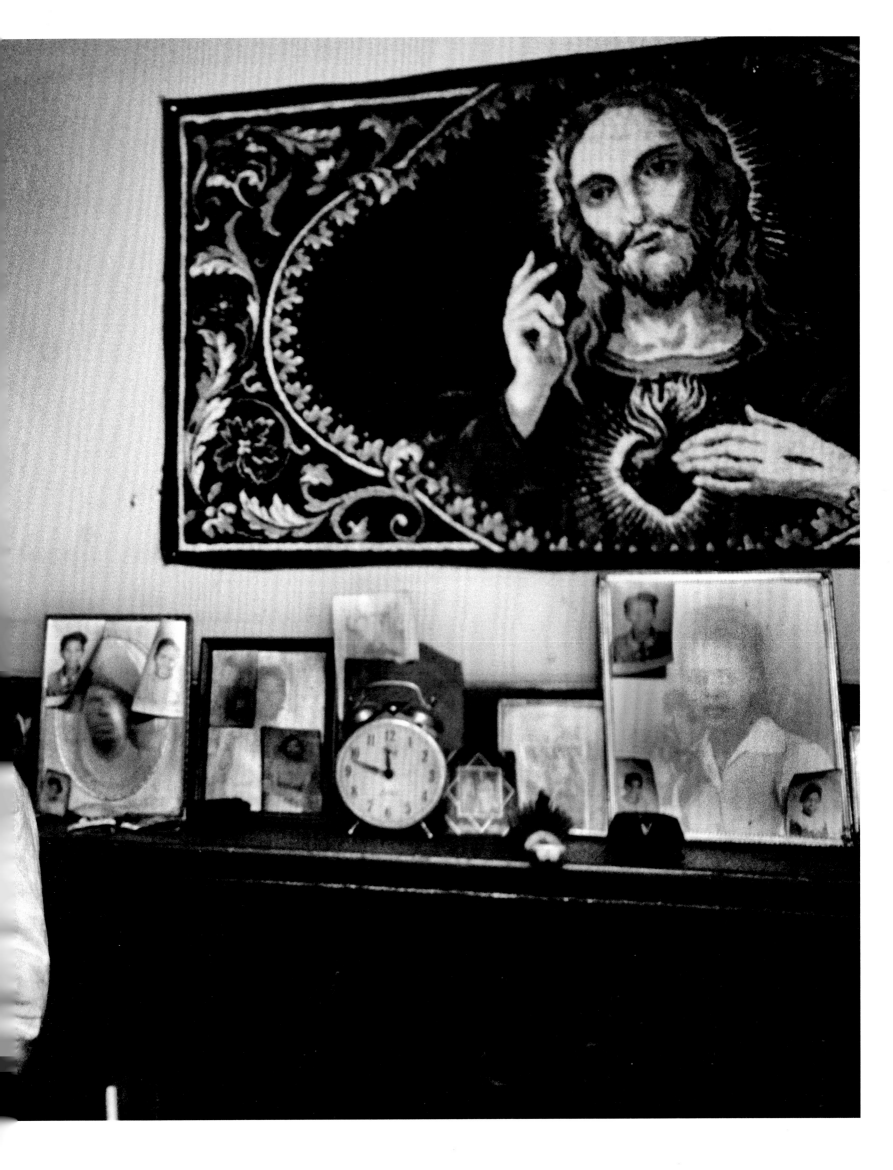

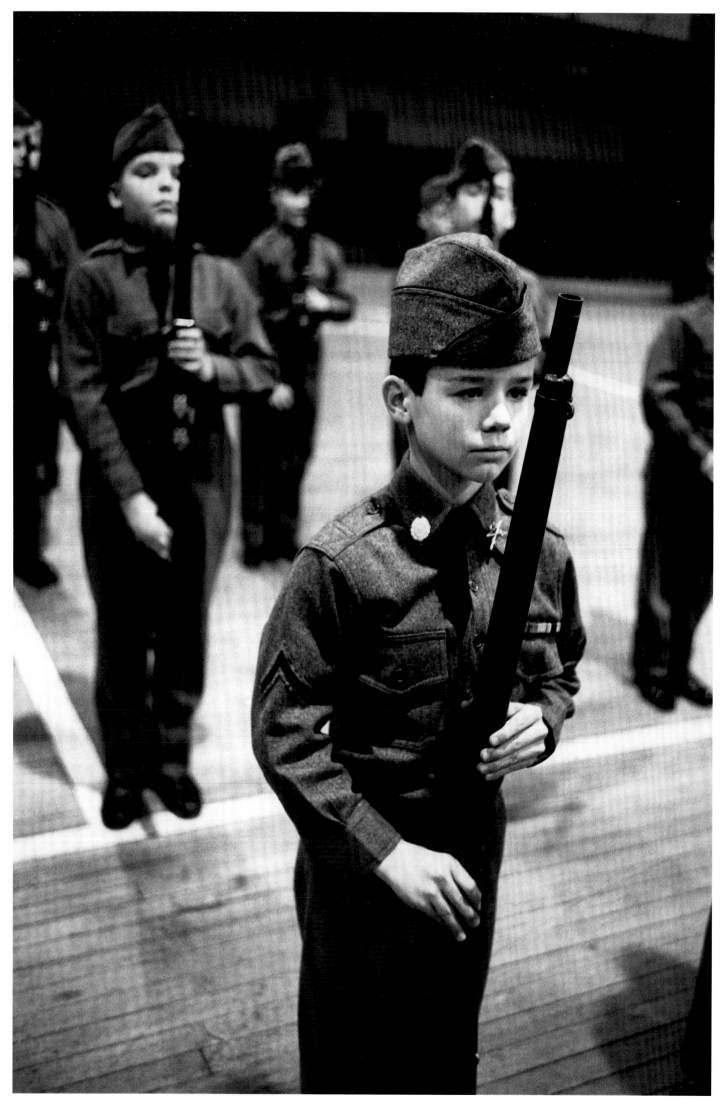

Military School, New York, 1962

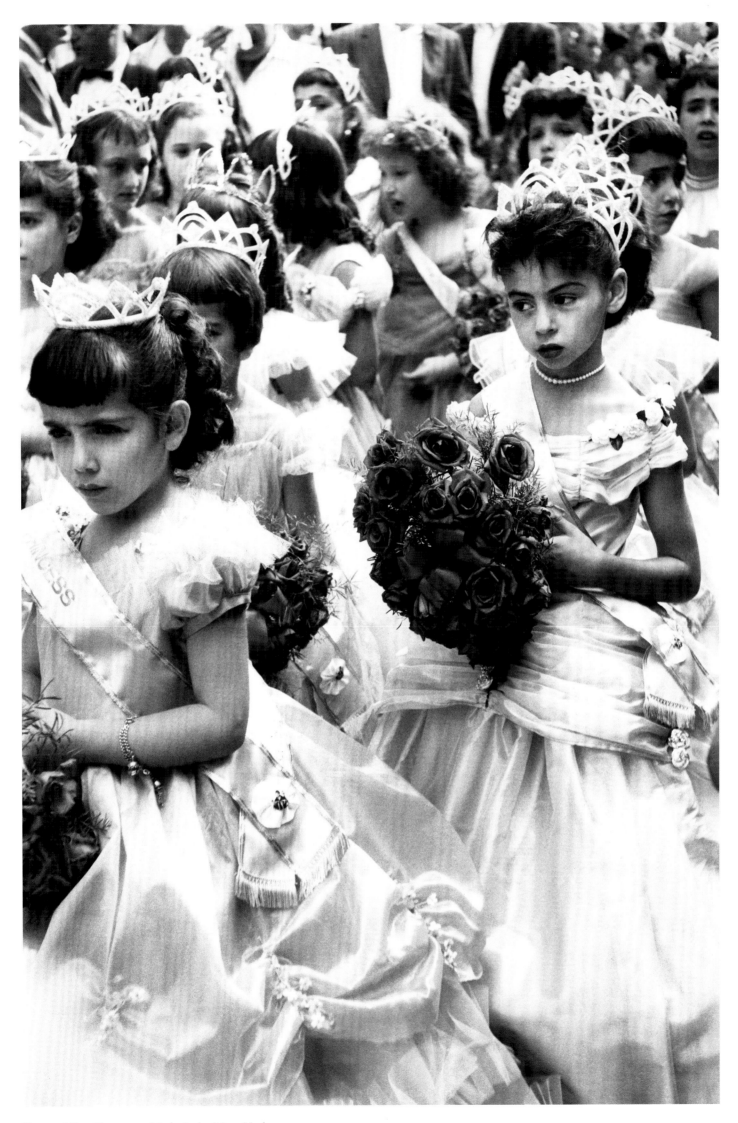

Feast of San Gennaro, Little Italy, New York, 1959

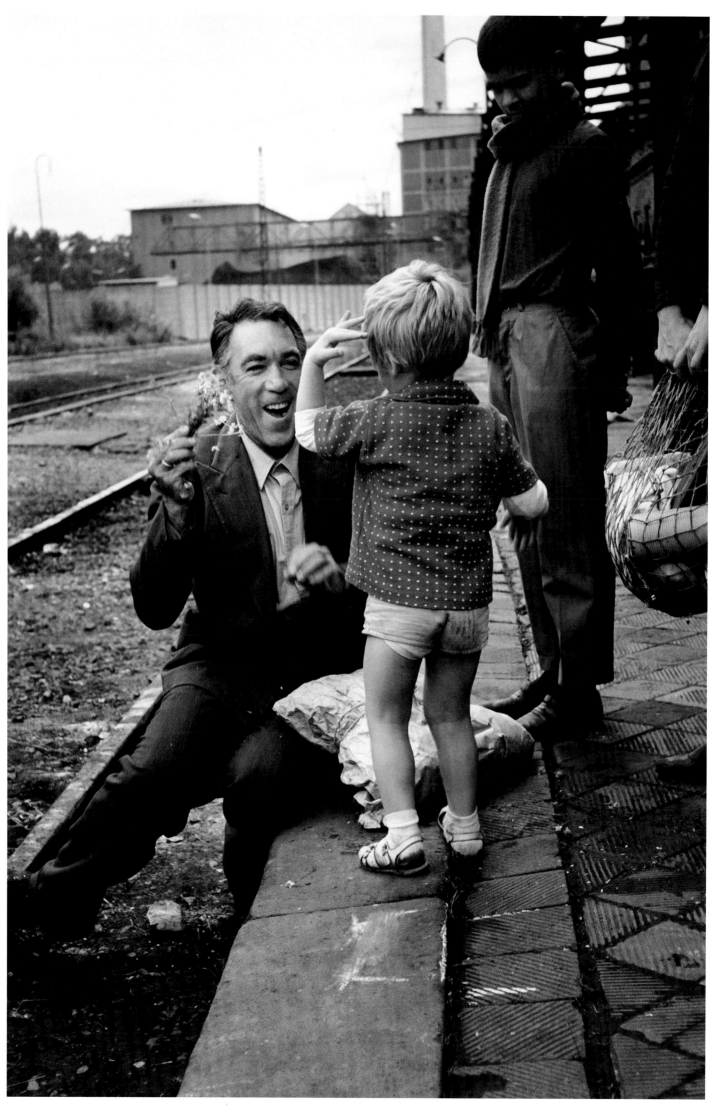

Anthony Quinn, Udine, Italy, 1966

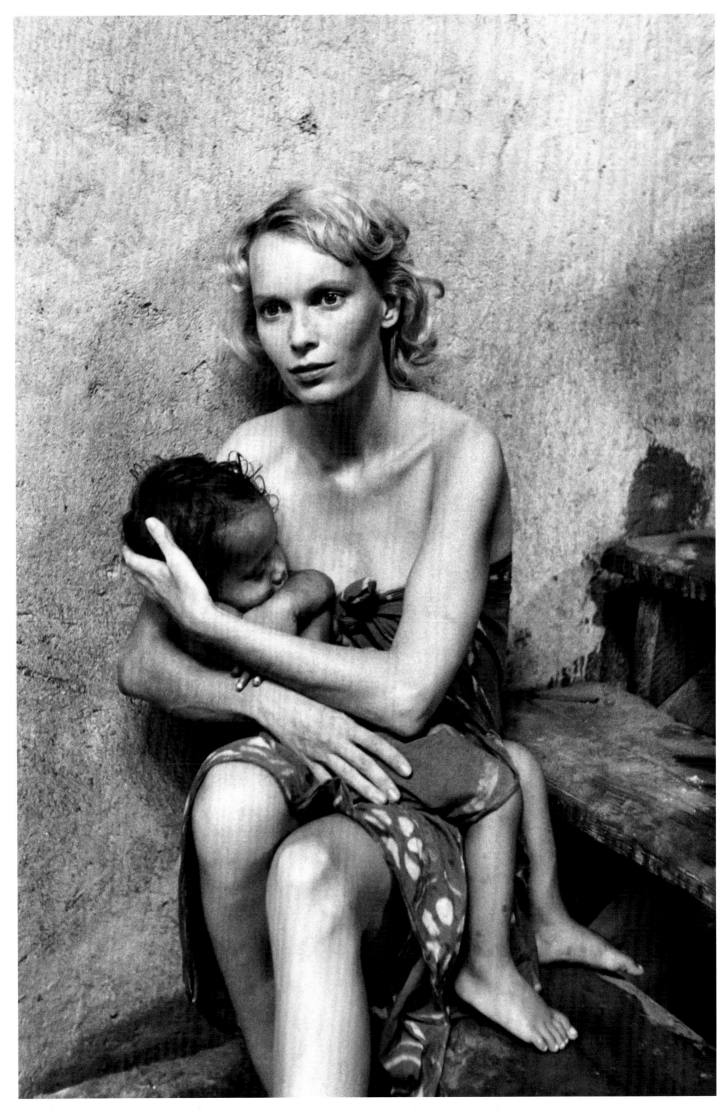

Mia Farrow, Bora Bora, 1978

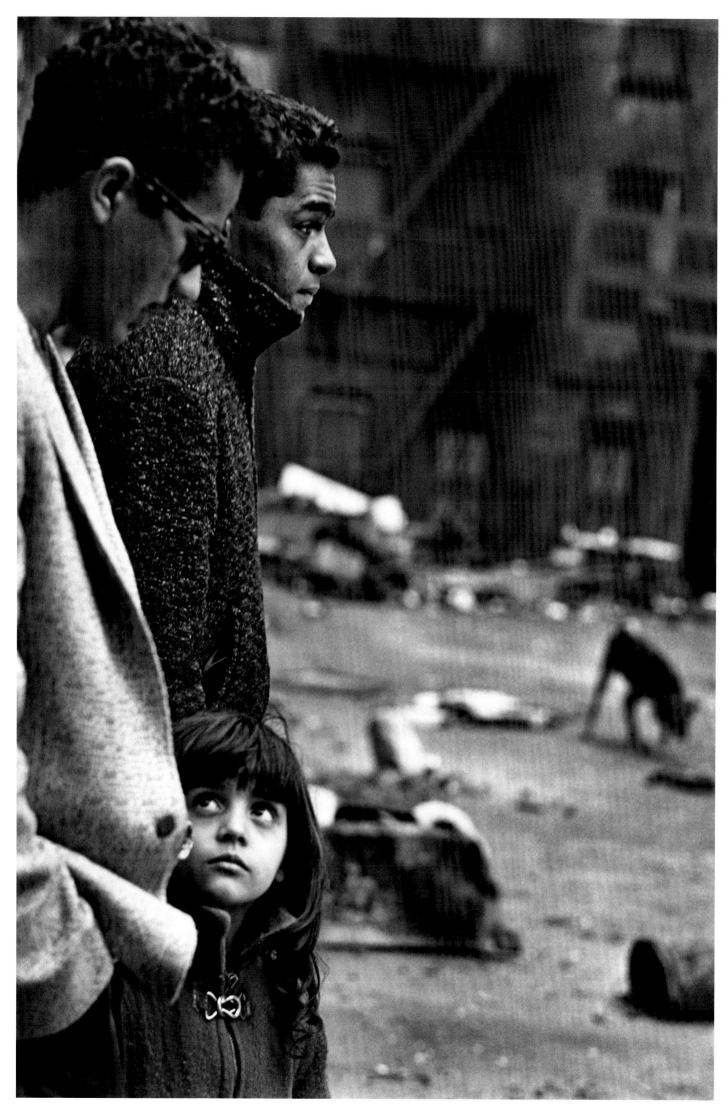

East Harlem Addict Series, 1960

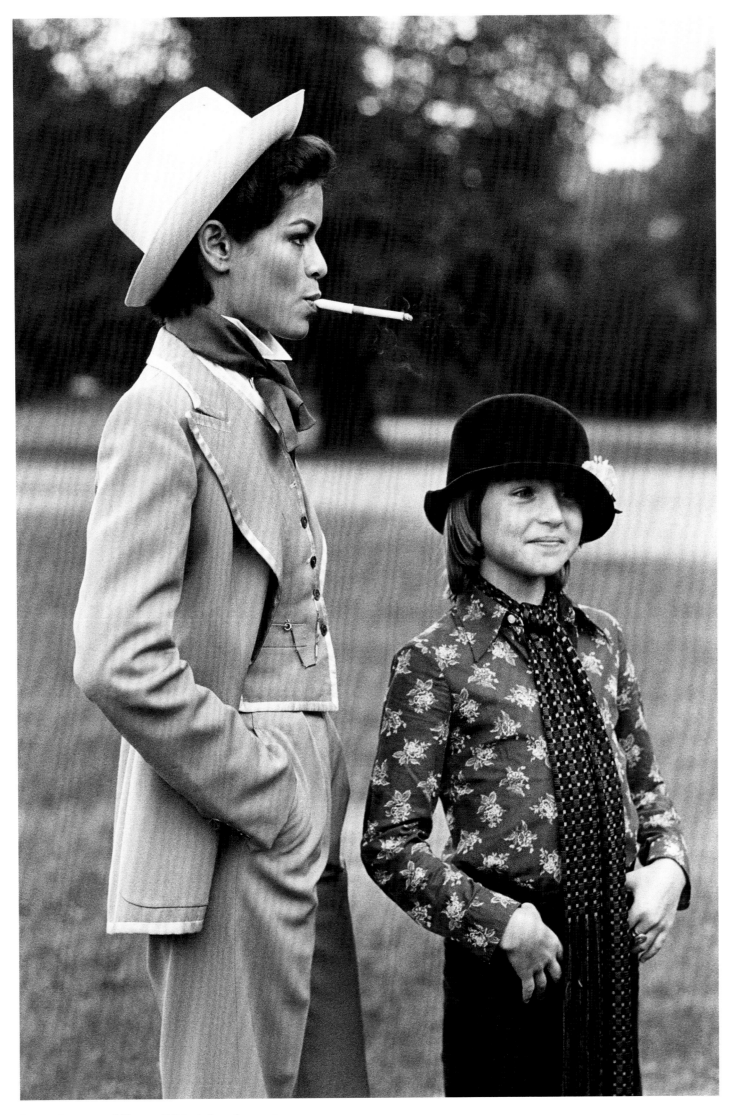

Bianca Jagger and Tatum O'Neal, London, 1964

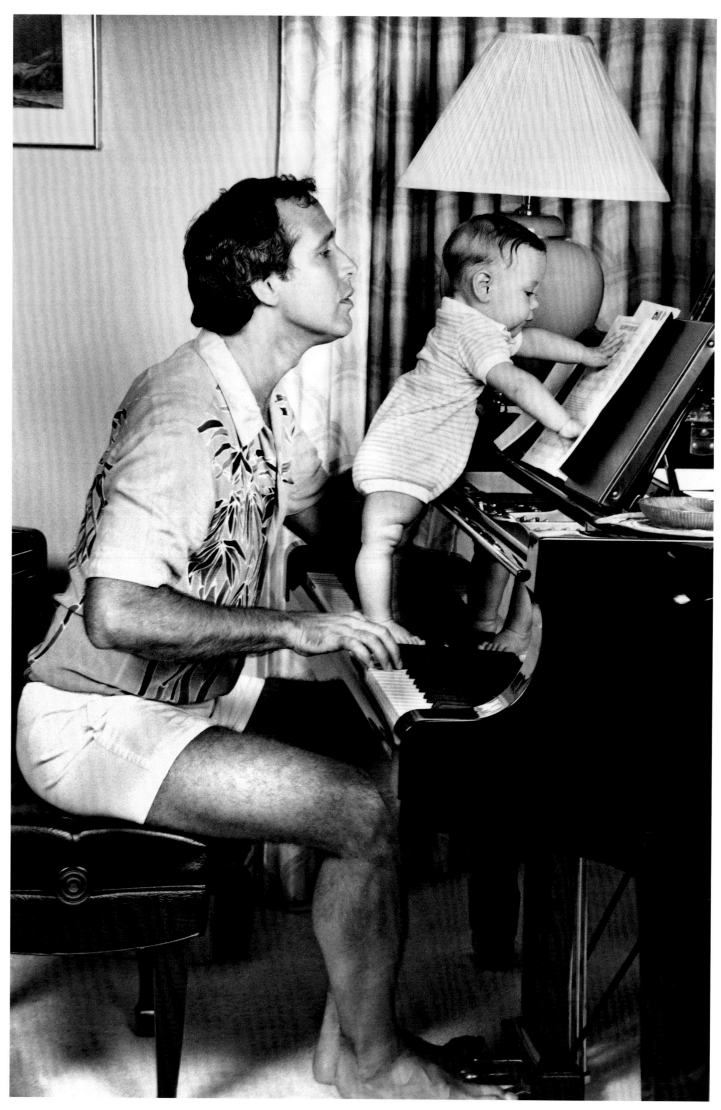

Chevy Chase with Daughter, Cydney, Los Angeles, 1983

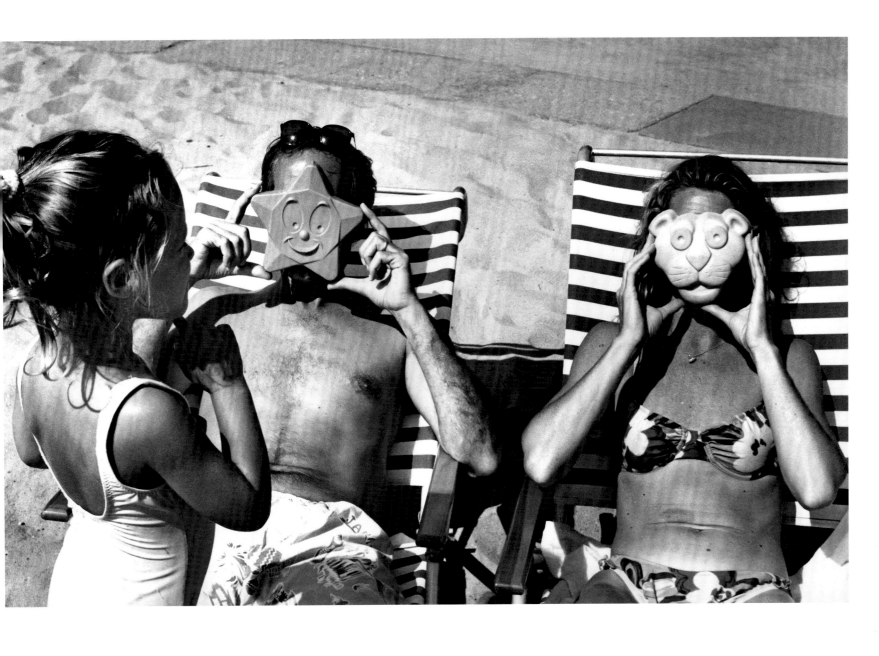

Chase Family, East Hampton Beach, 1991

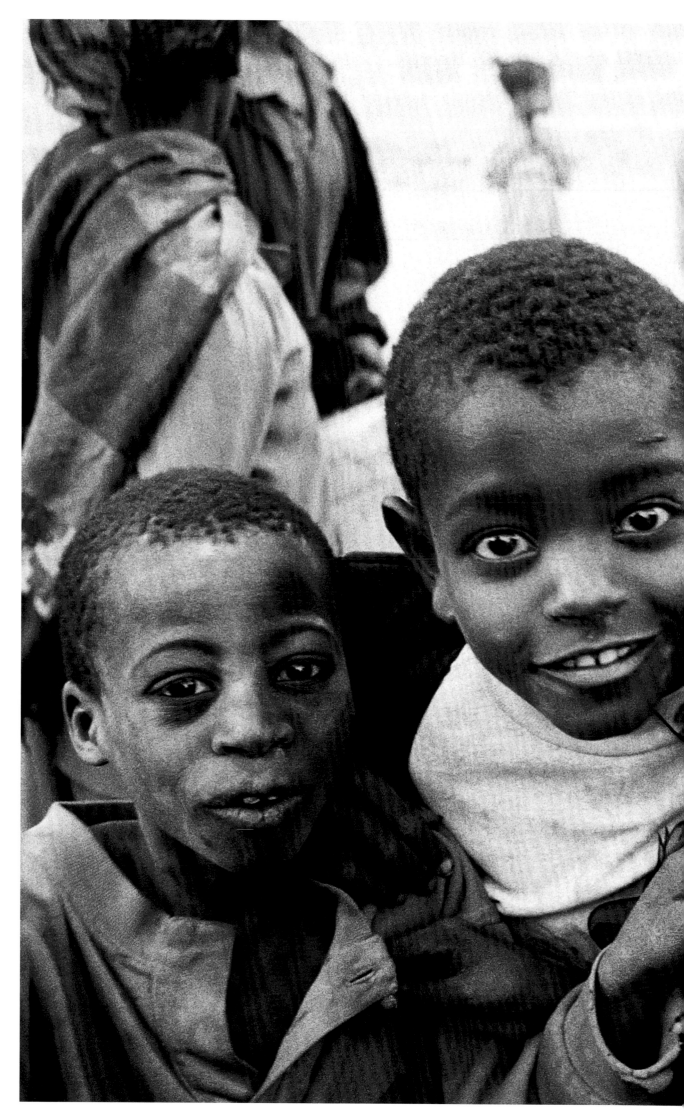

Ethiopian Boys, Ziway, Ethiopia, 2001

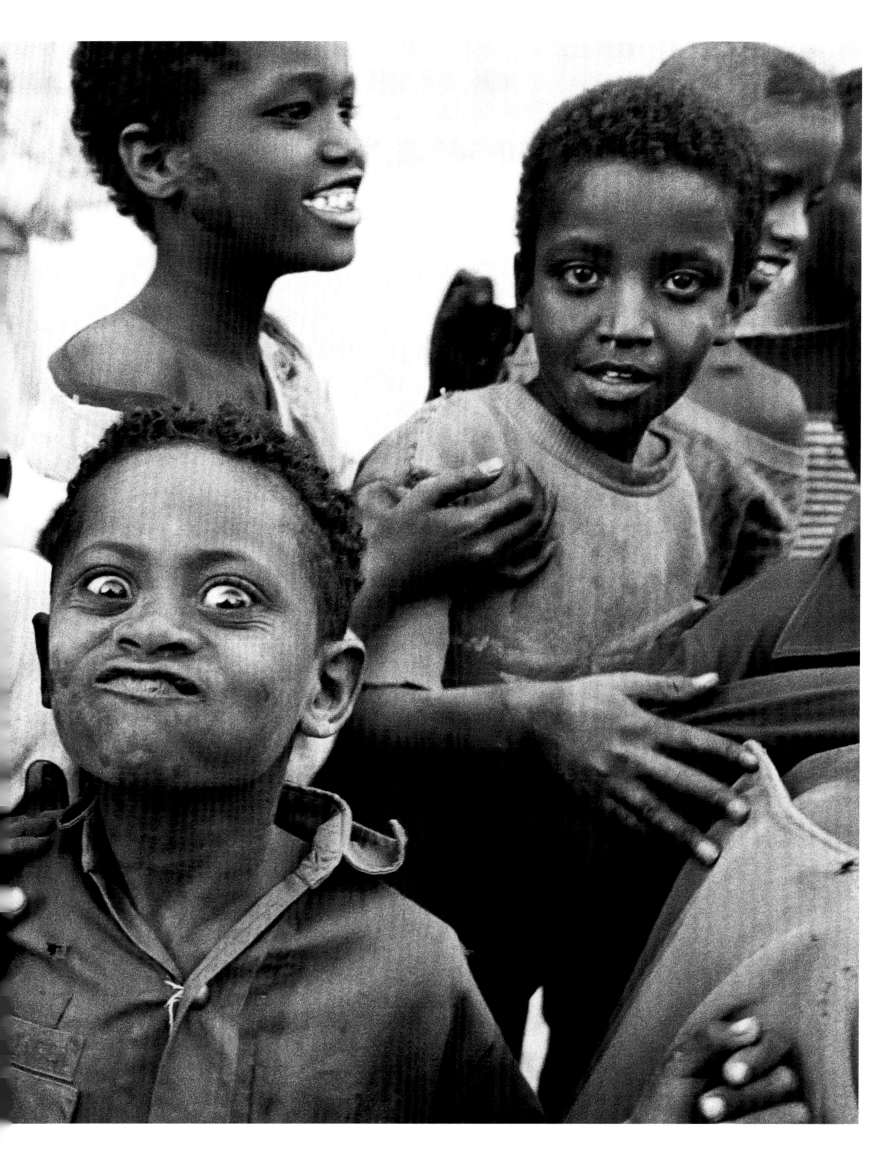

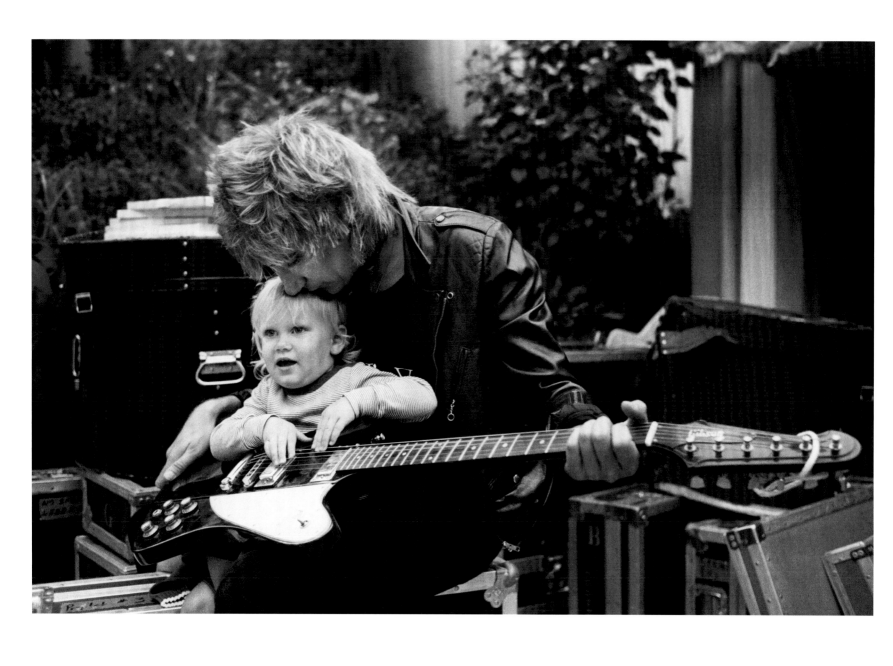

Rod Stewart with Daughter, Kimberly, Bel Air, 1981

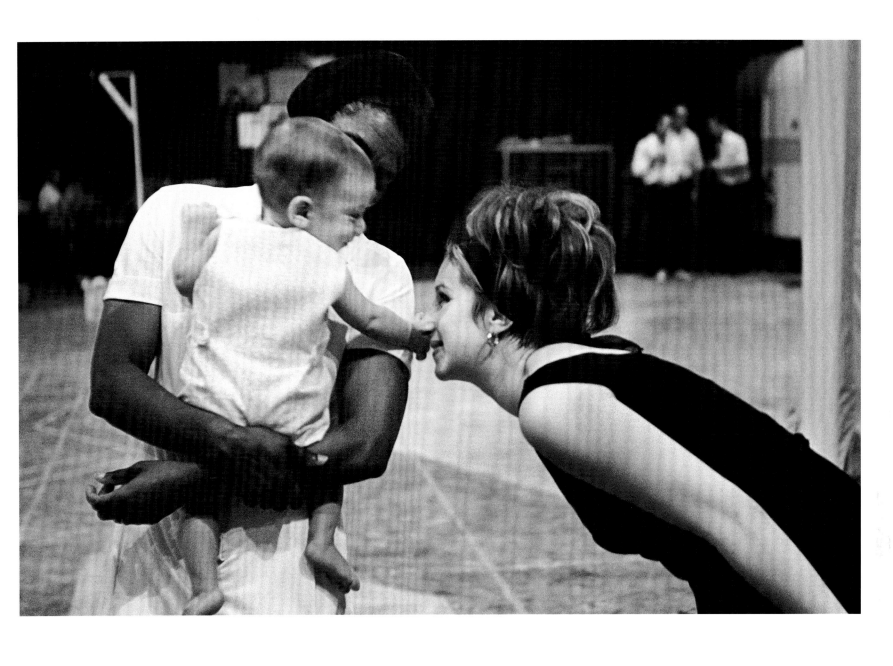
Barbra Streisand with Son, Jason, Malibu, 1967

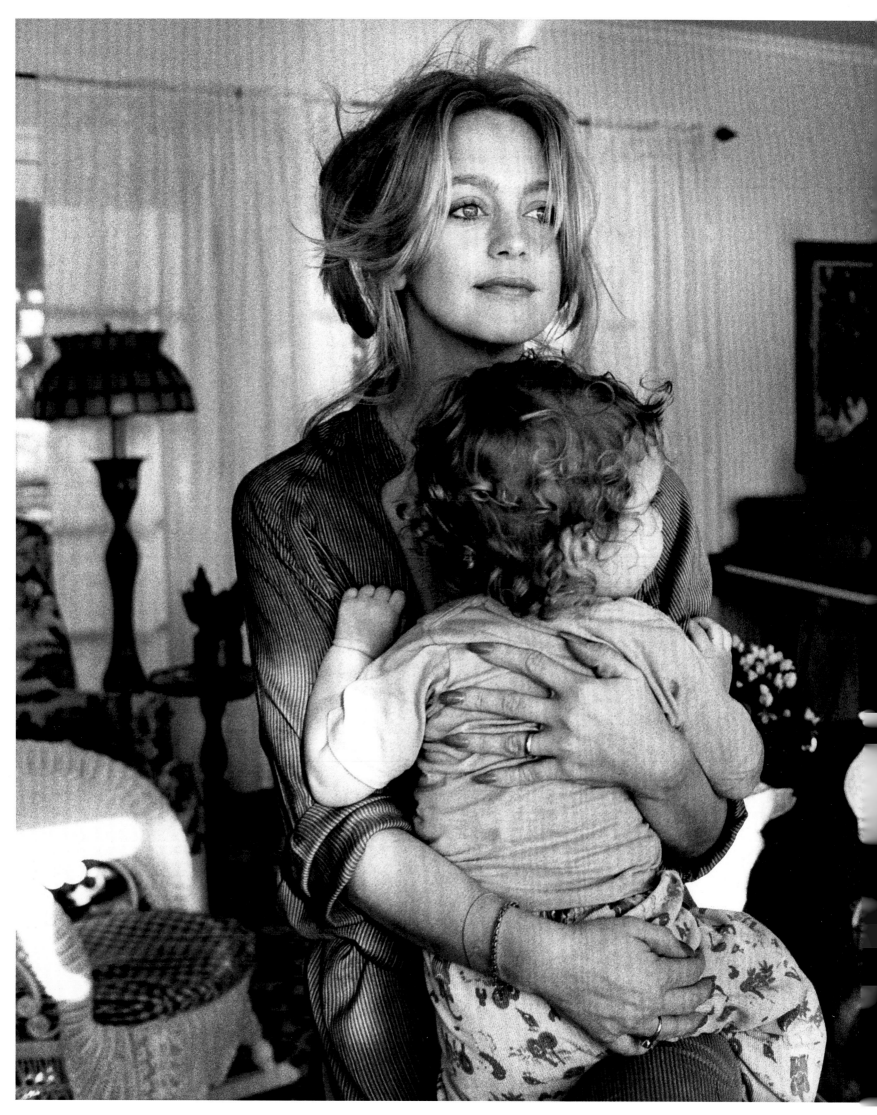

Goldie Hawn with Son, Oliver, Los Angeles, 1978

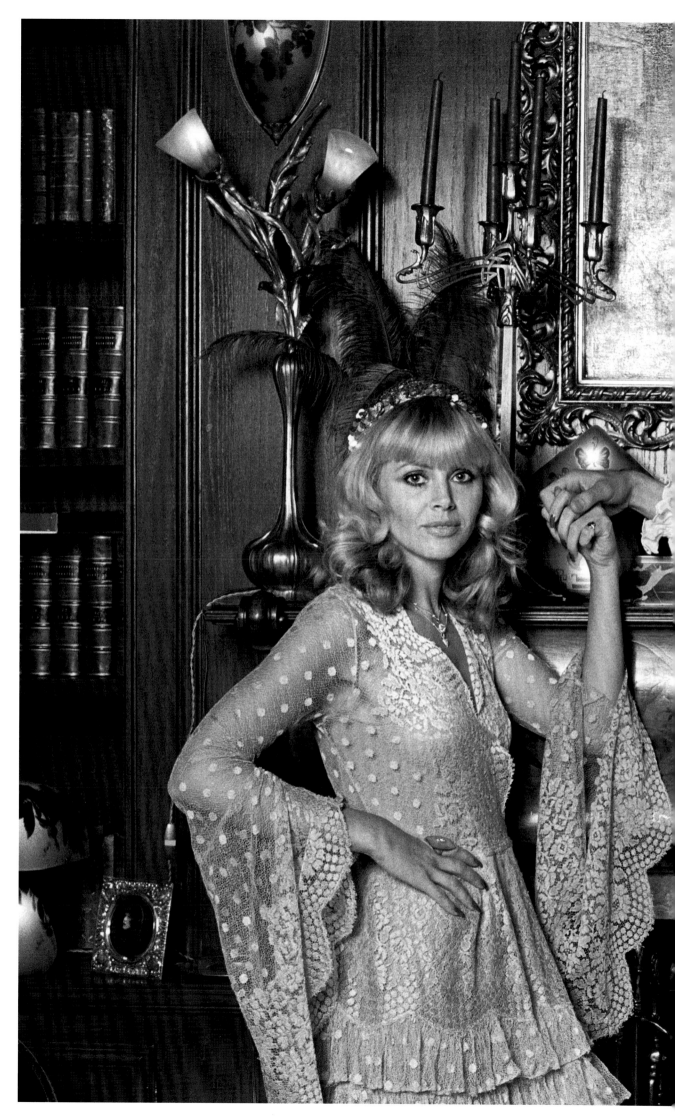

Britt Ekland and Rod Stewart at His Bel Air Home, 1977

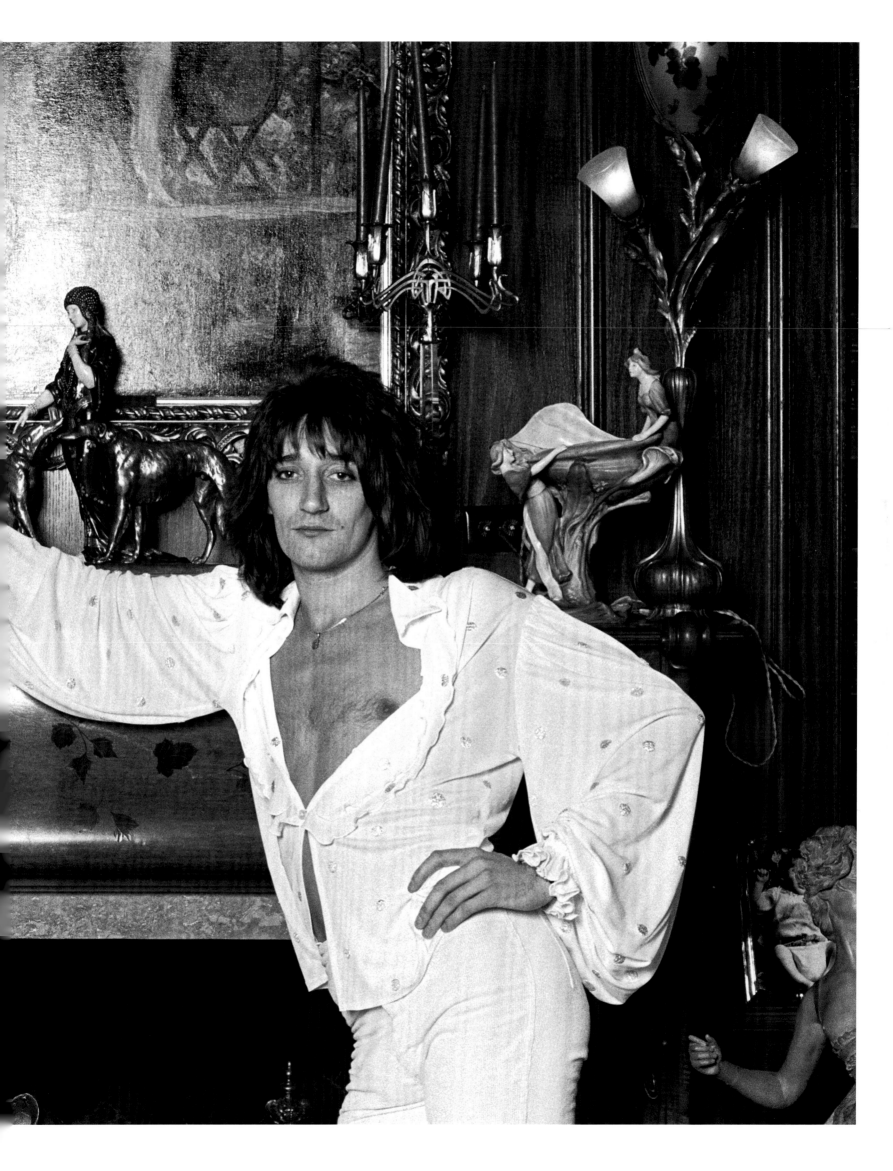

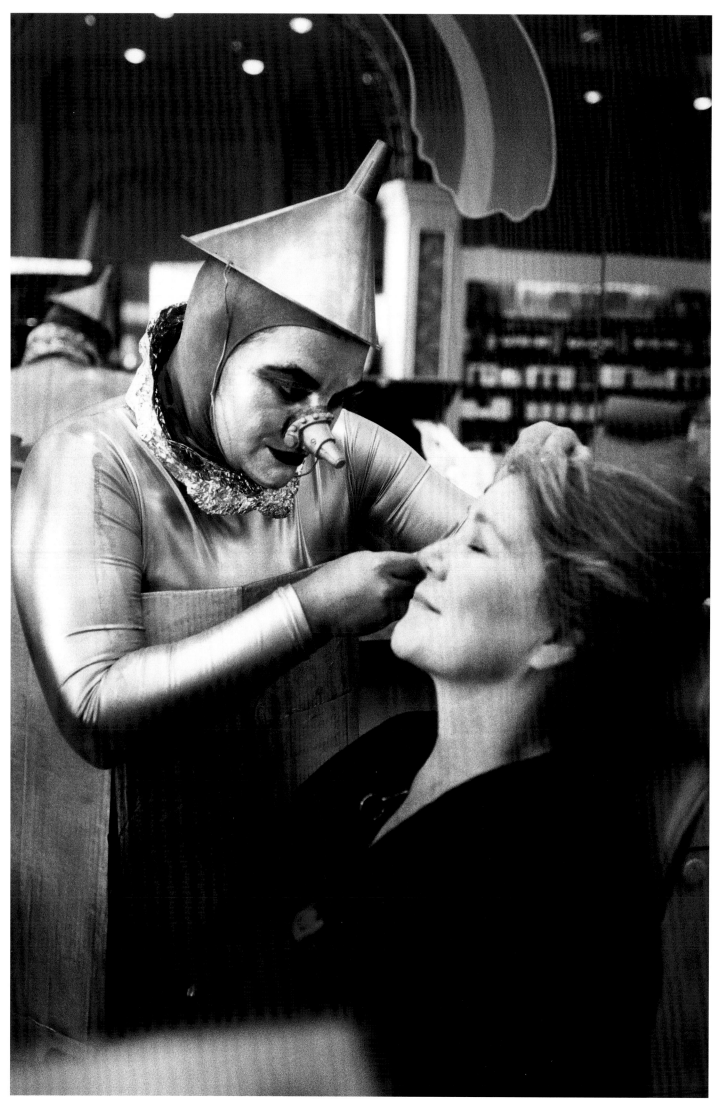

Tin Man Hairdresser, Los Angeles, 2002

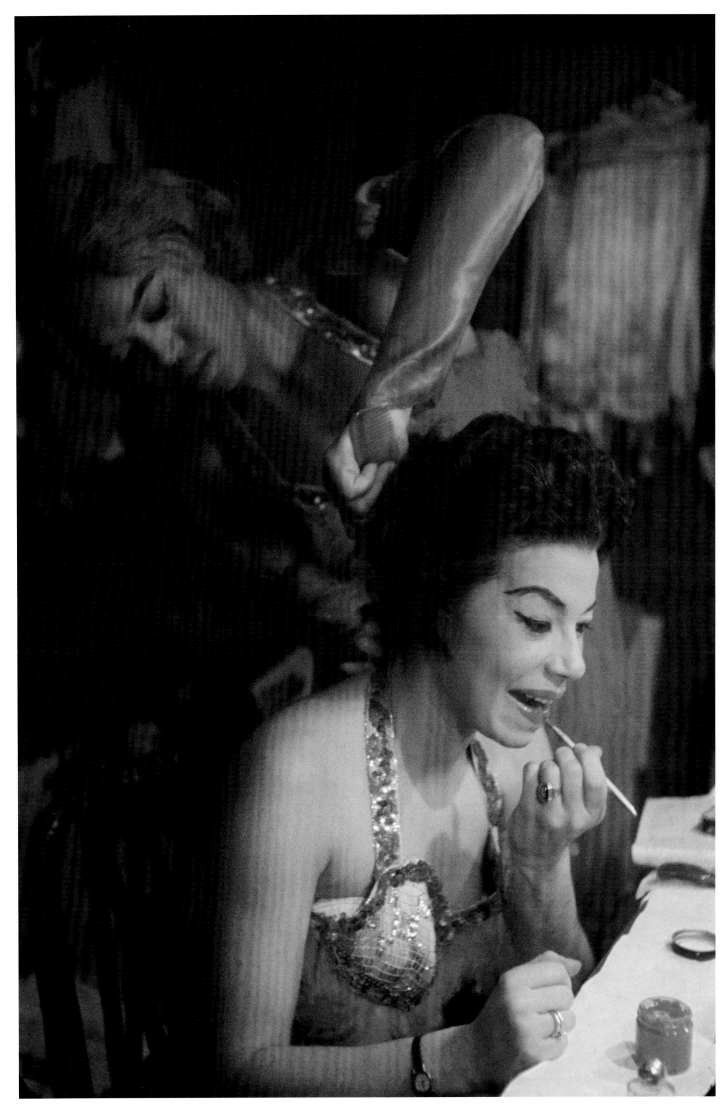

Backstage Dancers, The Apollo Theater, Harlem, 1961

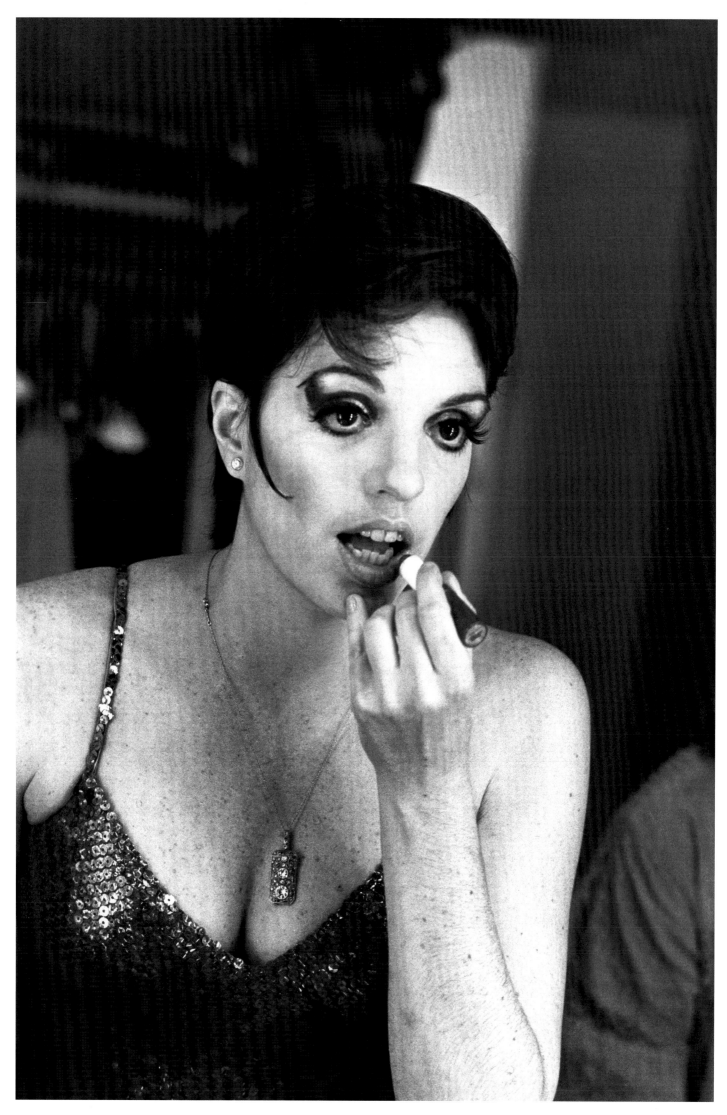

Liza Minnelli Backstage, New York, 1964

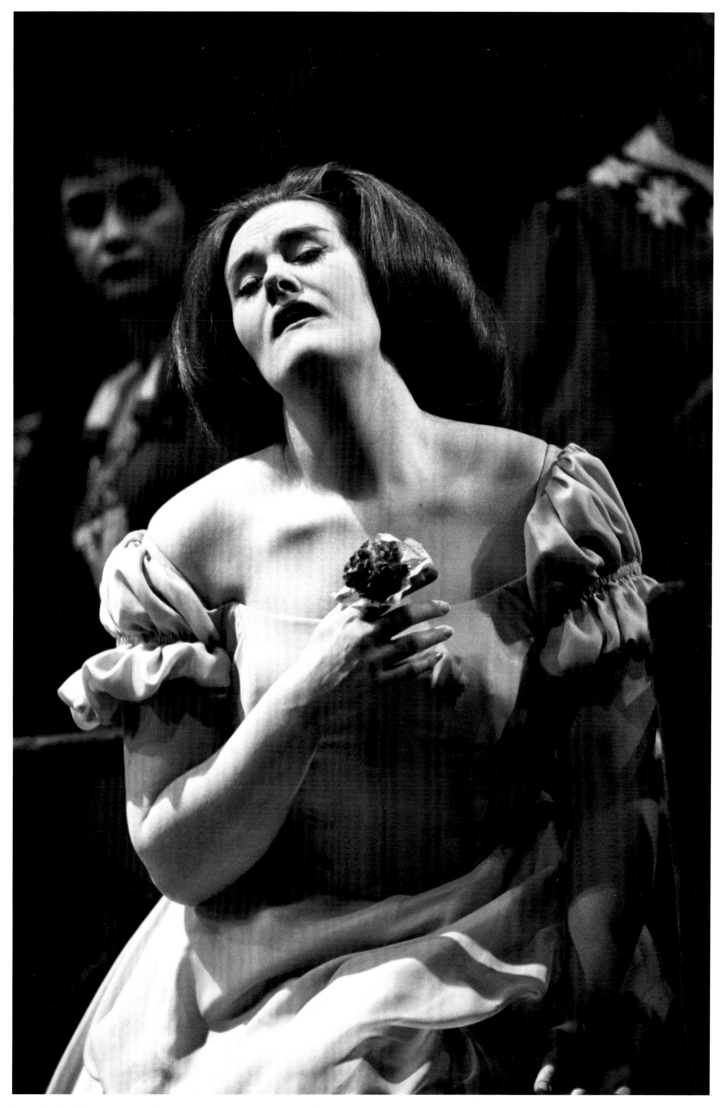

Joan Sutherland, Metropolitan Opera House, New York, 1966

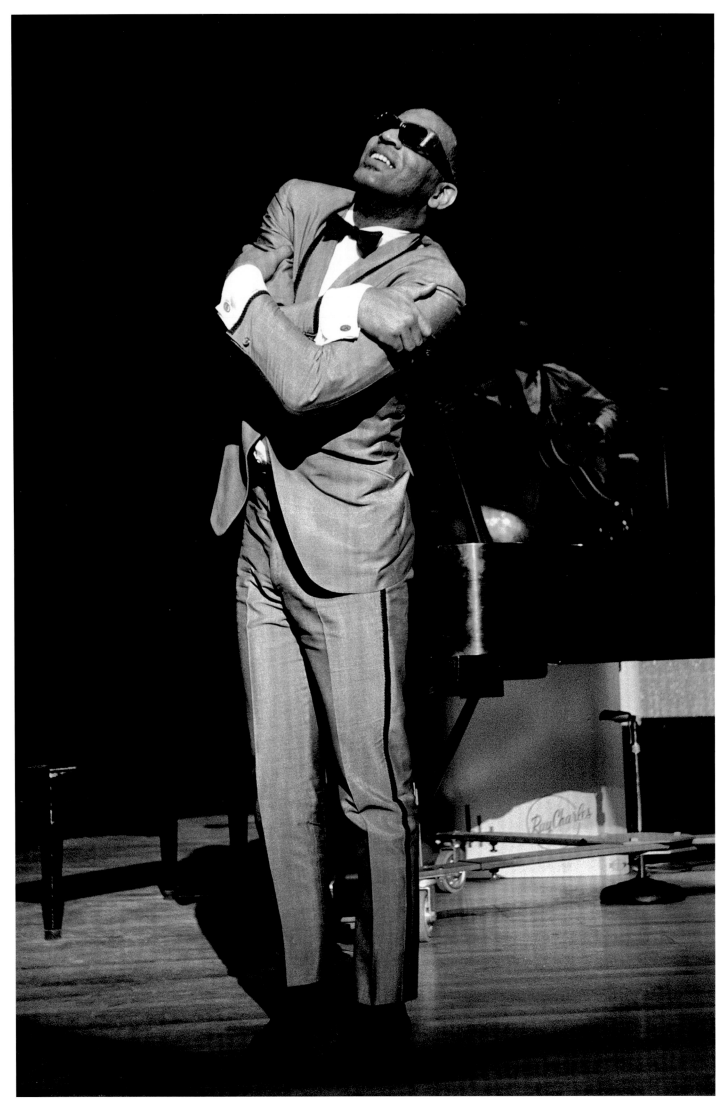

96    Ray Charles, New Jersey, 1966

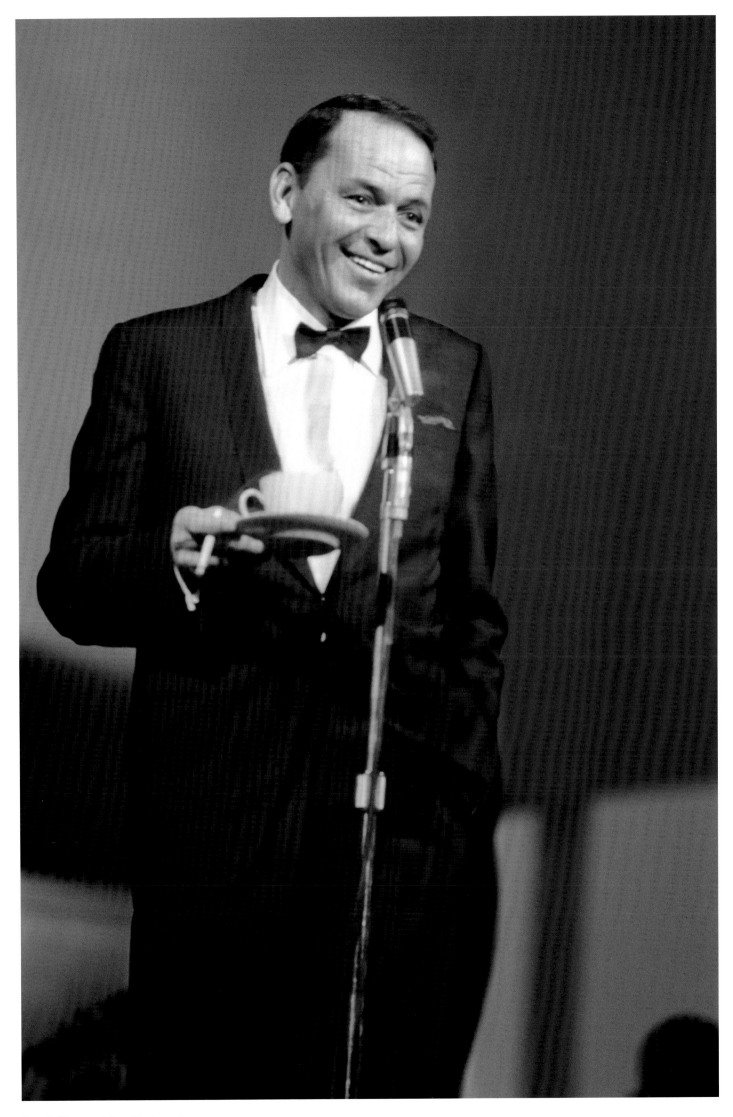

Frank Sinatra, New York, 1963

Paul Simon and Art Garfunkel, New York, 1967

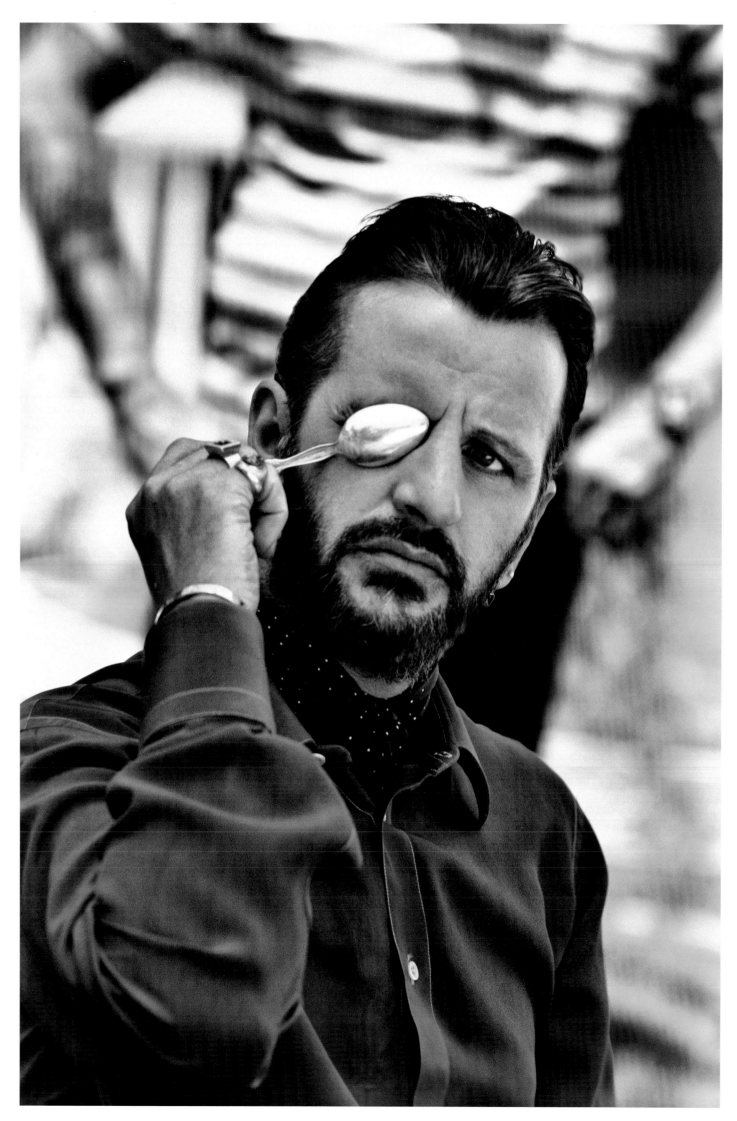

Ringo Starr, Kansas, 1979

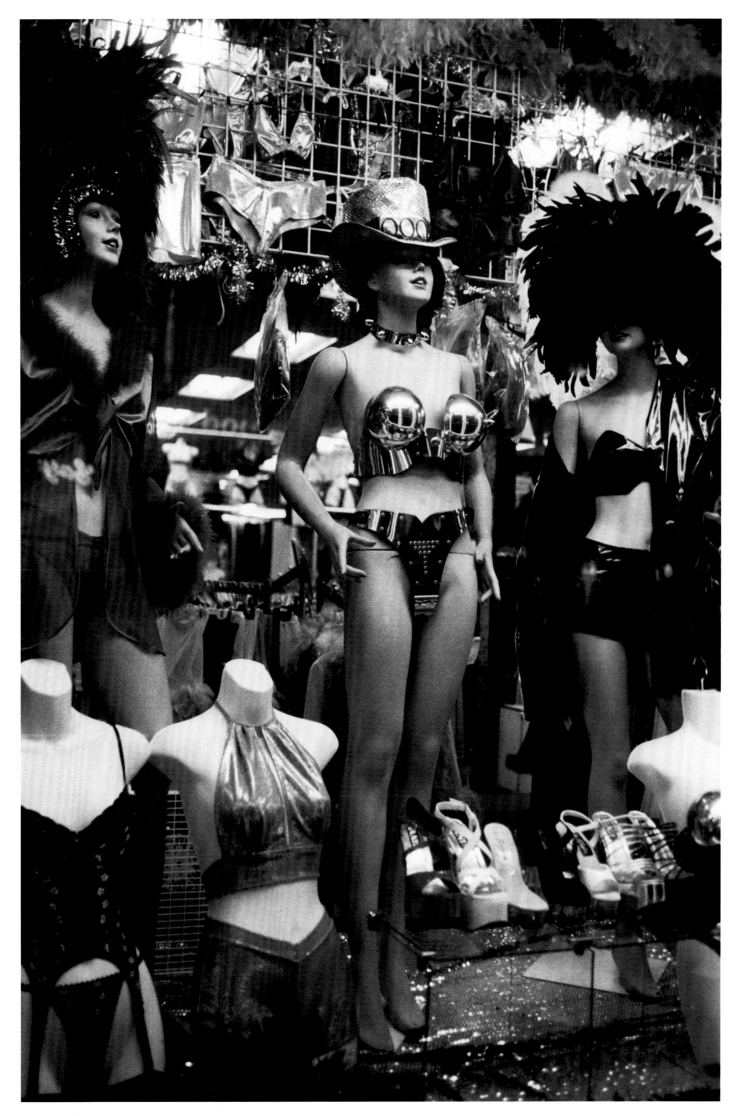

Hollywood Store Window, 1998

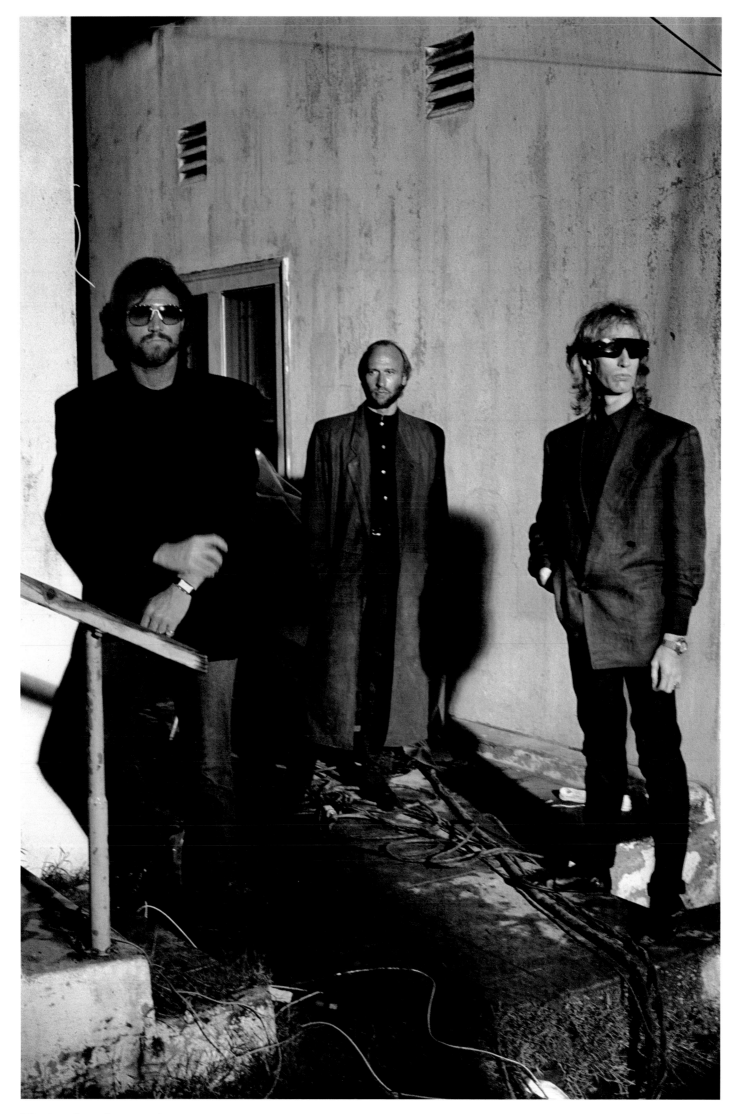

The Bee Gees, Los Angeles, 1977

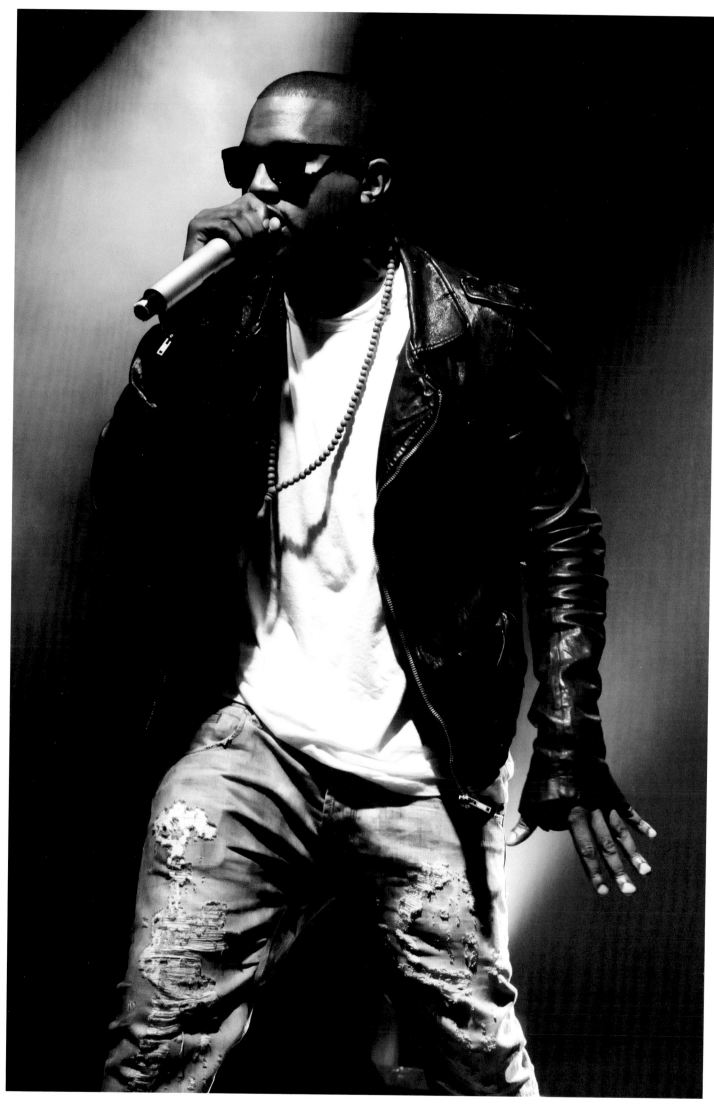

Kanye West, Chicago, 2010

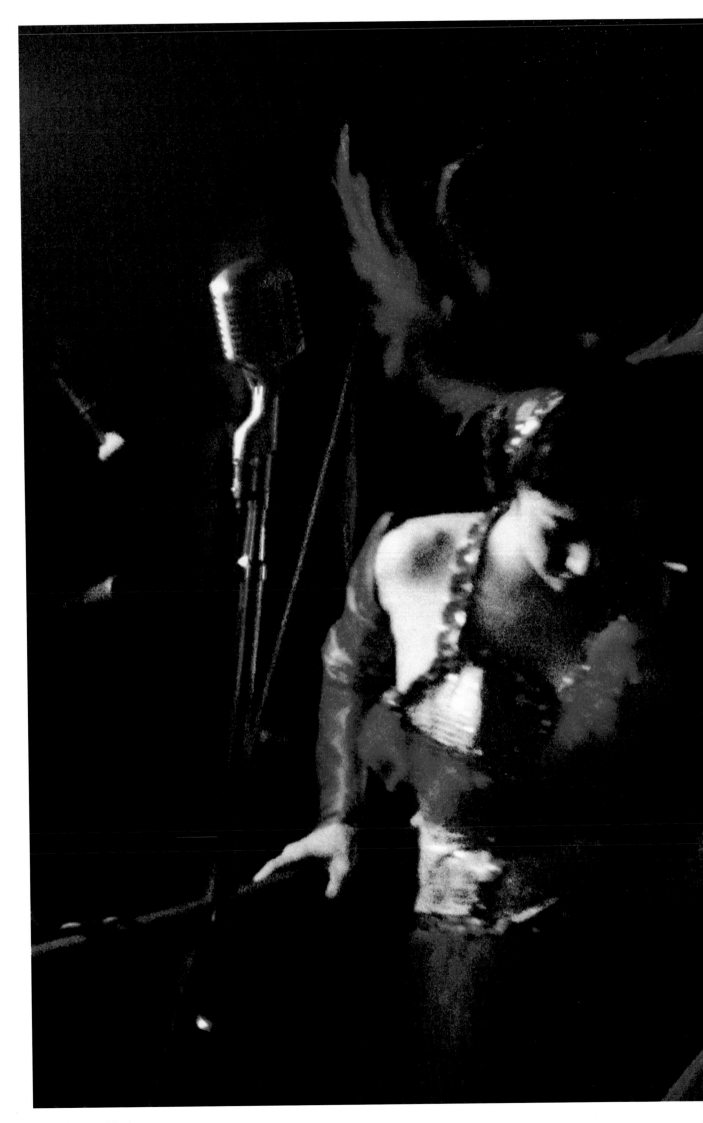

Dancers at The Apollo Theater, Harlem, 1961

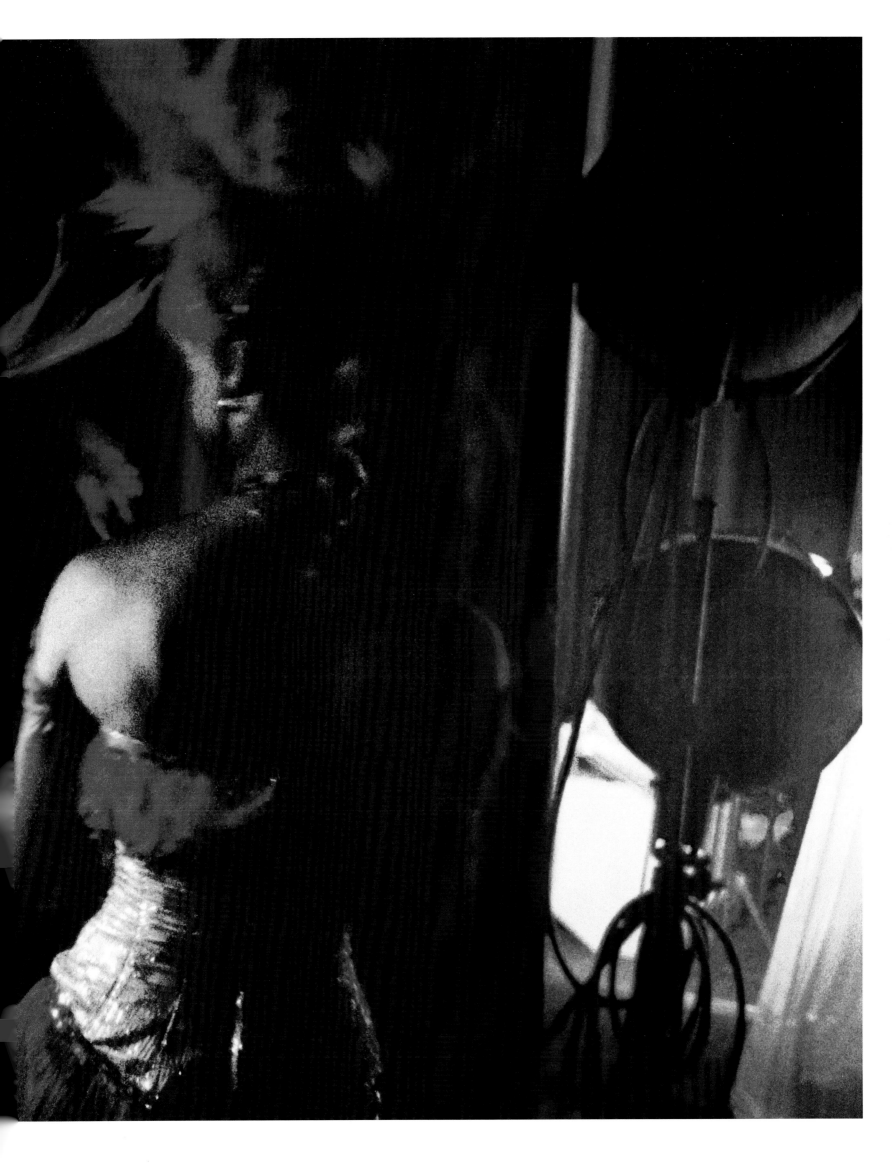

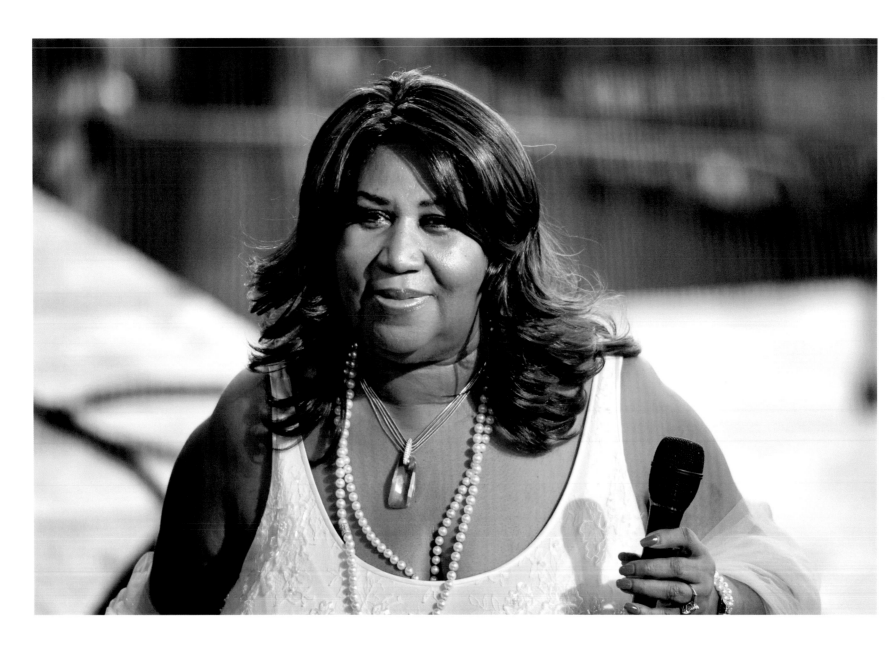

Aretha Franklin, Newport Jazz Festival, 2008

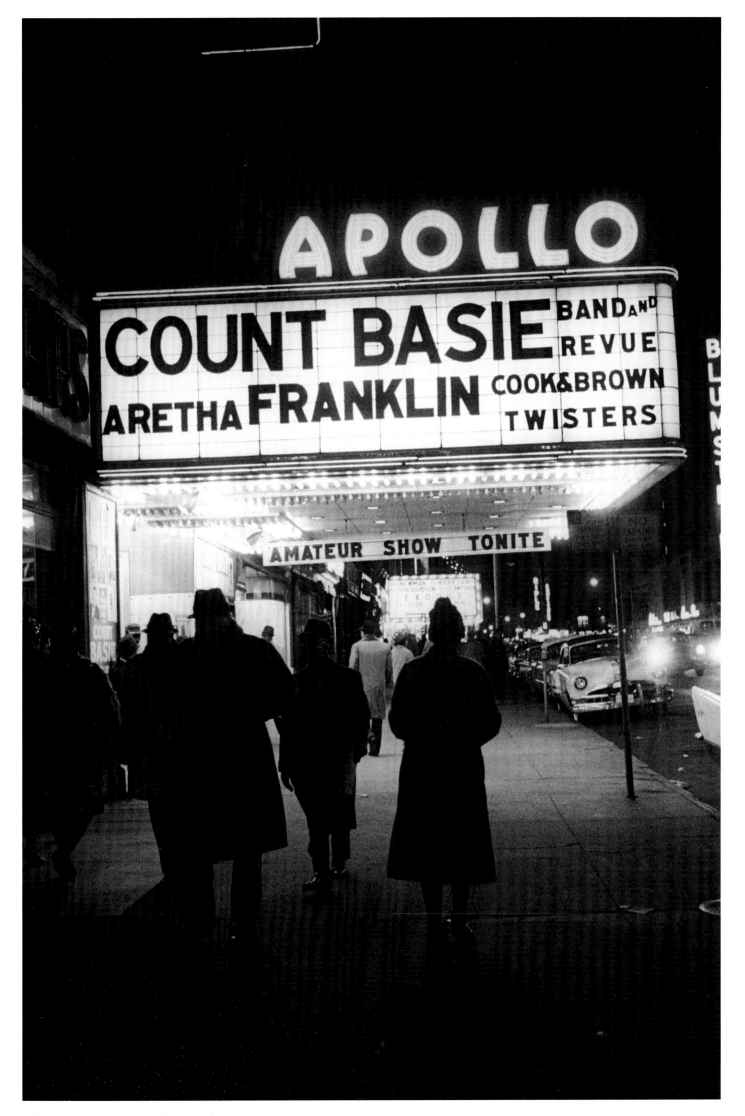

The Apollo Theater, New York, 1961

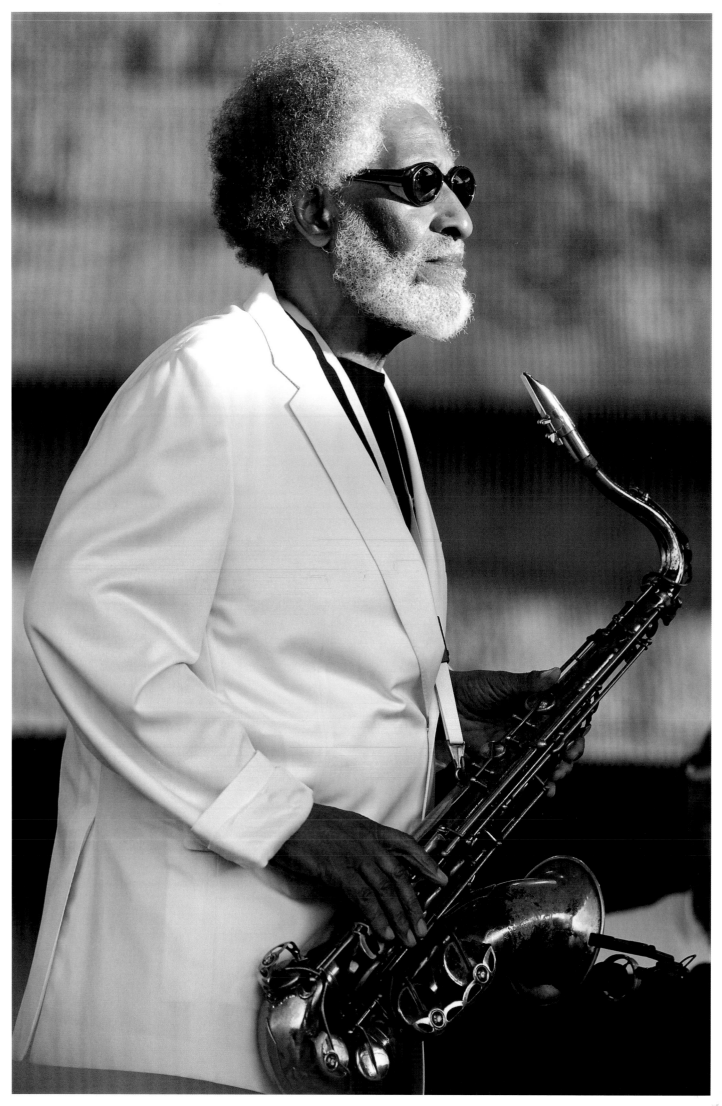

Sonny Rollins, Newport Jazz Festival, 2008

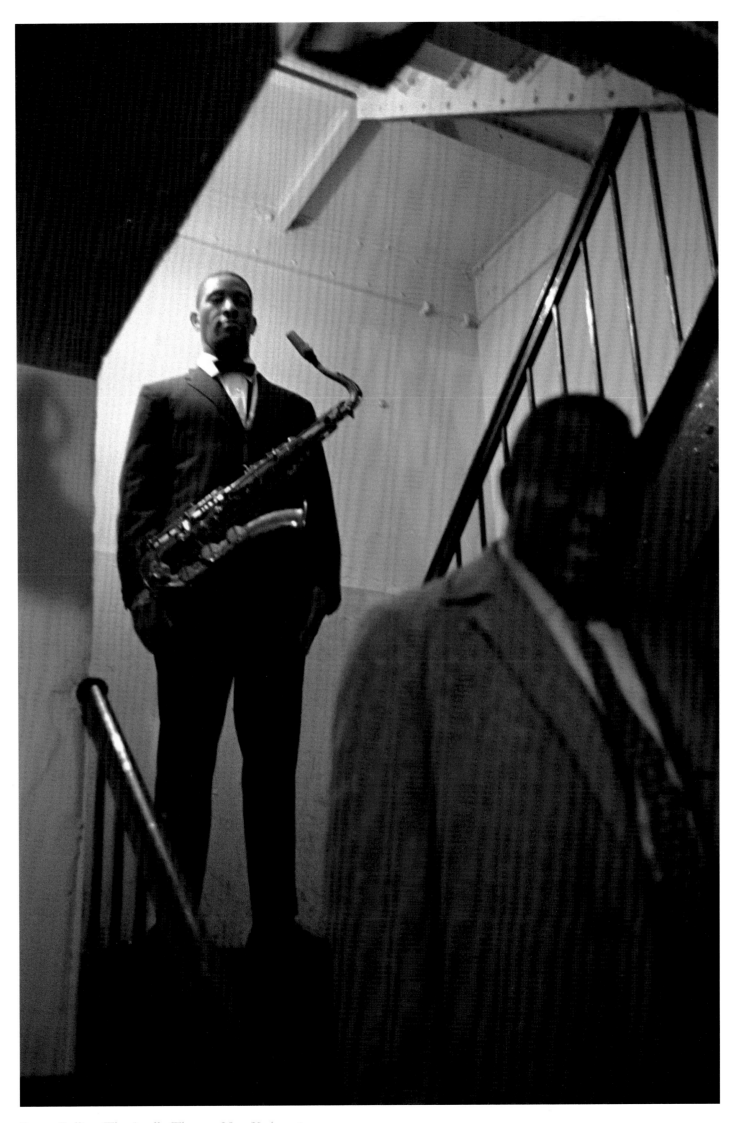

Sonny Rollins, The Apollo Theater, New York, 1961

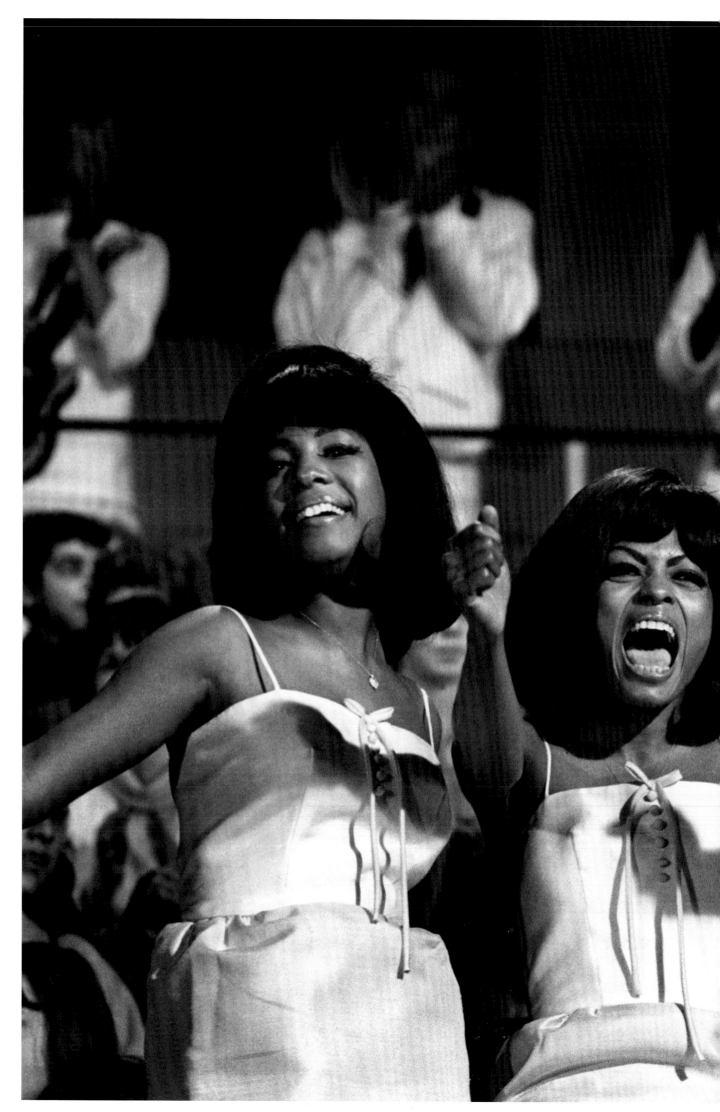

The Supremes, New York, 1965

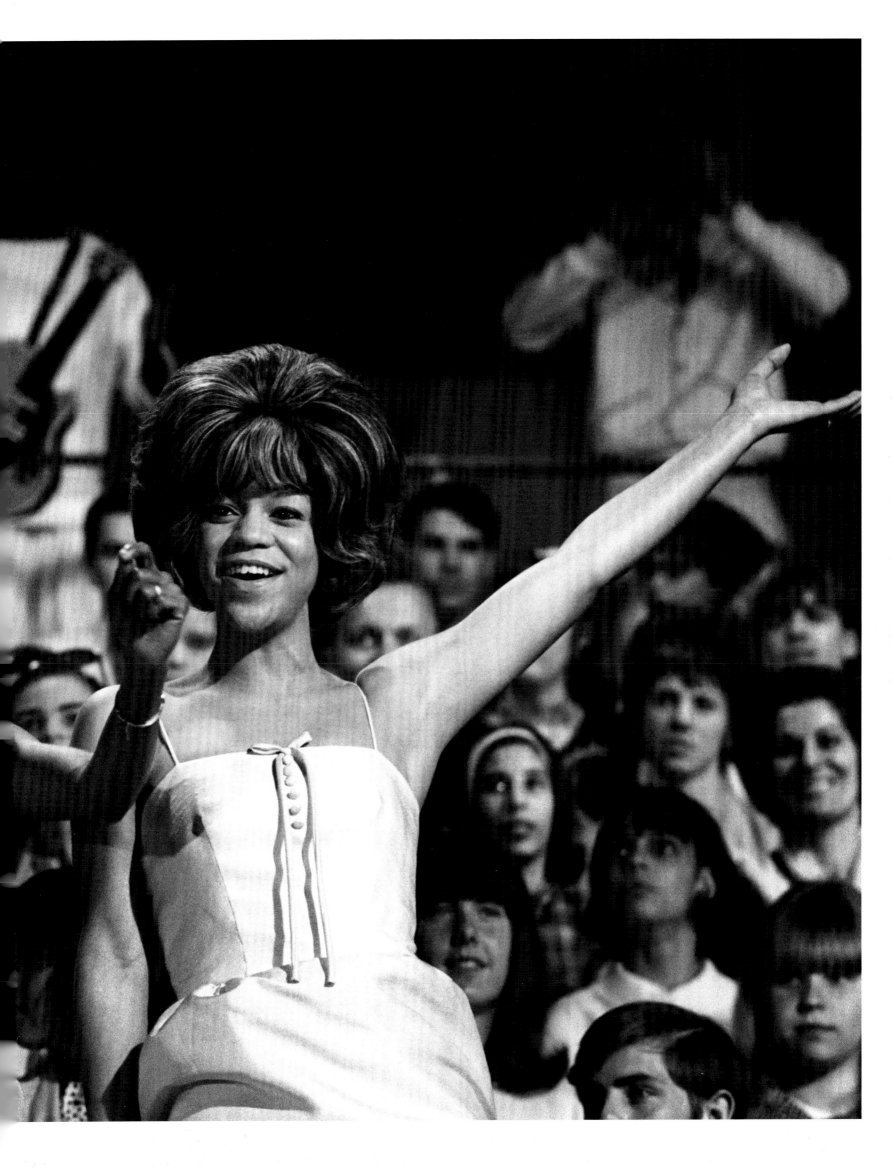

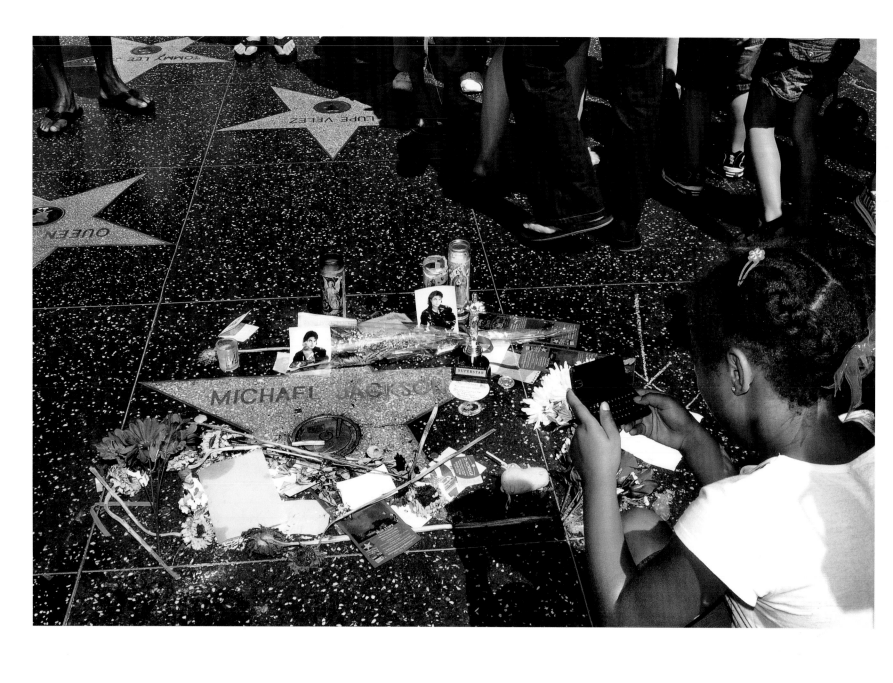

Michael Jackson's Hollywood Star, Los Angeles, 2010

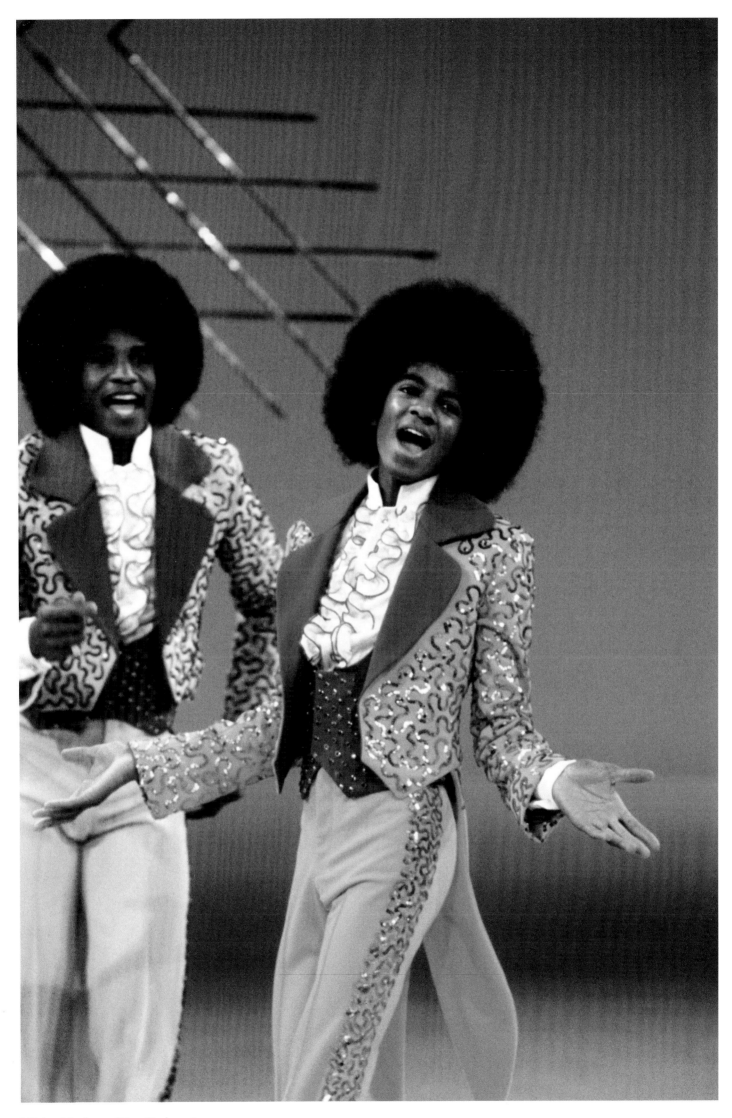

Michael Jackson, New York, 1963

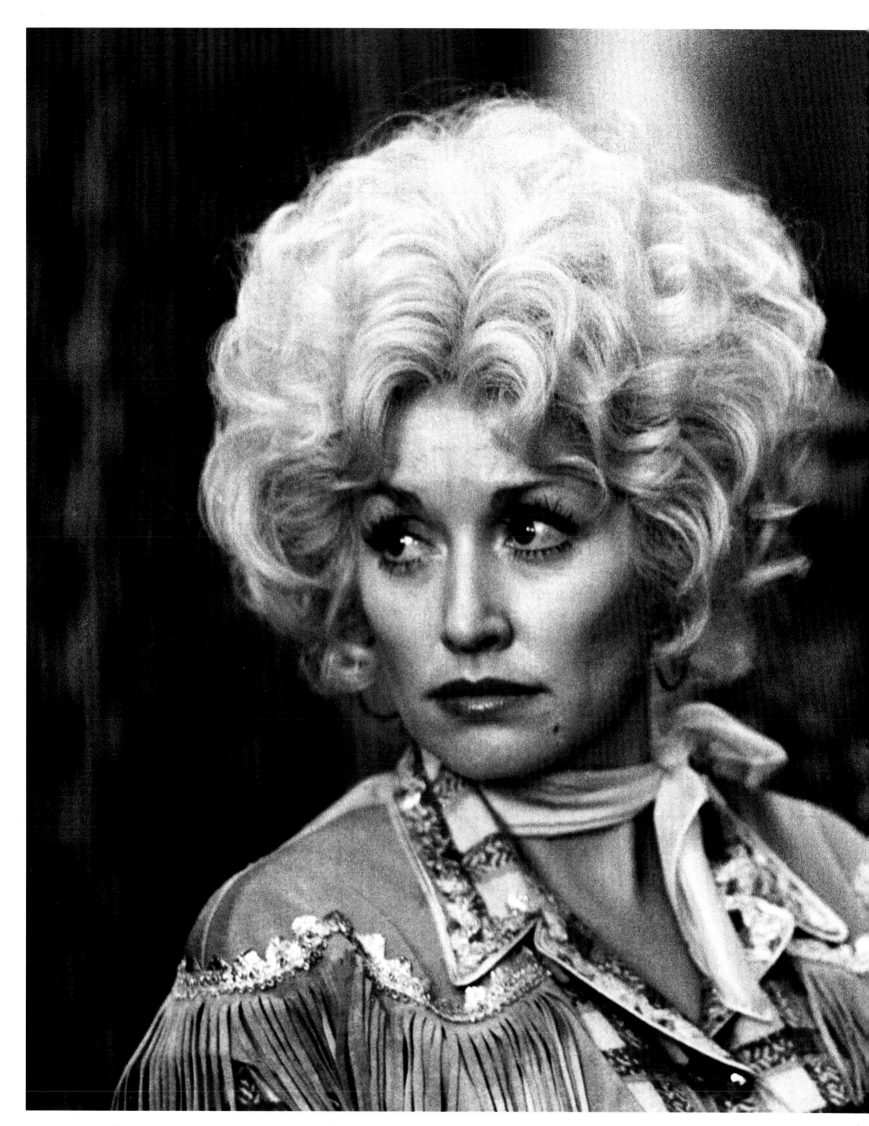

Dolly Parton, Los Angeles, 1979

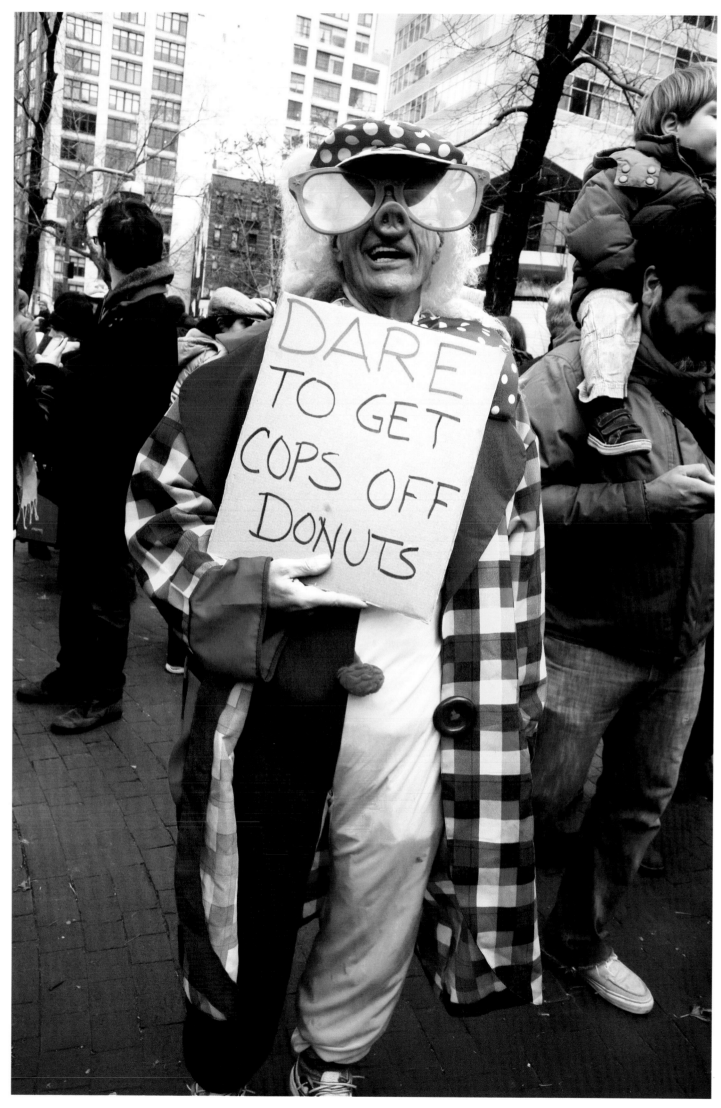

Dare to Get Cops off Donuts, Occupy Wall Street, New York, 2011

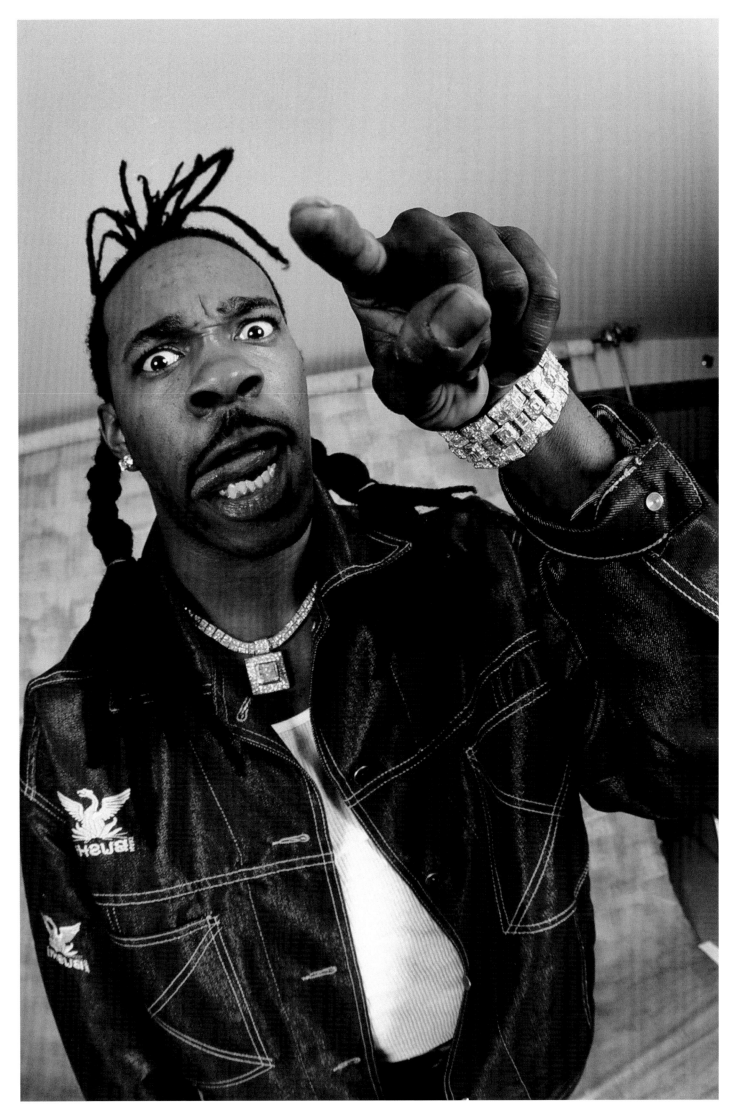

Busta Rhymes, Los Angeles, 2002

Bret Michaels at Home, Los Angeles, 1991

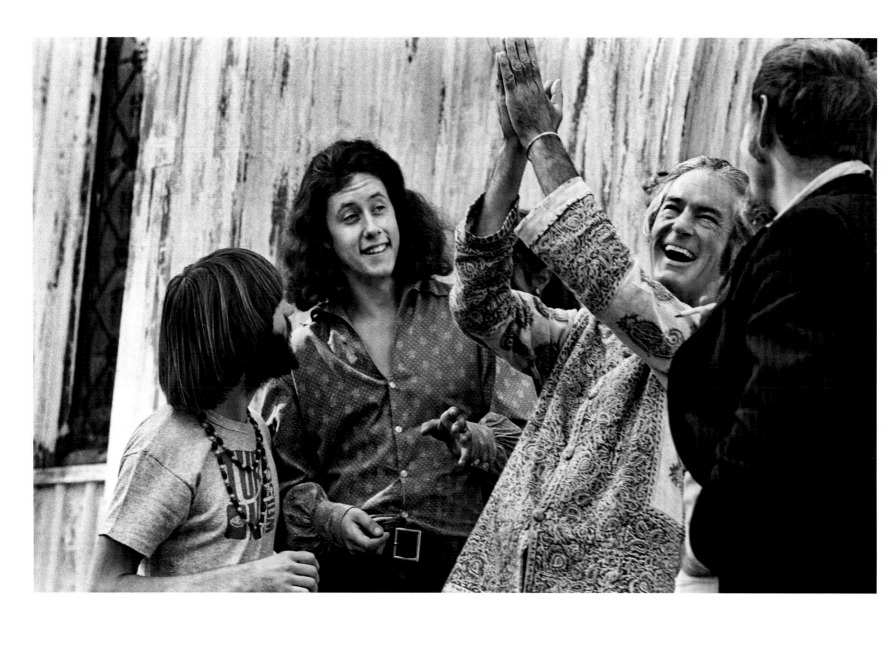

Timothy Leary and Arlo Guthrie, Stockbridge, Massachusetts, 1968

Be Happy, Michigan City, Indiana, 1999

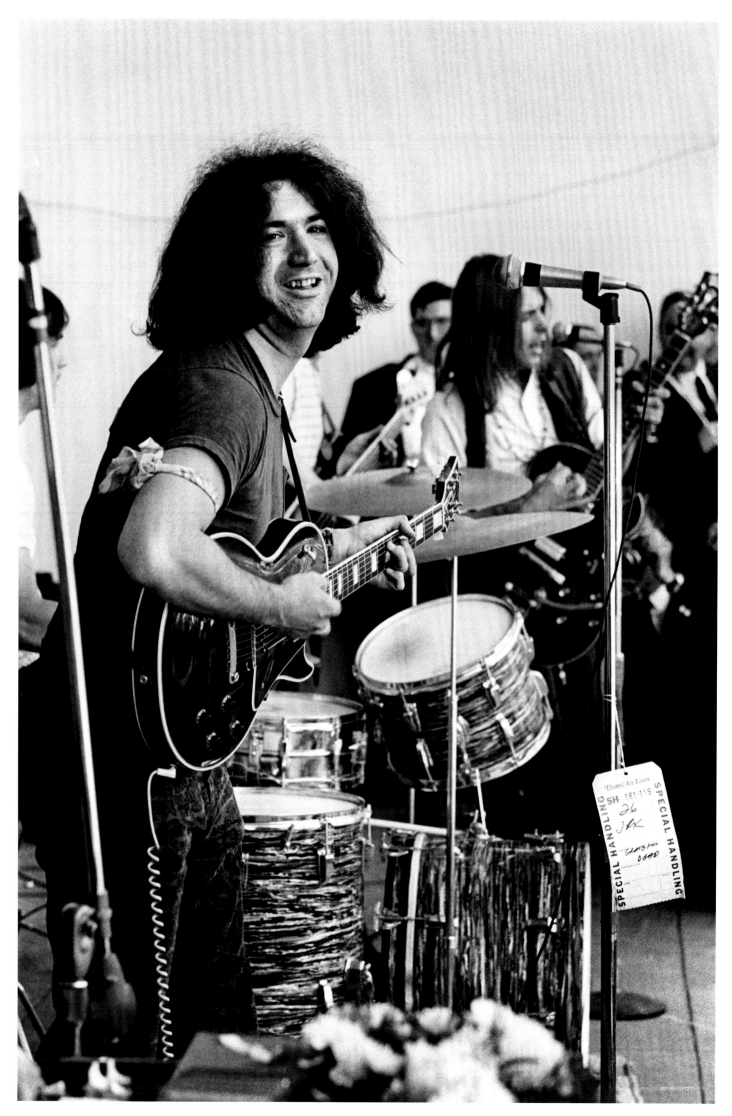

Jerry Garcia, Haight-Ashbury, San Francisco, 1967

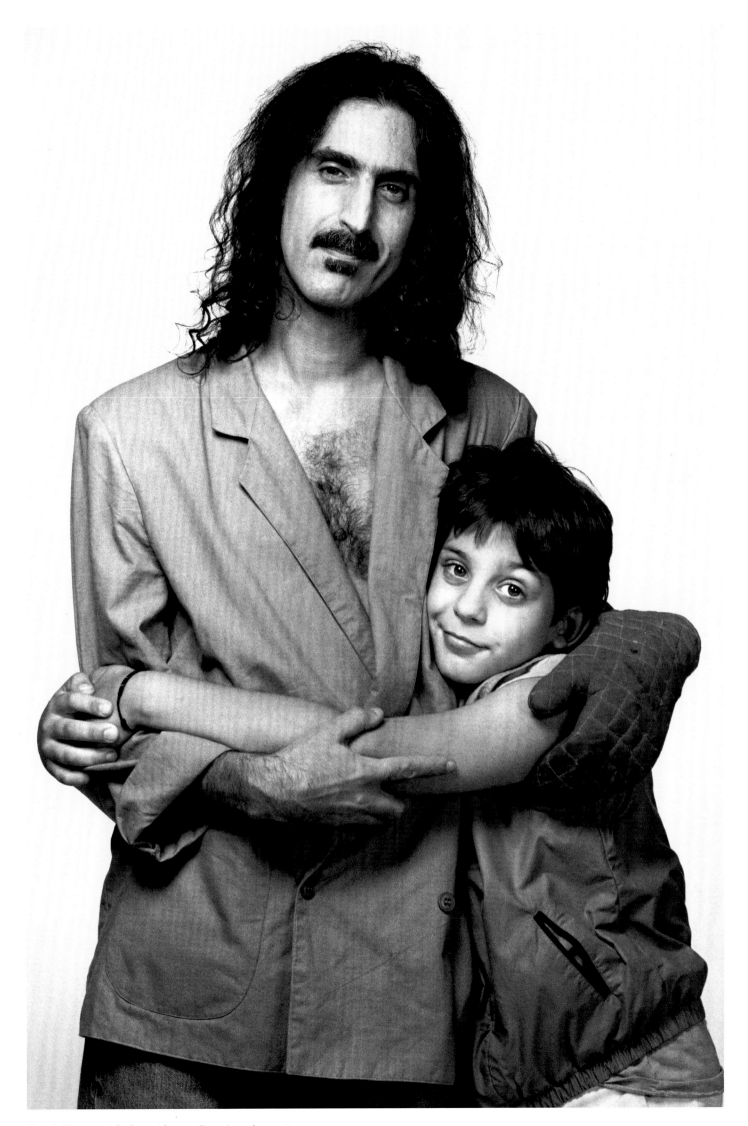

Frank Zappa with Son, Ahmet, Los Angeles, 1984

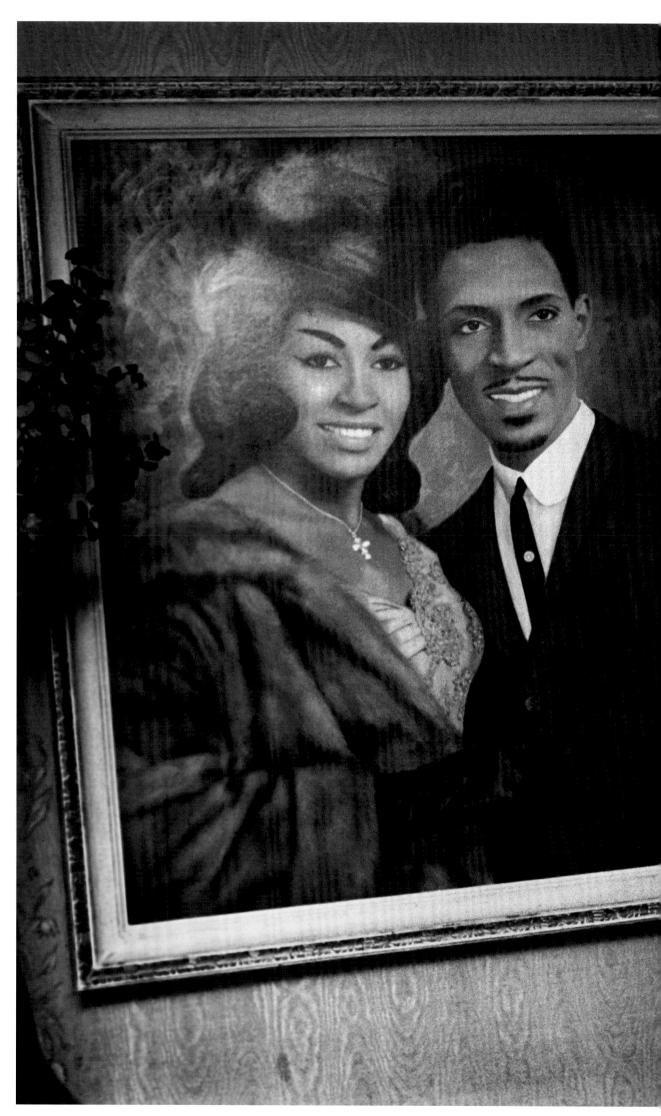

Ike and Tina Turner at Home, Los Angeles, 1974

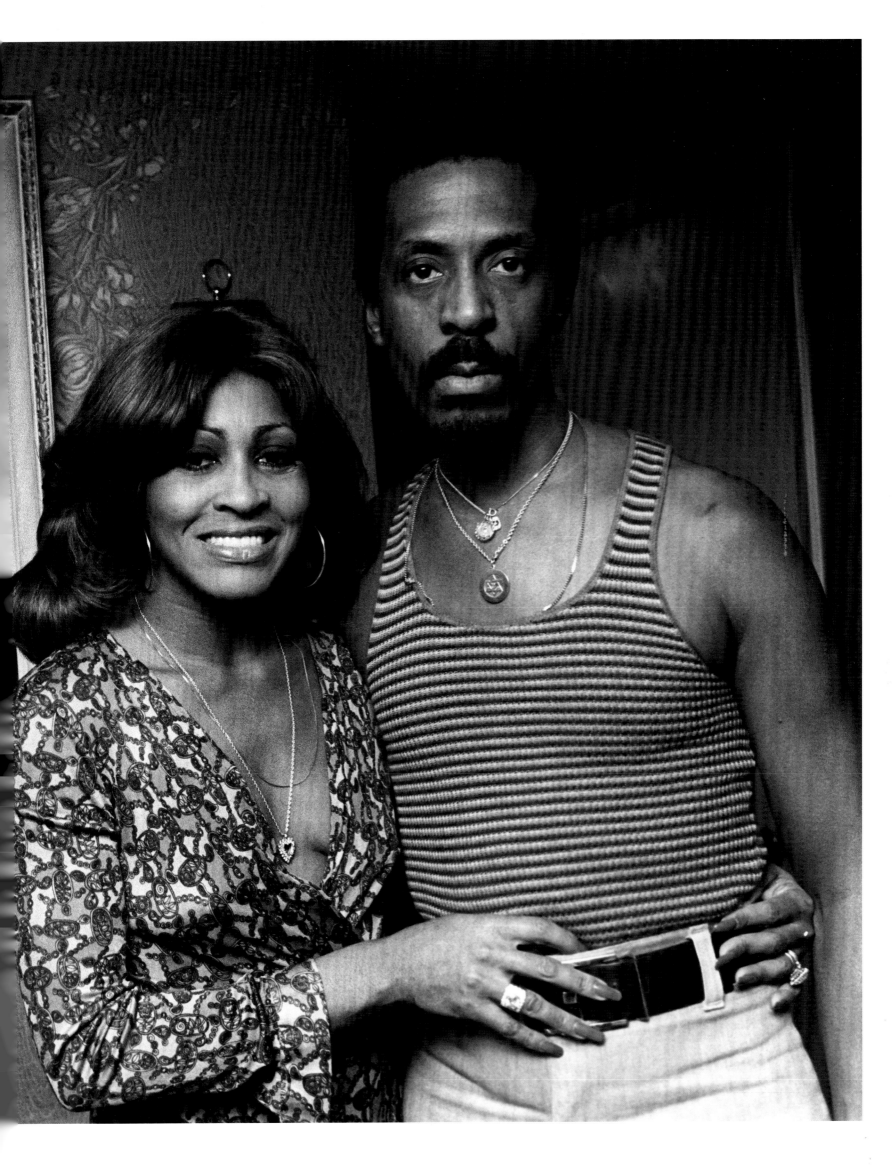

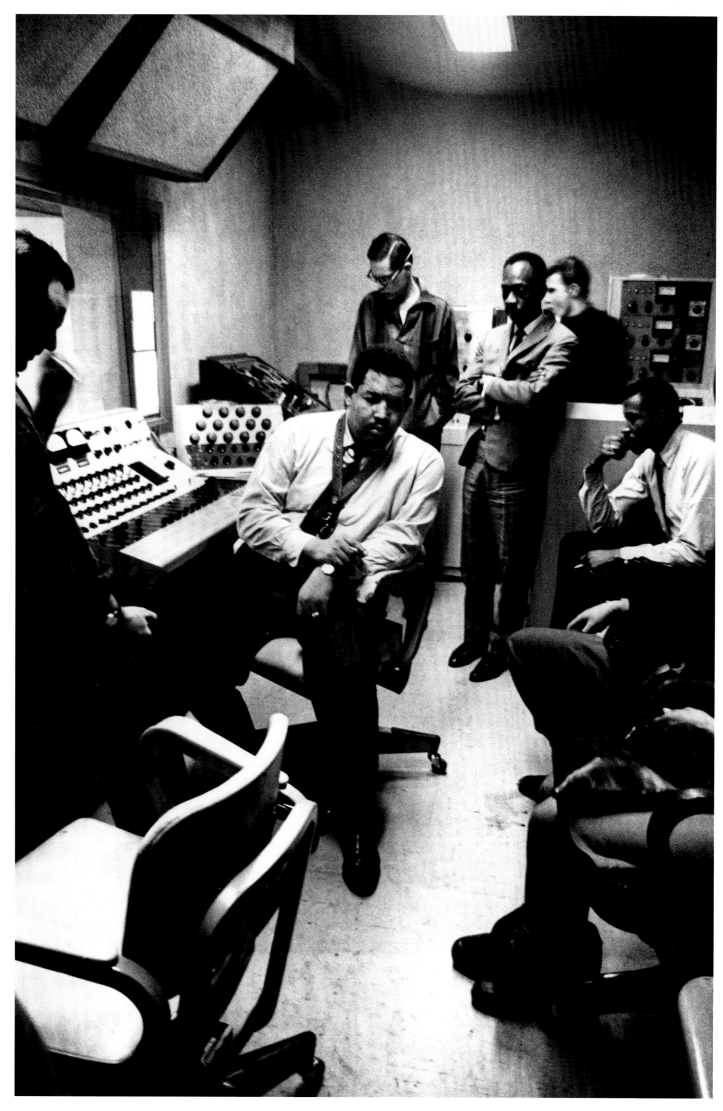

Cannonball Adderley and Bill Evans Recording, New Jersey, 1961

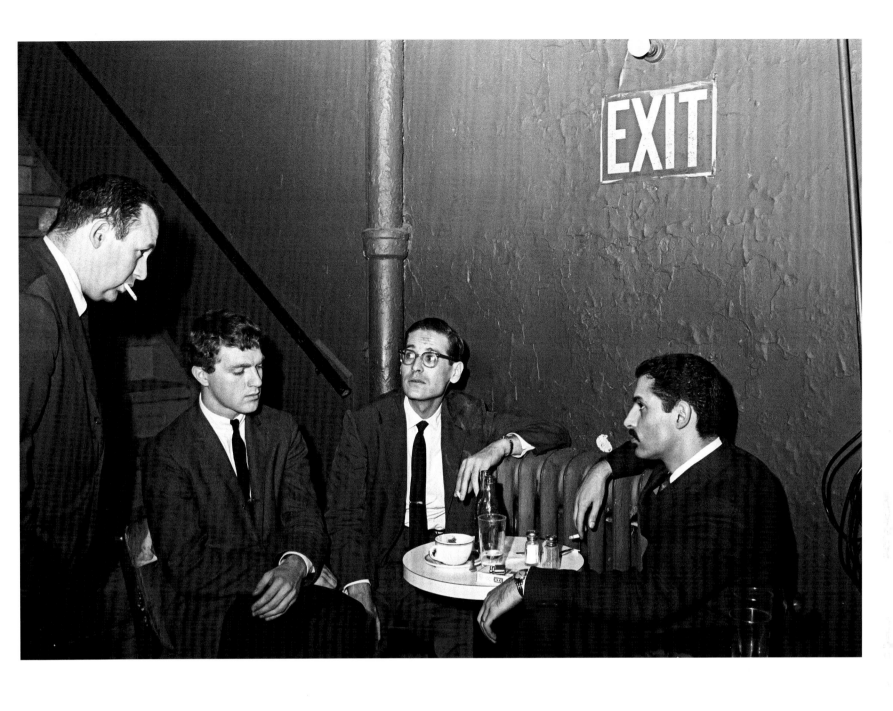

Bill Evans Trio at the Village Vanguard, New York, 1961

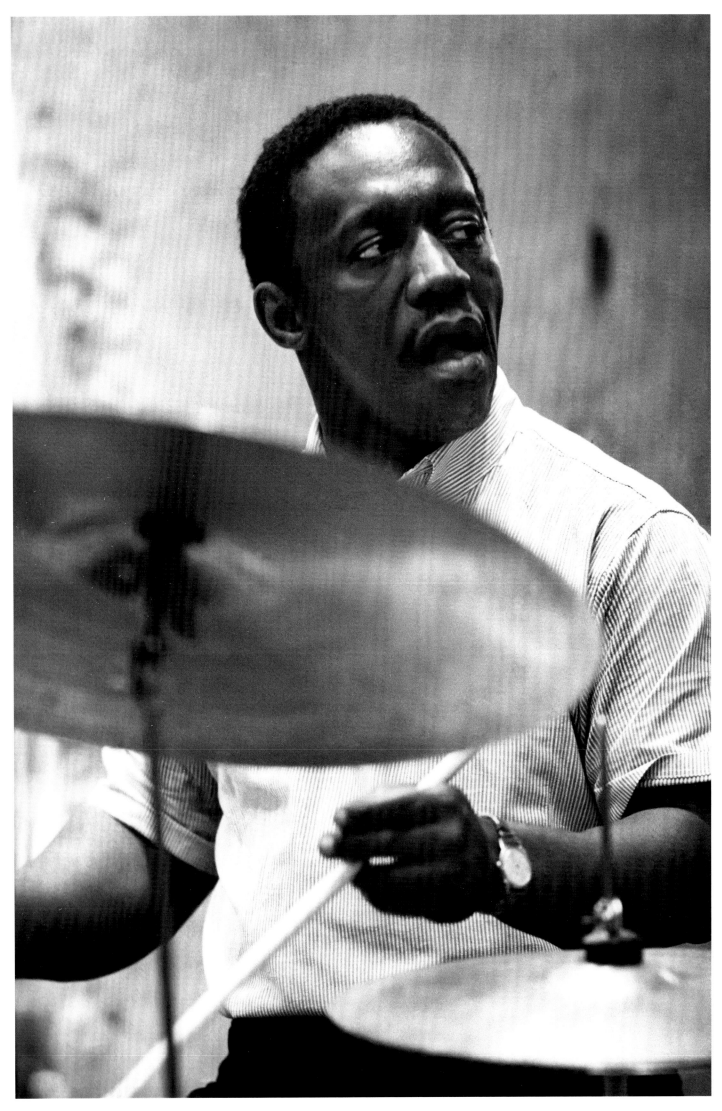

Art Blakey, New Jersey, 1961

Bill Evans, New Jersey, 1961

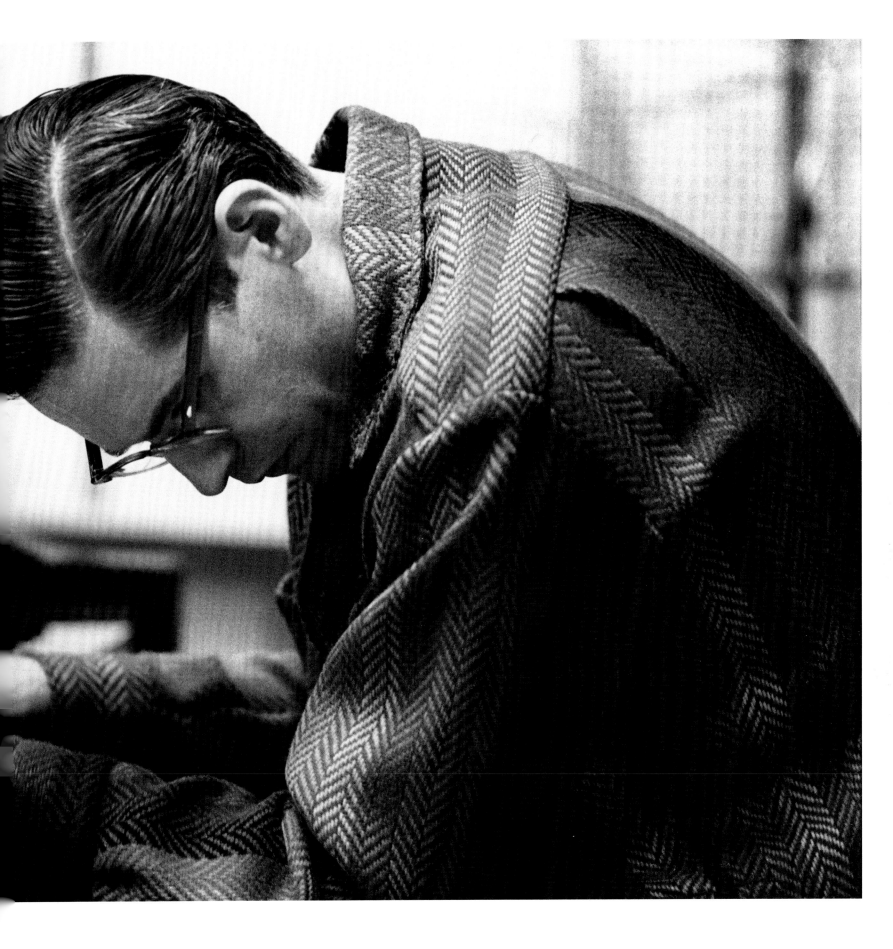

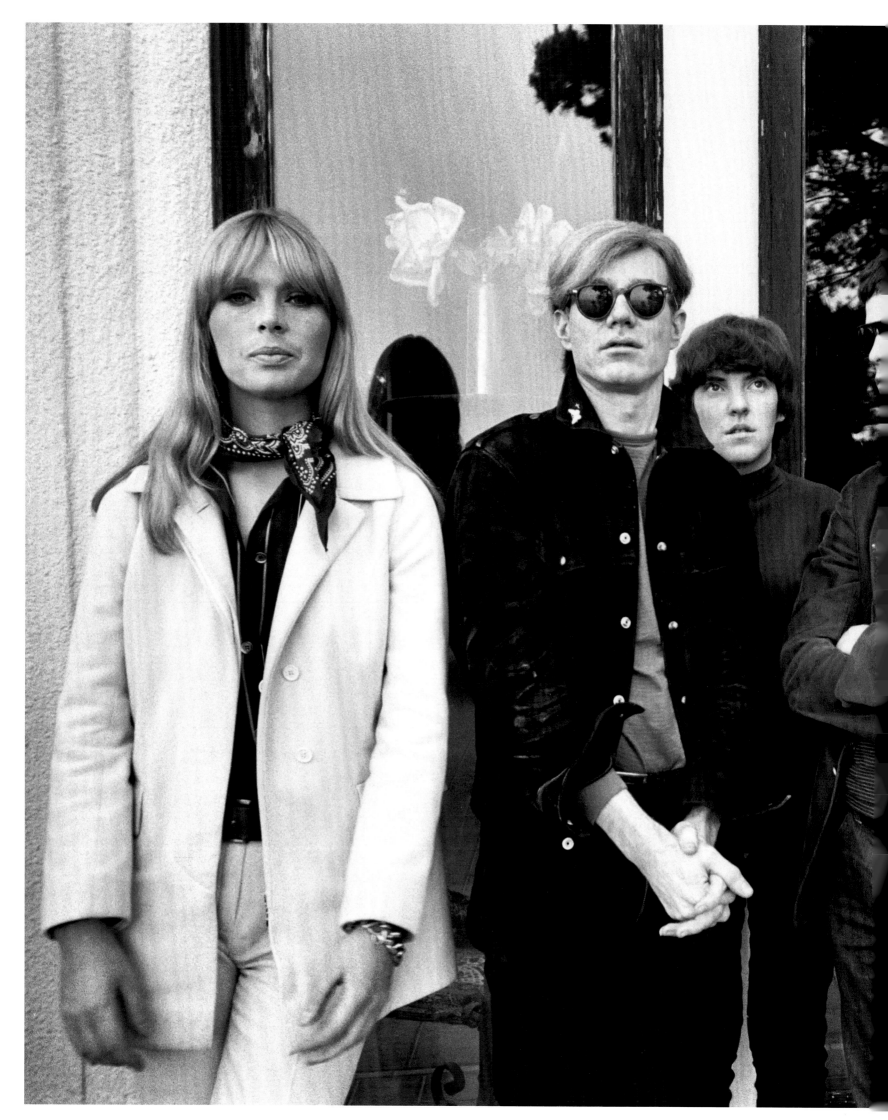

Nico, Andy Warhol, and The Velvet Underground, Los Angeles, 1966

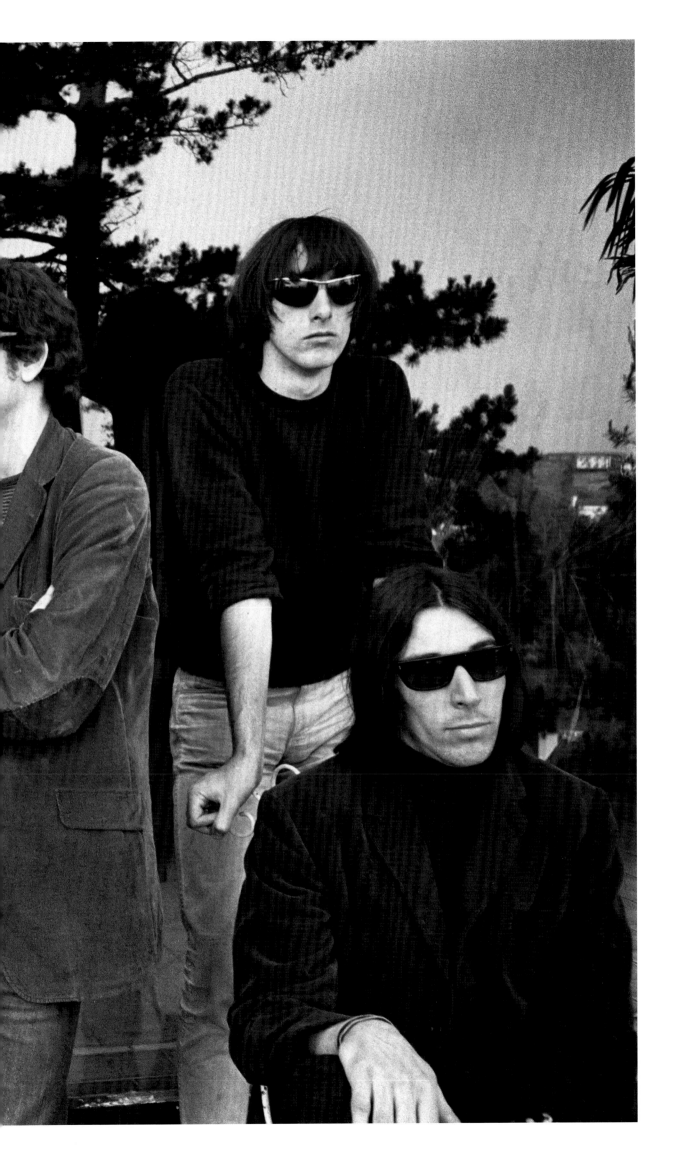

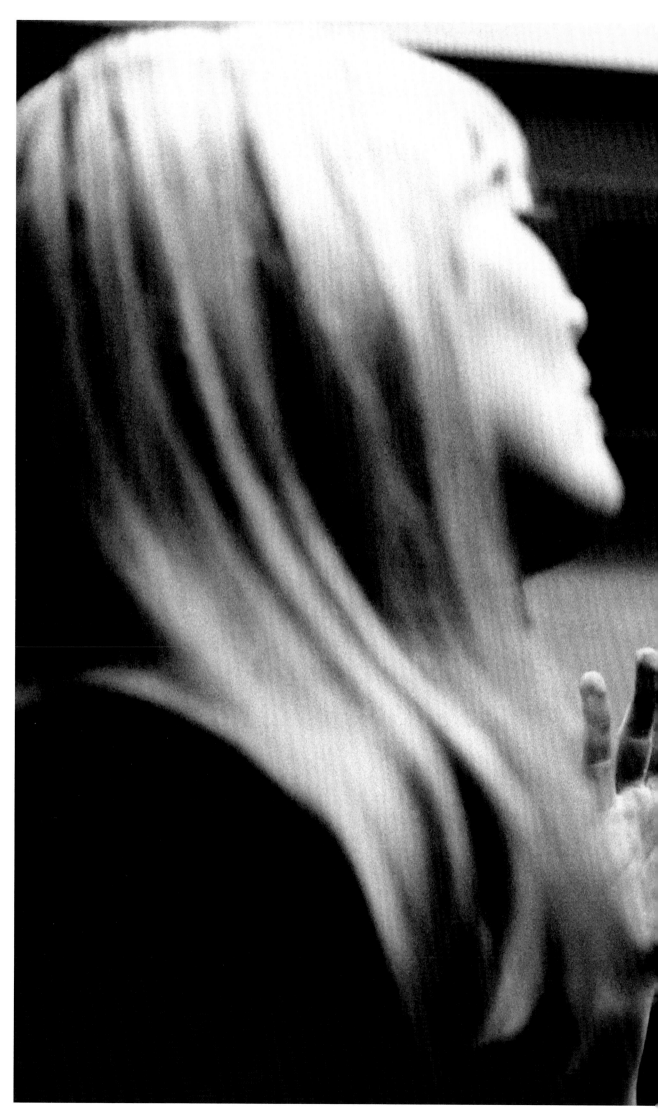

Nico and Lou Reed, New York, 1965

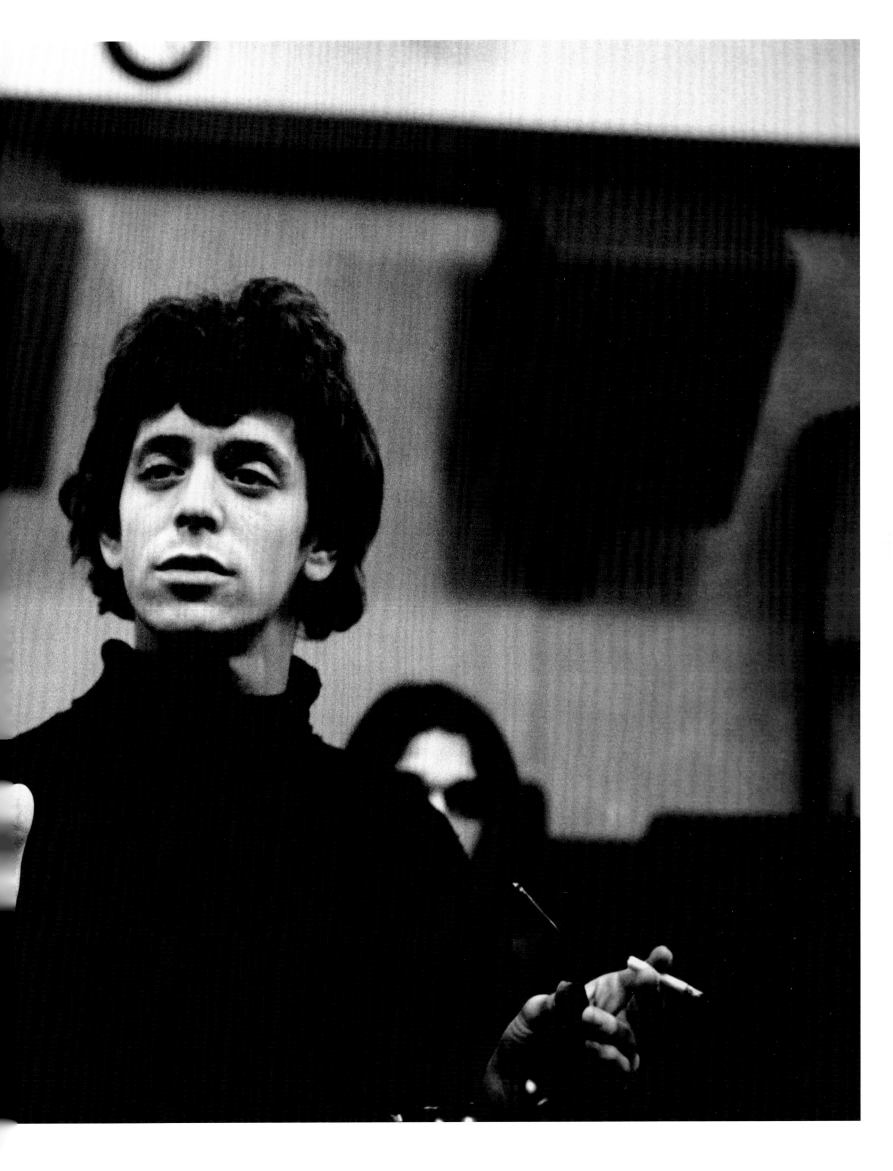

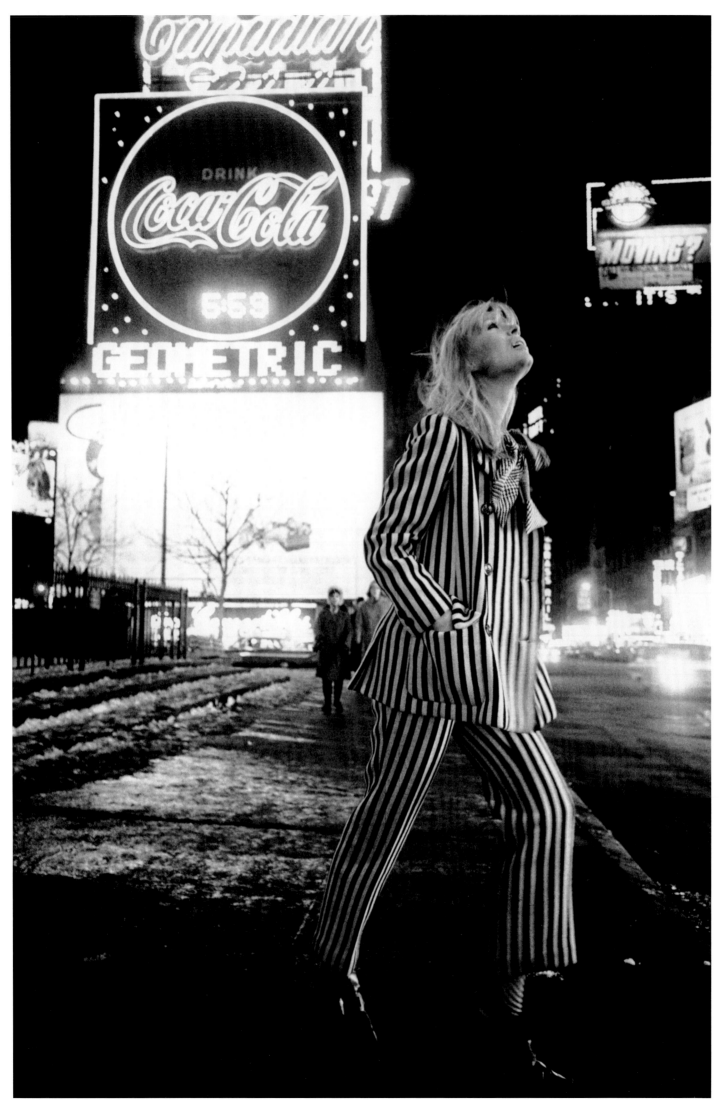

Nico at Times Square, New York, 1965

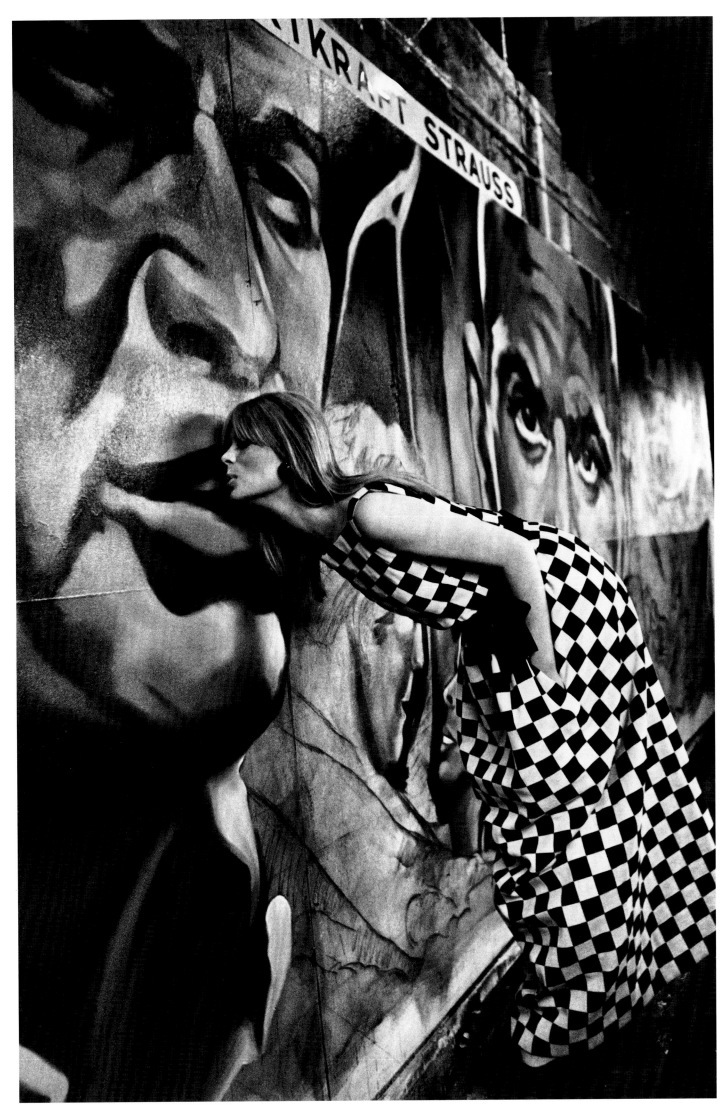

Nico, Artkraft Strauss Signs, New York, 1965

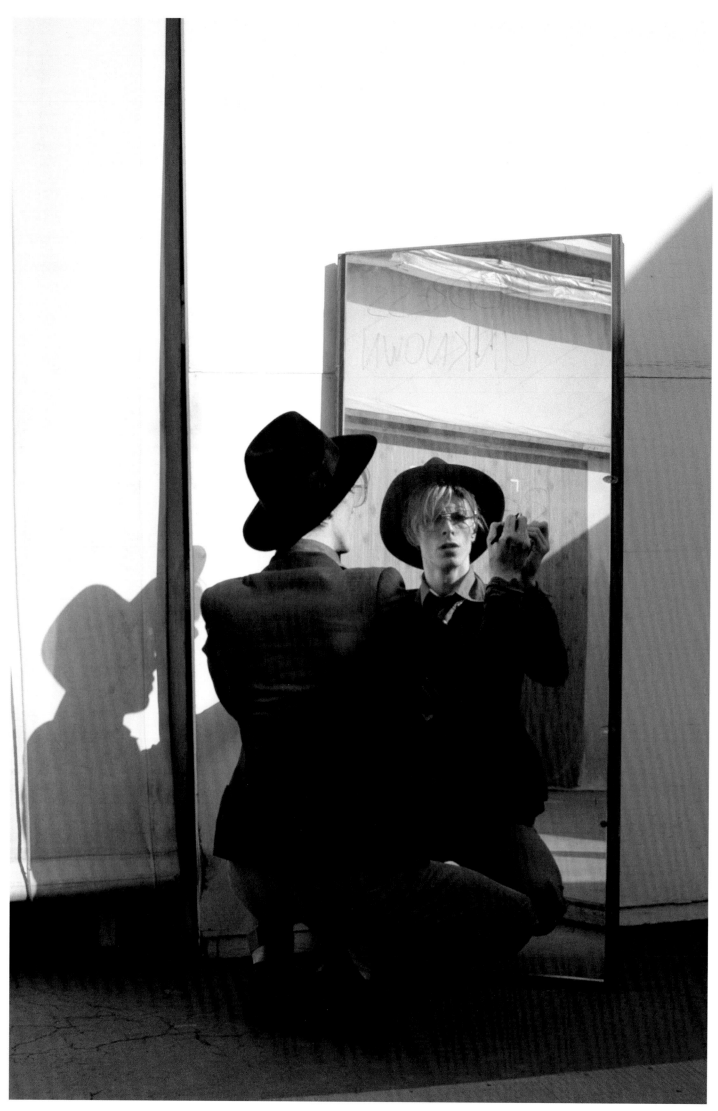

138    David Bowie, Los Angeles, 1974

David Bowie, *The Man Who Fell to Earth*, 1975

David Bowie on Bike, Los Angeles, 1974

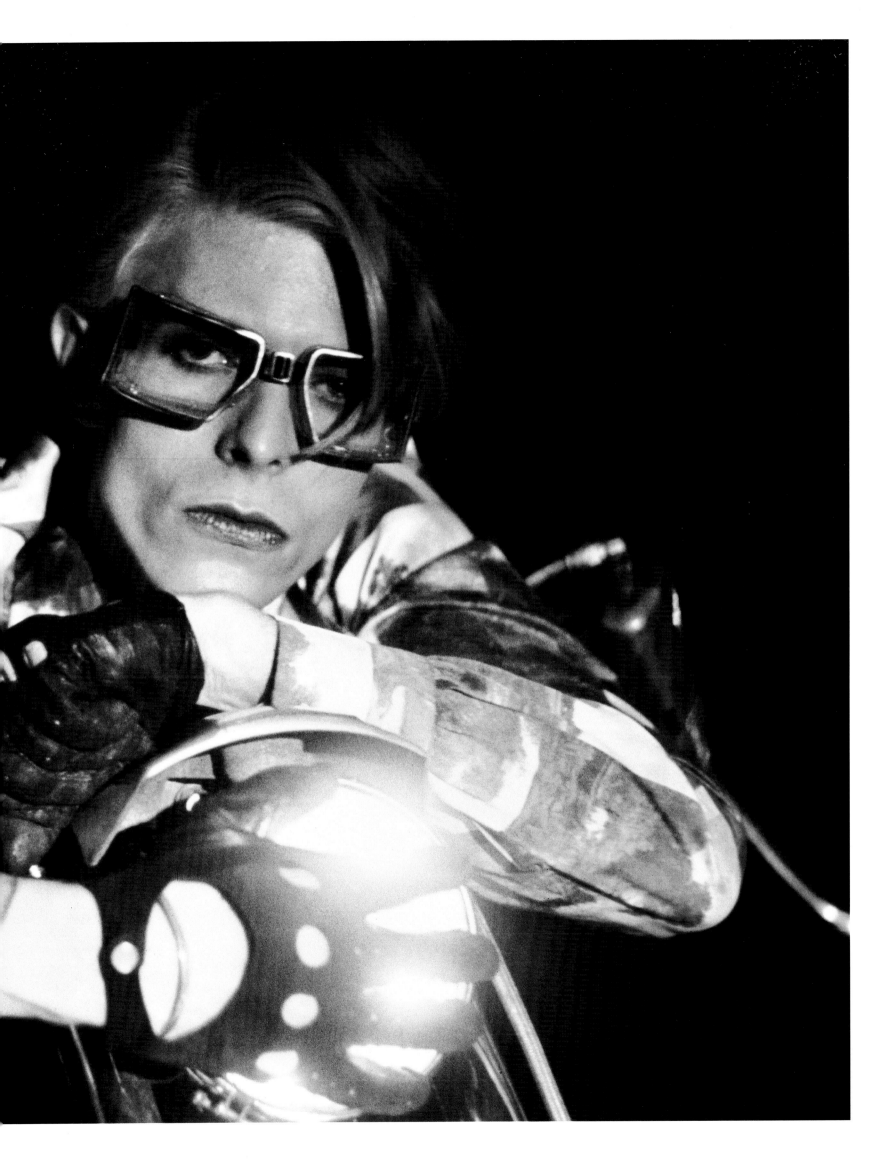

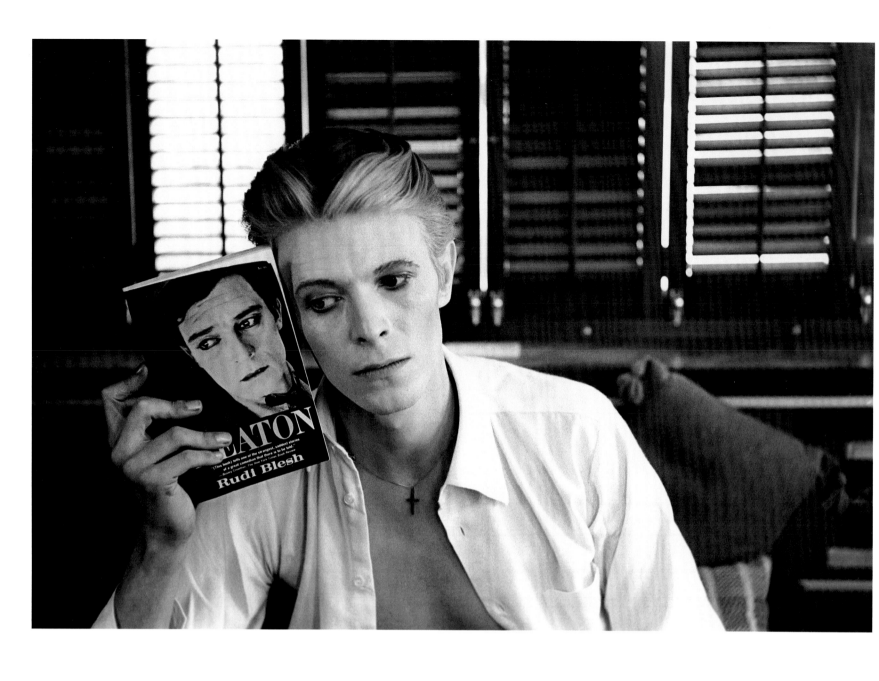

David Bowie with Buster Keaton Book, Los Angeles, 1975

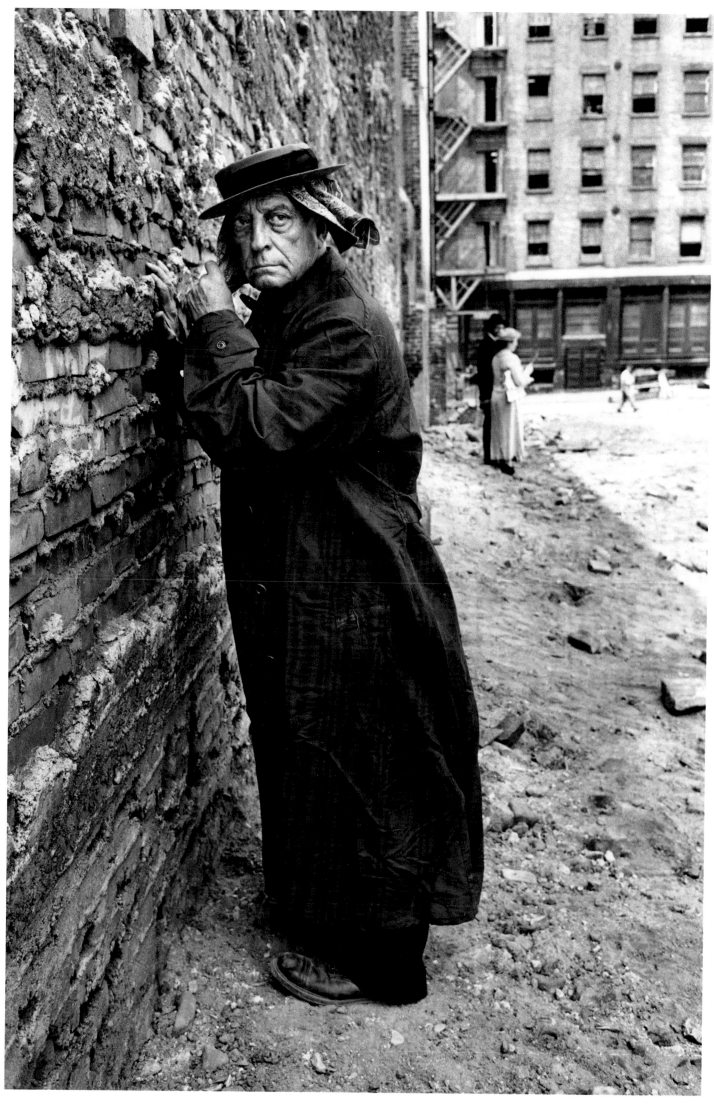

Buster Keaton, New York, 1964

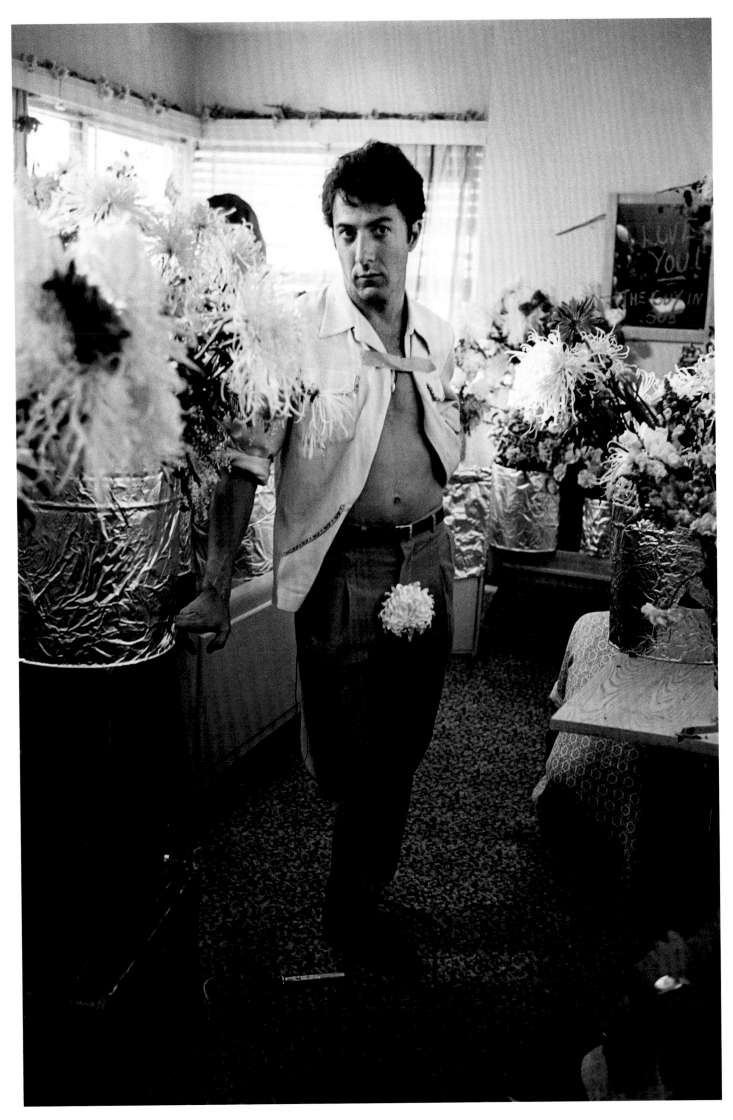

Dustin Hoffman, Miami, 1973

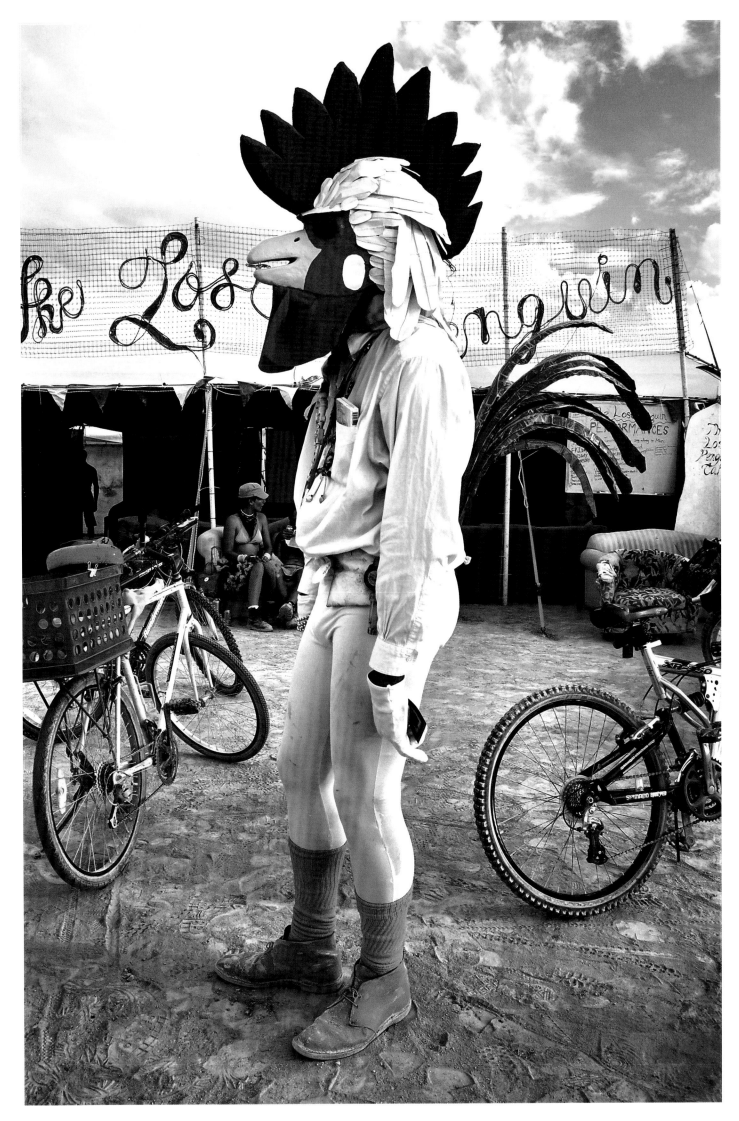

Rooster, Burning Man, Nevada, 2009

Roman Polanski and Jack Nicholson, *Chinatown*, Los Angeles, 1973

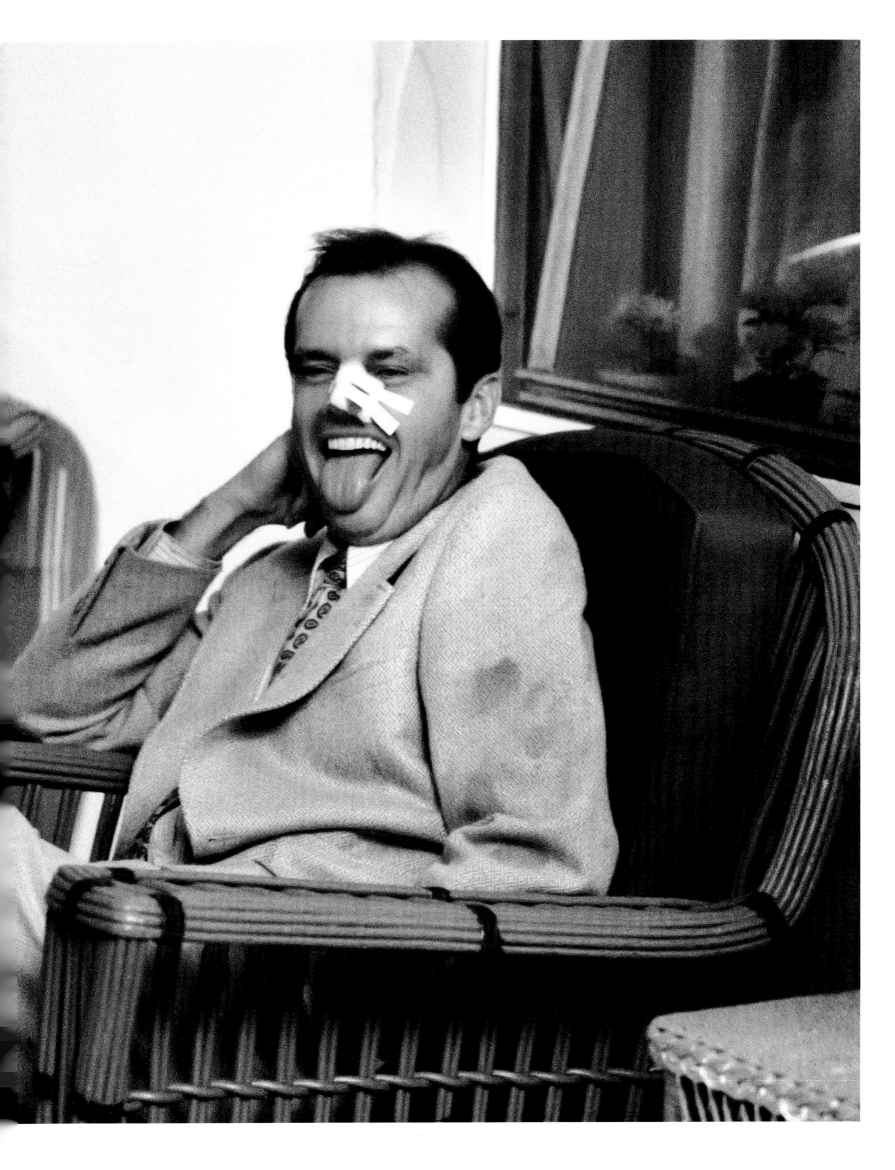

Masks, New York, 2009

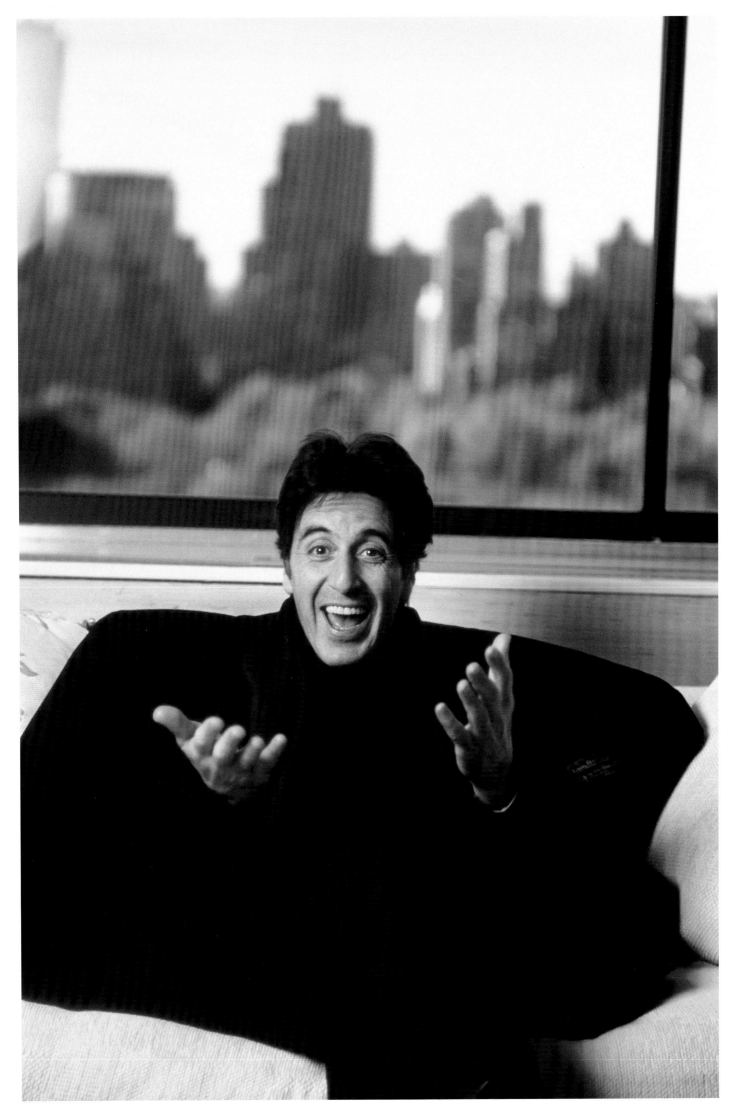

Al Pacino, New York, 1991

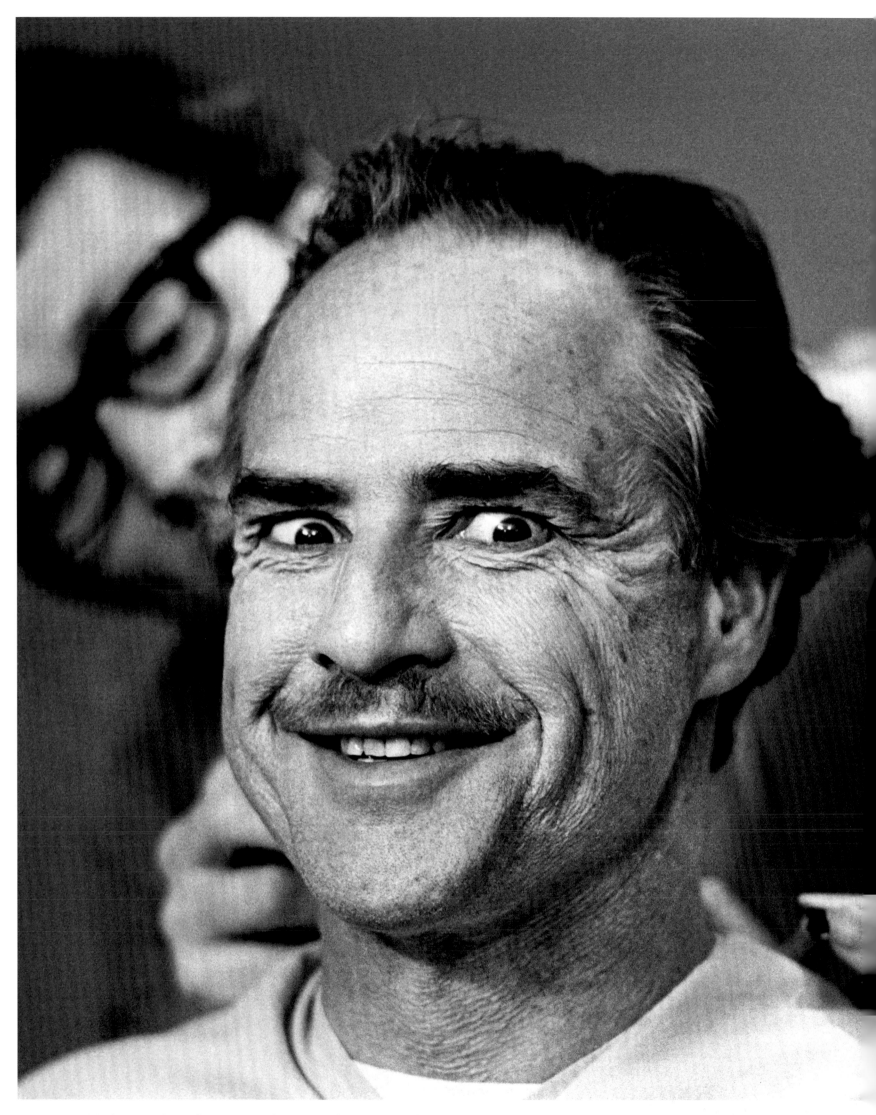

Marlon Brando, Makeup Session for *The Godfather*, New York, 1971

Katharine Hepburn, London, 1964

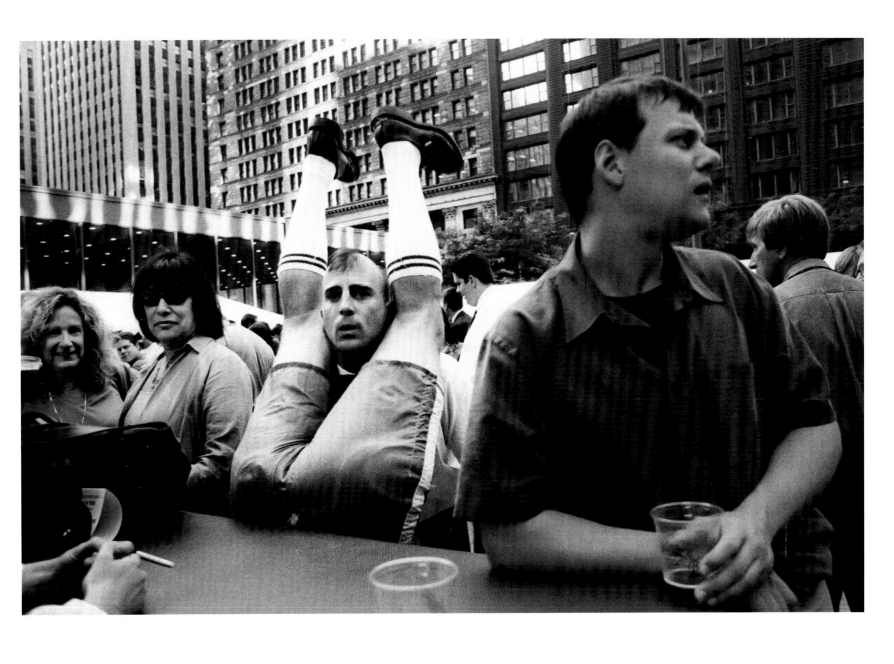

500 Clown, Chicago, 2010

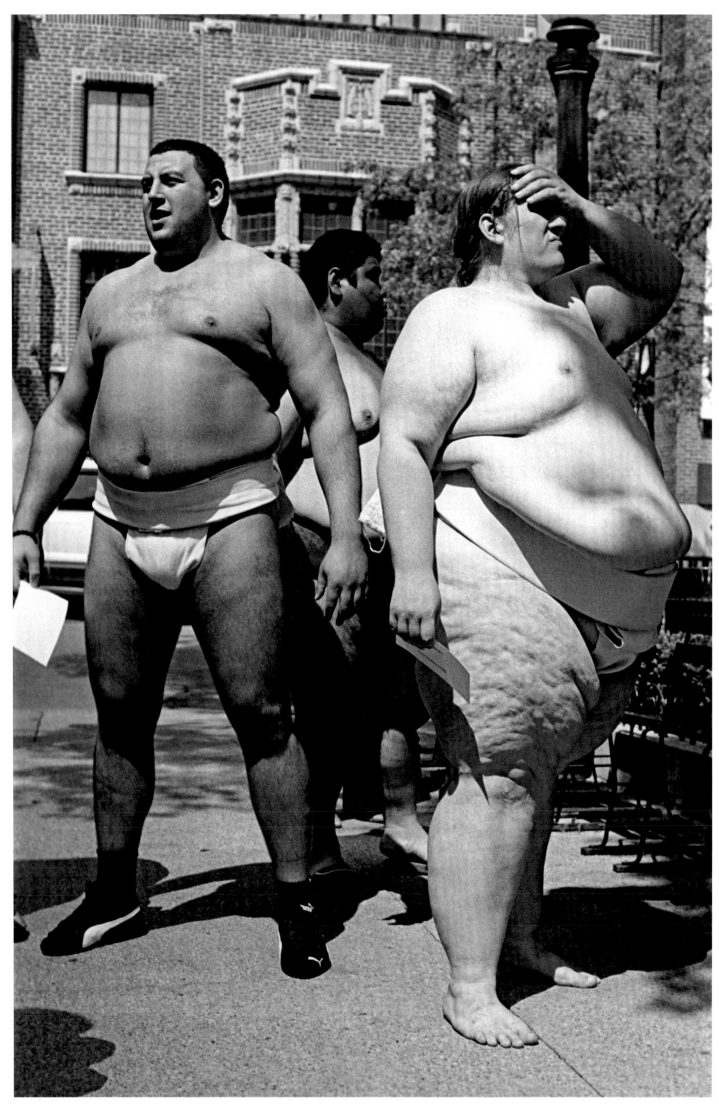

Sumo Wrestlers, Chicago, 2010

Jane Fonda, 1983

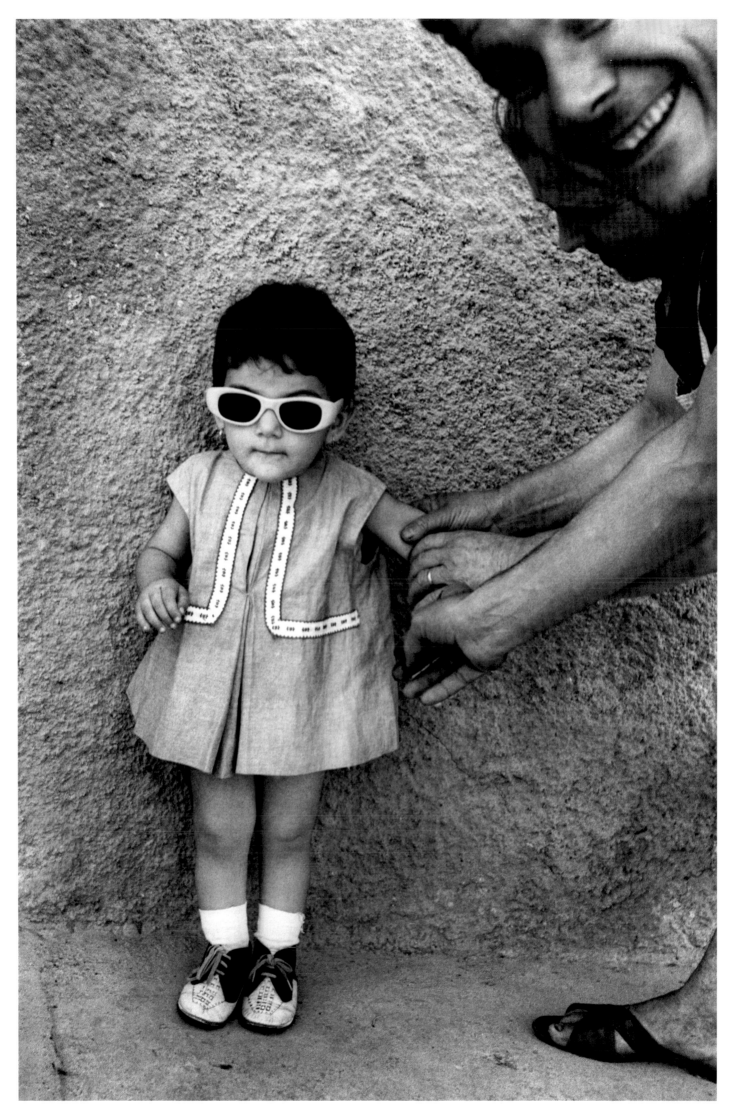

Little Girl with Glasses, Rome, 1964

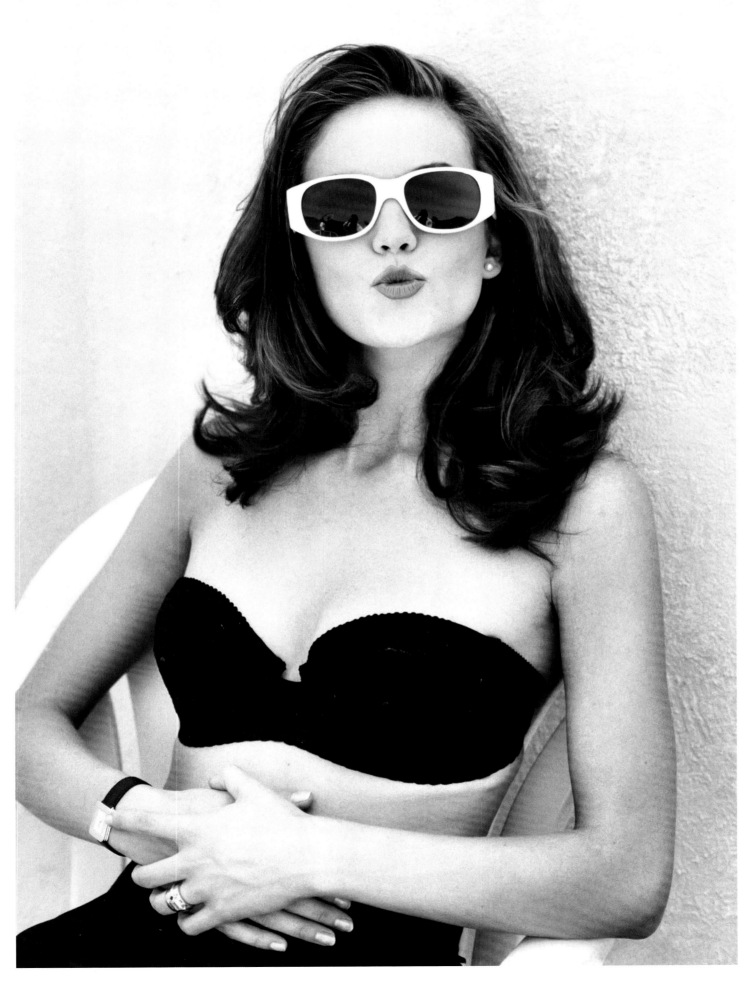

Diane Lane with Glasses, Los Angeles, 1994

Paul Newman, Fort Lauderdale, Miami, 1983

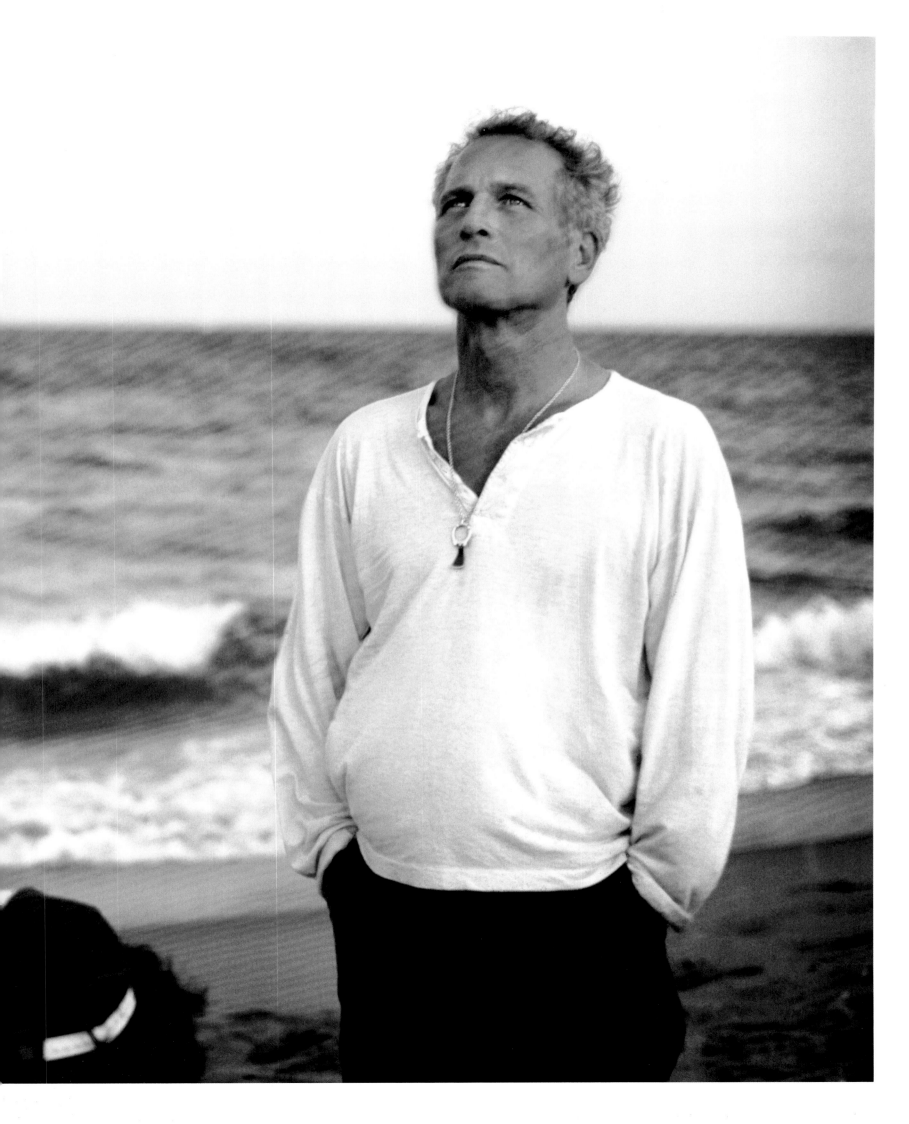

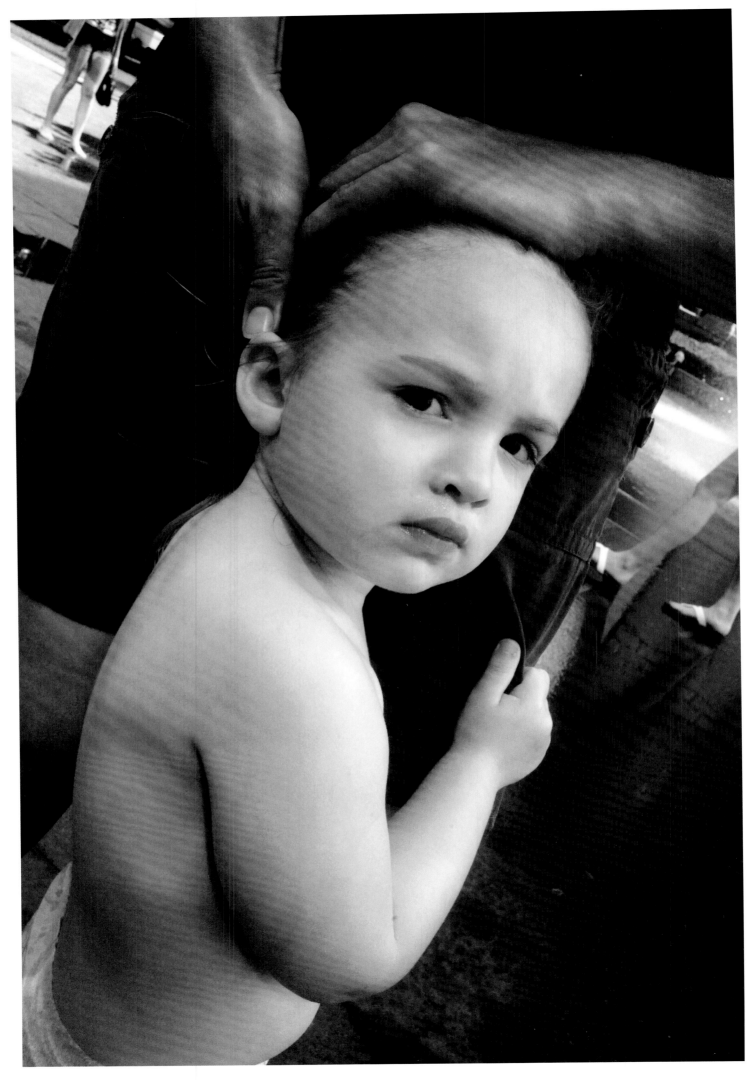

Lily, Chicago, 2010

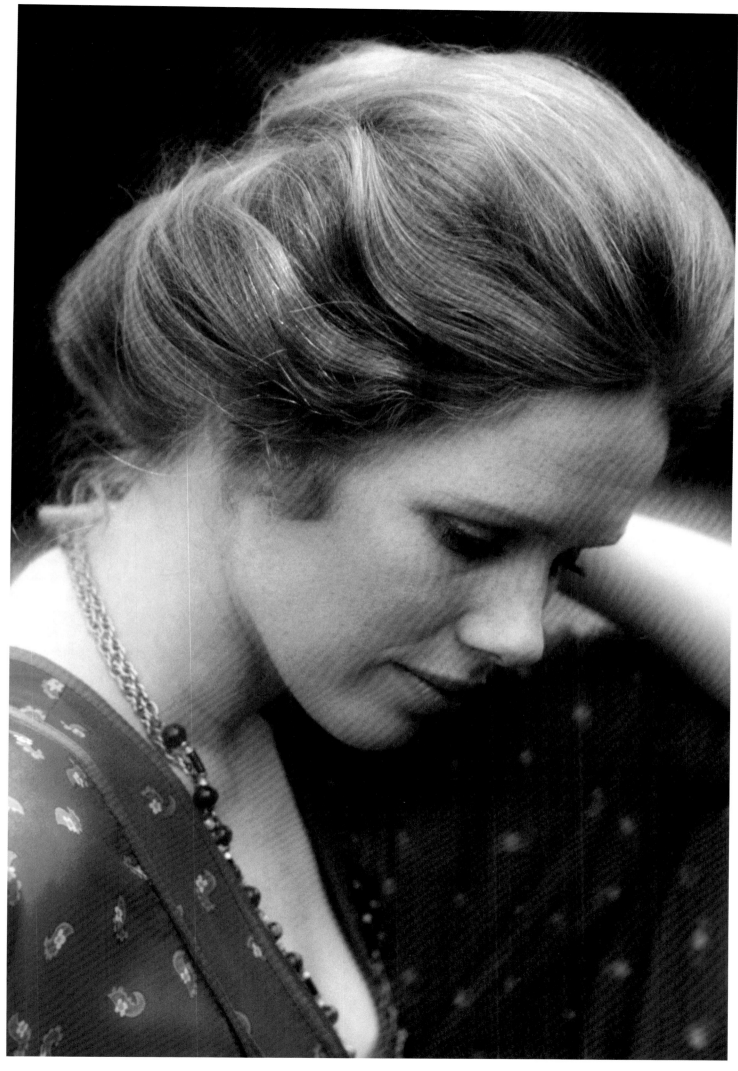

Liv Ullmann, Mexico, 1986

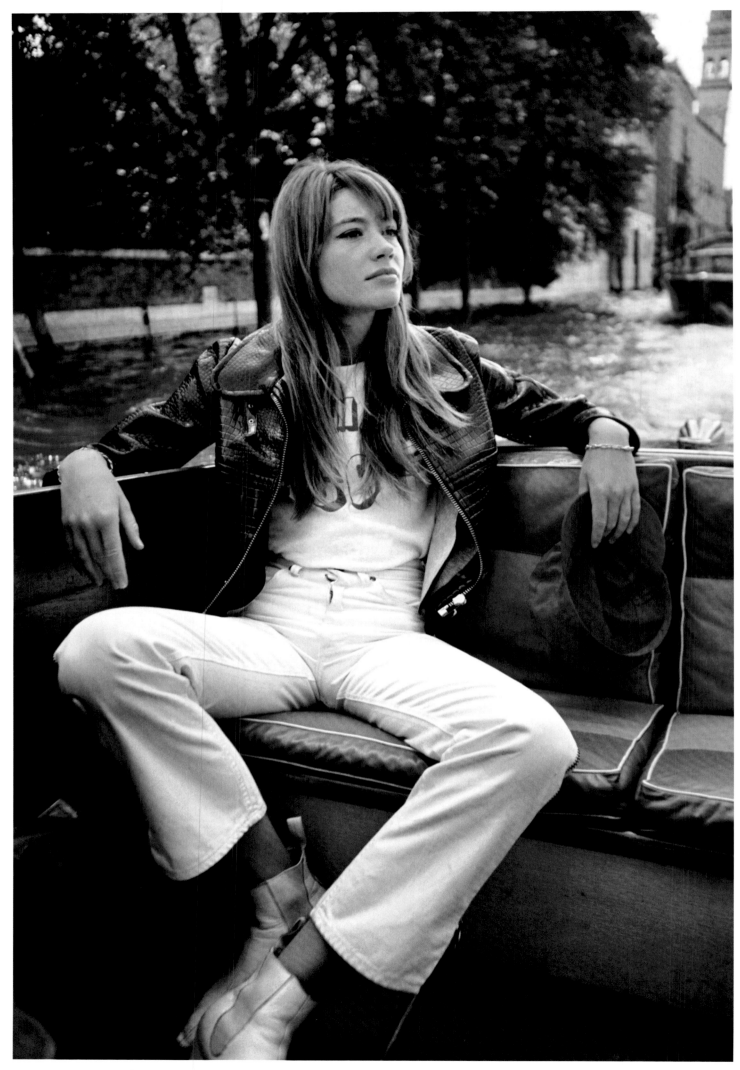

Françoise Hardy, Venice, 1964

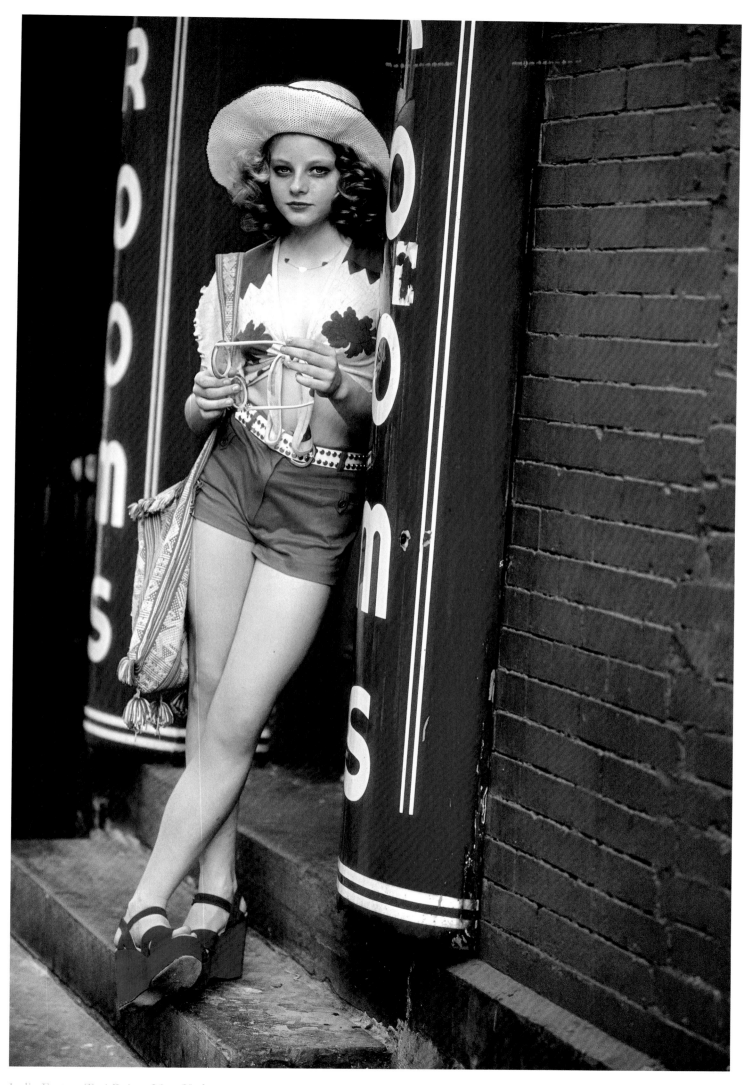

Jodie Foster, *Taxi Driver*, New York, 1975

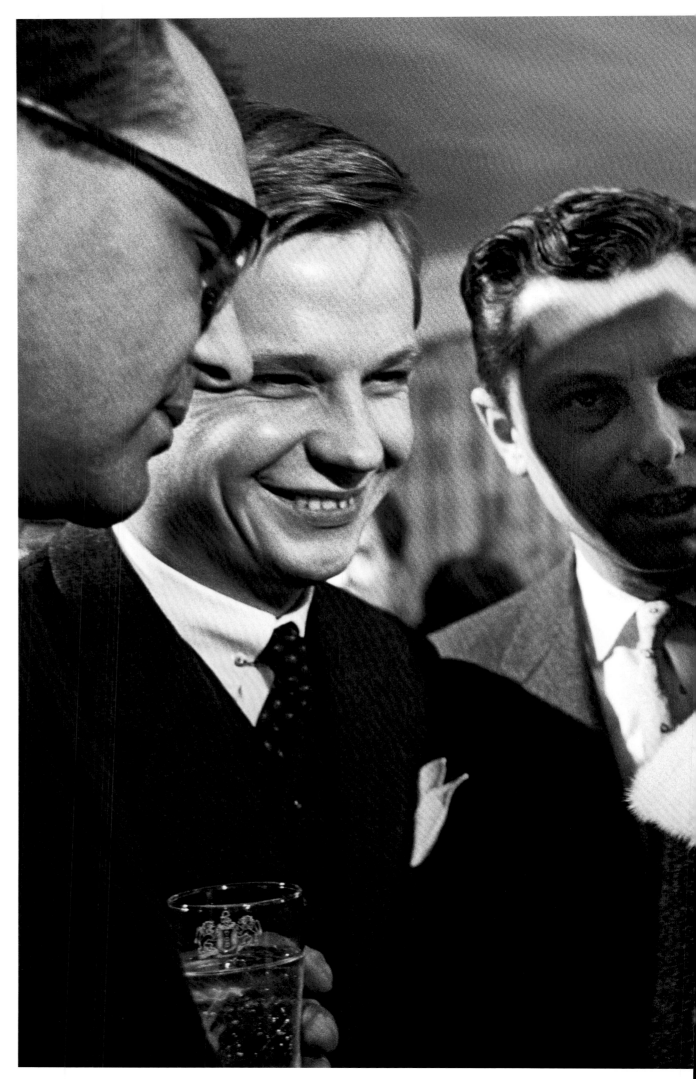

Romy Schneider, Boston, 1962

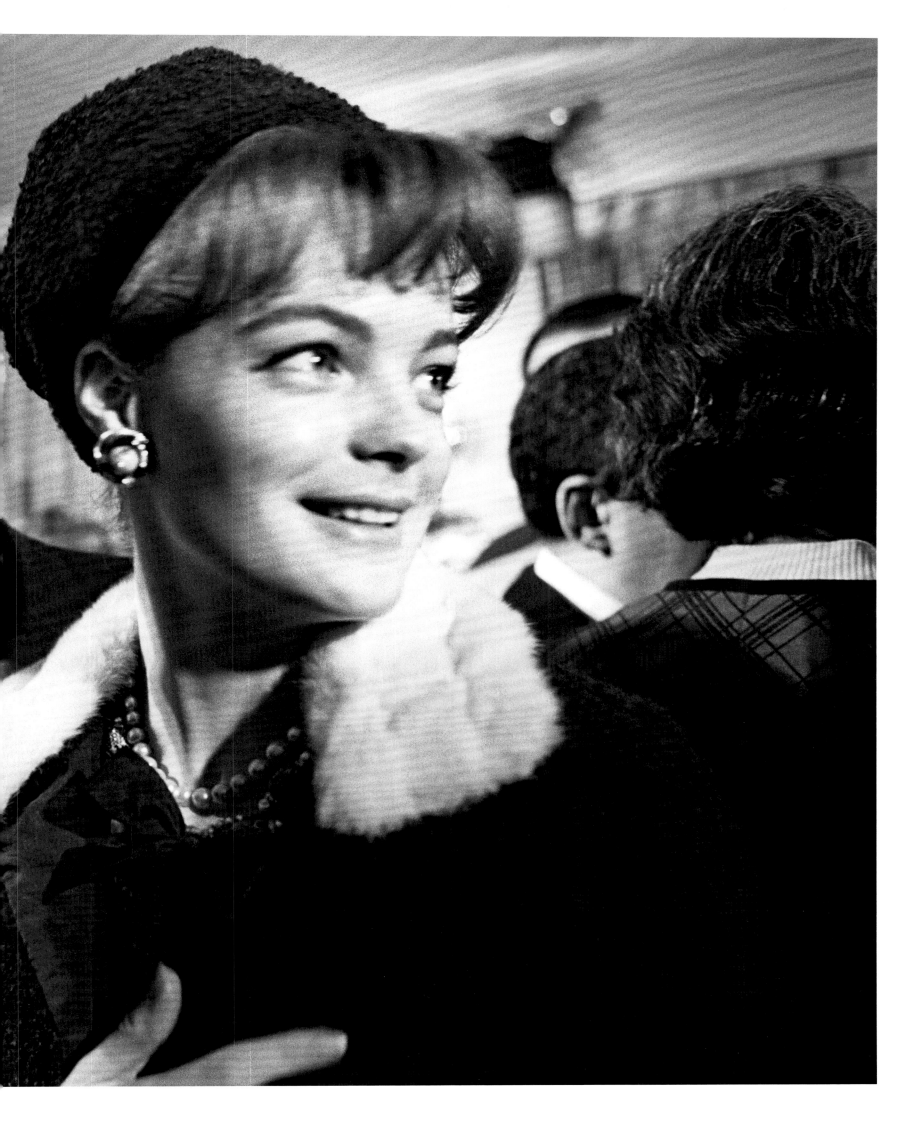

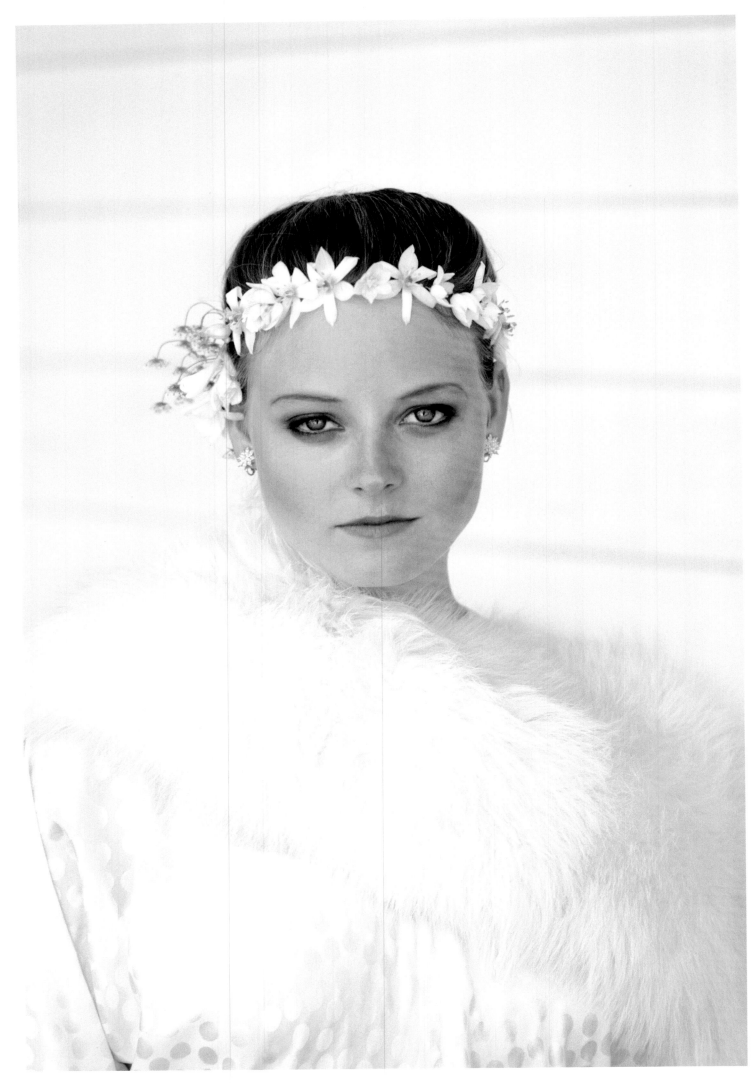

Jodie Foster, Ontario, Canada, 1983

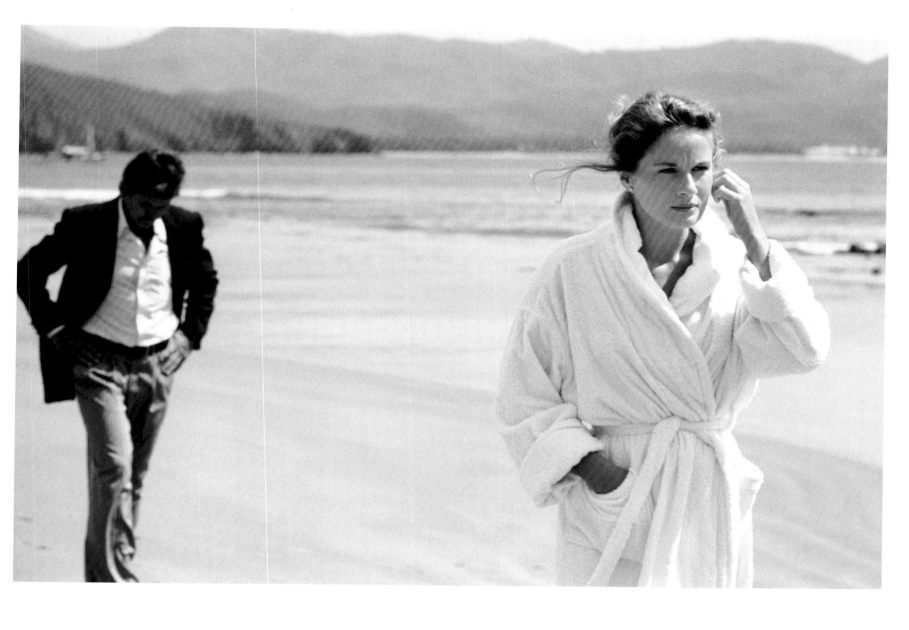

Dominique Sanda, Mexico, 1979

Barbra Streisand, Lazy Afternoon, Malibu, 1975

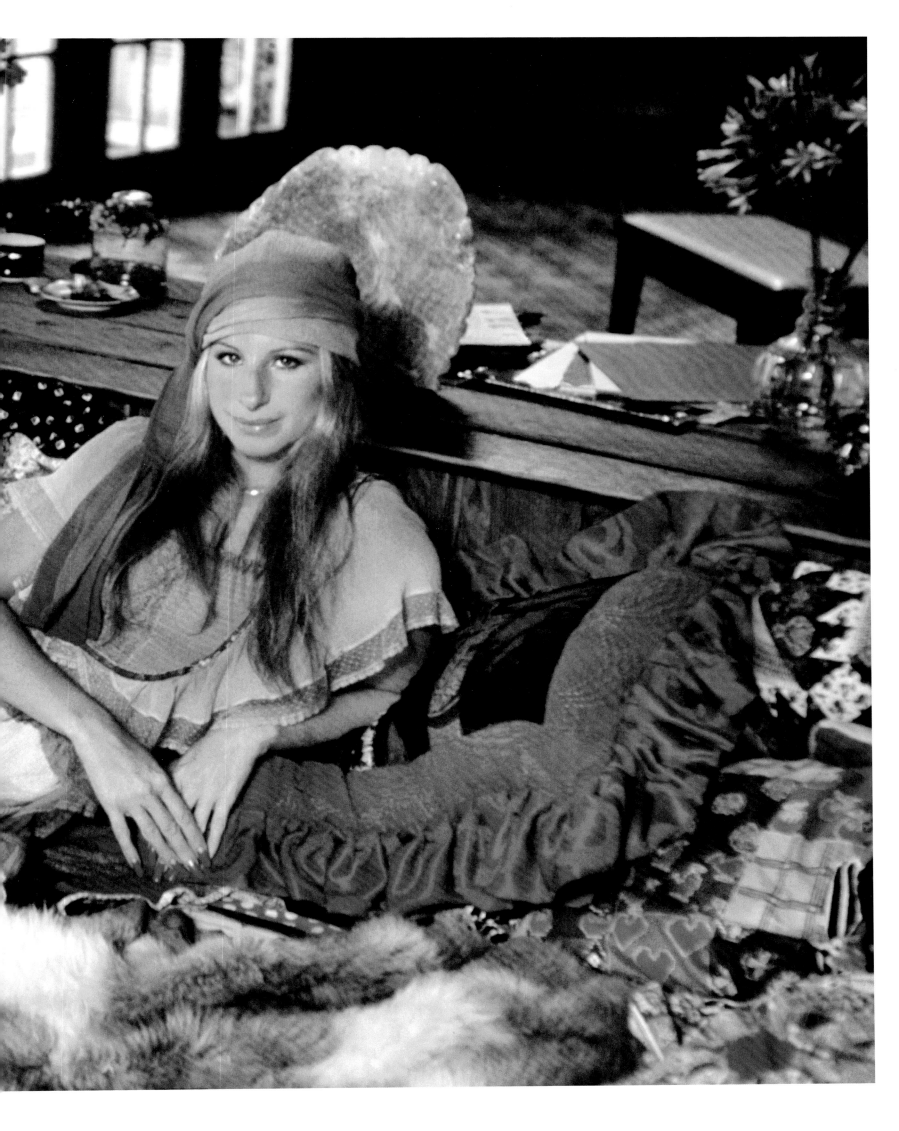

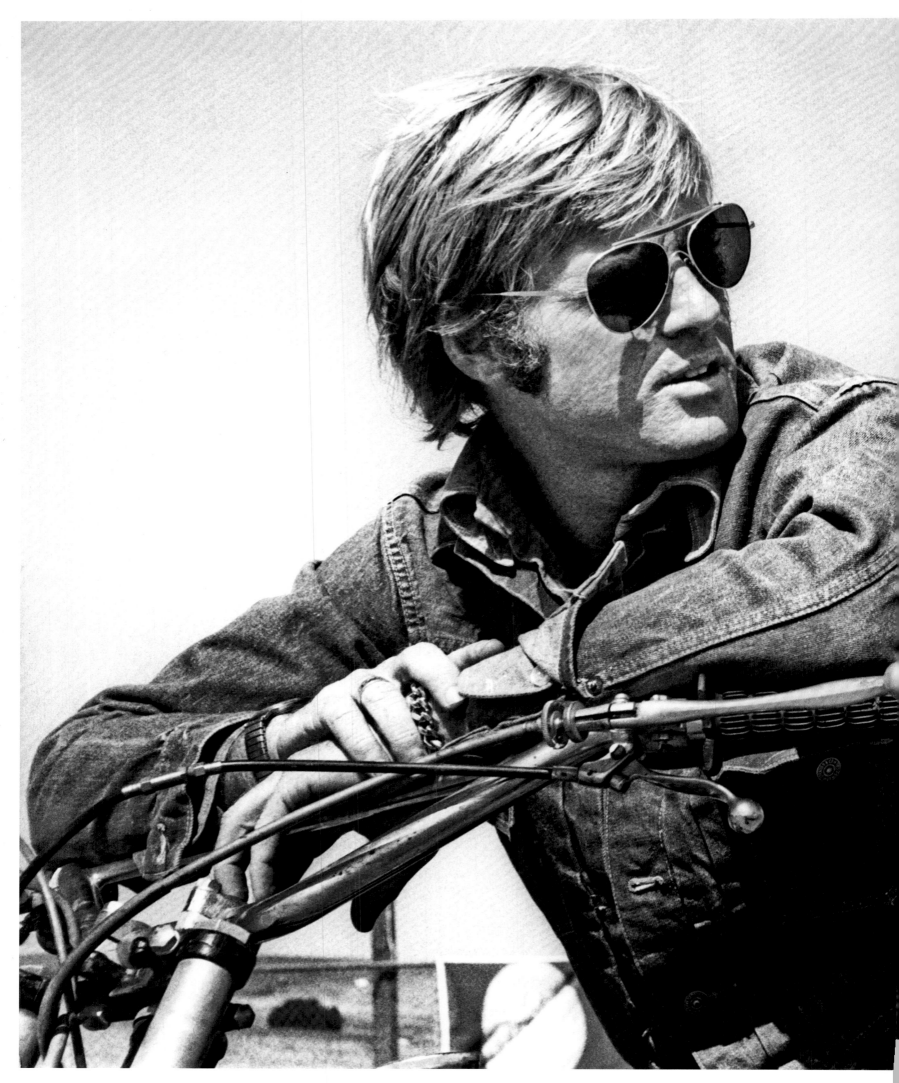

Robert Redford and Lauren Hutton, Sonoma, California, 1970

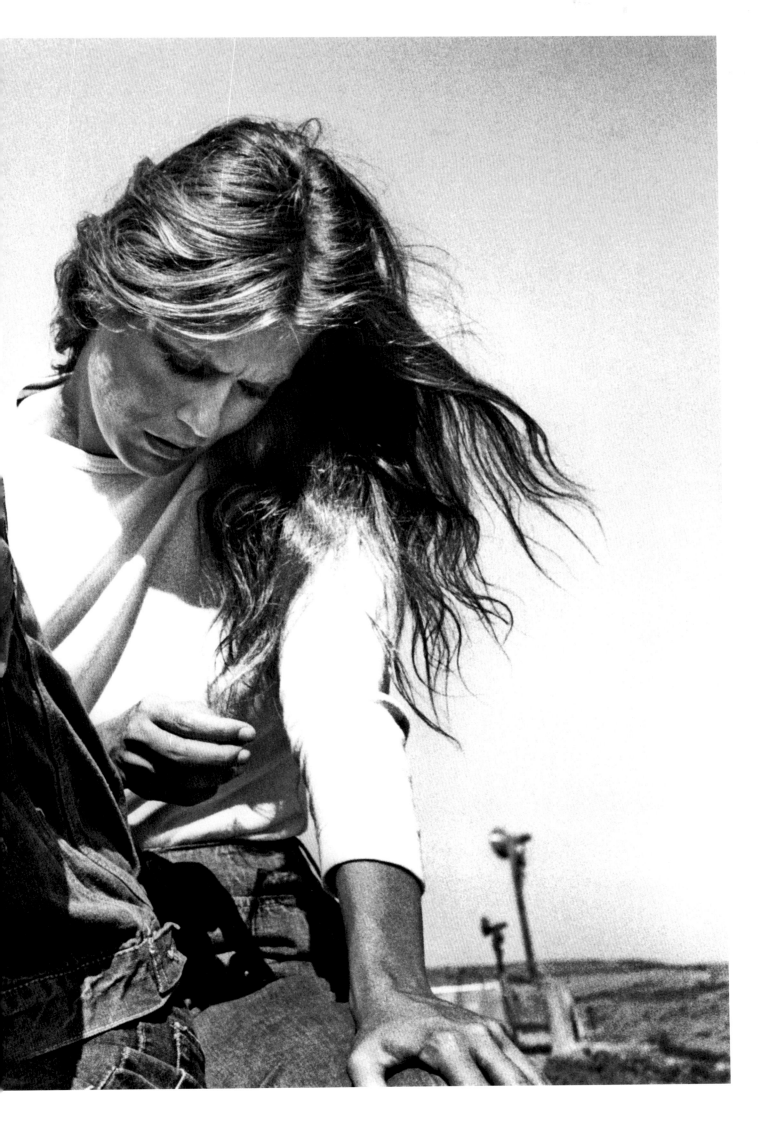

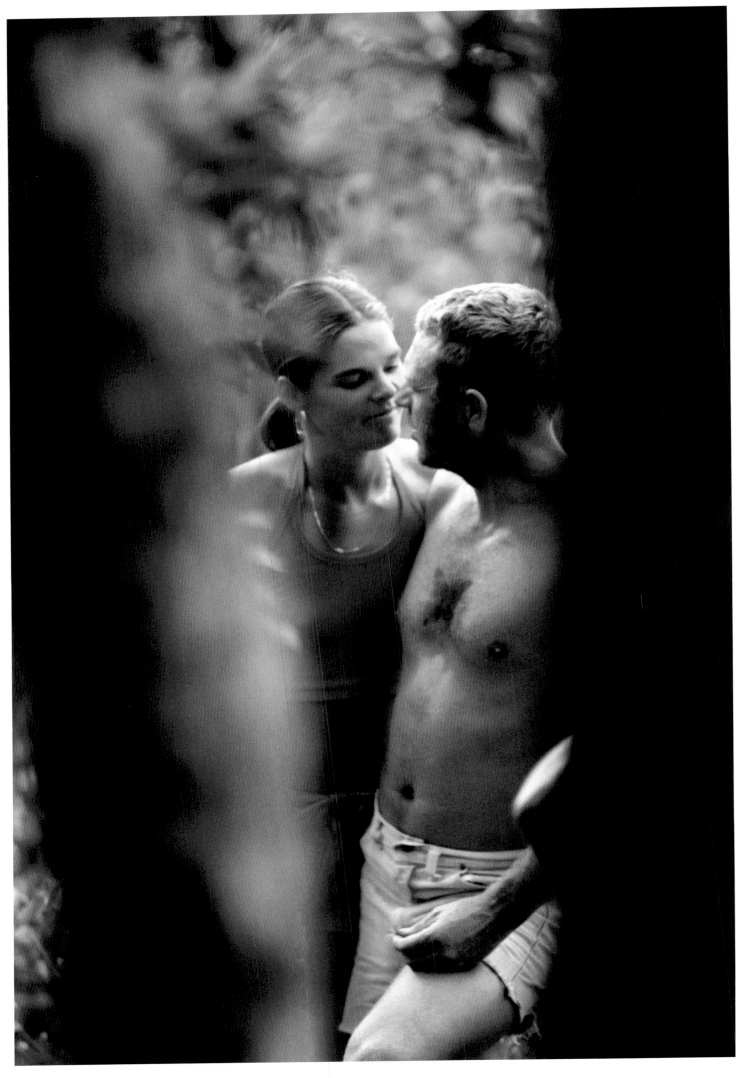

Ali MacGraw and Steve McQueen, Jamaica, 1972

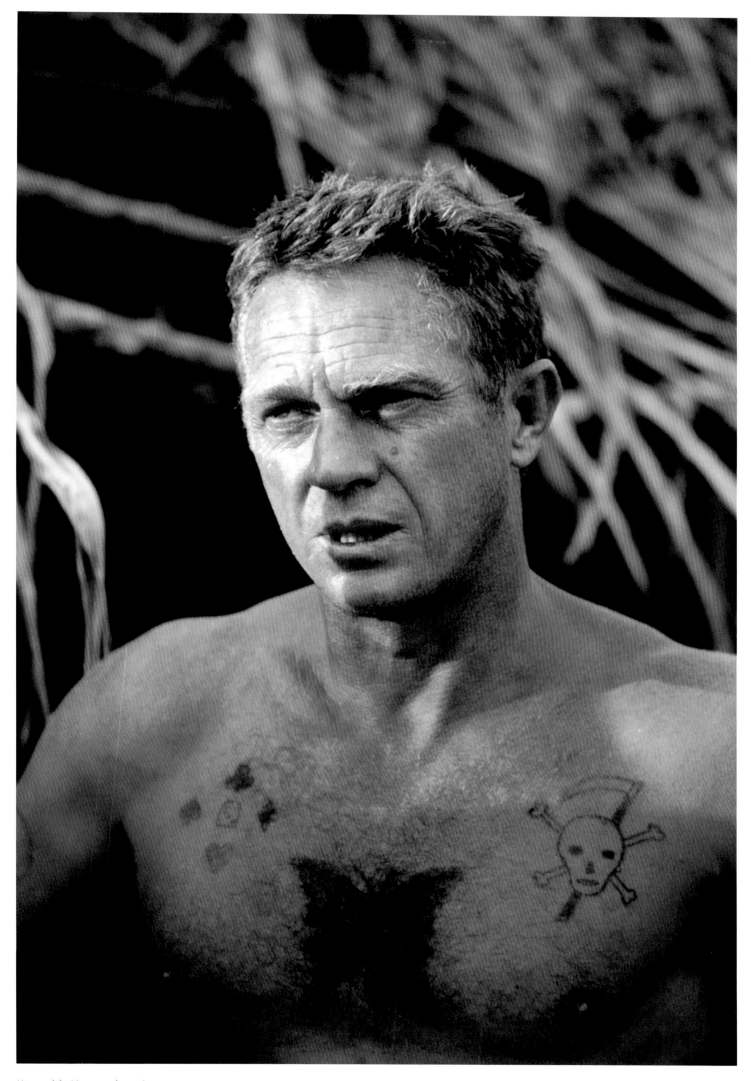

Steve McQueen, Jamaica, 1972

174    Robert Wagner and Natalie Wood on The Splendor, Catalina, 1976

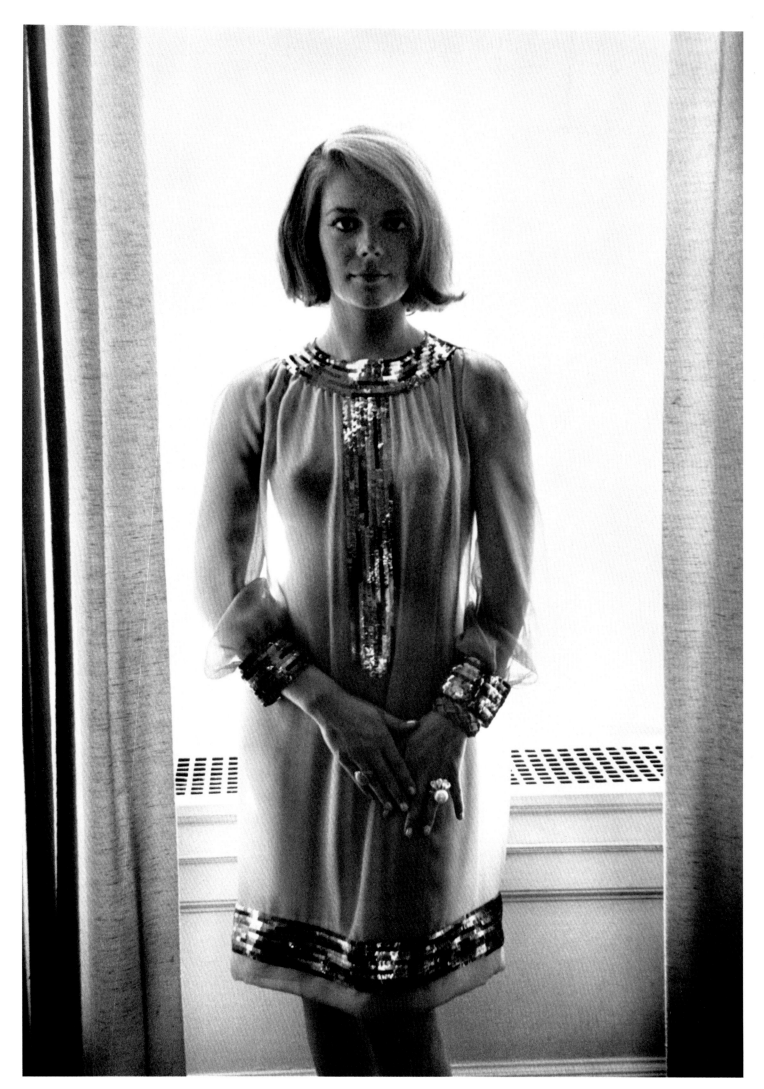

Natalie Wood, New York, 1963

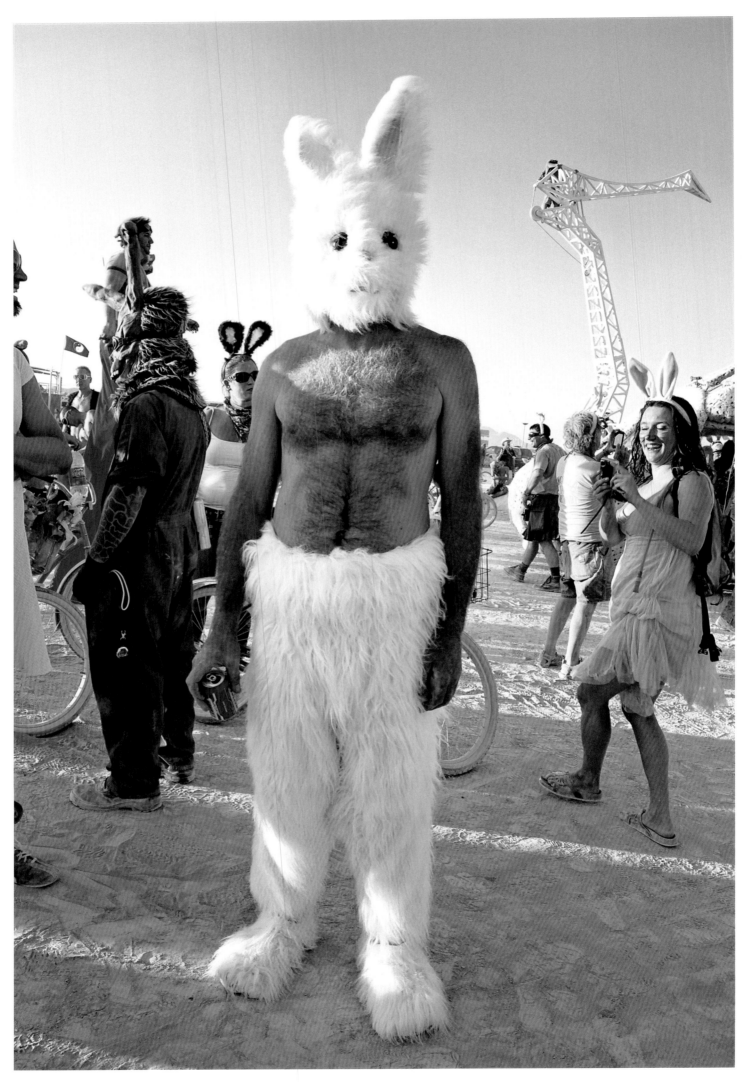

Man with Bunny Head, Burning Man, Nevada, 2009

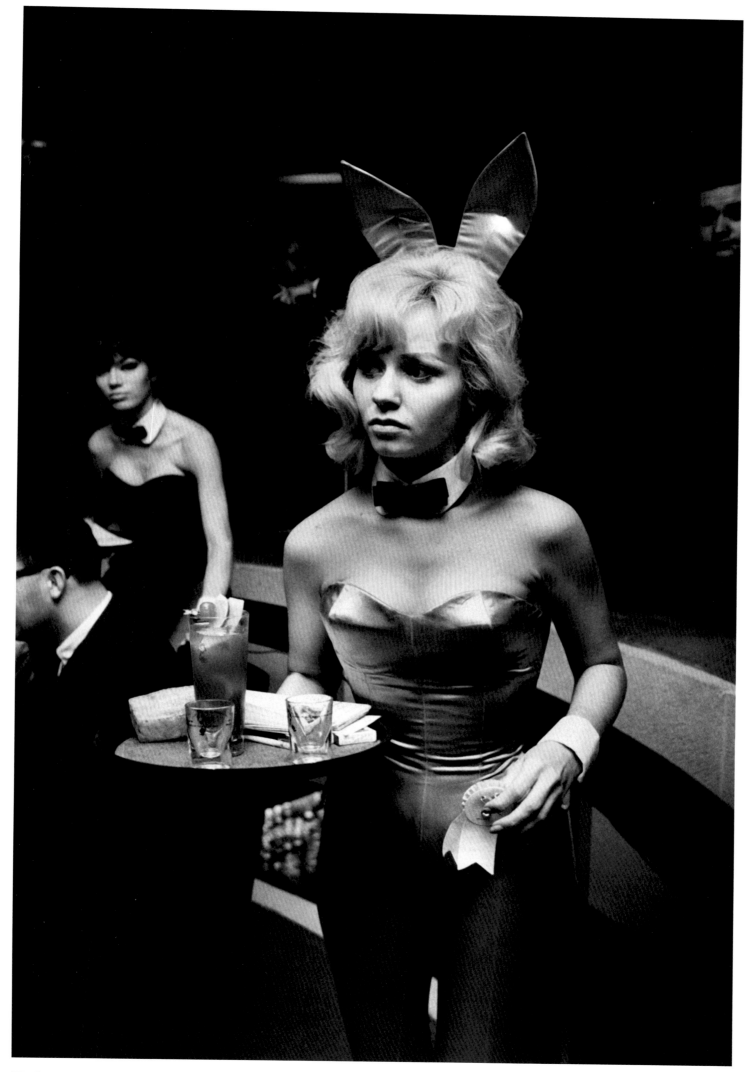

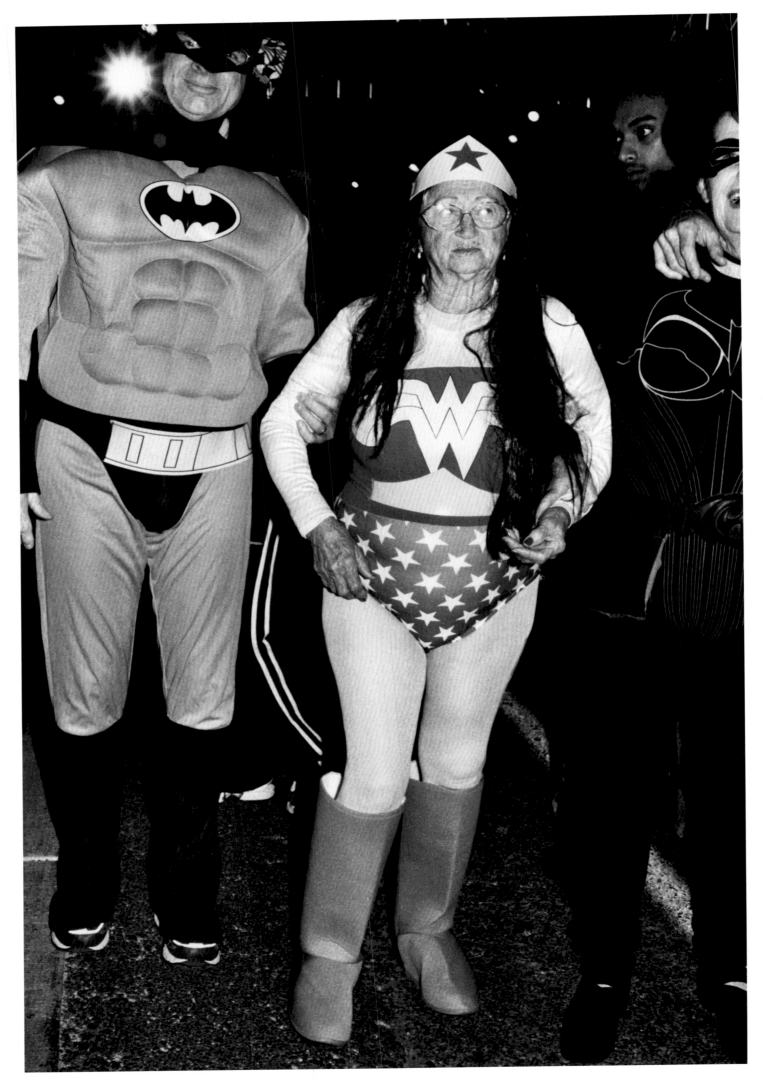

Wonder Woman, Los Angeles, 1998

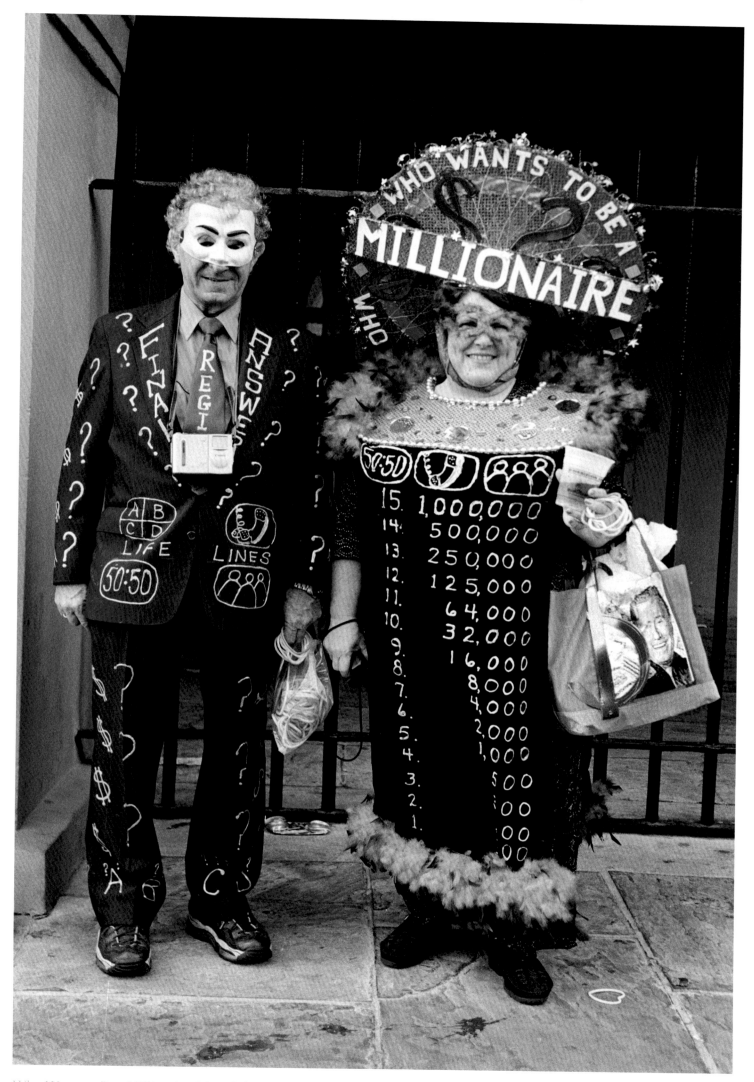

Who Wants to Be a Millionaire, New Orleans, 1999

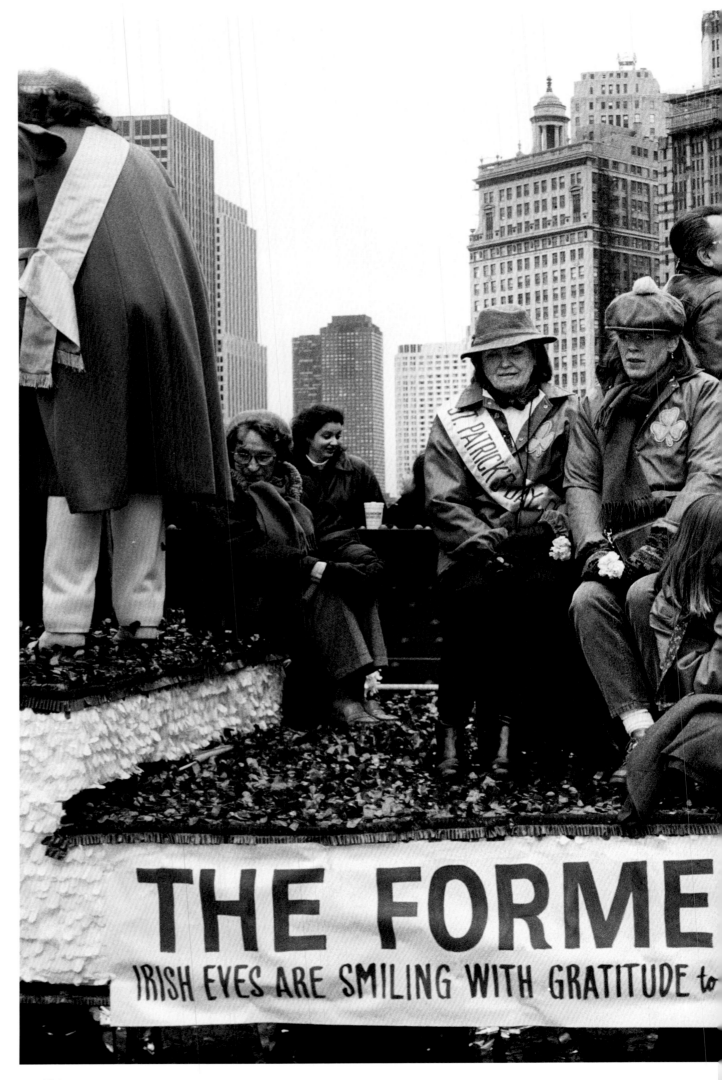

The Former Queens, Chicago, 2009

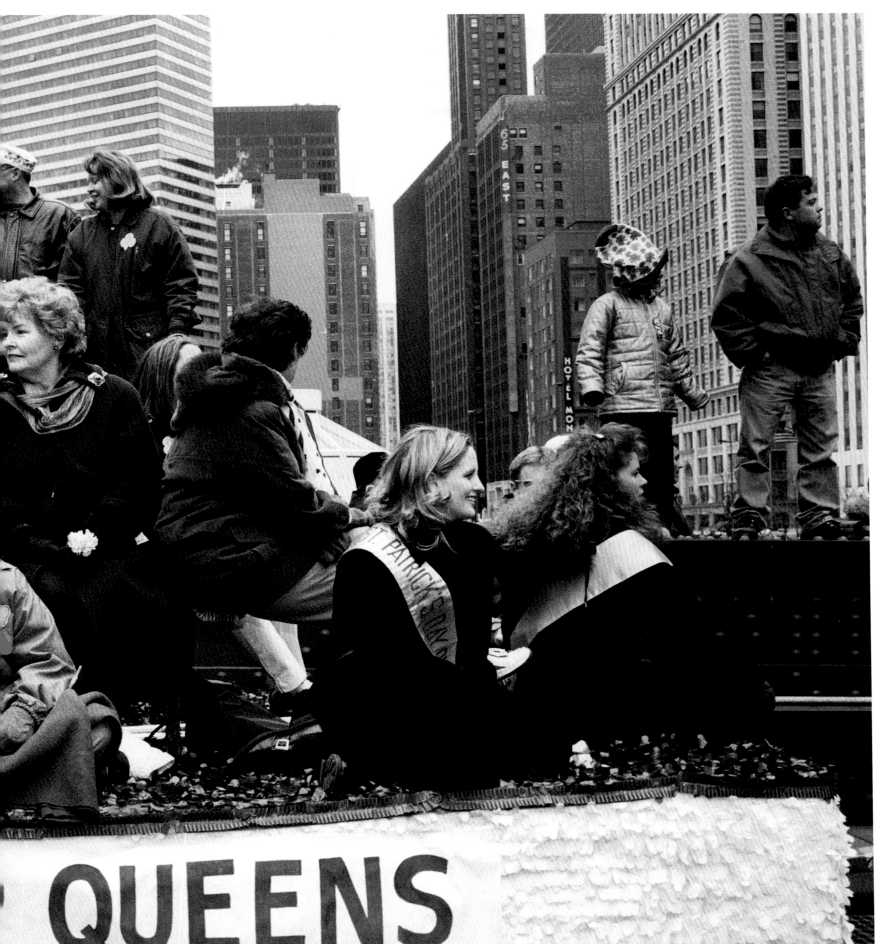

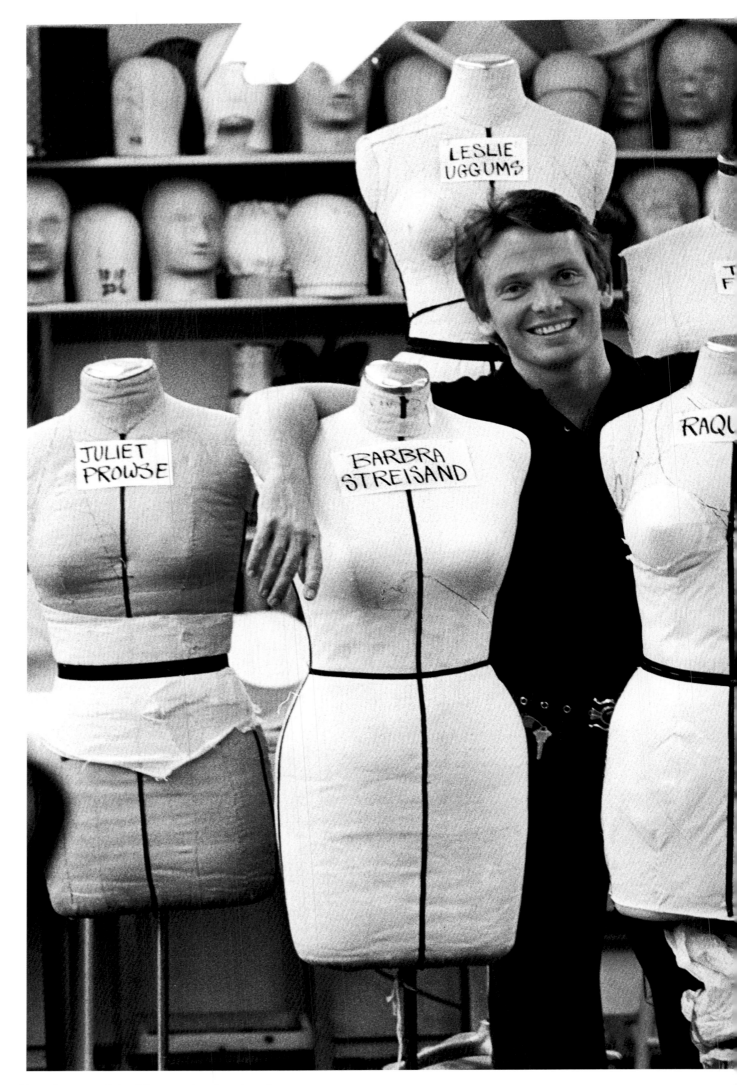

Bob Mackie and Ray Aghayan, Diva Mannequins, Los Angeles, 1975

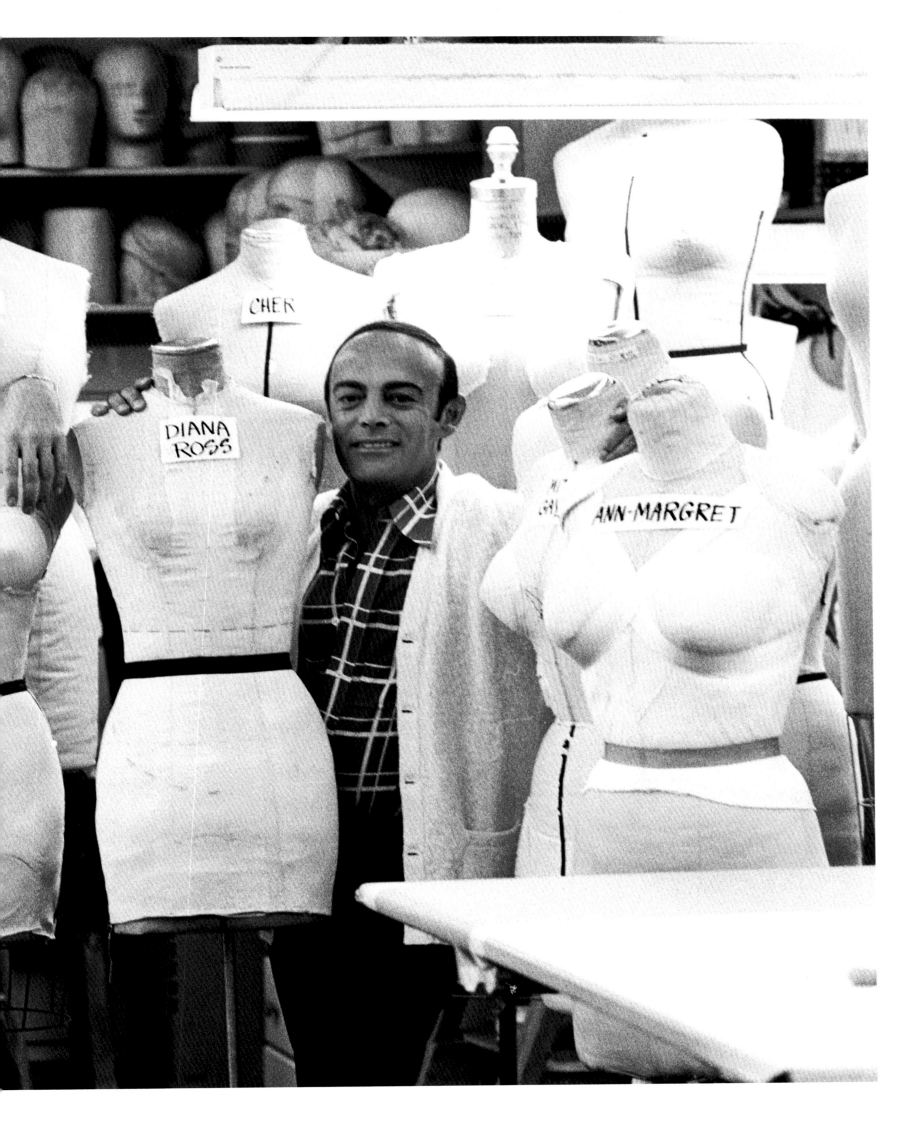

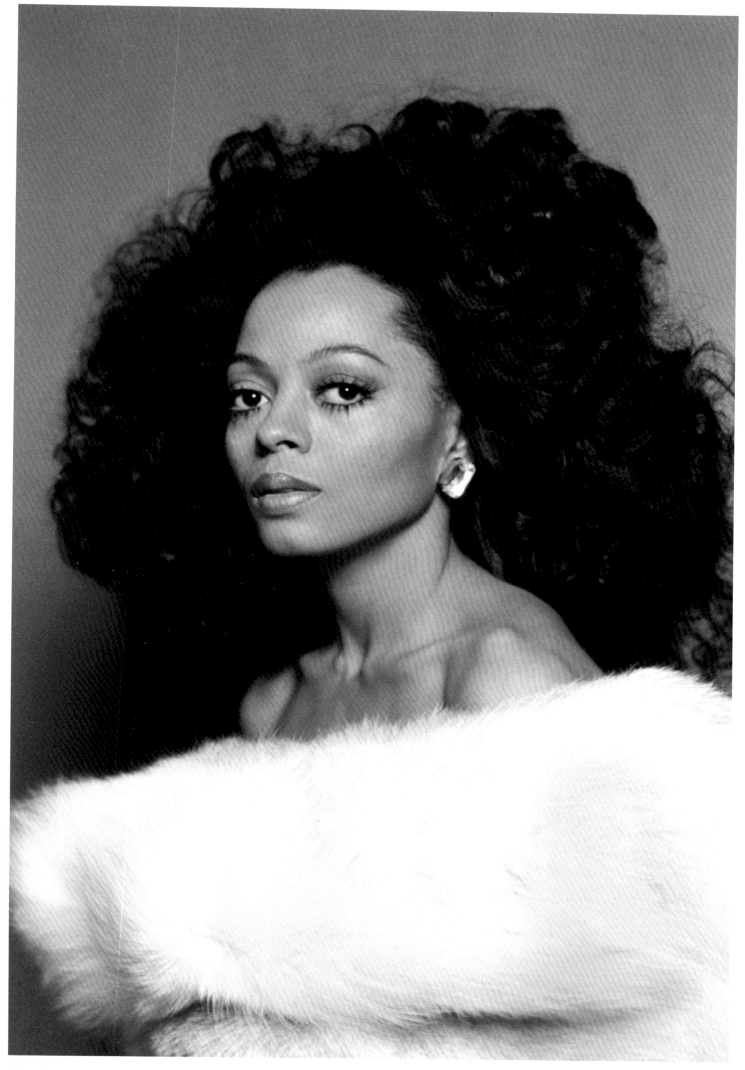

Diana Ross, Las Vegas, 1974

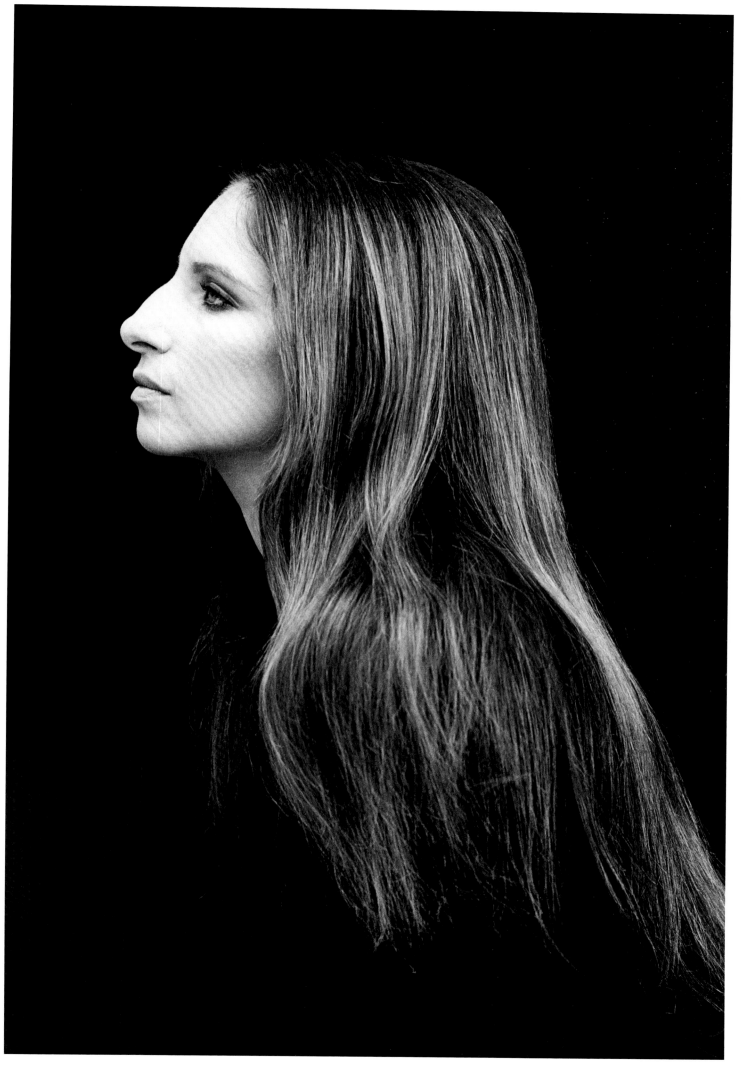

Barbra Streisand, Los Angeles, 1972

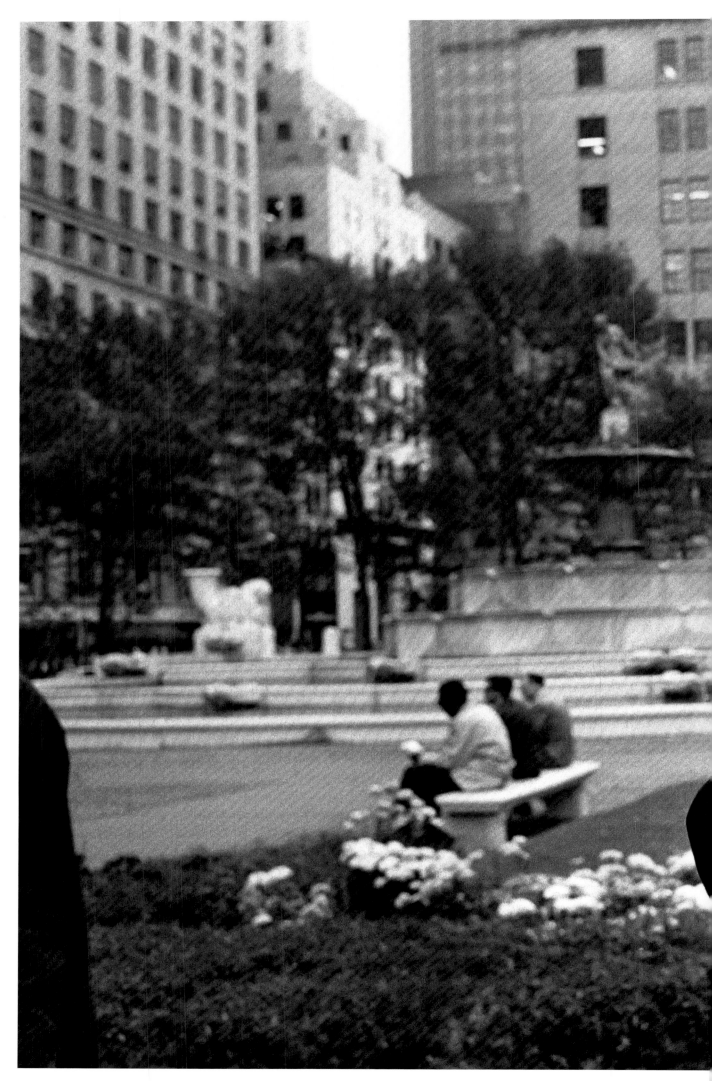

Marcello Mastroianni, New York, 1962

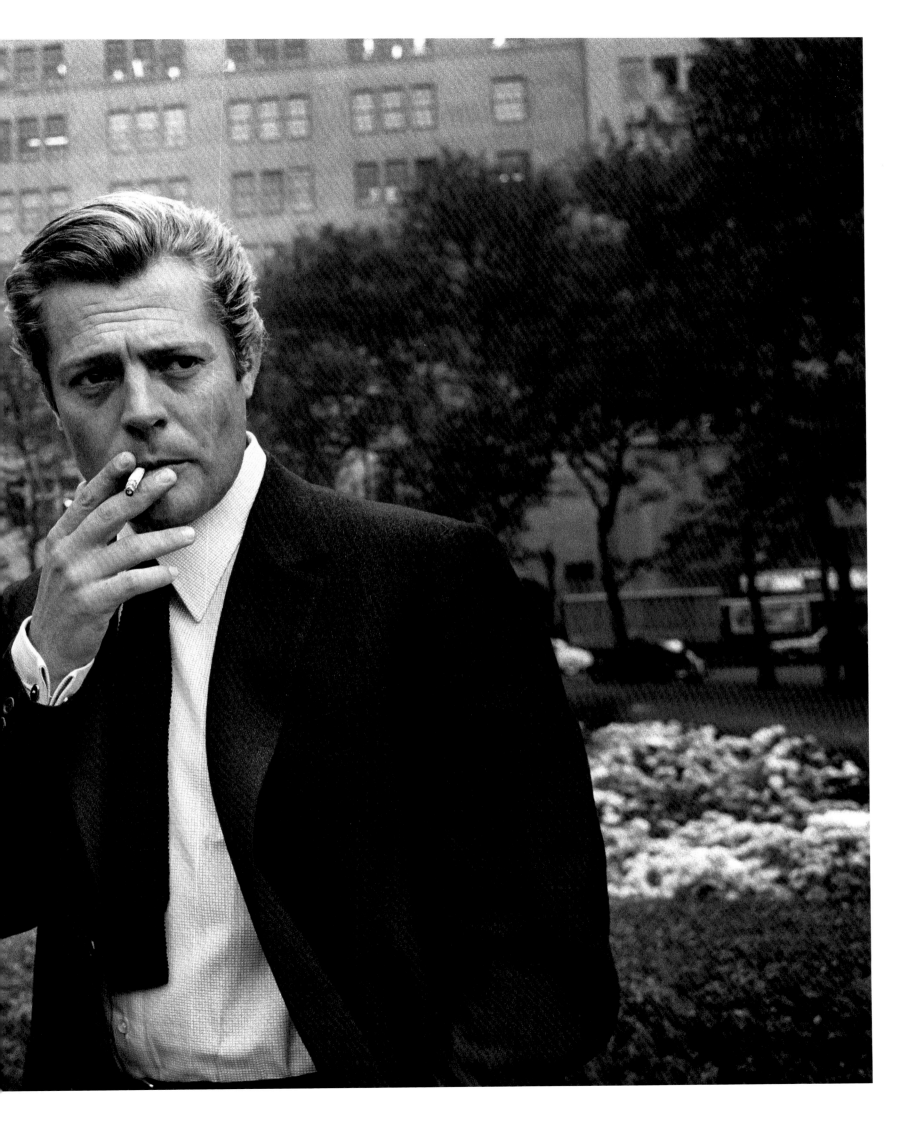

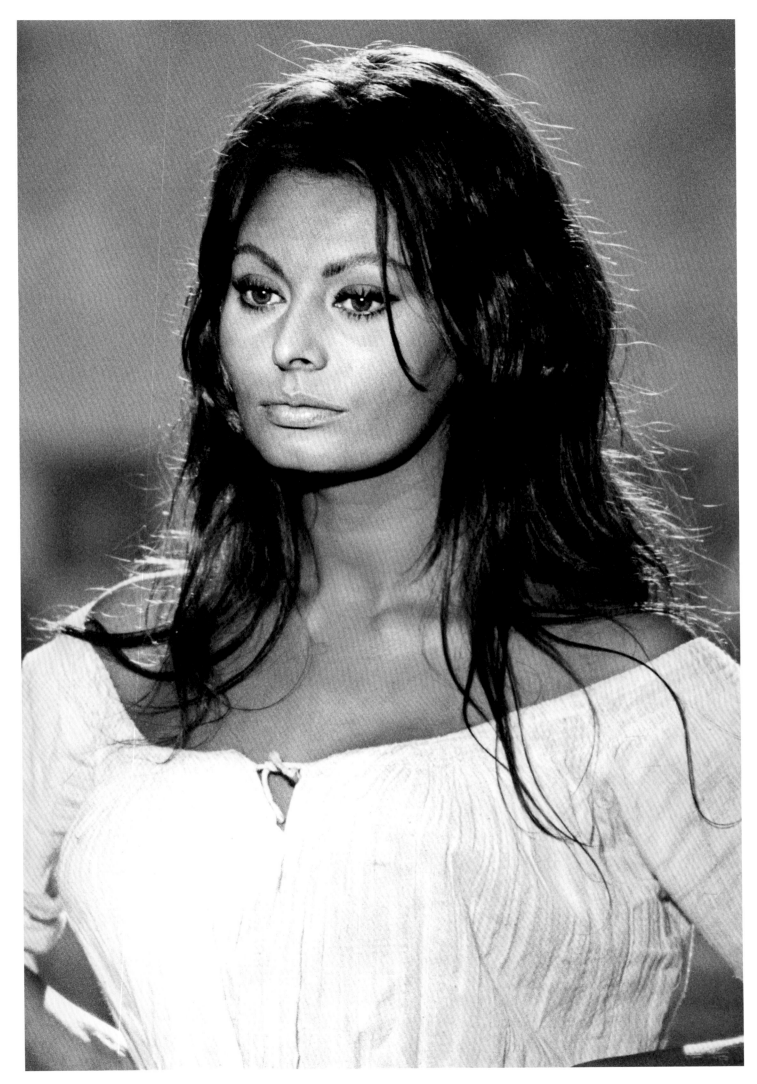

Sophia Loren, Padua, Italy, 1964

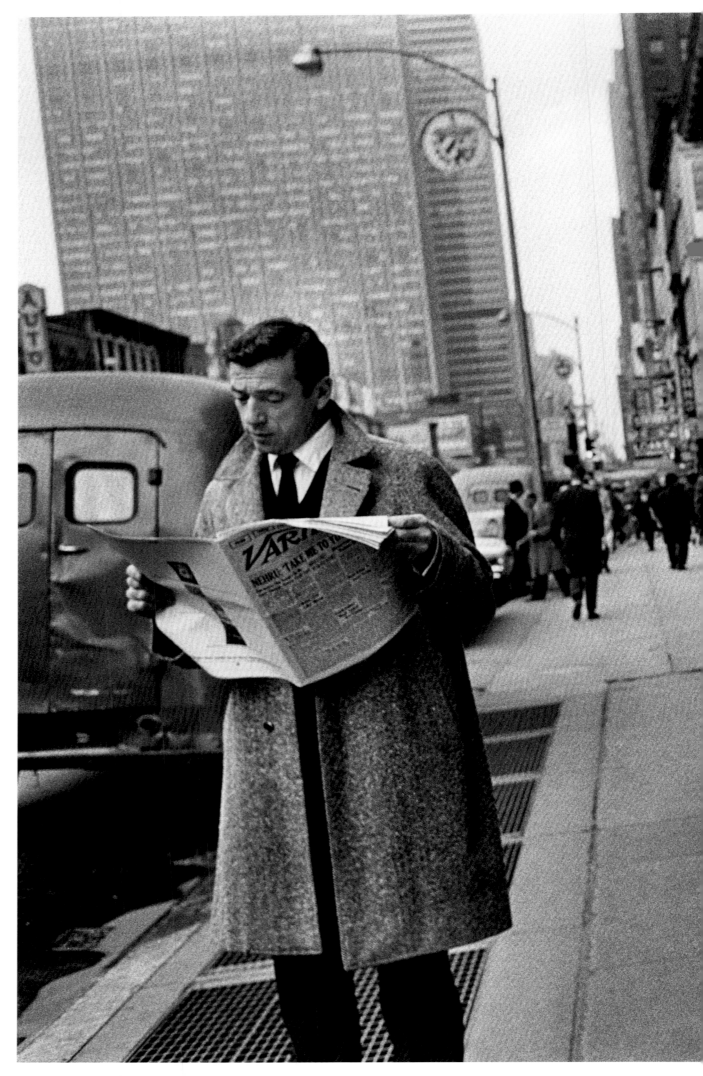

Yves Montand, Fifth Avenue, New York, 1961

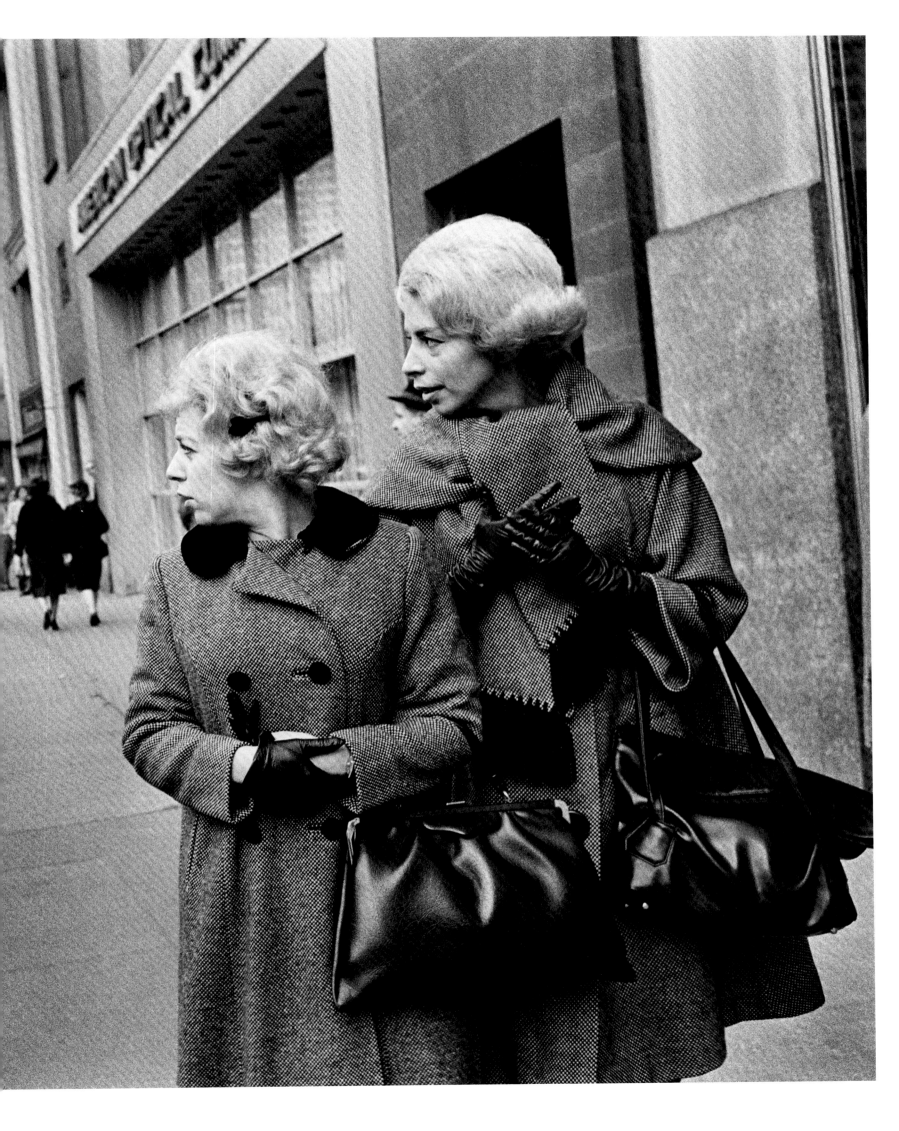

Richard Pryor Fiddling with Cigarette Lighter, Maui, 1981

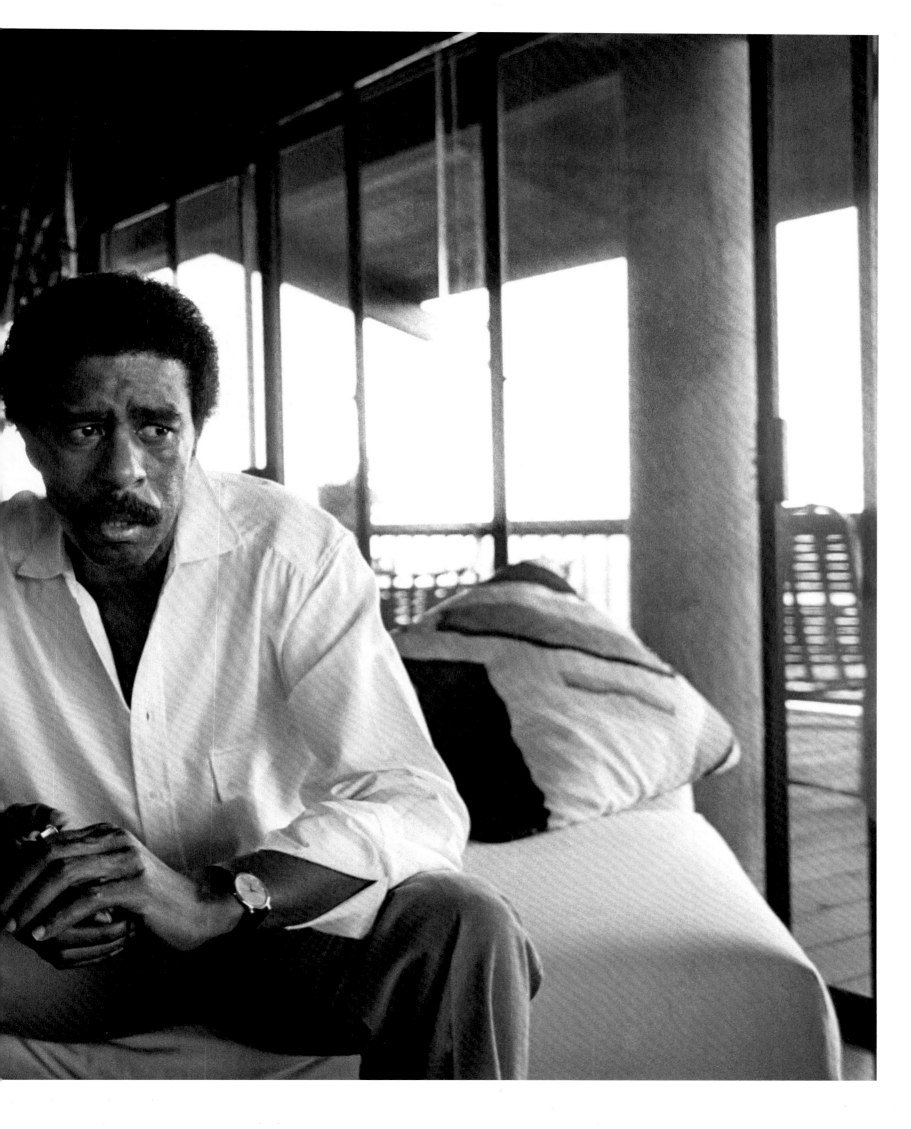

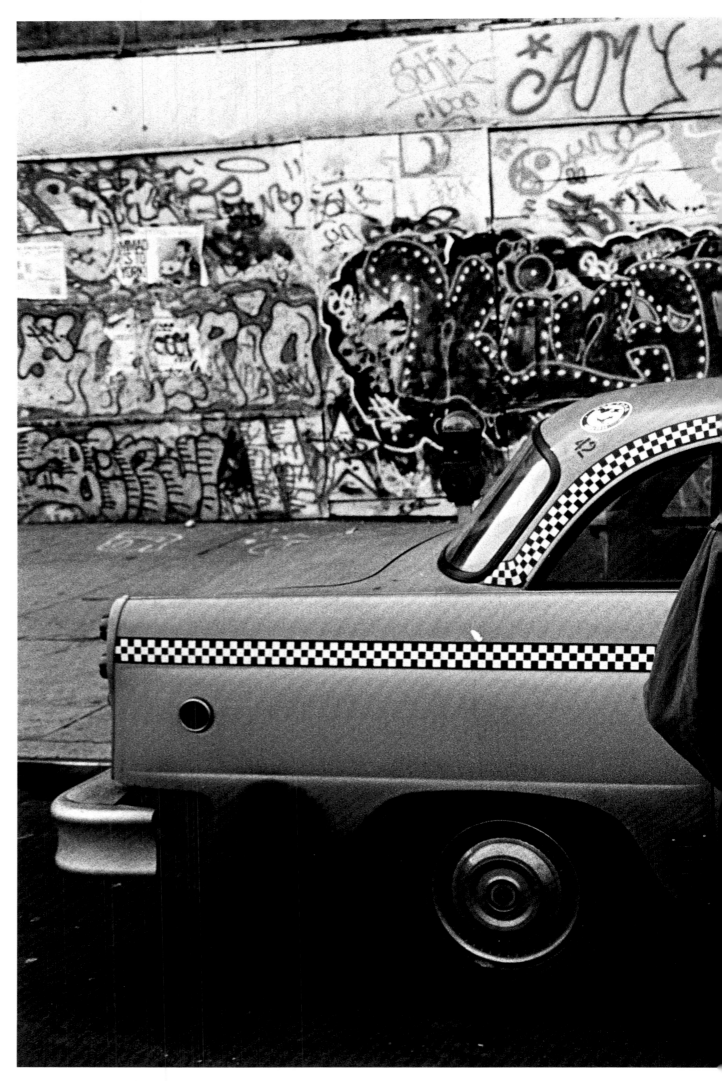

Robert De Niro, *Taxi Driver*, New York, 1975

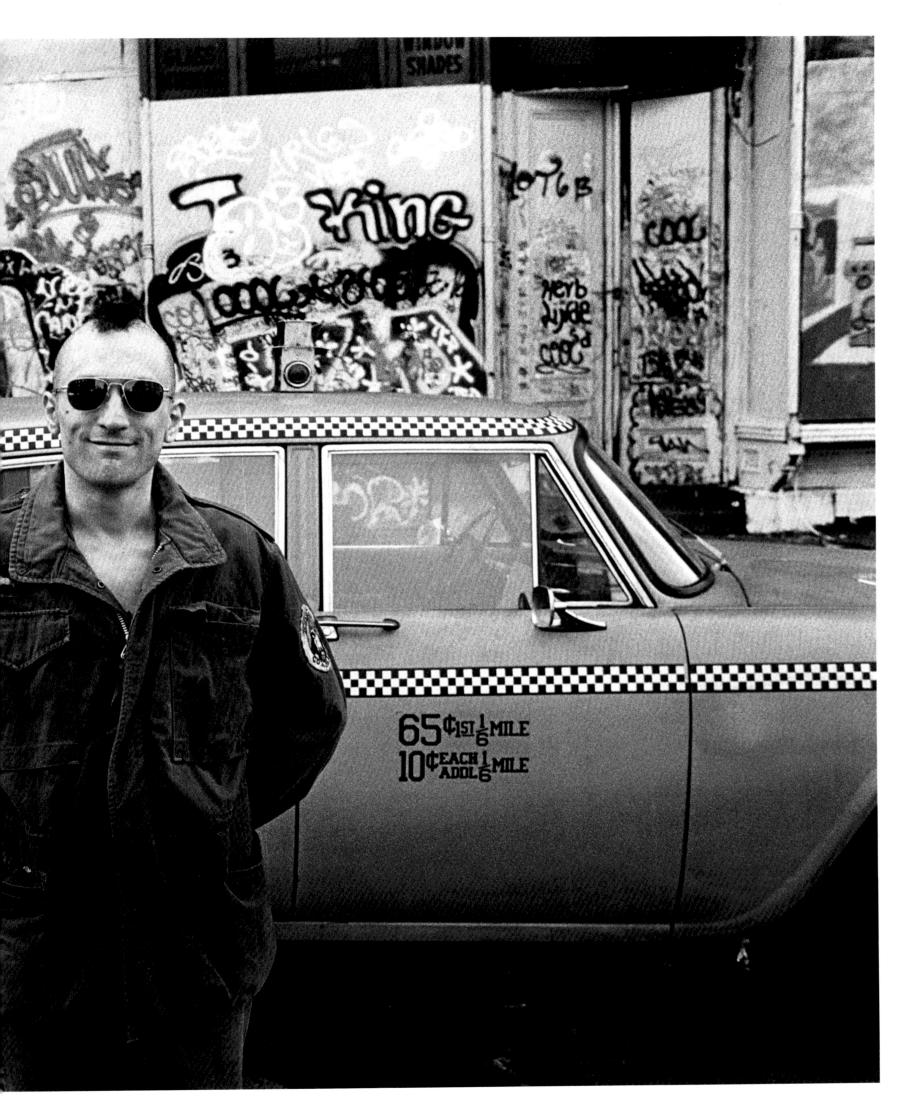

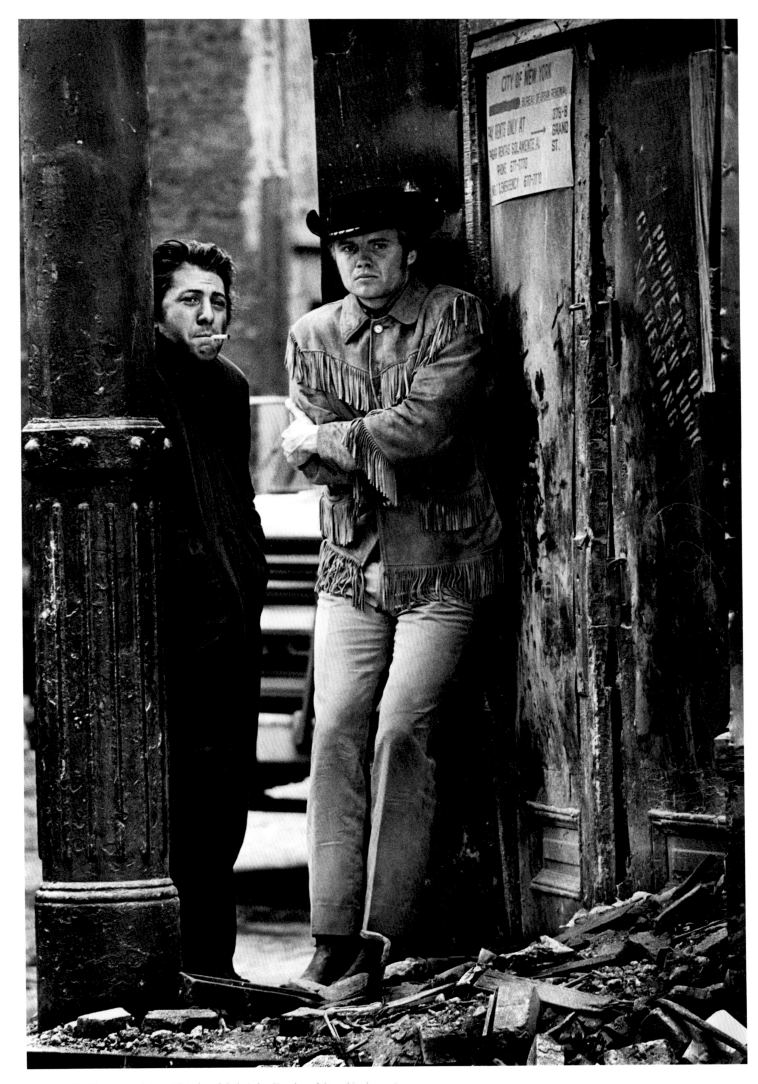

Dustin Hoffman and Jon Voight, *Midnight Cowboy*, New York, 1969

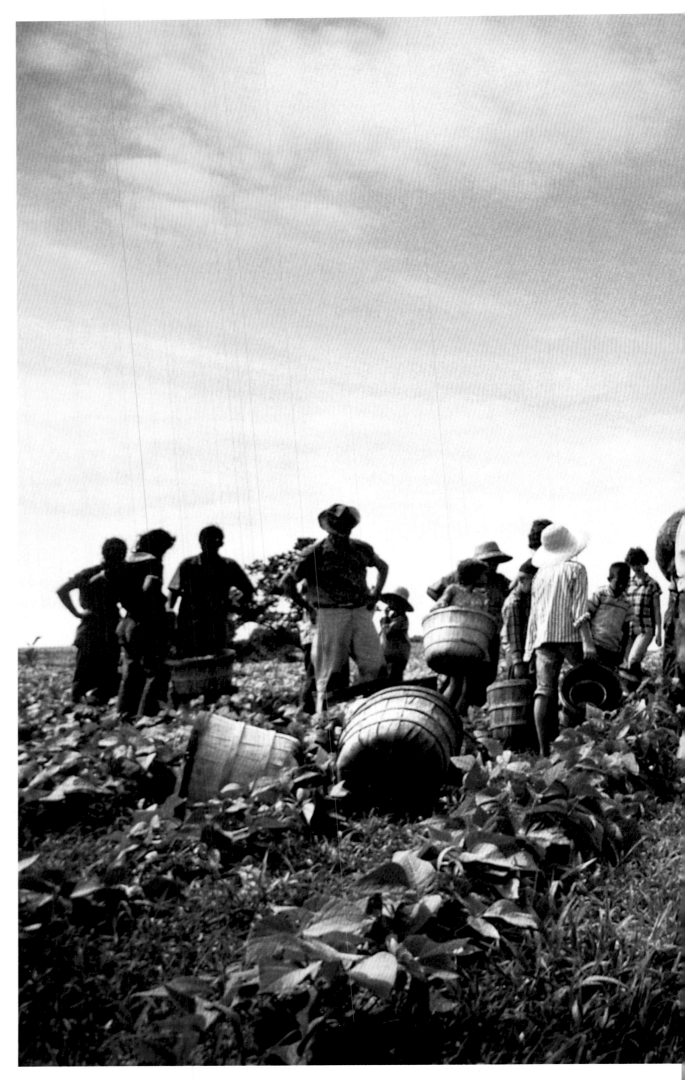

Bean Pickers, Migrant Workers, Arkansas, 1961

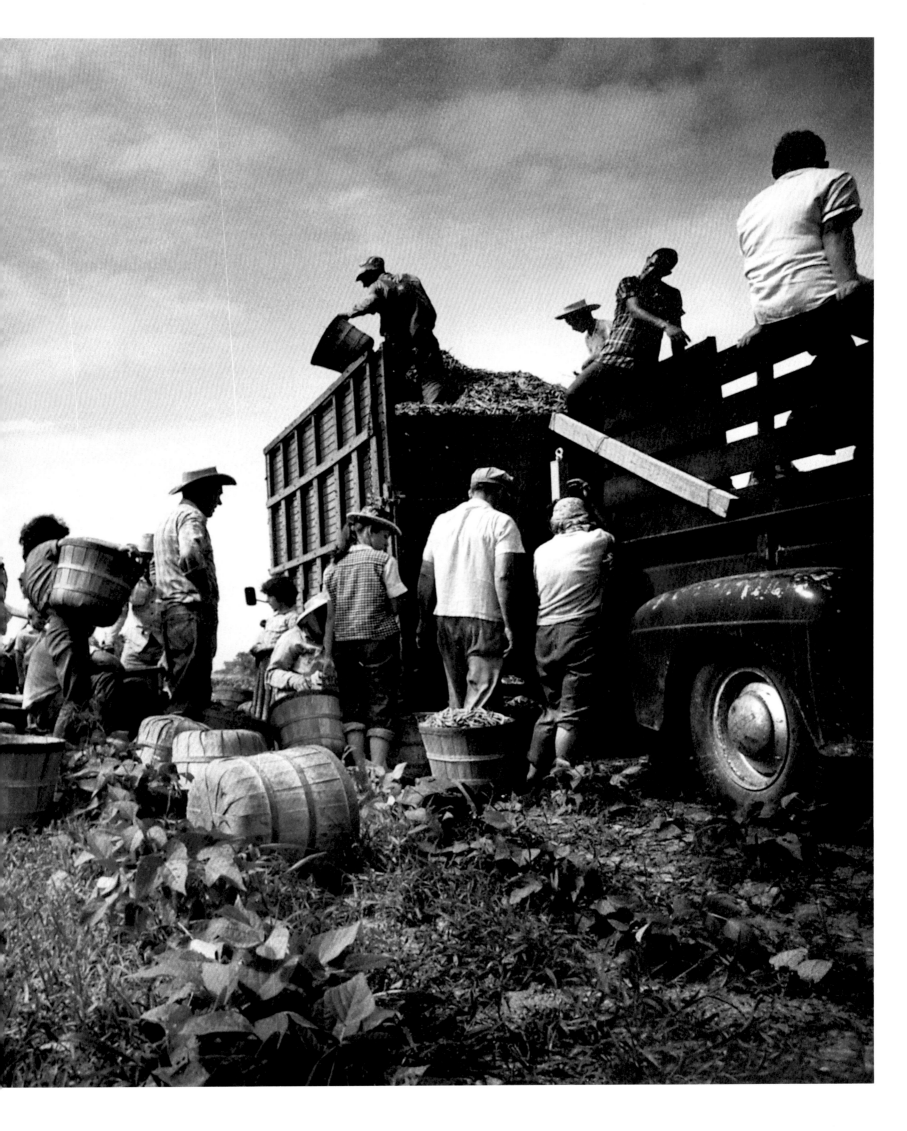

Club Monaco, Fifth Avenue, New York, 2009

Superman, New York, 2010

Superman, Los Angeles, 2001

Painting on Berlin Wall, 2011

Homeless Woman, Fifth Avenue, New York, 2011

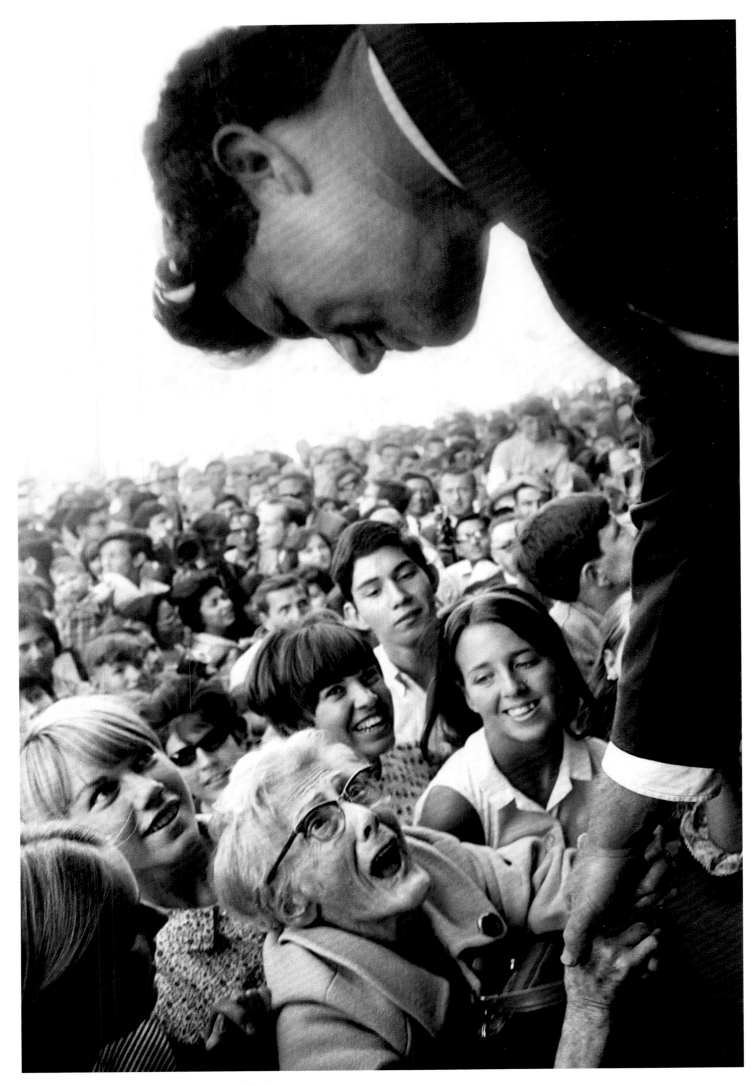

Robert F. Kennedy Campaigning, New York, 1963

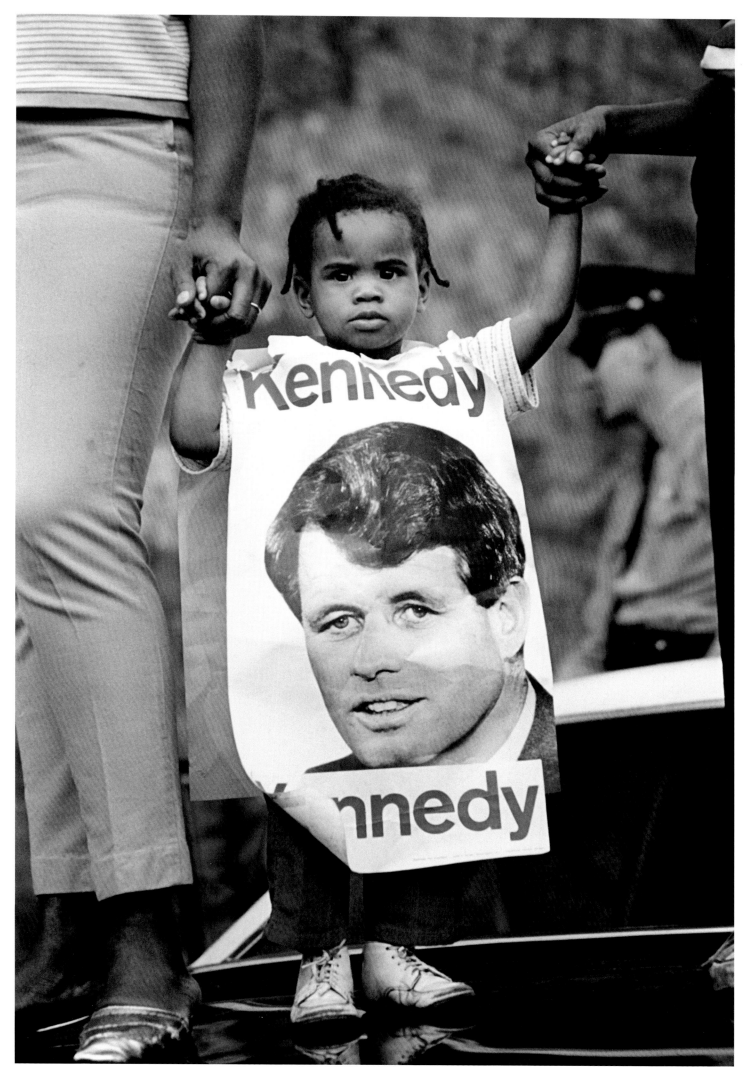

Child with Robert F. Kennedy Campaign Poster, California, 1967

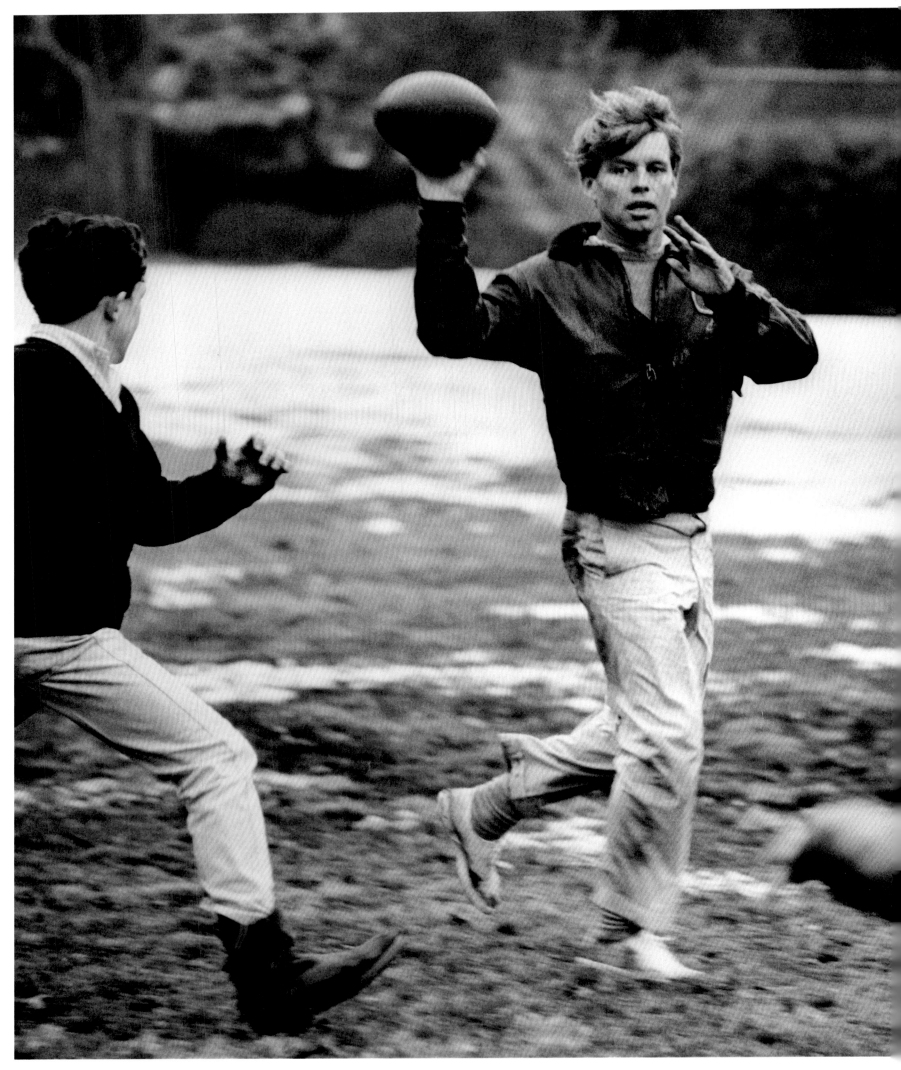

Robert F. Kennedy, Hickory Hill, Virginia, 1967

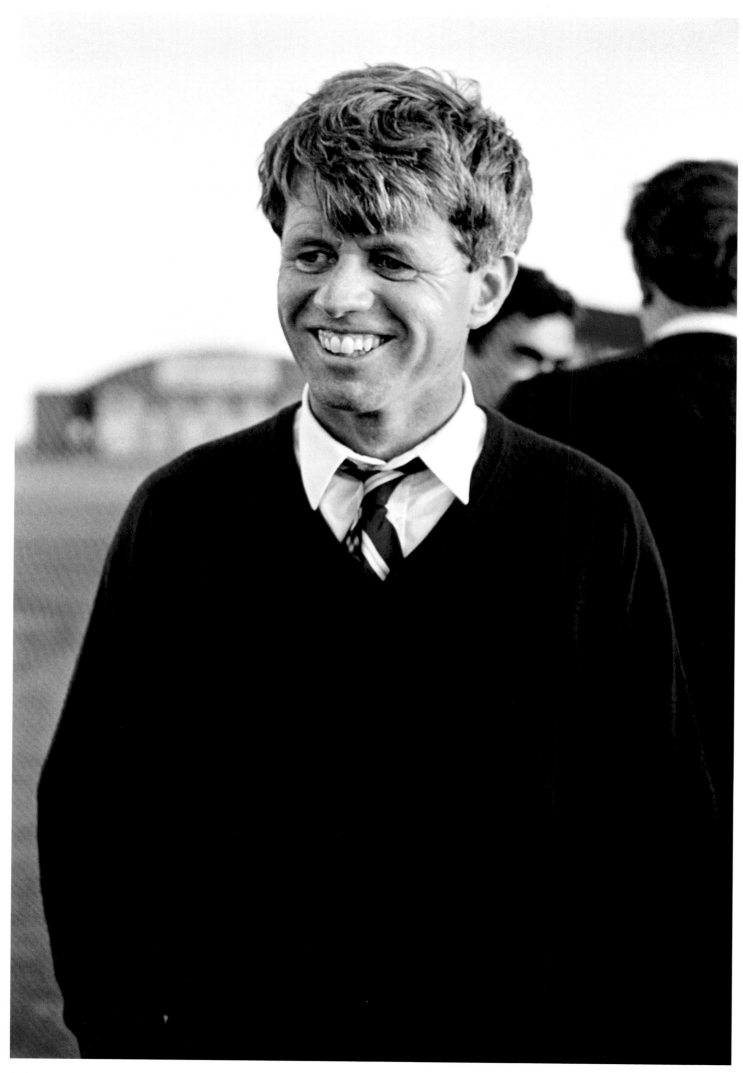

Robert F. Kennedy, Indiana, 1968

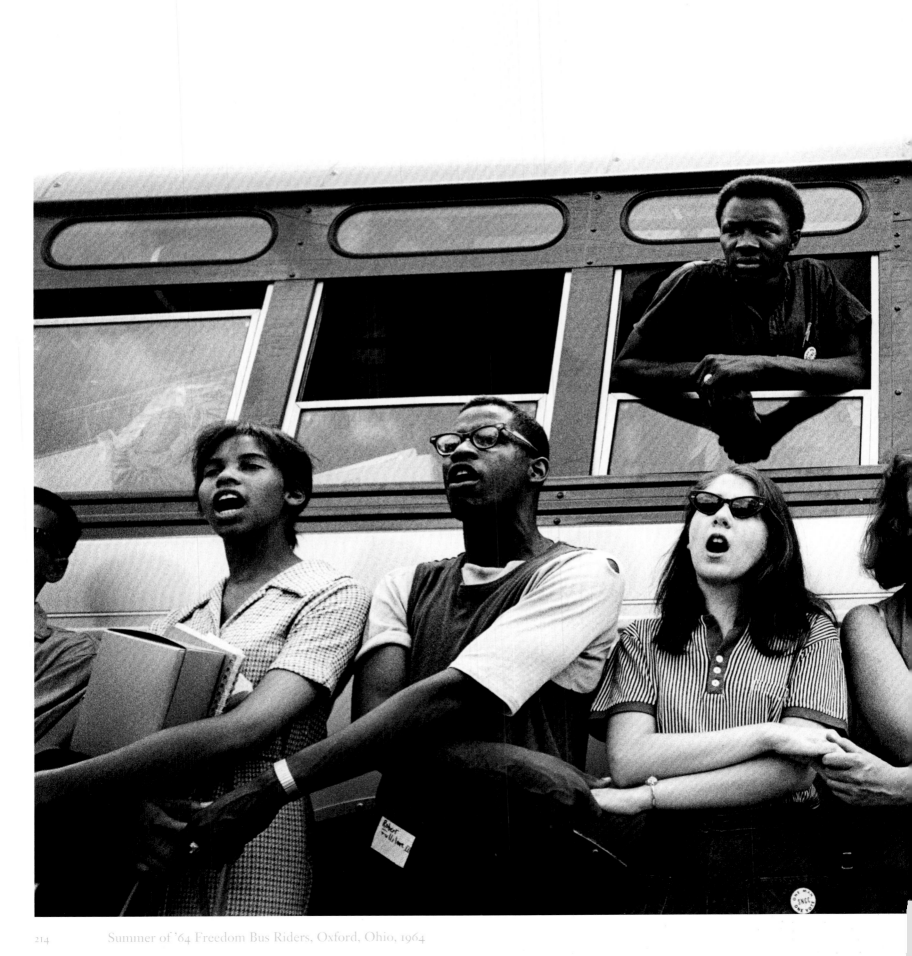

Summer of '64 Freedom Bus Riders, Oxford, Ohio, 1964

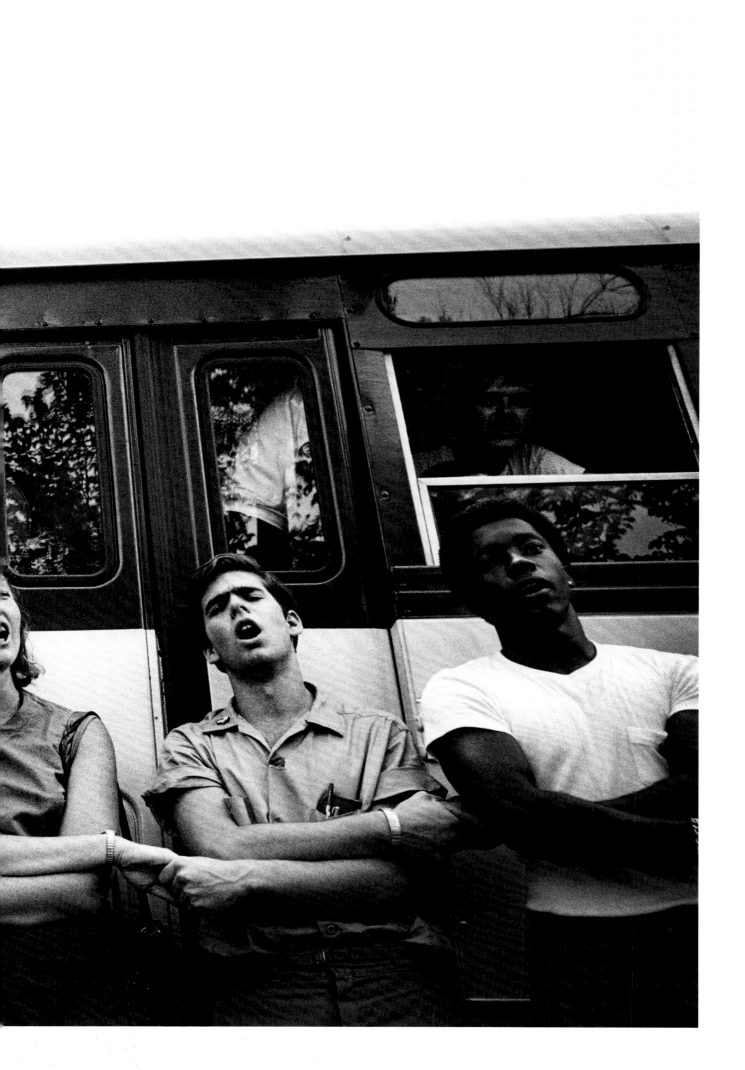

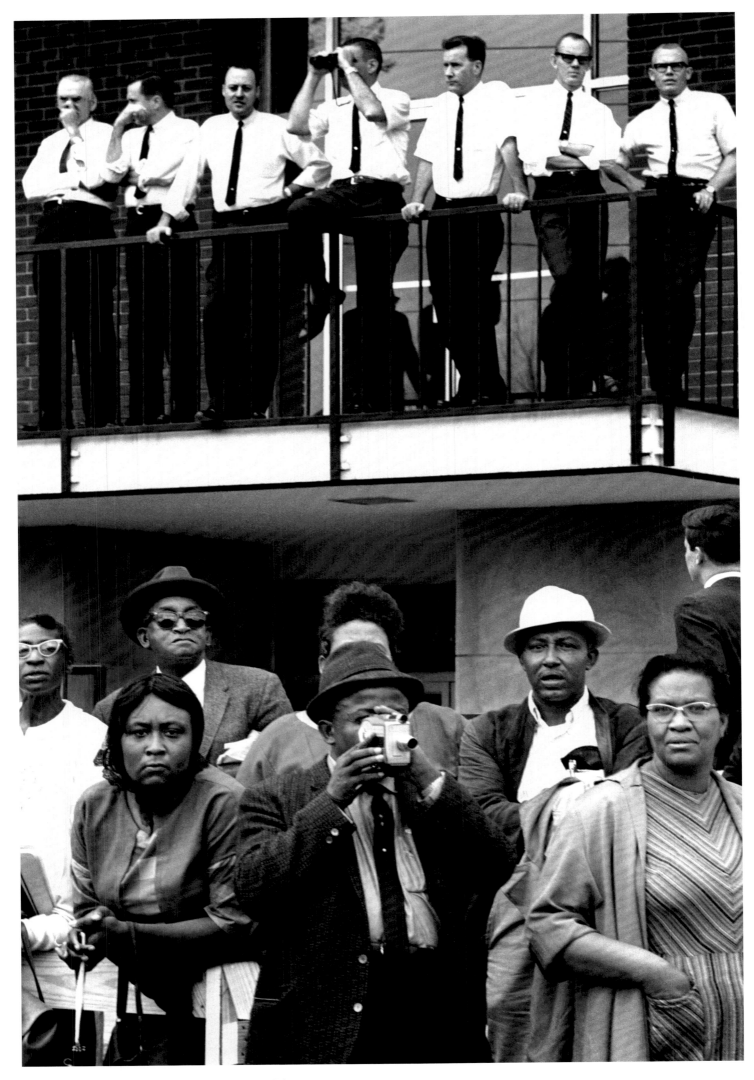

Watching the Selma March, Montgomery, Alabama, 1965

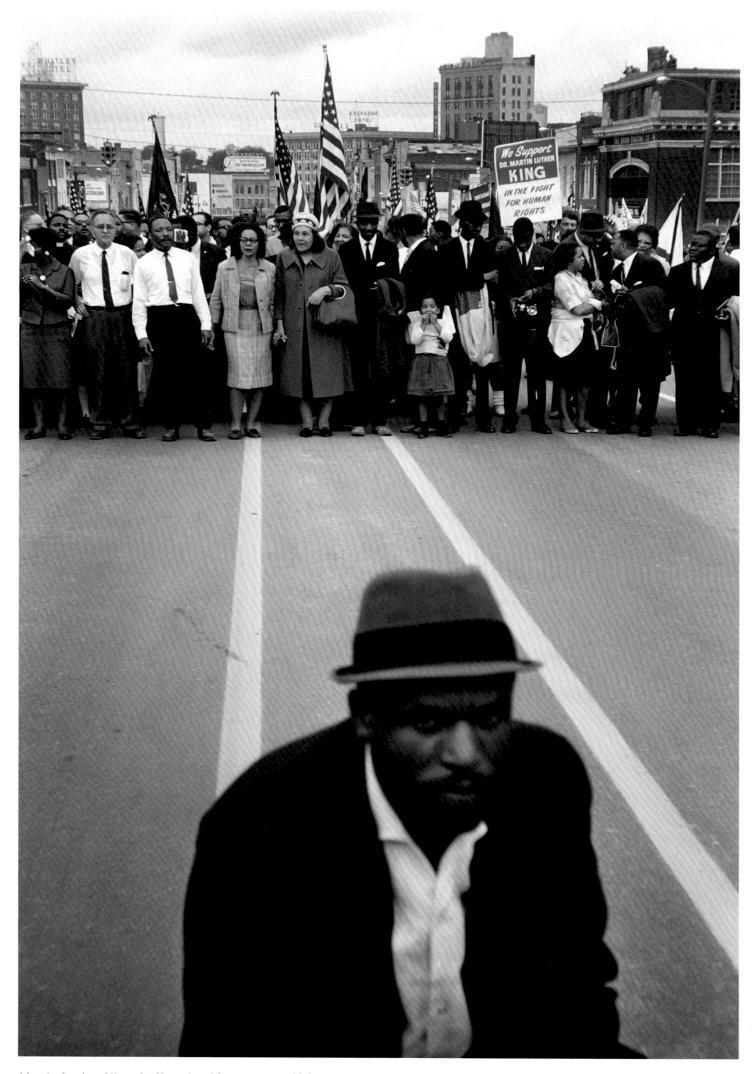

Martin Luther King, Jr. Entering Montgomery, Alabama, 1965

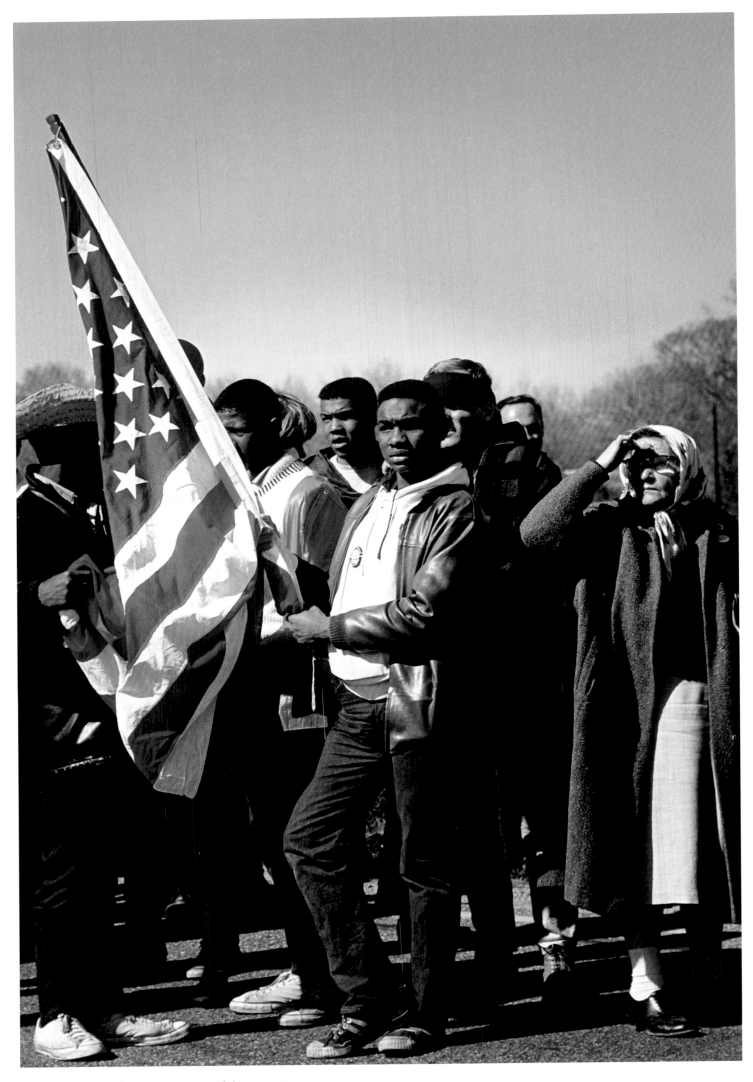

Flag, Selma March, Montgomery, Alabama, 1965

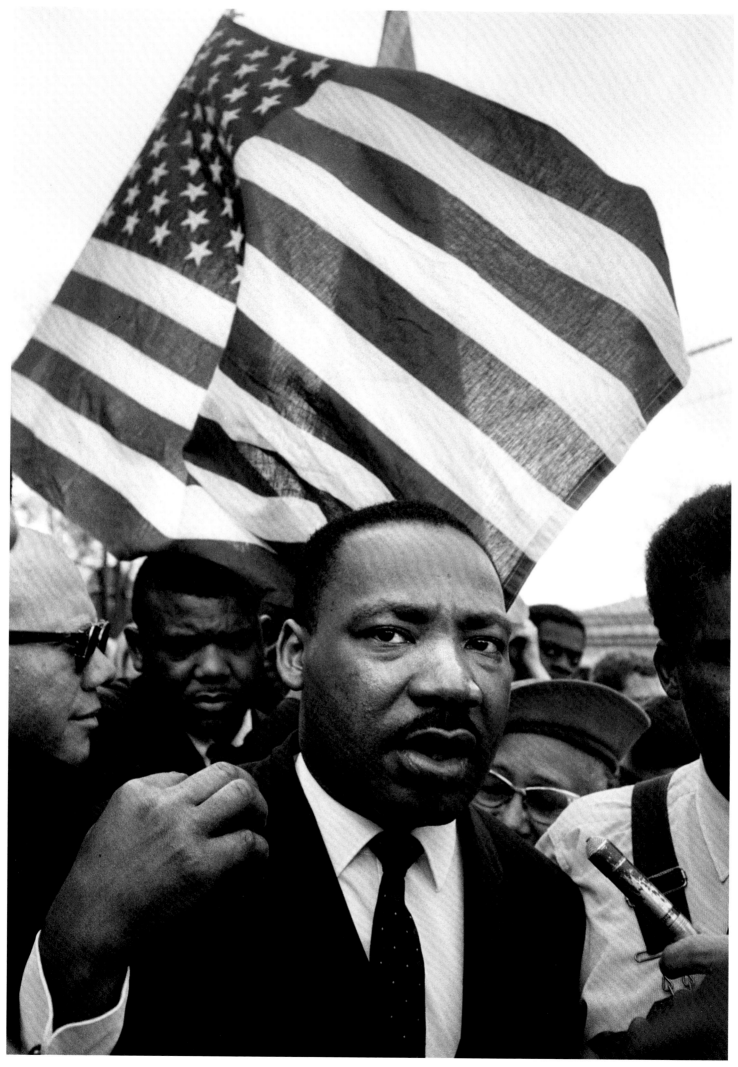

Martin Luther King, Jr. and Flag, Selma March, Montgomery, Alabama, 1965

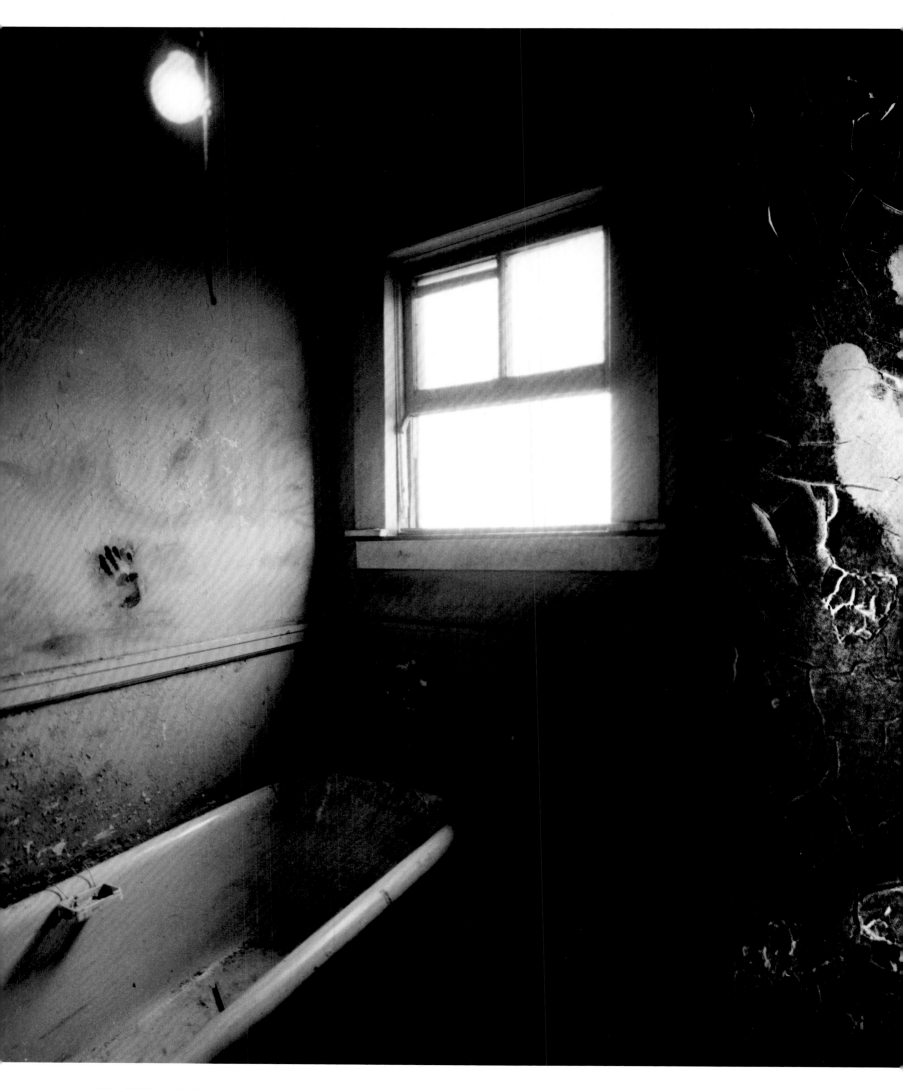

The Killing of Martin Luther King, Jr. Triptych, Memphis, Tennessee, 1968

It was 7 PM on a Thursday night. I was in my loft on Lafayette Street going through recent contact sheets from the Bobby Kennedy campaign when I got the call from Life magazine.

Martin Luther King, Jr. had been shot.

I needed to get to Memphis immediately.

I arrived early the next morning, April 5th. I first went to the boarding house bathroom from where the shot had been fired. I noticed a dark, ominous hand print on the wall above the bathtub in which the assailant had stood, leveling his gun on the window sill. I was sure that it was the assassin's fingerprints. That hand print was published as a full-page image the following week in *Life* magazine.

I then went across to the Lorraine Motel where Martin Luther King, Jr. had been staying. I knocked on the door of Room 306. Hosea Williams, one of King's aides answered the door. Two other photographers were already there.

King's open briefcase, a wrinkled shirt, and Styrofoam coffee cups were scattered on the ledge below the television set. On the TV was a commentator talking about the assassination. A ghostly image of Martin Luther King, Jr. appeared on the television. I photographed it all.

It gave me an eerie feeling. The physical body of King was forever gone, leaving some small material remnants behind—that wrinkled shirt, a book with a cover photograph of the Selma March, a *Soul Force* magazine, and a can of Magic hairspray. Nonetheless, his spirit continued to linger, floating above us from that television set on the wall, from which Dr. King continued to speak.

The half-finished cup of coffee gave me a moment of pause. King had left this room planning to return. Although the other two photographers saw the same image, it did not seem to affect them as it did me. I was the only one who took that photo of the briefcase and television image.

Thirty-eight years after photographing the aftermath of that fateful event, I returned to Memphis for the first time. My initial experience had been emotional, almost traumatic. My return was anything but that. The boarding house rooms were gone. Walls had been torn down, and only the shell of the building remained. Videos about the murder, murals, and James Earl Ray's white car now decked the interior of the bare, bricked structure. The entire bathroom I had photographed had been scooped out and extended beyond the walls of the rooming house, and a thick sheet of plastic allowed you to peer in. I have no doubt that the bathtub was the same one I had seen before, but the uneven cracked wall with the hand print I had photographed was gone, replaced by smooth, green, unblemished plasterboard. A true part of history had vanished.

Dr. King's Lorraine Motel room had also been preserved for tourists who now flock to the National Civil Rights Museum. The wall on which the television set was mounted is gone. Visitors can easily peer into Dr. King's motel room, but no one will ever get to see that eerie image that is forever imbedded in my mind. The sad event has become a memorial spectacle of remembrance. The things that had been so emotional to me at the time—the handprint on the wall, the television set in Dr. King's room on which he appeared, and his open briefcase—are all gone.

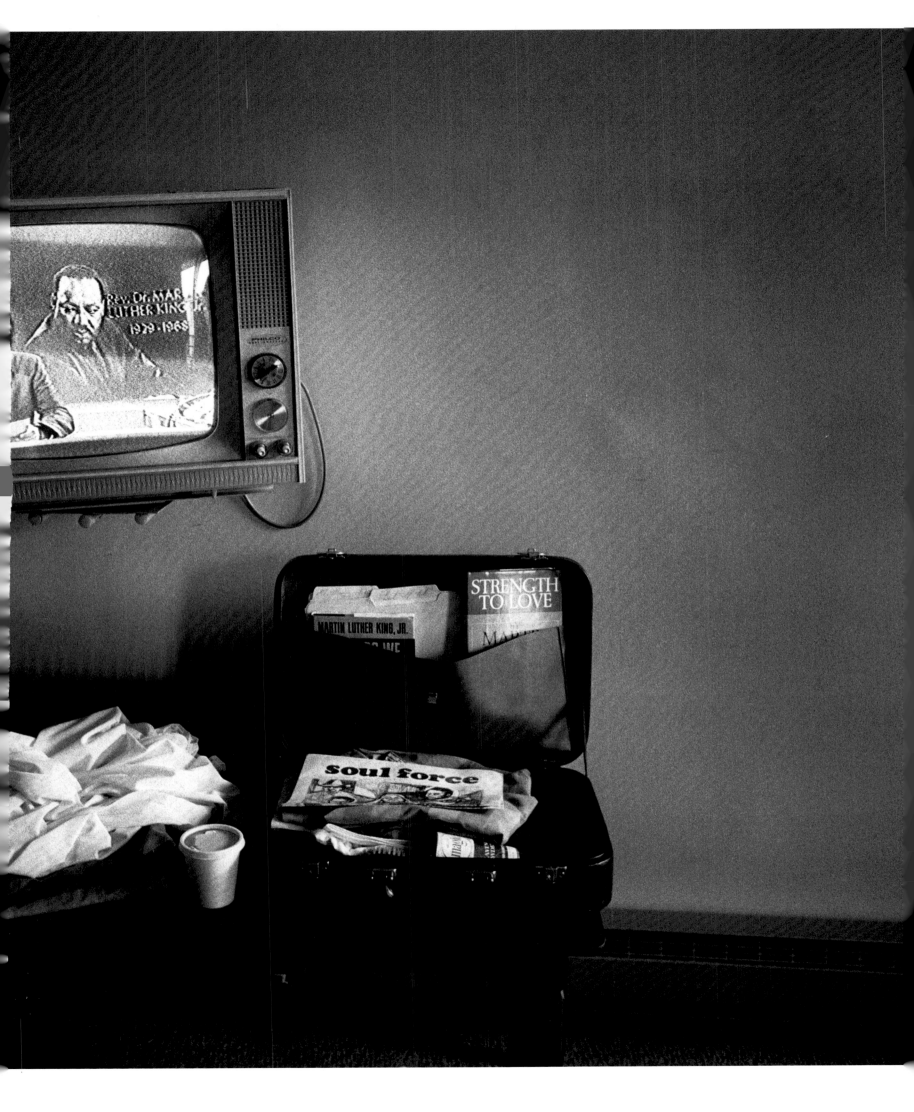

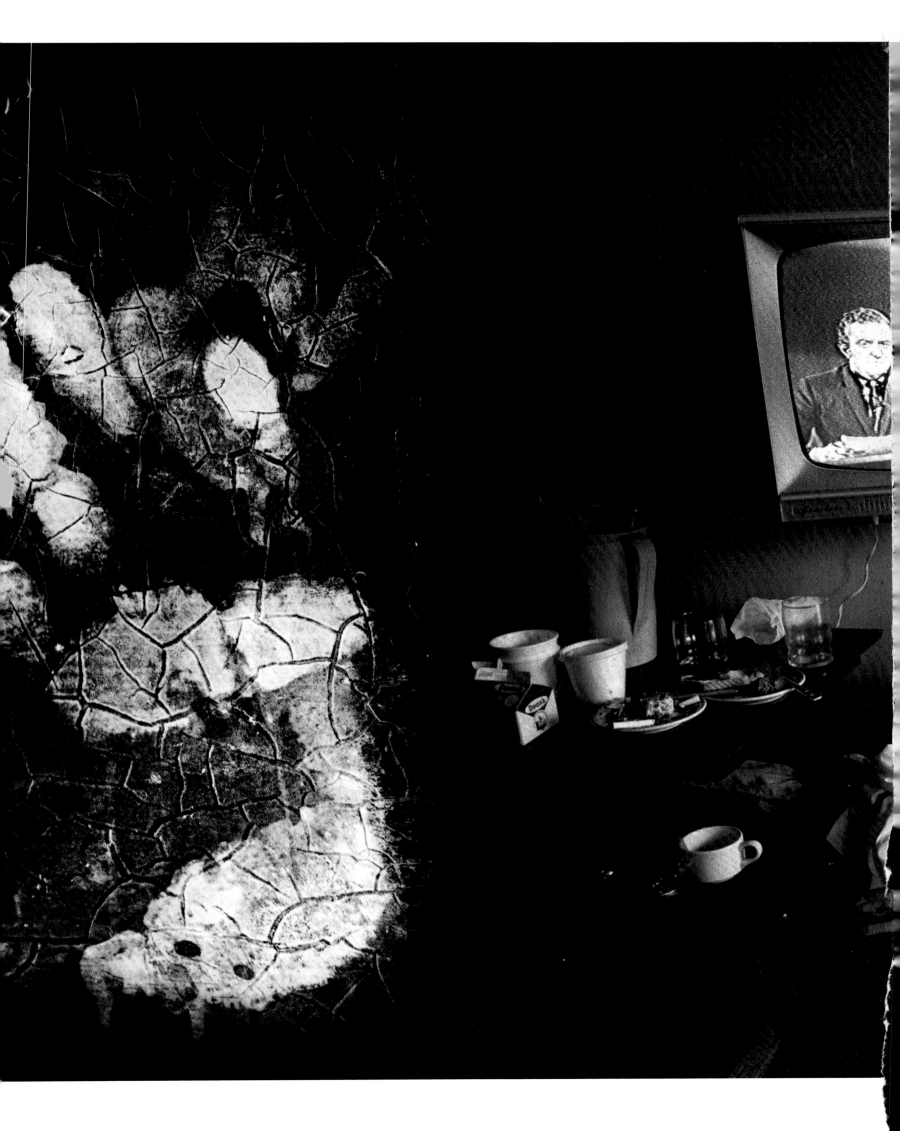

The Worst Is Yet to Come, New York, 1966

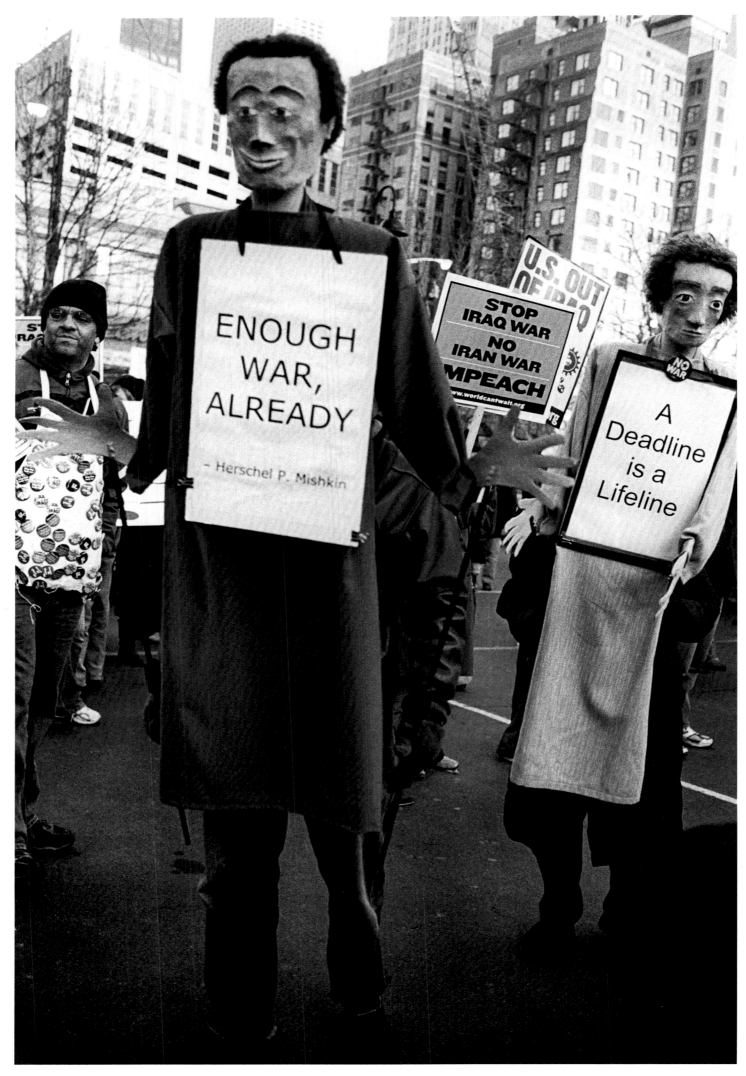

Enough War, Chicago, 2009

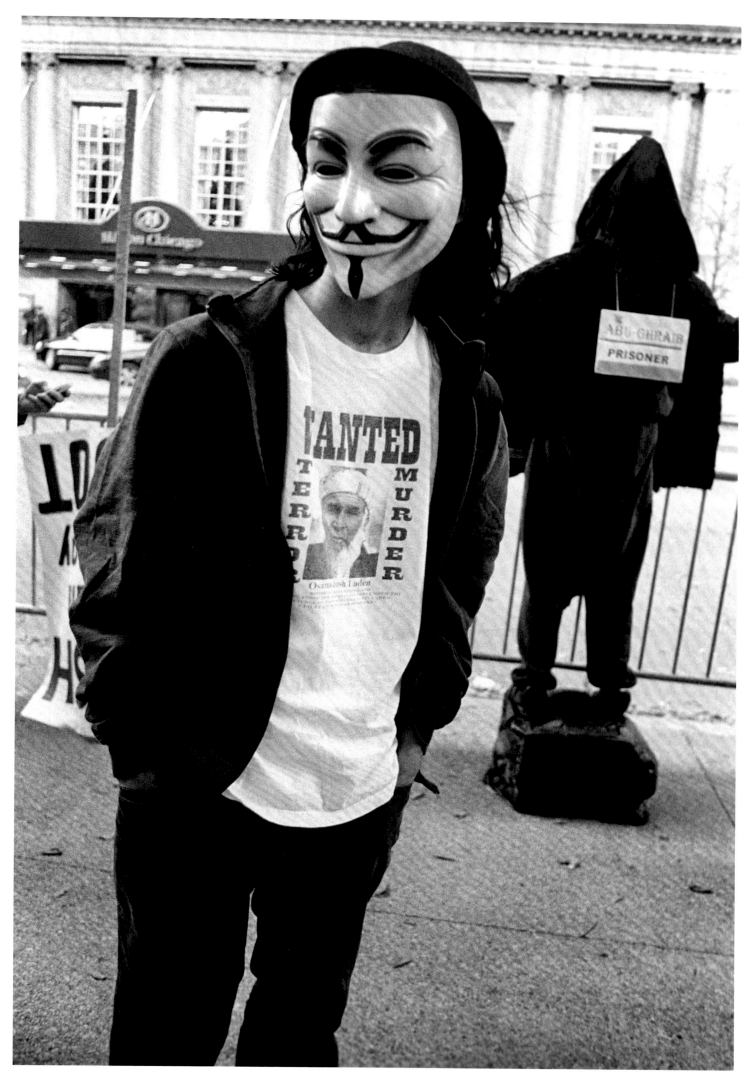

Abu Ghraib Protest, Chicago, 2008

Jerome Smith, Mississippi, 1963

Theophilus Meditating at Synphoria Temple, 2011

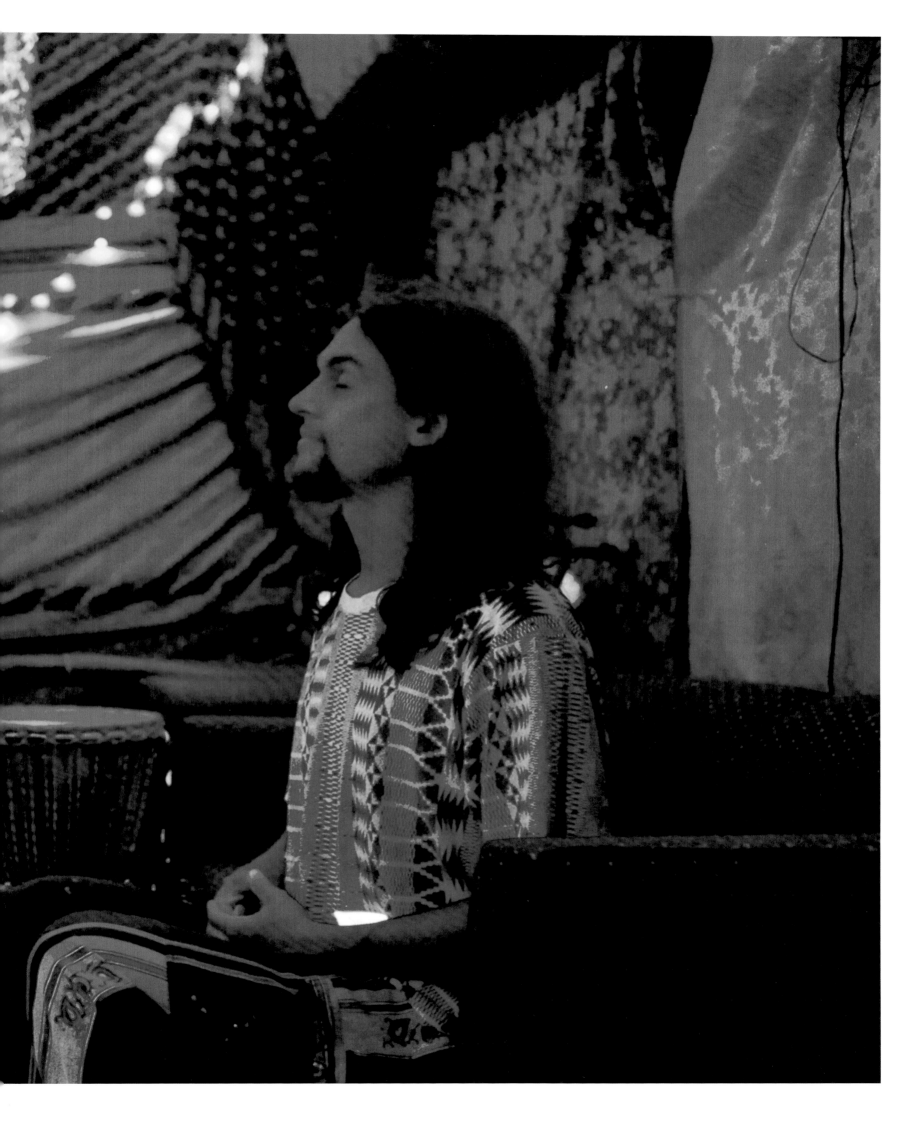

Matthias Harder

# CHARAKTERKÖPFE, IM FILM UND AUF DER STRASSE

Es existieren die unterschiedlichsten Ansätze und Methoden, sich seinen Mitmenschen mit der Kamera zu nähern; deshalb sollte sich jeder Fotograf im Laufe seiner Karriere eine Art Alleinstellungsmerkmal erarbeiten, das gilt für das Porträtfach ebenso wie für die anderen Genres. Steve Schapiro ist dies gelungen. Ihm verdanken wir eindrückliche Fotografien vom Set bedeutender Filme wie *Der Pate* oder *Taxi Driver*. Doch neben diesen Ikonen existiert ein ebenso interessantes wie facettenreiches Werk, das nichts mit Film zu tun hat.

Bereits in ganz jungen Jahren rezipierte Steve Schapiro begeistert Henri Cartier-Bressons sprichwörtlich gewordenen »entscheidenden Augenblick« in der Fotografie. Beim Versuch, es dem berühmten Kollegen gleichzutun, scheiterte er nach eigener Aussage zunächst – und kam auf Umwegen über die Literatur wieder zur fotografischen Visualisierung der Welt zurück. Nach einem Studium bei dem bedeutenden amerikanischen Magazinfotografen W. Eugene Smith arbeitet Schapiro seit 1961 bis heute journalistisch und dokumentarisch – und porträtiert eben nicht nur Schauspieler und Musiker. Seine Aufnahmen werden in renommierten Magazinen und auf zahlreichen Covern weltweit publiziert, darunter *Life*, *Look*, *Vanity Fair*, *Paris Match*, *People* oder *Rolling Stone* – und immer steht der Mensch im Mittelpunkt. Seit nunmehr einem halben Jahrhundert entstehen unzählige Aufnahmen, gleichberechtigt in Schwarz-Weiß und Farbe, von vielen berühmten Zeitgenossen, insbesondere amerikanischer Herkunft; aber auch unbekannte Mitmenschen interessieren Schapiro, wie wir hier sehen können. Sie werden im Freiluftatelier der Großstädte, auf dieser Bühne des Alltags, durch seine Aufnahmen zu Typen stilisiert. Und manche dieser Porträts verwandeln sich in Genreszenen, die wir auch der »Street Photography« zuordnen könnten. Es ist die Zeit der sogenannten humanistischen Fotografie; so überraschen auch die gesellschaftskritischen und politischen Themen nicht, denen sich Schapiro in den 1960er-Jahren im Auftrag der Magazine mit seiner Kamera engagiert zuwendet, etwa die schwierigen Arbeits- und Lebensbedingungen von Wanderarbeitern in Arkansas, die Situation nach dem Attentat auf Martin Luther King oder der Präsidentschaftswahlkampf von Robert F. Kennedy – all dies begegnet uns auch in dieser Monografie, die einer Revision des Werks gleichkommt. So gehört Steve Schapiro zu den großen Geschichtenerzählern Amerikas, auch wenn diese Geschichte in statische, zweidimensionale Bilder komprimiert ist.

Der New Yorker Fotograf scheint auf die Aufnahmesituationen spontaner zu reagieren als mancher Kollege – oder sie gelegentlich gar selbst zu erschaffen. Er verfügt über ein immenses Kommunikationstalent und Einfühlungsvermögen, ansonsten wären so unterschiedliche Ausdrucksmodi schlicht unmöglich. Steve Schapiro scheint gleichzeitig auf und hinter die Fassade des Menschlichen zu schauen und mit jenem Antagonismus subtil zu spielen. So wird er zu einem genauen Beobachter von natürlichem Selbstbewusstsein, von aufgesetzten Posen oder schüchternen Blicken: Schapiro dokumentiert nicht allein das Aussehen der berühmten oder namenlosen Zeitgenossen, sondern fängt ihre Ausstrahlung ein, darunter befinden sich eine Menge Charakterköpfe. Freilich bleibt all dies subjektiv.

Seit Anfang der 1970er-Jahre interessiert er sich für das Medium Film und seine Protagonisten – seitdem werden Schapiros Schauspielerporträts für die Bewerbung von Filmen oder als Postermotiv

verwendet, und manches Musikerporträt landet auf einem Plattencover. So führt er innerhalb der »Celebrity Photography« die Bildsprache eines Alfred Eisenstaedt oder Edward Quinn weiter, und gleichzeitig treten die ersten Paparazzi auf den Plan, die sich mit aufdringlichen Tricks Zugang zur Welt der Schauspieler und Musiker, der Schönen und Reichen verschaffen – und ihre »geraubten« Schnappschüsse, darunter etwa Ron Galellas berühmte Jackie-O.-Aufnahmen, meistbietend an mitunter die gleichen Magazine verkaufen, für die Schapiro arbeitet. Doch bis zu David LaChapelles grellbunten, mit dem Stilmittel der Übertreibung inszenierten Aufnahmen der amerikanischen Gesellschaft und ihres Starkults ist es ein gewaltiger Schritt.

Steve Schapiro hingegen interessiert sich eher für gradlinige Bildkompositionen ohne barocke oder dramatisierende Überladung. Unter seinen Arbeiten sind überraschend wenig klassische Studioaufnahmen, die Mehrzahl seiner Fotos entsteht vielmehr im öffentlichen Raum, am Filmset oder im privaten Umfeld. Inszenierte stehen gleichberechtigt neben spontan entstandenen Bildern, und trotz mancher Aktion oder Reaktion der Porträtierten wirken Schapiros Fotografien bedächtig und ruhig. Sie verbinden Distanz und Nähe, Konzentration und Unmittelbarkeit: Mal ist es ein offener und erwartungsvoller Blick, etwa bei Orson Welles und Marlon Brando, bei Frank Zappa oder auf der Straße spielenden Kindern, in anderen Aufnahmen besticht eine gewisse Kontemplation, etwa bei David Bowie und Aretha Franklin, bei Paul Newman oder Steve McQueen. Gleichwohl können wir nie sicher sein, ob die dargestellte Konzentration dieser Medienprofis nicht doch nur Pose ist. Die Verinnerlichung in der Aufnahme eines unbekannten schwarzen Manns beim Kirchgang hingegen ist real; manchmal ist Schapiro, wie wir hier sehen, auch ein heimlicher Beobachter. Sein Porträt von Martin Scorsese wiederum überrascht hinsichtlich der Bildkomposition: Der Regisseur blickt gebannt auf die Mündung einer schwarzen Pistole in seiner rechten Hand, während er links einige Weintrauben hält, so als ob er beide Accessoires ausbalancieren wolle. Scorsese wird gleichsam zum Schauspieler vor Schapiros Fotoapparat. Dieser Rollenwechsel ist nicht selten in Schapiros fotografischem Werk. Agieren und Reagieren fallen hier im Moment der Aufnahme in eins.

Auf seinen Straßenbildern begegnen uns manche Menschen verkleidet und vermummt, im Batman-Kostüm, mit Hasenkopf oder Anonymous-Maske; sie geben ihre Persönlichkeit für einen Moment auf und schlüpfen in Rollen, auch wenn sie keine professionellen Schauspieler sind. Barbra Streisand hingegen wird hier gleich mehrfach charakterisiert. In diesem Buch finden sich unter anderem ein repräsentatives Profilporträt vor dunklem Hintergrund sowie die intime Momentaufnahme ihrer Begegnung mit ihrem Baby, eine anrührende, menschliche Geste. Viele Akteure scheinen Schapiros Kamera zu vergessen und gleichzeitig die Gegenwart seiner Person zu schätzen. Und so ist der Fotograf fester Bestandteil von Kunst-Jetset und Showbusiness geworden, dabei arbeitet er lieber hinter den Kulissen und nicht am roten Teppich.

In den Porträtsitzungen, ob sie nun in den 1970er-Jahren oder heute stattfinden, herrscht vermutlich ein intellektuelles und kommunikatives Spiel zweier Gleichberechtigter, ein Geben und Nehmen, ein Zeigen und Verbergen. Der Fotograf lässt seinen Protagonisten genug Raum für eine Selbstinszenierung, obwohl viele Inszenierungsideen auch von ihm stammen. Überzeugende Porträtfotografie versucht stets, den Darstellungstrieb des Gegenübers hervorzulocken und zu lenken. René Magritte etwa taucht in beiden in diesem Buch gezeigten Bildnissen als Realfigur vor und in Interaktion mit seinen illusionistischen Gemälden auf, die sich unmittelbar hinter ihm befinden. Woody Allen führt vermeintlich eine Ameise an einer Hundeleine spazieren, so verrät uns zumindest die Bildunterschrift, während Dustin Hoffmann auf einem anderen Bild durch einen langen Flur springt, Schapiros Kamera dabei fest im Blick. Weiterhin begegnen wir Muhammad Ali, wie er ein Paar winzige Boxhandschuhe zusammenknotet, oder Jack Nicholson, der dem Fotografen (und somit auch dem Bildbetrachter) während der Dreharbeiten von *Chinatown* grinsend die Zunge

herausstreckt. Dies ist eine bestechende Charakterisierung des Schauspielers und seiner Rolle, und durch eine derartige Interaktion wird das Gegenüber zum Komplizen des Fotografen. Gleichwohl sind es ungewöhnliche und überraschende Momente, welche die Bildnisse auch zu visuellen Kommentaren über die Dargestellten werden lassen. Schapiros geradezu essenzielle Porträts können auch als Interpretationsangebot an uns Rezipienten verstanden werden, und so meinen wir in manchen Aufnahmen dem Wesen der Porträtierten näherzukommen – was selbstverständlich reine Illusion ist.

In Berlin entdeckte Steve Schapiro an einer Hauswand jüngst ein überlebensgroßes Graffitiporträt von Marlon Brando in der Rolle des Don Corleone. So werden Francis Ford Coppolas Filmgestalt und Steve Schapiros ikonische Visualisierung durch einen unbekannten Street Artist mithilfe eines medialen Sprungs in die heutige Zeit transformiert. Jeder Fotograf ist Kind seiner Zeit, seiner Generation. Nur sehr wenige vermögen zwischen den Dekaden und Stilen zu springen und zeitlos-zeitgenössisch zu bleiben. Schapiro scheint dies zu gelingen. Mit Humor und Neugierde nähert er sich noch immer so angst- wie rastlos den Stars und Sternchen, vor und hinter den Kulissen, sowie ihrem Publikum, seinen Mitmenschen, bis hin zu den weltweit aktiven Demonstranten der Occupy-Bewegung. Schapiro entwickelte früh einen individuellen, essayistischen Stil in seiner Fotografie, mit der er an das Werk von W. Eugene Smith und Henri Cartier-Bresson anknüpft und en passant den jeweiligen Zeitgeist widerspiegelt. Nicht nur seine berühmten Einzelaufnahmen und Werkgruppen aus der Beschäftigung mit dem Hollywoodfilm sichern ihm einen festen Platz in der Fotogeschichte des 20. und 21. Jahrhunderts, sondern auch die Varianz seiner Themen und ihre souveräne Beherrschung über einen so langen Zeitraum.

»Ich habe alles fotografiert, vom Präsidenten bis zum Pudel«

# MATTHIAS HARDER IM GESPRÄCH MIT STEVE SCHAPIRO

**Matthias Harder:** Wie kamen Sie zur Fotografie und zu Ihrem Lieblingsthema, dem Porträt?

**Steve Schapiro:** Ich habe mit zehn Jahren im Ferienlager zu fotografieren begonnen. Ich erinnere mich noch an diese kleinen Abzüge mit Büttenrand, die sich auf wundersame Weise zu Bildern von Wolken, Himmel und Seen entwickelten, wenn sie aus dem Chemiebad in unserer provisorischen Dunkelkammer kamen. Aber dann fing ich an, mich mehr für Menschen als für Landschaften zu interessieren, obwohl ich zunächst zu schüchtern war, um einfach auf der Straße zu fotografieren. Als Henri Cartier-Bressons Buchs *The Decisive Moment* erschien, war ich gerade mal ein Teenager und fasziniert davon, wie er es schaffte, Aufnahmen in genau den Momenten zu machen, in denen Emotion und Form am stärksten ausgeprägt waren. Ich ging hinaus auf die Straßen von New York und versuchte, seine Arbeiten nachzumachen, aber mein Timing stimmte oft um Sekunden nicht, sodass ich mit Kontaktabzügen zurückkam, mit denen man nichts anfangen konnte. Eine Zeitlang hörte ich mit dem Fotografieren auf und wollte Schriftsteller werden. Die komplexe Welt der Menschen hat mich immer fasziniert. Nach dem College ging ich für sechs Monate nach Paris und Spanien und schrieb ein Buch mit, wenn auch sonst nichts, immerhin vier tollen Seiten. Ich merkte,

dass ich mir beim Schreiben nie sicher war, ob ich ein Bild mit Worten wiedergeben konnte. Bei der Fotografie hingegen weiß man sofort, was man darstellt. Die faszinierendste Arbeit, die man sich als junger Fotograf vorstellen konnte, war als Fotojournalist für das *Life*-Magazin zu arbeiten. Ich zog auf eigene Faust los, um Beiträge über Wanderarbeiter in Arkansas, Drogenabhängigkeit in East Harlem und ähnliche Geschichten zu erarbeiten, die ich dem Bildredakteur von *Life* vorschlug. Und irgendwann bekam ich dann meine Chance. Ich erhielt den Auftrag für eine Geschichte, aus der etwas wurde, und seitdem arbeitete ich regelmäßig für *Life* und andere Magazine. Ich habe für die meisten Zeitschriften der Welt vom *Rolling Stone* bis hin zu *Time*, *Life*, *Sports Illustrated*, *Vanity Fair*, *Stern* und *Paris Match* sowie die erste Ausgabe von *People* Coverfotos gemacht.

**M.H.:** So ist über die Jahre ein sehr eindrucksvolles Werk entstanden. Stört es Sie, wenn Leute Sie in erster Linie für einen Standfotografen beim Film halten?

**S.S.:** Ja, es stört mich, wenn die Leute mich hauptsächlich als einen Filmfotografen sehen. Da meine Fotos der Filme *Der Pate* und *Taxi Driver* in den letzten Jahren viel Aufmerksamkeit bekommen haben, hat man mich als Fotografen wahrgenommen, der am Filmset arbeitet. Die Dokumentarprojekte, die den Löwenanteil meiner Arbeit ausmachen, und die Geschichten, an denen ich aktuell arbeite, haben mit dem Film nichts zu tun. Und hier liegt nach wie vor mein Hauptinteresse. Ich habe in den 1960er-Jahren, die man heute als goldenes Zeitalter des Fotojournalismus bezeichnet, ständig gearbeitet. Wenn man als Fotograf eine gute Idee hatte, dann konnte man sich eine Zeitschrift suchen, die einem dann den Auftrag dazu erteilte. Ich hatte immer Glück mit den Aufträgen, um die ich gebeten habe oder die ich zugeteilt bekam. Ich reise mit Bobby Kennedy und machte das Foto für seine Präsidentschaftskampagne. Ich fotografierte den Marsch von Selma mit Martin Luther King, Andy Warhol in der Factory und Muhammad Ali, als er noch Cassius Clay hieß. Ich habe alles fotografiert, vom Präsidenten bis zum Pudel. Und als Martin Luther King erschossen wurde, schickte mich *Life* sofort nach Memphis, um über dieses traurige Ereignis, das die Geschichte veränderte, zu berichten. Diese Arbeiten und meine aktuellen Projekte sind mir wichtiger als die Arbeit, die ich für Filme gemacht habe, auch wenn ich das Glück hatte, ikonische Momente für *Der Pate*, *Asphalt-Cowboy*, *Taxi Driver* und viele andere wichtige Filmprojekte einzufangen. Ich war nie ein regulärer Standfotograf, sondern eher ein »Spezialfotograf«, also einer, der Fotos für Werbung und Öffentlichkeitsarbeit macht und den man in einer heißen Phase der Filmproduktion holt. Man hofft dann, dass der Fotograf seine Bilder in Zeitschriften weltweit unterbringt. Für mich besteht eigentlich kein Unterschied, ob man Menschen in der realen Welt oder am Filmset fotografiert. Als Fotograf sucht man immer nach der gleichen Art Emotion, Form und Information, die zusammen ein Foto erfolgreich machen. Man sucht nach diesem ikonischen Moment, in dem sich das Besondere eines Menschen oder eines spezifischen Moments offenbart. Der einzige Unterschied am Filmset ist, dass man, wenn man das Drehbuch gelesen hat, eine Idee davon hat, was im nächsten Moment geschieht, während man das in der wirklichen Welt natürlich nie so genau weiß.

**M.H.:** Wo sehen Sie Ihre Aufnahmen am liebsten veröffentlicht oder gezeigt: in Tageszeitungen oder Zeitschriften? In Fotobüchern oder Ausstellungen? In Galerien oder Museen?

**S.S.:** Am liebsten sehe ich meine Arbeiten in Museen. Damit will ich nicht sagen, dass ich nicht auch Galerieausstellungen oder Bücher schätze, wo eine Reihe von Bildern vielleicht einen besseren Eindruck von einem Ereignis oder einer Person als eine einzelne Aufnahme vermitteln kann. Obwohl ich mich inzwischen seit fünfzig Jahren mit der Fotografie beschäftige, habe ich nicht das Gefühl, ganz erwachsen zu sein. Ich glaube immer noch, dass meine Zukunft vor mir liegt. Ich möchte mein Handwerk weiter verbessern und habe viele Projekte und Ideen für die Zukunft. Die Art und Weise, wie wir miteinander kommunizieren, verändert sich ständig und schafft so laufend neue Möglichkeiten für Fotografen.

**M.H.:** Sie haben berühmte Schauspieler am Filmset und Künstler im Studio sowie anonyme Menschen auf der Straße fotografiert. Welcher Zugang zum Menschen fällt Ihnen leichter?

**S.S.:** Die Haltung des Fotografen bestimmt sowohl das Fotografieren von Menschen auf der Straße als auch das von Schauspielern am Set. Wenn man entspannt und unaufdringlich ist, mögen einen die Leute. Die meisten Menschen werden gerne fotografiert, solange sie nicht den Eindruck haben, dass man sich über sie lustig macht oder irgendeine böse Absicht hegt. Natürlich hilft es beim Fotografieren auf der Straße, wenn man schnell und unauffällig ist, weil dann nur die Kamera als Eindringling wahrgenommen wird und nicht man selbst. Schauspieler tun sich oft schwer mit Standbildern. Am Filmset oder auf der Bühne kennen sie ihre Rolle in- und auswendig, aber wenn sie sich selbst darstellen müssen, kann das Gegenüber der Kamera eine Qual für sie sein. Oft sind sie sich nicht sicher, wer sie sein sollen. Sie hören das Klicken der Kamera und werden nervös, weil sich nicht wissen, welches Image sie gerade ausstrahlen. Dann spielen sie keine Rolle mehr, und man selbst zu sein, ist komischerweise schwieriger. Wenn man mit besonders begabten Schauspielern arbeitet, entstehen oft – bewusst oder unbewusst – tolle Gemeinschaftsprojekte, weil sie die besseren Einfälle haben. Als ich mit Barbra Streisand zusammenarbeitete, kamen die Ideen, die wir für ihre Alben *Streisand Superman* und *Lazy Afternoon* umsetzten, von ihr. David Bowie liebte es, eine Vielzahl unterschiedlichster Charaktere zu erschaffen. Es gab nur ein Problem: Ich musste sehr schnell sein, ehe er wieder in die Garderobe zurück rannte, um sich erneut zu verwandeln.

**M.H.:** Fotografie »friert«, wenn man so will, den Moment ein; gute Porträts, auch wenn sie unbeweglich sind, fangen eine Geschichte ein. Möchten Sie mit Ihren Fotos Geschichten erzählen?

**S.S.:** Es macht natürlich mehr Spaß, wenn es einem gelingt, mit einer einzigen Fotografie eine Geschichte zu erzählen, aber das geht nicht immer. Wenn man eine Geschichte erzählen will, wird die Umgebung in der Regel wichtiger, weil man durch sie etwas über das Leben der Dargestellten erfährt. Als ich die Serie über die Wanderarbeiter in Arkansas machte und sie auf dem Feld und in ihren Hütten fotografierte, schlich sich die Umgebung in jedes Porträt hinein und zeigte ihr hartes Leben. W. Eugene Smith, bei dem ich studiert habe, mochte es, wenn eine Fotografie zwei interessante Aspekte hatte, sodass der Blick hin- und herwechseln musste und man mehr erfuhr. Meine Fotografie von James Baldwin, der ein verwaistes Kind im Arm hält, hätte ein in sich geschlossenes Bild der beiden sein können, aber meine Entscheidung, auch Teile der Hütte, die Fotografien und den Jesus-Wandteppich zeigen, trägt zum narrativen Charakter der Aufnahme bei.

**M.H.:** Sie lassen beim Fotografieren den Schauspielern und Künstlern viel Raum für eine Selbstinszenierung. Wer denkt sich die Posen aus? Haben Sie ein genaues Bild vor Augen oder reagieren Sie spontan auf die jeweilige Situation?

**S.S.:** Normalerweise habe ich vor einem Shooting keine genauen Vorstellungen, es sei denn, es gibt Requisiten, von denen ich weiß, welche Rolle sie spielen sollen. Manchmal recherchiere ich ein wenig, aber meistens weiß ich nicht genau, was mich erwartet, und ich bin offen für. Letztlich suche ich immer nach den besonderen Qualitäten einer Person, die ich meist nie zuvor getroffen habe. Natürlich habe ich bestimmte Vorstellungen, aber ich bin offen für das, was ich vielleicht sehen werde.

**M.H.:** Manche Leute halten jedes Porträt auch für eine Art Selbstporträt. Sehen Sie das auch so?

**S.S.:** Bei manchen Fotografen kann man durch ihren Stil sowohl etwas über sie selbst als auch über die abgebildeten Menschen erfahren. Ein Porträt von Irving Penn, auch wenn es natürlich etwas über den Dargestellten aussagt, lässt sich immer als Irving-Penn-Porträt identifizieren. Ein Porträt von Bill Brandt ist aufgrund der Behandlung von Licht und der starken Kontraste in den Abzügen zu allererst einmal ein Bill-Brandt-Porträt. Da ich nicht oft im Studio arbeite, verändert sich die Ausleuchtung meiner Bilder vom einen zum anderen Mal; auch gibt es bei mir keine bestimmten Posen, die sich immer wiederholen. Ich bemühe mich um eine entspannte Atmosphäre und darum,

meine Person (außer vielleicht einem Lächeln) soweit wie möglich rauszuhalten. Ich warte, bis die von mir Porträtierten sie selbst sind, und dann stürze ich mich leise auf sie. Aber jedes Porträt ist in gewisser Weise auch ein Selbstporträt, weil der Fotograf entscheidet, wann er den Auslöser drückt. Ein Foto mag Tausende Worte sagen, aber sicherlich nicht die »Wahrheit«. Die einzigartige Perspektive des Fotografen entscheidet, wann der Auslöser gedrückt wird. Ich kann Menschen glücklich oder traurig zeigen, würdevoll oder betrügerisch. Wenn diese Fotografie dann in einer Zeitschrift erscheint, wird sie für Millionen von Menschen zur Grundlage für ihre Meinungsbildung über die Dargestellten.

**M.H.:** Und wie hat sich Ihrer Meinung und Erfahrung nach die Porträtfotografie im Laufe der Jahre und Jahrzehnte verändert?

**S.S.:** Ich habe in den 1960er-Jahren angefangen, als Fotograf zu arbeiten. Das war, wie ich schon sagte, die große Zeit des Fotojournalismus. Wenn man für eine Zeitschrift wie *Life* fotografierte, verbrachte man zuweilen vier bis sechs Monate mit einer Person. Dabei kam man sich dann recht nah. Wenn die Geschichte zu Ende war, sah man einander vielleicht nie wieder, aber zwischendurch kam es einem so vor, als wäre man eng befreundet. Ich machte das erste Cover für die Zeitschrift *People*, die am Anfang dessen steht, was ich Medienjournalismus nenne. Ab der Mitte der 1970er-Jahre gab es PR-Leute, die von da an den Umgang mit ihren Kunden und deren Karriere dominierten. Die persönliche, vertraute Beziehung zwischen Fotograf und Modell war in Gefahr, weil immer eine dritte Person anwesend war, die Stimmung und Verlauf des Shootings beeinflusste. Der Medienjournalismus veränderte die lockere Beziehung miteinander. Früher konnte man im Laufe der Zeit einen gewissen Rhythmus in die Bilder bringen und neue Facetten an den Personen entdecken, jetzt bekam man ein Zeitfenster von zwei Stunden, in denen die Modelle sich alle fünfzehn Minuten umziehen mussten, damit, wenn die Geschichte veröffentlicht wurde, der Eindruck entstand, dass man ihnen tagelang gefolgt war. Für die Fotografie im Allgemeinen ist die Kamera heutzutage nahezu überflüssig. Im Jahr 1963 gab es immer noch Zeitungsfotografen, die mit einer großformatigen 4-x-5-Zoll-Kamera mit Blitzbirnen, die man nach jedem Auslösen erneuern musste, arbeiteten. 35-mm-Film-Kameras waren schon modern und wurden überall verwendet. Heute hat der digitale Speicher den Film ersetzt. Jeder hält sein Smartphone hoch, wenn er eine Berühmtheit oder einen Politiker sieht. Die Smartphones werden immer besser, sodass man immer größere Abzüge machen lassen kann. Die Kommunikation verändert sich und wird sich weiter verändern. Das Geheimnis von guter Fotografie liegt nicht in der Ausrüstung, sondern in der Fantasie und den besonderen Eigenschaften des jeweiligen Fotografen. Jeder sieht auf seine Weise, und je einzigartiger die Sichtweise ist, desto besser sind die Fotografien.

**M.H.:** Hat eigentlich je einer der Prominenten darauf bestanden, dass ein bestimmtes Porträt nicht veröffentlicht wird, obwohl er anfänglich dem Fotoshooting zugestimmt hatte? Gab es in den 1970er-Jahren überhaupt solche Freigaben?

**S.S.:** Ich hatte Anthony Hopkins zuerst mit blutverschmiertem Gesicht und zwei abgetrennten Köpfen in den Händen fotografiert, als er an Francis Ford Coppolas *Dracula*-Film arbeitete. Mitten im Shooting wurde Anthony klar, dass sein letzter Film *Das Schweigen der Lämmer* gewesen war, und er bat mich, das Foto nicht zu veröffentlichen, weil es der Rolle zu ähnlich war. Ein anders Mal fotografierte ich die Komikerin Carol Burnett und ihre Tochter für ein Zeitschriftencover. Ich hatte schon ein paar Mal mit Carol zusammengearbeitet, aber dieses Mal konnte ich sie, so sehr ich auch versuchte, kaum zum Lächeln bringen. Was weder sie noch die Zeitschrift mir erzählt hatte, war, dass ihre Tochter gerade aus einer Suchtklinik entlassen worden war.

**M.H.:** Das lässt sich natürlich gut nachvollziehen. Ist es nicht schwierig, nach so vielen Jahren künstlerischen Schaffens immer noch neugierig auf das nächste Treffen mit einem Schauspieler oder einem anderen Prominenten, den Sie noch nicht getroffen haben, zu sein?

**S.S.:** Schauspieler zu fotografieren ist nur ein kleiner Teil meiner Arbeit. Wegen dem Erfolg von *Der Pate* und *Taxi Driver* bin ich immer wieder in eine bestimmte Schublade gesteckt worden. Tatsächlich waren aber in meinem ersten Buch, *American Edge*, überhaupt keine Filmstars vertreten. Und auch wenn es in *Schapiro's Heroes* eine Reihe von Bildern von Barbra Streisand und eines von Buster Keaton gab, war der Rest des Buchs mit Fotografien von Muhammad Ali, Martin Luther King, Samuel Beckett und Robert F. Kennedy ernsthafter gehalten. Aber um Ihre Frage zu beantworten: Wenn man nicht mehr neugierig ist und sich nicht mehr dafür interessiert, wen man fotografiert, warum sollte man überhaupt fotografieren?

**M.H.:** Verlassen Sie das Haus wie mancher Kollege nur mit einer Kamera, etwa im Hinblick auf eine besondere Situation auf der Straße, die Ihnen gleich widerfahren könnte? Oder verwenden Sie inzwischen auch schon ein Smartphone, um ein Foto zu machen?

**S.S.:** Wenn ich das Haus in der Hoffnung auf eine interessante Situation verlasse, dann verwende ich eine Kamera als meinen visionären Vermittler. Obwohl das Smartphone früher oder später die Kamera ersetzten wird, benutze ich es dafür noch nicht.

**M.H.:** Gibt es ein Foto, das Sie im Laufe der Jahre aufgenommen haben und das für Sie einen besonderen Stellenwert hat? Oder sind Ihnen alle Fotos, die Sie als solche in der Vergangenheit als bildwürdig akzeptiert haben, gleich wichtig?

**S.S.:** Ich glaube nicht, dass ich mein wichtigstes Foto schon gemacht habe. Mir gefallen viele meiner Aufnahmen: die Porträts von Samuel Beckett und René Magritte, die Warhol-Entourage, das Motelzimmer von Martin Luther King, die Bilder vom Marsch von Selma und viele andere. Aber ich konzentriere mich immer auf die Zukunft.

Wie Jackie Kennedy, Jim Morrison und William Burroughs liebte auch ich es, am angesagtesten Ort der 1960er-Jahre zu sein: in Andy Warhols Factory. Meine Karriere war gerade erst ins Rollen gekommen, und dann hatte ich – neunundzwanzig Jahre alt und ohne nennenswerte Lebenserfahrung – auf einmal die Möglichkeit, das zu machen, wovon alle jungen Fotografen träumten: für die Zeitschrift *Life* zu fotografieren. Mitte der 1960er-Jahre, als nur wenige Leute Andys Siebdrucke für Kunst hielten, machte ich die ersten Aufnahmen von ihm. Zu Beginn seiner Karriere fertigte Andy Warhol für Kaufhäuser Zeichnungen von Schuhen an, am Ende war er mit seinen Siebdruckgemälden, seinen Filmen und seinen Texten zum einflussreichsten Künstler des 20. Jahrhunderts geworden. Obwohl er unglaublich schüchtern war, verstand er es im Laufe der Zeit, eine charismatische Persönlichkeit zu entwickeln, die von der ganzen Welt hofiert wurde. Heute sind sein Einfluss und seine Anziehungskraft noch größer als zu seinen Lebzeiten.

Andy Warhol erweckte den Eindruck, introvertiert, naiv und unschuldig zu sein, aber mit seinem stillen Charisma zog er Leute in den Bann seiner sich auf der Höhe der Zeit befindlichen Welt. Wir alle kennen Geschichten über seine auf die Fragen der Journalisten mit leiser Stimme gegebenen Antworten: »Hm, ich weiß nicht. Können Sie das nicht einfach für mich beantworten?« Und dann schickte er Andy-Doppelgänger los, die überall in Amerika Vorträge hielten. Mit regungslosem Gesicht und dem Finger am Mundwinkel beobachtete er, nahm alles wahr und kommentierte wenig. Er liebte Klatsch und Tratsch und notierte alles, was er hörte, in ein Tagebuch.

Mitte der 1960er-Jahre betrat ich einmal das Bad in der Galerie von Leo Castelli, der Andy vertrat. Über der Toilette war ein langes Regal voller identischer Siebdruckgemälde von Jackie Kennedy. Alle kosteten 350 Dollar und waren nicht verkauft. Andy produzierte Bilder wie Campbell Dosensuppen. Einmal nahm ich sechs seiner leuchtend bunten Selbstporträts auf Leinwand, die heute wahrscheinlich Millionen wert sind, mit nach Hause. Hätte ich sie einfach nur behalten!

All die Vertreter der New Yorker Kunstszene, die zeigen wollten, wie hip sie waren, luden Andy Warhol ständig zum Essen ein, als ob sie ganz eng mit ihm wären. (Für 35.000 Dollar fertigt Warhol einem ein eigenes Siebdruckporträt an.) Aber Andy unterhielt sich auf diesen Partys kaum mit ihnen, er blieb mit seinen Freunden zusammen und tuschelte mit diesen. Jeder Hipster und »Weltstar« der Popkultur wollte die Factory sehen, dieses legendäre, mit Aluminiumfolie ausgekleidete und mit silberner Farbe besprühte Loft, wo Andy seine ersten Gegenkultur-Filme drehte und wo es endlose Geschichte von Sex, Drogen und (nun ja) Sex und Drogen gab. Bob Dylan und Dennis Hopper tauchten dort auf, und einmal kamen Tennessee Williams, Judy Garland und Rudolf Nurejew zu einer Party.

In der Öffentlichkeit schien sich Andy Warhol hinter einer aufgesetzten, teilnahmslosen Maske zu verstecken. So konnte er alles beobachten, ohne dass man ihm eine Reaktion abverlangte. Auf Fotos zog er es vor, eine Pose einzunehmen, einen Finger an den Mundwinkel zu legen. Eine Aufnahme, die ich auf einer von Andys Party von ihm und Edie Sedgwick machte, hat mich als Fotografen überrascht: Sie zeigt Andy, der von Edies Schönheit und überschäumendem Temperament begeistert zu sein scheint. Für einen Moment war die Maske verschwunden und stattdessen erschien ein großes, menschliches Lachen.

Auf dem Triptychon der Warhol-Entourage sieht man links im Bild auch Henry Geldzahler, der Kurator für zeitgenössische Kunst am Metropolitan Museum of Art in New York war. Er war gewissermaßen das »Auge« der Pop-Art-Bewegung. Er war ein besonders enger Freund Andys und schlug ihm viele der Themen wie die Serie *Death and Desaster* und auch die Blumengemälde vor.

Andy entdeckte Edie Sedgwick und machte sie zur Hauptdarstellerin seiner Factory-Filme, wie zum Beispiel *Poor Little Rich Girl*. Für sechzehnjährige Mädchen aus den Vorstädten war Edie eine Fantasiegöttin, weil sie das unkonventionelle Leben, das ihnen die Eltern verboten, führte.

An Andys linker Seite sieht man den Dichter und treuen Andy-Warhol-Mitarbeiter Gerard Malanga, der wohl einen nennenswerten Anteil von Andys vielen Gemälden und Siebdrucken herstellte. Warhol prägte den Ausdruck, dass in der Zukunft jeder Mensch fünfzehn Minuten lang berühmt sein wird. Aber Andy hat deutlich mehr als diese fünfzehn Minuten gehabt. Sein Ruhm vergrößert sich von Jahr zu Jahr.

Seite 20/21

12. Februar 2012

Lieber Herr Schapiro,

ich heiße Lonnie Ali und bin die Frau von Muhammad Ali. Vor fast fünfzig Jahren (1963) kamen Sie nach Louisville, um Muhammad, der damals noch Cassius Clay hieß, in seinem Elternhaus im Verona Way zu fotografieren. An diesem Tag traf ich Cassius Clay zum ersten Mal. Es war Schicksal, dass Sie an diesem Tag im Mai zum Fotografieren da waren, denn Sie haben den Moment unseres Kennenlernens eingefangen. Ich war das einzige kleine Mädchen in einer Gruppe von Nachbarjungen. Wie waren gerade erst in diese Gegend gezogen. Wenig später schickten Sie meiner Familie einige Abzüge der Fotos, die Sie an diesem Tag aufgenommen hatten und auf denen ich und meine Brüder zusammen mit Cassius zu sehen waren.

Ich wusste nicht, wie Sie hießen oder wie ich es hätte herausfinden können. Es war ein glücklicher Zufall, dass ich letzte Woche zu meinem Friseur in Scottsdale ging und dort ein Buch im Regal sah, auf dessen Einband Muhammads Gesicht neben dem von Martin Luther King und Bobby Kennedy zu sehen war, *Schapiro's Heroes*. Ich hatte dieses Buch nie zuvor gesehen. Ich nahm es und öffnete es genau bei einer Fotografie, die mir so vertraut war – einem Bild von Muhammad vor seinem Elternhaus. Vor ihm stand mein kleiner Bruder, der voller Bewunderung zu ihm aufschaute.

Letzten Freitag ging ich mit Howard Bingham zur Beerdigung von Angelo Dundee und erzählte ihm, was ich herausgefunden hatte. Ich war sehr überrascht, als er mir erzählte, dass er Sie vor Kurzem in L.A. gesehen hatte. Ich wünschte, ich hätte schon lange gewusst, dass Howard Sie kennt. Ich hätte mich schon vor langer Zeit mit Ihnen in Verbindung gesetzt.

Ob Sie es glauben oder nicht: Ich habe immer noch Ihre Fotografie von dem Moment, in dem ich Muhammad zum ersten Mal traf. Sie hängt gerahmt in unserem Haus in Michigan. Ich möchte mich bei Ihnen dafür bedanken, dass Sie meiner Familie diese Fotos geschickt haben, weil ich glaube, dass es Schicksal war, Muhammad an dem Tag kennengelernt zu haben, an dem Sie da waren, um den Moment für immer in Schwarz-Weiß zu bannen.

Ich weiß nicht, ob diese Fotos ein Teil Ihrer Sammlung sind und zum Verkauf stehen, aber ich würde gerne alle Fotos kaufen, die Sie an diesem Tag aufgenommen haben. Wären Sie so nett, sich mit mir in Verbindung zu setzen? Ich würde mich Ihnen gerne ein zweites Mal vorstellen.

Mit sehr herzlichen Grüßen,
Lonnie Ali

Seite 60/61

Es war 19 Uhr an einem Donnerstagabend. Ich war in meinem Loft in der Lafayette Street und schaute mir die neuesten Kontaktabzüge der Kampagne von Bobby Kennedy an, als mich jemand vom *Life*-Magazin anrief.

Martin Luther King war erschossen worden.

Ich musste sofort nach Memphis fahren.

Ich kam am nächsten Tag, am 5. April, frühmorgens an. Zuerst ging ich in das Badezimmer der Pension, von dem aus der Schuss abgefeuert worden war. Mir fiel ein dunkler, unheilvoller Handabdruck an der Wand über der Badewanne auf, in der der Attentäter gestanden hatte, als er seine Waffe auf das Fenstersims gestützt hatte. Ich war mir sicher, dass es die Fingerabdrücke des Attentäters waren. Dieser Handabdruck wurde eine Woche später ganzseitig in *Life* abgedruckt.

Dann ging ich auf die andere Straßenseite zum Lorraine Motel, wo Martin Luther King gewohnt hatte. Ich klopfe an die Tür des Zimmers 306. Hosea Williams, einer von Kings Assistenten, öffnete die Tür. Zwei andere Fotografen waren bereits da.

Kings geöffnete Aktentasche, ein verknittertes Hemd und Kaffeebecher aus Styropor lagen auf dem Tisch unter dem Fernseher. Im Fernsehen lief ein Beitrag über das Attentat. Ein gespenstisches Bild von Martin Luther King erschien auf dem Bildschirm. Das alles fotografierte ich.

Mir wurde ganz mulmig. King würde hier nie wieder körperlich präsent sein, aber er hatte kleine materielle Spuren hinterlassen – das verknitterte Hemd, ein Buch mit einem Foto des Selma-Marsches auf dem Umschlag, eine Ausgabe der Zeitschrift *Soul Force* und eine Dose Magic-Haarspray. Gleichwohl war sein Geist noch präsent, schwebte über uns, von diesem Fernseher an der Wand aus, in dem King immer noch sprach.

Ein halb ausgetrunkener Kaffeebecher ließ mich einen Moment stutzen: King hatte beabsichtigt, in das Zimmer zurückzukommen. Obwohl die beiden anderen Fotografen das gleiche Bild sahen, hatte es auf sie scheinbar nicht die gleiche Wirkung wie auf mich. Ich war der einzige, der ein Foto von der Aktentasche und dem Fernsehbildschirm machte.

Erst achtunddreißig Jahre nachdem ich die Nachwehen dieses verhängnisvollen Ereignisses fotografiert hatte, kehrte ich nach Memphis zurück. Mein erstes Erlebnis dort war sehr emotional, fast schon traumatisch gewesen. Meine Rückkehr sah ganz anders aus. Die Pension gab es nicht mehr. Die Wände waren eingerissen worden und nur die Gebäudehülle stand noch. Videofilme über das Attentat, Wandgemälde und das weiße Auto von James Earl Ray schmückten nun das Innere der ansonsten kahlen Backsteinstruktur. Das Badezimmer, das ich fotografiert hatte, war komplett geöffnet und über die Wände der Pension hinaus vergrößert worden. Durch eine dicke Plastikplane konnte man hineinsehen. Ich zweifle nicht daran, dass die Badewanne dieselbe war, die ich damals gesehen hatte, aber die unebene Wand mit den Rissen und dem Handabdruck, den ich fotografiert hatte, war nicht mehr da. Stattdessen sah man eine grüne, makellose Gipskartonwand. Ein echtes Stück Geschichte war verschwunden.

Das Zimmer von Martin Luther King im Lorraine Motel wurde ebenfalls für Touristen erhalten, die nun in Massen zum National Civil Rights Museum strömen. Die Wand, an der früher der Fernseher befestigt war, gibt es nicht mehr. Besucher können sich ganz einfach das Motelzimmer von King anschauen, aber niemand wird je das schaurige Bild sehen, das sich für immer in mein Gedächtnis eingebrannt hat. Das traurige Ereignis ist zum Erinnerungsspektakel verkommen. Die Dinge, die mich damals so berührten – der Handabdruck, der Fernseher, auf dem er zu sehen war, und seine offene Brieftasche –, sind alle verschwunden.

Photo editing: Maura Smith

Copyediting: Sandra-Jo Huber, Julika Zimmermann, Hatje Cantz

Translations: Amy Klement, Sibylle Luig

Graphic design and production: Julia Günther, Hatje Cantz

Typeface: Janson

Reproductions: Jan Scheffler, prints professional

Printing: Offsetdruckerei Karl Grammlich GmbH, Pliezhausen

Paper: Galaxi Supermat, 170 g/m²

Binding: Lachenmaier GmbH, Reutlingen

Published by

Hatje Cantz Verlag

Zeppelinstrasse 32

73760 Ostfildern

Germany

Tel. +49 711 4405-200

Fax +49 711 4405-220

www.hatjecantz.com

Hatje Cantz books are available internationally at selected bookstores. For more information about our distribution partners, please visit our website at www.hatjecantz.com.

ISBN 978-3-7757-3426-4

Printed in Germany

Steve Schapiro thanks Margaret Hankel, Jr., Printlab, and Steffi Schulze, Camera Work.

Two separate Collector's Editions of Steve Schapiro's photographs are available for purchase. Please contact Hatje Cantz at collectorseditions@hatjecantz.de.

Halloween in Brooklyn Heights, 1960 (p. 67)
Handmade print, with signed book
Sheet size: ca. 38 x 28 cm
Limited edition of 18 + 4 a.p., signed and numbered

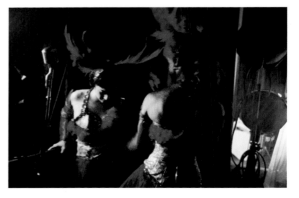

Dancers at The Apollo Theater, Harlem, 1961 (pp. 104–05)
Fine Art Premium Print on Hahnemühle Photo Rag 308 g, with UPON PAPER #02
Sheet size: ca. 50 x 60 cm
Limited edition of 100 + 10 a.p., signed and numbered